To
Gerald Peck

who helped me to realize that being a man
need not be such a bad thing

SOLDIER HEROES

'This is an innovative and challenging study of popular fantasies of masculinity in the epoch of modern British imperialism. Rich and provocatively written, it is always a compelling read.'
Sally Alexander, University of East London

'A major advance in the theorisation of masculinity and the analysis of its historical forms . . . lucid, stylish and eloquent, the book is an important contribution to cultural analysis and to the long-awaited rapprochement of historical and psychoanalytic understandings.'
Tony Davies, University of Birmingham

Soldier heroes of the modern world have proved potent images of Britishness and the masculine. *Soldier Heroes* presents a ground-breaking exploration of the imagining of masculinities in adventure stories. Its analyses range across biographies and news reports, novels and play fantasies. Drawing on literary theory, cultural materialism and psychoanalysis, it traces a history of British heroic masculinities from nineteenth-century imperialism to the present, and examines their internalization in the lived identities of men and boys.

Graham Dawson is Senior Lecturer in Humanities at the University of Brighton.

SOLDIER HEROES

British adventure, empire and the imagining of masculinities

Graham Dawson

Routledge
Taylor & Francis Group

LONDON AND NEW YORK

First published 1994
by Routledge
2 Park Square, Milton Park, Abingdon, Oxon, OX14 4RN

Simultaneously published in the USA and Canada
by Routledge
711 Third Avenue, New York, NY 10017, USA

Routledge is an imprint of the Taylor & Francis Group, an informa business

© 1994 Graham Dawson

Typeset in Garamond by
Florencetype Limited, Stoodleigh, Devon

British Library Cataloguing in Publication Data
A catalogue record for this book is available from the British Library

Library of Congress Cataloging in Publication Data
A catalogue record for this book has been requested
ISBN 0–415–08881–X (hbk)
0–415–08882–8 (pbk)

CONTENTS

CONTENTS

Part II The hero-making and hagiography of Havelock of Lucknow: Imperialism and military adventure in the nineteenth century

Part III The public and private lives of T. E. Lawrence: The imperial adventure hero in the modern world

CONTENTS

Part IV Soldier heroes and the imagining of boyhood masculinity

FIGURES

ACKNOWLEDGEMENTS

Writing this book has been a lengthy adventure that began back in the early 1980s. I have enjoyed the help and inspiration of many friends and colleagues along the way, but the support of several people in particular has been indispensable. My warmest thanks go to Richard Johnson, supervisor of the doctoral thesis upon which the book is based, for his insight and generosity; to Dorothy Sheridan and Alistair Thomson, whose consistent support since the early stages has made its writing a less anxious undertaking than might otherwise have been the case, and whose sensitive and critical comments from the earliest drafts onwards have enriched and clarified my arguments immeasurably; to Sally Alexander and Tony Davies, my examiners, who have given me their time and encouragement, and the benefit of their experience, far beyond the call of duty; to Claire L'Enfant of Routledge for her confidence in the project and thoughtful advice on its completion; and to Sue Dare, whose meticulous reading of all 'final' drafts has refined the sense and grammar of my prose, and who has sustained me with her love and friendship ever since I resumed work on the project in 1987.

Particular chapters of the book have also benefited at various stages from the criticism of colleagues: I would like to thank Alison Light; Catherine Hall; Mike Roper and John Tosh for their editorial comments on Chapter 6, most of which appeared originally in their collection, *Manful Assertions: Masculinities in Britain since 1800* (Routledge, 1991); Judith Squires for her editorial comments on Chapter 7, most of which first appeared in *New Formations*, 16, Spring 1992; and Paul Thompson for his editorial comments on material used in Chapters 9 and 10, an earlier version of which appeared in *Oral History*, 18/1, Spring 1990. I am also grateful to those who have participated in the numerous forums where I have been able to discuss aspects of the book: at History Workshop conferences, 1984–91; the HOMME (History of Men, Masculinity Etc.) group which met in London, 1988–9; the Work-in-Progress Seminar of the Faculty of Art, Design and Humanities at the University of Brighton, 1992; the Gender and Colonialism conference at the University of Galway, 1992; the Colloquium

on Popular Culture at the English Department, University of Southampton, 1992; and the Seminar of the London Group of Historical Geographers, 1993. I owe a special debt to the Popular Memory Group at the Centre for Contemporary Cultural Studies, University of Birmingham, 1982–5, which formed a crucible for many of the ideas and approaches developed in the book: thanks to Mariette Clare, Chris Glen, Richard Johnson, Jill McKenna, Pat McLernon, Laura di Michelle, Michelle Weinroth and Bob West. Finally, thanks for practical and moral support of many kinds, to Firdaus Azim, Peter Bishop, Graham Blight, Bob Brecher, Glynis Flood, Diane Harris, Jennifer Henley, Becky Johnson, Paul Johnson, the late Jill Johnson, Clare Jones, John McNamara and Andy Porter.

INTRODUCTION
Soldier heroes, masculinity and British national identity

Masculinities are lived out in the flesh, but fashioned in the imagination. Among the many and varied imaginings that have given shape, purpose and direction to the lives of men, I am concerned in this book with only one: the soldier hero of adventure. The soldier hero has proved to be one of the most durable and powerful forms of idealized masculinity within Western cultural traditions since the time of the Ancient Greeks. Military virtues such as aggression, strength, courage and endurance have repeatedly been defined as the natural and inherent qualities of manhood, whose apogee is attainable only in battle. Celebrated as a hero in adventure stories telling of his dangerous and daring exploits, the soldier has become a quintessential figure of masculinity.

Heroic narratives have been given a particular inflection in discourses of the nation generated since the emergence of the nation-state in early-modern Europe. Intimately bound up with the foundation and preservation of a national territory, the deeds of military heroes were invested with the new significance of serving the country and glorifying its name. Their stories became myths of nationhood itself, providing a cultural focus around which the national community could cohere. In England, soldiers such as Shakespeare's patriot king, Henry V, and popular heroes such as Drake, Marlborough, Wolfe, Nelson and Wellington have historically occupied the symbolic centre of English national identity. Later, during the growth of popular imperialism in the mid-to-late nineteenth century, heroic masculinity became fused in an especially potent configuration with representations of British imperial identity. This linked together the new imperialist patriotism, the virtues of manhood, and war as its ultimate test and opportunity. A 'real man' would henceforth be defined and recognized as one who was prepared to fight (and, if necessary, to sacrifice his life) for Queen, Country and Empire.

If masculinity has had a role in imagining the nation, then so too has the nation played its part in constituting preferred forms of masculinity. Those forms of manliness that have proved efficacious for nationalist endeavour have been approvingly recognized and furthered with all the power at the

1

disposal of the state, while other subversive or non-functional forms (notably the effeminate man or the homosexual) have met with disapprobation and repression in explicitly national terms. A dominant conception of masculine identity – the true 'Englishman' – was both required and underpinned by the dominant version of British national identity in such a way that each reinforced the other.[1] Within nationalist discourse, martial masculinity was complemented by a vision of domestic femininity, at home with the children and requiring protection. The nation itself came to be conceived as a gendered entity, analysis of which is necessarily bound up with the theorizing of dominant, hegemonic versions of masculinity, femininity and sexual difference.[2]

Historical imaginings of the soldier hero of adventure and the patriotic mother, made dominant as preferred forms within nationalism, have put down deep roots into the culturally gendered emotions of women and men, surviving two world wars and the advent of the nuclear bomb and the computer-guided 'weapons delivery system'. The continuing resonance in late twentieth-century Britain of heroic national adventure and its gendered imagery of the nation was unequivocally demonstrated by popular support for the 1982 Falklands-Malvinas War. In news stories of the sailing and subsequent trials of the Task Force, the British nation was represented as strong, freedom-loving and prepared (as in the 1940s) to go to war in defence of democratic principles. Amplifying and developing the Thatcher government's patriotic rhetoric, this narrative defined and celebrated Britishness both during and after the war. In its mode of address to the nation, however, it appealed to different components of that nation in different ways, among the most significant of these being gender. A Task Force composed exclusively of men became the representative of the nation's will. British men and women were encouraged, as in the Second World War, to identify with it, and with them, through gendered inflections of the national myth. The 'feminine' narrative stance concentrated on the tearful goodbyes of girlfriends, wives and mothers; on their hopes, anxieties and grief; on their sense of the terrible vulnerability of those they waited for, and pride in their suffering and loss. The 'masculine' version, by contrast, found the military technologies and strategies of the war fascinating, the prospect of battle exciting, and British soldiers, sailors and airmen heroic.[3]

For myself and other socialists of a post-1945 generation, this latest war was a profoundly shocking recapitulation of the imperial past: the nation was mobilized in support of an unnecessary and opportunistic modern war by discursive themes that had been in manifest decline since the Suez Crisis of 1956. I remember watching television with my father in utter disbelief as news of the sinking of HMS Sheffield came through. The unreality of these news reports was matched by the public marginalizing and silencing of voices opposed to the war; by the ferocious denigration of those who did speak out, as 'traitors'; by the flood-tide of xenophobia and racist violence

unleashed throughout the country. The conflict was to be fought 'in our name' whether 'we' wanted it or not. With support for 'our boys' at war become a litmus-test of national belonging, a particular version of Britain and Britishness was powerfully installed and morally policed. Despite active support for the Government by the bulk of the Parliamentary Labour Party, on grounds of national unity, all the political kudos of this national-popular mobilization went to the Conservatives. The left opposition – caught by surprise and split by the collusion of Labour's front bench – found itself unable to mount an effective campaign against the war, not least because of the lack of any credible popular alternative to this resurgent patriotic identity.[4]

The Falklands-Malvinas War constitutes the context in which work for this book was first conceived and begun. Its original motive was a wish to understand how popular support for such a war was possible in post-imperial Britain, fuelled by my desire to see emerge a politically effective refusal of the Britishness asserted and celebrated in this way. In Conservative thinking, British national identity was construed as an unchanging essence of qualities supposedly common to the British people. For this to be contested, an alternative account would need to emphasize instead those material processes, both cultural and political, through which a national collectivity comes to recognize itself as such and secures the affiliations of men and women.[5] Integral to this analysis would be a theorization of national identity as a fundamentally gendered construct, and an exploration of how masculinities and femininities can be mobilized on behalf of the nation.

The work originated and took shape in close relation to the collective project of the Popular Memory Group at the Birmingham Centre for Contemporary Cultural Studies (CCCS), of which I was a member from 1979 to 1985.[6] Developing our conception of popular memory as the cultural significance of the past in the present – produced through the interaction between the particular, 'private' memories of individuals and social groups and the generalized 'public' memories issuing from the state, political parties and the culture industries – we began to study the popular memory of the Second World War and its deployment as a key reference-point in competing versions of Britain. In the period immediately before the sailing of the Task Force, we were working on the relation between different hues of nationalist political discourse about the Second World War (some produced during the war itself) and the subjectivities in play within popular cultural forms.

Of particular interest to me was the intense fascination and excitement generated for men and boys by the military side of the war. This was evident across a wide range of contemporary cultural forms: from the massive popularity of war adventure stories as bestselling fiction, comics, films and television series, to the use of war themes by the tourism and leisure

industries, and by the military themselves, in museums, open days, historic sites and spectaculars such as the Royal Tournament; as well as war play and games, from toy soldiers and modelling to computer games. Images and stories about military war, concerning not only 1939–45 but also countless other conflicts, clearly provided pleasure and excitement for very large numbers of men and boys, to the extent that it seemed feasible to speak of a popular masculine pleasure-culture of war. I began to work on boy culture, hypothesizing that the use of war stories and images provided boys with shared forms of fantasy and play, through which their own masculinity could be imaginatively secured. To grow up a boy in Britain seemed to have meant, for generations, an unavoidable encounter with the potency of national military manhood. Might there be a relation between the fantasies of boyhood, the reproduction of idealized forms of masculinity, and the purchase of nationalist politics?

Under the impact of the 1982 war, this project assumed new urgency and greater clarity. The focus of the Popular Memory Group settled firmly onto the forms of popular conservative nationalism (with a small 'c') and our analyses now began to emphasize the pleasure and comfort of the already known and familiar and the deep pull to 'conserve' an imaginative continuity with the past. These impulses could be seen operating throughout everyday life, among people far from nationalistic, let alone Conservative, by political persuasion. Yet, we argued, they were the source of the emotional purchase of popular conservative national identity, to which Conservative politicians had proved especially adept at speaking. From this perspective, studying the masculine pleasure-culture of war might throw light on the popular adventure narratives of the Falklands-Malvinas War which, being rooted in it and reproducing its forms, would thereby be able to tap these sources of excitement and pleasure in providing frameworks for making sense of the war. In turn, the war might be understood as providing the opportunity to make collective and individual imaginative investments in heroic British masculinity, not just for those already steeped in adventure stories about the Second World War or the post-war, anti-colonial independence struggles, but for a whole new generation of British boys.[7] Pursuing an historical understanding of masculine pleasure-culture and its forms of national adventure, my own study returned to the era of popular imperialism in the nineteenth century, to investigate its emergence, to consider the extent to which its forms survived the First World War, and to trace their continuities and transformations into the later twentieth century.

Given the concern at CCCS to move beyond purely textual analyses of public representations, my study aspired to investigate the cultural conditions in which adventure narratives were produced and consumed, and their heroes constituted and used as figures for identification. The Popular Memory Group began to pursue that problematic question of the consumption and 'use' of cultural forms through the development of a research

method based on our own memories. A long-established interest in the use of life-histories as a tool for exploring subjectivities informed our writing, and subsequent analysis, of autobiographical accounts that aimed to trace our personal connections to popular conservative nationalism. In my own case, a significant personal motive for my work on the soldier hero emerged.

I myself, as a boy, had been deeply involved in the pleasure-culture of war, and some of my earliest and strongest memories of childhood are about playing at war and enjoying war stories on television and in comics. As a teenager I had completely renounced these adventure forms in the name of pacifism, and later of socialism and feminism. Arguments with my father, about whether war films like *The Dirty Dozen* were just harmless fun or served as vehicles for militarism and the celebration of masculine toughness and aggression, made me aware that I continued to make powerful invest-ments (albeit of a negative kind) in these forms. There seemed to be more at stake in our disagreement than the films themselves merited; as if the possibility of our acceptance and recognition of each other depended upon the enjoyment of a shared culture, with mutual misrecognition as the result of my rejecting it. I began to wonder whether I might not secretly still rather enjoy war stories and whether my rejection of them might not be motivated by a search for other forms of recognition. If so, what implications might this have for my own masculinity, my sense of 'being British' and my ways of thinking about social identities in general? I became curious about what happens to identities that have apparently been superseded. Are their forms sloughed off like a snake's skin, or do they persist, continuing to exert a pull, in contradiction to new and preferred forms of imagining the self? My investigation of these issues now began to take the Gramscian form of exploring the self as a jumbled repository of unsorted traces from the past, and the compilation of an historical inventory;[8] and so meshed with my wider enquiry into the historical origins, use and effects of the adventure form.

If the agenda of the present book was established in this context, pursuing it to completion has taken me far from its original conception. The book does not attempt, as I first envisaged, to provide a comprehensive linear history of the forms and vicissitudes of British adventure over the last 150 years; nor does it deal directly with the Falklands-Malvinas War, the Second World War or most of the numerous other wars Britain has fought during this period. Returning to the study in 1988, after a three-year hiatus follow-ing the dissolution of the Popular Memory Group, it became apparent that I needed to develop a more persuasive account of the relation between changing historical forms of adventure narrative and the imagining of mas-culine subjectivities. This involved theoretical clarification of how adventure can be described as a 'fantasy'; how what is usually taken to be an exclus-ively psychic phenomenon could also be understood as a cultural phenom-enon shaped by socio-historical as well as psychic determinants; and how

these determinations interact in processes of representation, identification and recognition. Detailed exploration of these processes at work in historically concrete contexts, as they shape the cultural production and circulation of 'public' imaginings, and the consumption and use of these forms within 'private' fantasies, was then necessary. These concerns have precluded a more comprehensive mapping of forms and prompted instead a rather different methodology and mode of presentation, the aim of which is to elucidate how we might think of fantasy historically, and explore the interrelation of the public and the private, the social and the psychic.

Part I of the book establishes a language and conceptual framework for this investigation, while Parts II, III and IV each focus on a real historical person and the adventure narratives through which they were imagined – or imagined themselves – as 'soldier heroes'. In Part II, I take Sir Henry Havelock, leader of the Relief of Lucknow during the Indian Rebellion (or 'Mutiny') of 1857, as the prototype of those Victorian imperial soldier heroes who played such a powerful role in national imaginings before the First World War. My focus is on the production of Havelock as a public figure, the emergence of a stable 'heroic image' from the conflicting versions of his 'life and adventures', and the subsequent retelling of the Havelock story to new audiences between 1857 and 1914. In Part III, I trace the adventure tradition across the watershed of 1914–18 into the 'modern' period, through the stories told about my second hero, T. E. Lawrence. I analyse the form and determining conditions of the Lawrence of Arabia legend, examine its complex inter-relation with the fractured and contradictory lived masculinity of T. E. Lawrence himself and trace the impact of far-reaching changes in the imagining of Empire between the 1920s and 1960s on retellings of his story.

While the investments made by audiences in these heroes is part and parcel of their popularity, both these case studies are primarily interested in the way that the psychic and the social intermesh in the cultural production of powerful public narratives for a national (indeed, international) stage. Detailed consideration of the moment of consumption – when such narratives are used by, and work upon, their readers – is developed in Part IV. Here, I examine the place of heroic fantasy within the psychic economy and in wishful imaginings of a secure and coherent masculine identity, through an autobiographical case study about my own formation in boy culture of the late 1950s and the 1960s. Autobiography enables an 'internal' approach to the imaginative investments made in soldier heroes, within the social relations of family, school and neighbourhood that constitute a child's world. In exploring these fantasies of boyhood masculinity, I also reflect upon the continuing 'life' of these investments into adulthood, and the extent to which their presence or absence affects critical analysis of adventure narratives. The three studies should be read, therefore, as distinct but complementary perspectives on the complex dialectical process whereby the

idealized masculinities of adventure are produced, circulated and used in everyday life, being at once psychic fantasy and a cultural commodity, the product of the unconscious as well as of culture industries.

I have chosen to develop my argument through biographical (and auto-biographical) narratives rather than 'literary' adventure for a number of reasons. One is the relative neglect of biography in cultural studies, despite it being perhaps the most popular form of history-writing. This is especially noticeable in studies of the narratives of Victorian imperialism, which until recently have concentrated predominantly upon imaginative fiction.[9] Biography also offers particularly interesting possibilities for exploring the inter-relation of textual representations of masculinity and its lived forms. Stories told about 'real people' have, I believe, greater resonance as (to use the Victorian expression) 'exemplary lives'; and when these real people who come to be narrated as 'heroes' have themselves identified with and been inspired by the exemplary lives of other men, the circuit of imagining takes on a peculiarly rich texture. By focusing on the narration of real lives, it is possible to explore their fascinating overlap with the explicitly fictional – that blurring of the distinction between 'fact' and 'fiction', 'real' and 'imaginary', which has come to be such an intense preoccupation of our contemporary Western culture. In this respect, the strikingly different relations of the living man and boy to his heroic image in each case are also important. In Havelock, we have a 'frontier hero' who barely lived long enough to learn that he had been recognized as such. The stories told about him were entirely unencumbered by his own investments in their telling. In Lawrence of Arabia, by contrast, we can study how a man becomes embroiled in the creation of a hero-figure that is initially his own, but is taken over and transformed by the investments of others, from which he can never subsequently free himself. My autobiographical study poses the question of 'real' and 'imaginary' in the formation of subjectivity in a particularly acute way, given the discrepancy between the imagined identity of a heroic soldier and the actual social position of a little boy.

The book aspires to draw from and connect areas of study that are more commonly kept separate. My study of adventure narratives straddles the divide between fact and fiction, criss-crosses between 'high' and 'popular' culture, and focuses on a variety of forms in both linguistic and visual media. These include biographies, novels, sermons, comic books, press reports, feature films and play fantasies. In methodological terms, I make use of textual analyses of narrative and genre developed in literary and media studies; develop a cultural materialist history of the transformation of forms within specific conditions; and draw upon Kleinian psychoanalysis to understand subjectivity. It is by establishing a dialogue between these different methods of study that I hope to make a contribution to the understanding of masculinity and national identity.

Despite the shift of focus outlined above, the Falklands-Malvinas War has

remained the primary cultural and political reference-point for the book throughout the lengthy period of its writing. Meanwhile, the politics of national identity has inevitably taken new configurations. The agenda of the early 1990s is dominated as never before by Britain's relation to Europe and its implications for internal relations between the so-called 'regions' of the so-called 'United Kingdom of Great Britain and Northern Ireland', rather than by aspirations to retain World Power status. Nevertheless, recent developments have also underlined the continuing importance of Britain's colonial past to current conflicts over 'being British' and over the policies that the British state sees fit to pursue in our name on the international stage. As I was completing the first version of this work, a doctoral thesis, in early 1991, British bombers returned to the skies over Iraq, the scene of the RAF's first experiments with saturation bombing upon the villages of rebellious tribespeople in the 1920s. Although the Gulf War following the Iraqi occupation of Kuwait differed markedly in both political and military terms from the 'Falklands adventure', the roots of both conflicts stretch into the colonial past, as does British readiness to use military force in these regions and the language in which this is justified at home and abroad. Within the United Kingdom itself, the *Satanic Verses* furore highlighted a complex of contradictions concerning the place within Britishness of peoples originating from the ex-colonies; while perhaps the most intractable political problem of all remains, in 1994 as in 1982, the colonial legacy of discord and violence engendered by British rule in Northern Ireland. In the course of writing this book I have become increasingly persuaded that the history of Empire continues to maintain a determining influence over cultural and political life in modern Britain. The book will, I hope, contribute to the better understanding of that influence, and suggest some of the ways in which the national past may persist in the psychic lives of post-imperial generations.

Part I

Soldier heroes, adventure and the historical imagining of masculinities

What qualities are there for which a man gets so speedy a return for applause, as those of bodily superiority, activity and valour? Time out of mind strength and courage have been the theme of bards and romances; and from the story of Troy down to today, poetry has always chosen a soldier for a hero. I wonder is it because men are cowards in heart that they admire bravery so much, and place military valour so far beyond every other quality for reward and worship?

<div align="right">William Makepeace Thackeray, Vanity Fair (1848)[1]</div>

One feature above all cannot fail to strike us about the creations of these story-writers: each of them has a hero who is the centre of interest, for whom the writer tries to win our sympathy by every possible means and whom he seems to place under the protection of a special Providence. If, at the end of one chapter of my story, I leave the hero unconscious and bleeding from severe wounds, I am sure to find him at the beginning of the next being carefully nursed and on the way to recovery; and if the first volume closes with the ship he is in going down at sea, I am certain, at the opening of the second volume, to read of his miraculous rescue – a rescue without which the story could not proceed. The feeling of security with which I follow the hero through his perilous adventures is the same as the feeling with which a hero in real life throws himself into the water to save a drowning man or exposes himself to the enemy's fire in order to storm a battery. It is the true heroic feeling . . . [that] 'Nothing can happen to me!' It seems to me, however, that through this revealing characteristic of invulnerability we can immediately recognize His Majesty the Ego, the hero alike of every day-dream and every story.

<div align="right">Sigmund Freud, 'Creative Writers and Day-dreaming' (1908)[2]</div>

Had he [Churchill] been entirely serious, I wondered, when he said that 'war is the normal occupation of man'? He had indeed qualified the statement by adding 'war – and gardening'.

<div align="right">Siegfried Sassoon, Siegfried's Journey (1945)[3]</div>

1

SOLDIER HEROES AND THE NARRATIVE IMAGINING OF MASCULINITIES

Masculinity and narrative in nationalist discourse

Within nationalist discourse, narratives about soldier heroes are both under-pinned by, and powerfully reproduce, conceptions of gender and nation as unchanging essences. The importance of essentialist conceptions of gender to the discourse of traditional British nationalism becomes evident in the unlikeliest of contexts. Early in 1981, for example, the first Thatcher government introduced in Parliamentary Committee its British Nationality Bill, by which it sought to redefine the notion of British citizenship. Hitherto, this had been an automatic and inviolable right of babies born in Britain, regardless of the nationality of their parents. The bill provided for citizenship in future to be exclusively dependent upon that of the parents, but it broke with precedent in allowing transmission to occur through the mother as well as the father. The bill, which became an Act effective from 1 January 1983, was widely attacked as a racist measure designed to further restrict the citizenship rights of black people from the new Commonwealth and their descendents.[1] At one point in the Committee debate, however, the complex and contentious issue of British nationality in the post-colonial world appeared to hinge upon the question of whether or not women were able to fight for their country.

The context was an amendment moved by the Ulster Unionist MP Enoch Powell, who sought to delete from the bill all reference to transmission of citizenship through the mother.[2] Such provision, Powell argued, was based on two 'dangerous and destructive . . . myths which are inconsistent with the nature of man and human societies'.[3] The first of these myths is that nationality can be defined other than as a matter of allegiance to a nation-state, the ultimate test of which is military service 'in the life and death conflict between nations'.

> Nationality, in the last resort, is tested by fighting. A man's nation is the nation for which he will fight. His nationality is the expression of his ultimate allegiance. It is his identification with those with whom he will stand, if necessary, against the rest of the world, and to whose

11

survival he regards the survival of his own personal identity as subordinate.

The second myth is that of discrimination against women. That this military form of collective identification and expression is exclusively open to men rests, Powell suggested, not upon discrimination, but upon 'the essential specialisation of the two sexes of our race'.[4]

> One of the essential differentiations of function is that between fighting on the one hand, and the creation and preservation of life on the other. The two sexes are deeply differentiated in accordance with those two functions. . . . One is specialised – to use an old-fashioned expression, but it will do for now – to bear arms, specialised for all the attitudes of killing and all the social emotions that are associated with the conduct of war. The other is specialised – however much it may sustain the society in that conflict – to the preservation and care of life.

Women are no less patriotic than men, no less committed 'to the national cause' and no less inclined to defend their country when under threat. The point is, Powell insisted, that the two sexes are specialized to serve their country by different means.[5]

Powell's argument offers a perfect example from contemporary political debate of that apparently residual conception of the gendered nation which informed the discourse of nationalism during Britain's imperial heyday. The confidence of its assertion here continues to derive from its philosophical foundation in two interdependent forms of essentialism. A racial, indeed Social Darwinist, conception of the essential being of the nation is at once grounded upon and helps to underpin supposedly 'natural' divisions of gender, in which womanhood and manhood are reduced to their fundamental, almost archetypal, functions of mother and soldier respectively.[6] Labour MP John Tilley objected, unsurprisingly, that Powell's argument bore relation neither to the realities of modern warfare nor to the real grounds for people's sense of national belonging and identity; and Conservative MPs, too, pragmatically distanced themselves from the more archaic elements of Powell's position. Although his amendment was defeated, it is apparent, reading the debate, that some of his arguments continued to exercise a deep emotional attraction for some Committee members. While Tilley denounced as sexist what he referred to, in a memorable phrase, as Powell's 'caveman-like distinctions' between men and women, the Home Office Minister, Timothy Raison, mounted a spirited refutation of Opposition claims that negative gender stereotyping contributed to discrimination against women. 'What are now described as the stereotypes of womanhood and manhood embody, or are expressed by, some of the supreme ingredients of our civilisation. Therefore to try to destroy these notions that permeate our

culture is nonsense.' Despite this, Raison had to concede that times were a-changing in warfare:

> At the heart of the old-style battle was simply the question of brute force. Of course courage, skill, tactics and all sorts of other things came into it, but the old-style fighting essentially depended on who was stronger. In those circumstances men would of course be stronger and their role in war would always be supreme. But nowadays it is changing.
>
> I am not particularly keen to think of women playing an active part in the Armed Forces, but . . . it is now acknowledged that they may be able to use weapons. . . . Nowadays the finger on the trigger – or on the button for that matter – can equally well be male or female.[7]

Politically unwilling to follow Powell's defence of traditional premisses to its logical conclusion, Raison's deep unease at the implications of his own reasoning is evident, and is hardly assuaged by his subsequent reference to Mrs Thatcher herself, the current Commander-in-Chief of the British Armed Forces.

The idea of the martial woman is deeply transgressive of traditional gender identities.[8] But it is also subversive of the essentialist conception of British national identity that lies at the heart of contemporary Conservatism. This is sustained by Whiggish historical narratives telling the story of the progress of the island race, never conquered since 1066, which established a bastion of freedom against tyranny and successfully defended it against successive waves of invaders, Spanish, French and German; which gave the world democracy, industry and free trade; and which exported its own superior way of life for the benefit of a quarter of the globe. This epic myth is held to express the very essence of national identity and the national character in the catalogue of its achievements. The master narrative of Britishness, it is constituted by numerous micro-narratives about the nation's Great Men: the success stories of poets and politicians, administrators and engineers, and of course soldiers and sailors. With the occasional, troublesome exception of a Queen Bess, a Florence Nightingale or a Margaret Thatcher, the national epic has been predominantly a man's story, and masculine prowess the dominant expression of national character.[9]

The theme of a national epic was a key motif in early Thatcherism. It underpinned an essentialist discourse of Britishness that had been strategically pivotal in establishing the New Right and securing its popular base during the 1970s. The Thatcherite inflection of the myth told of national decline from that previous greatness as a direct result of the Labour victory in 1945. This provided the foundation-stone for the Conservative ideological assault on social democracy, which bore fruit in the 1979 election and gave coherence to the programme of the Party in office. Versions of who 'we, the British people', essentially are and of our 'common' values and the sources

13

from whence these are threatened, were mobilized across the spectrum of policy, from the economy and 'law'n'order' to immigration and defence. The Second World War itself featured prominently as the last truly heroic chapter in the story. Drawing on the vigorous popular memory of the war, pervasive in British culture during the 1970s and 1980s, Margaret Thatcher and other leading Conservatives evoked the 'wartime spirit' of Churchill, Dunkirk, the Battle of Britain and the Blitz, as embodying the essential, valued qualities of national character. Claiming themselves to be the heirs of that generation – with Thatcher, famously, cast in the role of Churchill – the Conservatives promised to restore the nation to its rightful course and open up a new chapter of the epic.[10]

In the elaboration of Tory defence policy (always a notable ground for the reworking of national memories), British rearmament during the second Cold War was legitimated in comparisons of the Soviet Union to Nazi Germany. Thatcher argued that 'the strategic threat to Britain and her allies from an expansionist power was graver than at any time since the last war', and that 'the survival of our way of life' was at stake.[11] Two weeks after the meeting of the Nationality Bill Committee, during a major Commons debate on defence policy, Enoch Powell spoke in support of the proposed upgrading of the British nuclear arsenal through the Trident programme, by arguing not about 'technology or even military strategy', but about national identity.

> For the last thirty or thirty-five years, consciously or not, Britain has been seeking a substitute, something to replace what it imagined that it had lost; looking in one direction and another for a surrogate for Empire, for the means to believe that we are still strong and great as we used to tell ourselves in those years that we were. . . . The debate will be part of an attempt by this nation to rediscover its true self.

Against this disturbing theme of imagined loss – where Empire appears to assume the nostalgic shape of a beloved mother, source of succour and strength, the return to whom is yearned for amid substitutes that never suffice – Powell asserted that Britain is 'inherently immensely strong'. Acquisition of a genuinely 'independent' nuclear capability (free from American interference) would guarantee that 'we' remain 'invincible' and 'a formidable power in the world'.[12]

A year after these debates, the opportunity came for the British nation to rediscover itself, not by the flexing of nuclear muscles but in the traditional way, through what Timothy Raison had called 'old-style battle' in the Falkland Islands. In her notorious 'victory speech' at Cheltenham Racecourse, Thatcher could claim to have done what she had promised, re-awakening the nation to its essential greatness of spirit.

14

When we started out, there were the waverers and the fainthearts. The people who thought that Britain could no longer seize the initiative for herself. . . . that Britain was no longer the nation that had built an Empire and ruled a quarter of the world. Well they were wrong. The lesson of the Falklands is that Britain has not changed and that this nation still has those sterling qualities which shine through our history. This generation can match their fathers' and grandfathers' abilities, in courage, and in resolution. We have not changed. When the demands of war and the dangers to our own people call us to arms, – then we British are as we have always been – competent, courageous and resolute.[13]

Military victory in the Falklands gave Powell's archaic essentialisms a renewed lease of life, a fresh charge of emotional energy, exploited by Thatcher in her rhetorical shift of pronoun from 'they' to 'we'. The outcome of the war enabled a withering, residual form of identity to develop a growing tip which offered an organic connection with the energies that transfigured the past. This was not a nostalgic version of the nation, but one that connected to feelings of loss and decline in order to transform them: Britain has *not* changed; the British people have shown that they *still* possess the essential qualities that have always defined who they are. In mobilizing a collective identification with this version of the nation, the demonstrable continuities lie with our 'fathers and grandfathers': the celebration of national greatness is simultaneously a celebration of national manhood.

Traditional narratives of men and the nation at war appeared once again capable of offering an effective orientation within real conflicts in the present. By this means, an essentialist conception of masculinity was reinstated as a powerful component in the contemporary repertoire of British nationalism, and one that any effective critique of that politics ignores at its peril. Underpinning this possibility lies the deep-rooted popular conception that narrative simply expresses an identity that really exists, independently of its representation. The resonance of narratives like those of the Falklands-Malvinas War depend upon a continuing willingness to see stories about British soldier heroes as expressions of a national essence.

Feminism, fantasy and narrative

Contemporary critical writing about masculinity that sets out not to celebrate but to understand it almost invariably takes its orientation from feminism. Feminist politics and the scholarship derived from it have been almost single-handedly responsible for 'making men visible as gendered subjects' – without which a book like this would have remained inconceivable.[14] Yet its legacy has been an ambivalent one for men who, being sympathetic to feminist concerns and influenced by feminist thinking, have wanted to work through the implications for their own lives and identities.

Post-1968 feminism has placed a fundamental emphasis on the intimate correlation between the subjectivities and everyday behaviour of men and the social structures and institutions through which the collective subordination of women is effected. This important and productive connection, however, could all too readily freeze into a reductive equation in which masculinity and patriarchy became virtually interchangeable, with masculinity as such being understood as an expression of 'male power' within patriarchal society.[15] This tendency is less evident in feminist accounts sensitive to the interconnection of patriarchal structures with other historically specific relations and identities (of class, race and nation) than in radical feminist accounts that seek to make gender their primary or exclusive focus. These locate the source of patriarchy in a transcultural masculine nature, understood as a kind of will-to-power stemming from male aggression and issuing in acts of violence and destruction. Female nature, by contrast, is associated with love, nurturance and the principle of life itself.[16]

Radical feminism was a particularly influential position during the early 1980s, when it gave rise to a distinctive analysis of the renewed Cold War arms race. This was described, not as the outcome of a power struggle between the capitalist West and the Soviet bloc, nor as the result of economic and organisational pressures exerted on government by a 'military-industrial complex', but as a process run by 'white, educated men' and determined by their 'male rivalry' and 'ambition'.[17] Nuclear arms were seen to be only the most dangerous manifestation of a masculine pathology that takes many other forms:

> These men *could* kill us all with their nuclear weapons, but they are killing us right now by other means. In many parts of the world they are practising non-nuclear warfare, organised torture, and genocide. In Britain this direct sort of violence is limited mainly to police brutality, rape, incest, beating and individual murder by individual men. And from their fantasies, from the unavoidable beat-'em-up cops and robbers series on television, the war comics produced just for boys and the phenomenal amounts of sadistic pornography produced for men, it seems that men don't feel at all guilty about their violence. Rather, they seem to revel in it.
>
> This violence is at the core of the hierarchies that produce and maintain the bomb. It provides an affirmation and a reinforcement of the more subtle methods that the men in the nuclear arms race use – the seeking to control through status, wealth, and the power of nuclear weapons.[18]

The feminist peace slogan 'Take the toys from the boys' encapsulated this vision of the links between powerful public institutions, everyday social relations and the fantasies and desires for power of boys and men. It helped focus a political argument that feminists needed to move beyond calls for

16

disarmament alone, to 'challenge the men, the values [and] the institutions that created the bombs [and] . . . violence in all its forms'.[19] From this perspective, the adventure story, whether telling of soldiers or any other male hero, is understood as a form coining violence into pleasure and expressive of male power.

This analysis contributed to the mobilization of significant numbers of women in campaigns against 'male violence', the most popular being the women's peace movement against militarism and nuclear weapons, focused on the Women's Peace Camp at Greenham Common.[20] With its internationalist concept of women's solidarity – inspired by Virginia Woolf's anti-militarist assertion, that 'as a woman, I have no country, as a woman I want no country. As a woman my country is the whole world'[21] – it was able to issue an important challenge to the nationalist underpinnings of Thatcher's rearmament programme (while finding the phenomenon of Thatcher herself somewhat harder to engage with). Paradoxically, however, radical feminism – in itself promoting a view of essential differences between 'male' and 'female' – shared much common ground with the dichotomies of gender found within nationalist discourse. A conception of the fundamentally martial nature of masculinity remained in place, the values ascribed to it being merely reversed from positive to negative. Where nationalism lauds the soldier as its ultimate expression, radical feminism denigrates him as the quintessence of masculine brutality.[22] The naturalized equation of masculinity, military prowess and the nation is thereby effectively cemented. Sharing its ontological premises about gender, the challenge posed to nationalist politics by radical feminism was necessarily muted.

A further effect of feminist essentialism, which I myself experienced with some urgency, was to foreclose any possibility of theorizing alternative or oppositional masculinities. Like nationalist versions of British national identity, 'masculinity' was here conceived as a homogeneous collective identity having a single public face. This universalist abstraction was then offered as a description of 'men in general', without regard for differences in the identities, modes of behaviour or collective affiliations of actual men in their particular social circumstances. There was no possibility, here, of distinguishing men sympathetic to feminist concerns from those hostile to them; or pacifists from militarists; or men who enjoyed 'cops and robbers' stories from murderers. In this discourse, all men were guilty of violence, simply by virtue of being men: immutably fixed in, and defined by, their 'male power' for all time, without prospect of a transformative practice.[23]

One especially disabling result of this analysis was the inability, or refusal, to draw any distinctions between fantasies and real relationships and actions with consequences in the social world. Practices like the reading of comics and watching of television can be equated with killing and raping only if their symbolic and metaphorical character is not recognized. The corollary of this attempt to link narratives, fantasies and desires to social structures

was, paradoxically, to deny any autonomy to the psychic dimension of masculinity. This tendency is evident even in far more subtle cultural analyses, of forms such as adventure romance, based on radical feminist premises. A 'correspondence' is posited between this particular form of narrative, described as a 'masculine' genre, primarily concerned with the values and codes of masculinity – with, that is, 'male camaraderie, rivalry and contest' – and the 'lived ideology' of masculinity.[24] Here, adventure narratives become the simple expression of an ideology which also shapes lived identities that are rooted in oppressive social relations. Like the critique of male violence, this argument reifies masculinity as a generalized abstraction which it proceeds to equate with, and read-off from, fictional heroes and 'lived' forms alike. This is to take fantasies of heroic masculinity too much at face value and loses the opportunity to investigate them as idealizations. Through the notion of correspondence, the attempt to relate narrative imaginings to real social relations effectively abandons any sense of autonomous existence for fantasy. Its forms are reduced entirely to the effects of external social determinants and the psychic dimension to their existence disappears completely from view.

The motive behind such arguments was clearly to contest the complacent common-sense view that fantasy occupies a realm completely divorced from 'real life' and has no social repercussions. By this measure, a violent adventure story can be dismissed as 'harmless escapism': it is, after all, 'just a fantasy'. Other critical approaches, notably structuralist analysis of popular genre fiction, have effectively endorsed this view in arguing that these stories invite us to enter an imaginary world where we can 'temporarily forget about our own existence'. This 'can be for many people a profound experience in self-transcendence, a complete forgetting of the self, in the intense and momentary involvement in an external fantasy. . . . The more intense an experience is, the more it takes us out of ourselves.'[25] Within these opposing assessments articulated in critical debate about popular adventure fiction, it is possible to identify the horns of a dilemma that besets the wider field of thinking about fantasy, and indeed cultural forms of all kinds, which it is necessary to move beyond.

Their disagreements rest upon the competing paradigms of historical and structural analysis. In structural approaches, the fantasies embodied in narrative form tend to be granted autonomy from the 'real world' of social life (even if their forms are seen to shape human consciousness of that reality, by providing cultural 'maps' that render it meaningful); narratives constitute a self-contained and self-referential system of inter-related forms and conventions, grasped in its own terms as if free from any external determining contexts. In historical approaches, on the other hand, narratives are understood as a range of socio-historical forms, and their imaginings are related back to specific social relations, as their product or, in the tightest formulations, as their reflection. At stake in these differences about the

structural or historical roots of narrative are deeper disagreements about the relative weight of psychic or social determinations in giving shape to forms of imagination.[26] How might these be reconciled in a single analysis?

To suggest that radical feminist analysis over-emphasizes the historical shaping of adventure within social relations of domination and subordination, at the expense of giving due consideration to its psychic significance, is not to deny the validity of a political reading of gendered fantasies, but to identify the need for more subtle accounts of the relation between the psychic and the social. This failing has been systematically addressed in other feminist work on narrative, developed in the fields of cultural studies, literary criticism and social history, which has endeavoured to give full weight to the significance of the psychic domain. Much of this work draws upon psychoanalysis and has been influenced by post-structuralist theories of discourse and subjectivity. It is this strand, exemplified in the work of Valerie Walkerdine, Cora Kaplan and Carolyn Steedman, that has been most influential for my own project.[27]

One of the main thrusts of these feminist approaches to narrative has been an attack on the realist assumptions that give rise to literalist readings: those, that is, that look for direct mimetic connections between a text and the real world about which that text ostensibly speaks. Writing about the importance of 'the refusal of textual realism' for feminist literary criticism, Cora Kaplan argues that the literary text should be seen as

a system of signs that constructs meaning rather than reflecting it, inscribing simultaneously the subjectivity of speaker and reader. Fiction by bourgeois women writers is spoken from the position of a class-specific femininity. It constructs us as readers in relation to that subjectivity through the linguistic strategies and processes of the text. It also takes us on a tour, so to speak, of a waxworks of other subjects-in-process – the characters of the text. These fictional characters are there as figures in a dream, as constituent structures of the narrative of the dreamer, not as correct reflections of the socially real.[28]

Similarly, Carolyn Steedman has rescued from literalism the significance of storybook kings and queens, whether these appear in fairytales or school histories. Drawing on Freud's essay, 'Family Romances', Steedman suggests that children use these narratives to give form to their own intimate fantasies concerning the relative power and social standing of their parents, and thus of their own position in a social world differentiated in terms of class and gender.

Freud noted . . . the connection in form between these imaginative constructions and 'historical intrigues' – the dramas of revenge and death and triumph that control the heroic narrative of conservative history. The bravery of kings, great queens weeping, the world narrowed to an island, the figures on the stage moved by incomprehensible yet easily

labelled motives – greed, wickedness, folly – the heroic history that the child finds between the pages of her textbook, and embodied in its illustrations, may perhaps serve her in something of this way, enable her to manipulate her own family drama, and make it work to her own greater satisfaction.[29]

Narrative in Steedman's hands is an 'interpretative device'[30] through which the possible and the impossible, the wished-for and the feared may be registered and articulated, and the discrepancies between psychic and social realities given expression.

One of the clearest refutations of realism, so as to clear a space for analysis of the textual construction of gendered subjectivity, can be found in Valerie Walkerdine's work on the stories found in girls' comics such as *Bunty* and *Tracy*.[31] Writing about their imaginative significance for the working-class, prepubescent girls who read them, Walkerdine dismisses criticism that finds in these narratives only distorted stereotypes and fantastical circumstances apparently bearing little relation to the girls' real lives.

> Realist approaches to reading, which prevail in the radical work on children's fiction, treat readers as pre-existing classed, gendered and racial subjects who are formed through certain material relations of production, who have a 'lived reality', a material base, which stories help or hinder. It is in this sense that we can understand the movement towards more 'real' texts which 'reflect the reality' of (predominantly) working-class life. What, then, are these children, faced with what is represented as their 'reality', to do with such texts? What if the readers do not 'recognise themselves' and their lives in the stories, or what if they do not *want* to recognise? And what about desires to have and to be something and somebody different? Classical fairy tales are quite fantastic: they do not bear any resemblance to the lives of ordinary children. Yet they act powerfully to engage with important themes about 'what might be' . . . they engage with the very themes, issues, problems, fantasies (of escape, of difference) which the realist, 'telling it like it is' stories do not engage with at all.[32]

She proposes instead an analysis that operates at the level of fantasy and 'the psychic organisation of desire'. This is not construed in terms of escapism. On the contrary, the narratives in comics are seen to engage with the 'difficult emotions and less than perfect circumstances' encountered by their readers in their everyday lives. They relate to 'existing social and psychic struggle' not by offering an accurate diagnosis and a rational solution, but by displacing them into an imaginary world that the reader may enter through identification with characters and their fictitious circumstances.[33] By this process, the reader is provided with imaginary positions in which conflicts can be safely explored and worked through to a potential resolution. In its

movement towards resolution, a narrative constructs wished-for outcomes to its own scenarios of conflict, and as such constitutes, through its own form, specific modes of desire. The femininity of working-class girls, according to this account, is not a predetermined effect of their social position, but an imaginative construct. It is produced through the interaction of these psychic processes with the social pressures of material life, as girls strive to locate themselves within the family, school and the wider locality.

Although work on masculinities of comparable subtlety to the best feminist accounts of femininity has barely begun, one suggestion of the direction it might take can be found in Carolyn Steedman's essay on nineteenth-century soldiers' stories.[34] Her interest is in those told by working-class men of their times in the army, often in parts of the Empire remote from the experiences of their own communities. These, she argues, are among the only stories that poor and unimportant men have been allowed to tell with any certainty of meeting the narrative expectations and desires of a public audience. Pointing out that in nineteenth-century Britain the actual experience of soldiering was relatively rare, Steedman notes that being a soldier had become 'the very epitome of manhood'. Soldiers' stories, she suggests, can best be understood as 'the most common metaphorical expression of a man's life'.[35] In her account the soldier is considered as a symbolic as well as a literal figure: no longer the simple embodiment of innate male violence, but the inhabitant of an imaginative landscape where many kinds of psychic scenario may be staged.

For Steedman herself, these are primarily narratives of class rather than masculinity. They tell of 'terrible and sickening privations' and of 'powerlessness, and the situations that the powerless can get into, those places where people can do things to you, and with you, as if you were not properly human'. This metaphorical resonance is far from gender-exclusive, but speaks across gender boundaries, about 'what they can do to us' and 'what might happen to me'.[36]

> Soldiering is at once an experience that is absolutely divisive sexually, and is at the same time the experience that we all know about, whether we be men or women. . . . The [soldier's] story has a power that cuts across gender, and tells of life's struggles, in isolation and far from home, the body and its needs carried through that dark night, at the end of which it is not certain that death will be evaded. . . . a drama of alienation, journeying and arrival, . . . a tale about the compulsion of conflict.[37]

This metaphorical power is seen to stem not from the 'aboutness' of the story's apparent content, but from its underlying narrative structure of alienation, journeying, arrival and conflict. The imaginative significance of this structure is not divorced from its social context, but is seen to be imbued with a quality deriving from a shared social experience of powerlessness, which explains its resonance for others. Read in terms of class-specific

masculinities, the imaginative quality of conflict within these landscapes of suffering and struggle is in sharp contrast to the *joie du combat* found in the figurative landscapes of adventure that are my concern. Seen in these contrasting modes, the soldier now appears as a complex, nuanced imaginative figure, and soldiers' stories as modes for imagining alternative forms of masculinity.

Composure, recognition and the narrative imagining of masculinities

My own approach to narrative and gender derives from the assumption that these feminist accounts of class-specific femininities can be read as guides to a more general process, whereby boys and men, as well as women and girls, endeavour to locate themselves imaginatively within their complexly structured social worlds. This is what I mean by the narrative imagining of masculinities. As *imagined* forms, masculinities are at once 'made up' by creative cultural activity and yet materialize in the social world as structured forms with real effects upon both women and men. As *narrative* forms of imagining, they exist in a temporal dimension of flux and dynamic contradictions, within which men make efforts towards a degree of continuity and composure in psychic life.

Accounts of narrative as a general category have tended traditionally to centre upon its cognitive function in the shaping and organizing of temporal experience, but it is now possible to identify this as one aspect of a broader imaginative process suggested in the double meaning of the verb 'to compose'.[38] The cultural importance of storytelling lies not only in the stories we are told, in published modes such as the comic, the press report or the school history, but also in those we ourselves tell, or compose. It is a cultural practice deeply embedded in everyday life, a creative activity in which everyone engages. Even the most mundane of narratives is an active composition, created through the formal arrangement of narrative elements into a whole. In composing a story of the day's events, for example, a complex process of selection, ordering and highlighting gives prominence to some events over others and interprets their significance, thereby making sense of an objective world. At the same time, the telling also creates a perspective for the self within which it endeavours to make sense of the day, so that its troubling, disturbing aspects may be 'managed', worked through, contained, repressed. In this process, events themselves may become inseparably bound up with the storyteller's fantasies, becoming the site of imaginary scenarios with desired and feared outcomes, narrated 'as if' they had 'really' happened in just this way. These fantasy investments represent a range of possible selves, some powerful and effective in the social world, others threatened and at risk. In this second sense, then, storytelling also 'composes' a subjective orientation of the self within the social relations of its world, enabling it

to be imaginatively entered-into and inhabited. The story that is actually told is always the one preferred amongst other possible versions, and involves a striving, not only for a formally satisfying narrative or a coherent version of events, but also for a version of the self that can be lived with in relative psychic comfort – for, that is, subjective composure.

The effort towards composure is an inescapably social process. Stories are always told to an audience, actual or imagined, from which different kinds of response and recognition are elicited. Subjective composure fundamentally depends upon social recognition, with its power to confirm that the versions of self and world figured in a narrative correspond to those of other people; that they not only exist in the imagination of the storyteller, but resonate with the experience of others, as shared, collective identities and realities. Different kinds of recognition are forthcoming from variously constituted audiences, or publics. The recognition that one of the returning soldiers described by Steedman might expect to elicit in the intimacy of his own family or community, where soldiering would be a comparatively novel experience and the storyteller able to occupy the exotic identity of the wanderer returned, would differ markedly from that available in his regimental public, among comrades who had directly participated in those experiences with him. The social recognition offered within any specific public will be intimately related to the cultural values that it holds in common, and exercises a determining influence upon the way a narrative may be told and, therefore, upon the kind of composure that it makes possible. The narrative resource of a culture – its repertoire of shared and recognized forms – therefore functions as a currency of recognizable social identities.

The narrative imagining of lived masculinities is powerfully shaped by such a repertoire of forms. It organizes the available possibilities for a masculine self in terms of the physical appearance and conduct, the values and aspirations and the tastes and desires that will be recognized as 'masculine' in contemporary social life. Being subjectively entered-into and 'inhabited' through identification, the cultural forms of masculinity enable a sense of one's self as 'a man' to be imagined and recognized by others. Since the imagining and recognition of identities is a process shot through with wish-fulfilling fantasies, these cultural forms often figure ideal and desirable masculinities, in which both self and others may make investments. Men may wish and strive to become the man they would like to imagine themselves to be. They may also be compelled to identify with particular forms out of their need for the recognition of others. Since the demands and recognitions of social life are not uniform but many-faceted and contradictory, the achievement of an absolutely unified and coherent gendered social identity, for masculinity as for femininity, is an impossibility. Lived masculinities will necessarily be composed out of various forms from the range of possibilities within the repertoire. The 'choice' and inter-relation

between them, however – including the demand or desire for certain kinds of coherence and unity – is shaped by the powerful hegemonic constraints of an effectively established culture. These ensure that some forms are installed as more appropriate and recognizable than others – that some stories can be told, at the expense of others. They exert at best a pressure of conformity upon potential alternative narratives or, at worst, render unspoken and invisible that about which these alternatives would speak. The soldier hero can be understood as a hegemonic form of masculinity in this sense.[39]

For an analysis of how these hegemonic pressures are exerted, a useful conceptual map has been proposed by Richard Johnson, who outlines how narrative can be understood in terms of 'a circuit of the production, circulation and consumption of cultural products . . . [and] subjective forms'.[40] While many studies of narrative focus on the determinants operating upon one particular aspect – the structure of its forms, or their cultural production, or their reception and use by variously constituted public audiences – Johnson argues that these need to be grasped as different but inter-related moments, that together constitute the social existence of narrative forms. In the case of the soldiers' stories discussed by Steedman, their formal characteristics – as oral tales or written memoirs – are shaped by the specific conditions of small-scale cultural production and consumption that render the relationship of a nineteenth-century working-class storyteller to his audience a particularly intimate one. Told and received in the context of shared cultural values and assumptions, the 'textual form' of a story emerges directly out of, and circulates within, the lived culture of working-class life. Stories such as these, embedded in everyday social life, through which people live out their experience and inhabit their worlds, are referred to by Johnson as 'private' forms. 'Private', in this sense, means more than 'personal' or 'individual': these are shared, communal forms that relate to 'the characteristic life experiences and historically-constructed needs' of particular communities or social groups. For this reason they would be better referred to as 'local' or 'particular' public forms, since it is their 'particularity' and 'concreteness' that distinguishes them from more generally available public forms, especially those that reach and claim to speak to and on behalf of 'the nation' or some other large-scale collective entity.[41] Both the working-class family and the regiment remain localized, particular publics for soldiers' stories in comparison to the national public which bestows social recognition of the soldier as a national hero and construes his story in the more abstract and generalized terms of national identity.

Narratives of this latter, 'general-public' or 'national-public' kind, necessarily develop different conventions from those of local storytelling and establish a transformed relation to what has now become a 'mass' audience. The news story, the comic strip or the feature film, for example, are more general-public forms insofar as they have been abstracted from everyday life in the form of a text, the moment of consumption and use of

which is widely distanced both in space and time from the moment of its production. In the process of public-ation – the 'making public' of cultural products – they become detached from their immediate context and may achieve a wider, more general distribution than that of more 'limited, local, modest' forms.[42] To reach audiences of such a size, they depend upon the larger-scale cultural production made possible by advanced technologies such as print, broadcasting or film, and supported by the institutions of the culture industries. In the gap between production and consumption, general-public forms may come to have an apparent life of their own, independent of any particular, concrete historical conditions, constituting a tradition of recognizable public forms that tends both to define and to limit imaginative possibilities. Public representations produced under these conditions are able to acquire a more general significance, becoming altogether more visible and powerful.

Johnson's cultural circuit suggests why and how it is that some forms of masculinity are more readily accessible, and thus are in a better position to elicit public recognition, than others. This is not simply a matter of co-existence within sealed compartments. Johnson also proposes a complex inter-relation between private and public – or, in his more recent formulation, between local and general-public forms. Cultural production leading to publication characteristically roots itself in existing local forms, appropriating elements and making from them new forms for more general public consumption. These in turn are consumed, read and put to use by particular readers in concrete local situations. A girls' magazine like those discussed by Walkerdine, for example,

> picks up and represents some elements of the private [local] cultures of femininity by which young girls live their lives. It instantaneously renders these elements open to public evaluation – as, for example, 'girls' stuff', 'silly' or 'trivial'. It also generalizes these elements within the scope of the particular readership, creating a little public of its own. The magazine is then a raw material for thousands of girl-readers who make their own *re*-appropriations of the elements first borrowed from their lived culture and forms of subjectivity.[43]

However, while a public representation might, as in this case, be produced and consumed within a relatively tight circuit constituted by the readership of a particular social group, at the moment of publication it also becomes available for reading and use by others who may be massively distant – culturally, geographically, historically – from the girls' culture which it offers to articulate, and who may have their own stake in defining young femininity. Picked up and transformed within the conditions of production bearing upon the magazine, the narrative forms of girls' culture also enter the wider field of public representations concerning femininity and girlhood. Here, they become subject to powerful hegemonic pressures that tend to

frame and contain them within the terms of established general-public definitions. The power of established public representations ensures that all local public forms are forced to relate to and negotiate these general framing assumptions about 'real femininity' and 'real masculinity'.

My exploration of the soldier hero as a form of imagined masculinity will address these social determinations upon narrative imagining, and the concepts introduced here – subjective composure, social recognition, public representations and lived cultures, cultural production within general and particular publics – will underpin my later analyses of specific stories and their heroes. But there remains a psychic dimension to this process which requires further elucidation. Were fantasy to be conceived as an historical phenomenon pervasively interconnected with social life (rather than one shaped by an essential or archetypal human psyche), and due weight given to both its socio-political and its psychic determinations in their mutual interaction, then Johnson's cultural circuit could be linked to the psychic economies of particular social groups. In common with much contemporary feminism, the search for such a theory has led me to an engagement with psychoanalysis.

2

MASCULINITY, PHANTASY
AND HISTORY

Psychoanalysis, history and cultural studies

The turn to psychoanalysis in cultural studies since the late 1970s stems from its perceived potential to supply an account of human subjectivity as constituted in social life, that avoids the twin pitfalls of essentialism and reductionism. Freud's account of the acquisition of gender identities within the social relations of the modern family was used by feminists to challenge essentialist arguments that derived the characteristics of 'femininity' and 'masculinity' from the biological inheritance of human nature. At the same time, psychoanalytic insistence that social identities are occupied by individuals only as a result of complex and often-repeated processes of identification, and at no little cost in human suffering, offered a corrective to those materialist accounts that conceived identity merely as a function of objective social relations. Psychoanalysis has been read by feminists as a theory of the unconscious psychic processes through which oppressive, patriarchal identities are inscribed into the very fears and desires of infants, making gendered subjects – boys and girls – out of a previously polymorphous cluster of sexual and emotional impulses.[1]

Psychoanalysis itself, however, was founded precisely at the interface between the 'cultural' and the 'natural'. In its conception of their interaction within the psyche, classical Freudian theory established two difficulties which continue to pose problems for its use in historical and materialist cultural analyses. The first of these concerns the universalism of psychoanalysis. Freudian metapsychology posits the existence of universal psychic processes (fantasy, repression, sublimation) and structures (the ego, the id or unconscious), through which the individual comes to occupy a place in human culture. This necessary, if problematic, process occurs on a specific site within social relations – that of the family. In Freud's theory of the Oedipal scenario, the boy's impossible desire to possess his mother gives rise to castration anxieties of punishment by his father, and eventually to the 'resolution' of this conflict through renunciation of love for the mother and identification with the position of the father. In this account of the psychic

construction of sexual difference, the universal triangle of male–female–infant tends to be mapped onto a particular conception of the family as though it, too, were a universal. It can be objected that what Freud takes to be the 'universal family' is in fact one historically specific form – the bourgeois family of late nineteenth-century central Europe; and a highly selective account even of this, in which, for example, the psychic significance of important members of a household, such as nannies and maidservants, remains untheorized. According to this criticism, the clarity of Freud's universalist account of psychic life and sexual difference depends upon an ahistorical abstraction from the more complex social relations of actual families, and from the variable forms of masculinity and femininity upon which identification depends.[2]

This is related to a second and more fundamental problem. In Freud the psychic economy is conceived of as a 'closed system' driven by energy arising from within, 'which can be considered in terms of inputs and outputs without concern for the specifics of the world outside'. Greater emphasis is placed on the internal determinants of psychic and somatic activity (the libidinal and aggressive drives of human nature) than on the role of significant external 'objects' (prototypically, from earliest infancy, the breast and the mother), which are seen in general terms as 'anything that satisfies desire' – or thwarts it. Where satisfaction is frustrated, there emerges, according to Freud, wish-fulfilling fantasies wherein an hallucinatory satisfaction is substituted for actual gratification. The role of the social in Freud's thinking is fundamentally antithetical to fantasy: it operates to effect a necessary adaptation of desires that arise from within, according to the demands of an external reality.[3]

Freudian psychoanalysis depends upon a radical dichotomy between 'the individual' and 'the social', wherein psychic life itself becomes a phenomenon of individuality rather than sociality. 'Culture' appears only in the most general sense, as the necessary ground for a psychic process that takes the same course regardless of actual social circumstances. This gives rise to a fundamental difficulty in holding together simultaneously, in a single account, a developed sense of both psychic and socio-historical determinations. It is exacerbated by a tendency, manifest both between and within intellectual disciplines, to locate these determinations at different levels of explanation, as if one excluded the other. Where psychoanalysis tends to privilege the psychic level to the exclusion of public and political concerns, historians concerned with social determinations and outcomes are less likely to value the significance of the psychic in their own explanations.[4]

This tendency to separate the psychic and social into distinct domains of knowledge has been resisted in a rich body of work (including the feminist work on narrative discussed in the previous chapter) which seeks to establish cross-disciplinary dialogue between psychoanalysis, social and cultural theory, and the practice of history.[5] The psychoanalytic theory most widely

used in these debates and analyses has been that of Lacan's rereading of Freud. Here, sexual difference is understood as an effect of the human subject's entry into the symbolic systems of its culture. Acquisition of the linguistic means to name difference is, simultaneously, to place oneself in its terms, as 'a boy' or 'a girl', and, as the inverse of these structures, to repress that which is excluded by them into a distinct realm, the unconscious. Lacanian theory has been used in cultural analysis in two rather different ways. Linked to the Althusserian theory of ideology as a system of representations that position or 'interpellate' human beings as subjects within existing social relations, Lacanian psychoanalysis has been used to explain how, across a wide range of cultural forms and practices, the internalization of social identities functions to reproduce gender and class relations of dominance and subordination. An alternative emphasis has foregrounded instead the uneasy and incomplete sovereignty of these socially regulated forms over the turbulent and unruly processes of the unconscious, insisting that 'there is a resistance to identity at the very heart of psychic life'.[6]

The compatibility of Lacanian psychoanalysis with historical study has been evocatively defended by feminist historian Sally Alexander:

> Subjectivity in this account is neither universal nor ahistorical. First structured through relations of absence and loss, pleasure and unpleasure, difference and division, these are simultaneous with the social naming and placing among kin, community, school, class which are always historically specific.[7]

But this claim is not undisputed, and universalist assumptions have been identified even in this far more congenial brand of psychoanalysis. Controversy about the usefulness of Lacanian theory to generate a critical understanding of gender has focused on the centrality afforded to 'the phallus' as the privileged signifier of sexual difference in fantasies of its possession and lack. Critics have argued that, like Freud, Lacan reifies 'the law of the father' and therefore the centrality of psychic identifications based upon an authoritative and possibly punitive masculinity.[8]

Psychoanalysis has no easy answers to the problem of how to develop an historically informed theory of fantasy. However, further resources for such a project can be found in the Kleinian tradition of psychoanalysis, as yet largely untapped by cultural studies. This offers a potential solution to the problem of how the psychic and the social may be thought together without reducing one to the other: it 'holds out a perspective for the construction of a psychoanalysis that takes account of social relations'.[9]

The crux of Klein's difference from orthodox Freudianism is her redirection of emphasis from the Oedipal triangle to the pre-Oedipal dyad of mother and infant, and from the penis or phallus to the breast as the primary symbolic object. All psychic life, for Klein, has its foundation in the relations to this 'part-object', the breast, established in earliest infancy and in

subsequent relations to the mother as a 'whole object'. Object relations – the infant's sense of relatedness to its nurturing social environment – therefore exist from birth; and the development of psychic structures is theorized as a process of continual transformation that occurs through interaction with a social world. All subsequent emotional life, including the Oedipal scenario and the sense of gender identity, is understood by Klein to be founded upon the infantile relationship to the mother.

What attracted me to object-relations theory, however, was not its use in constructing a general account of masculinity based on large abstractions, as Nancy Chodorow has attempted;[10] but its potential willingness to investigate psychic life in terms of the particularity of social relationships to actual parents, themselves located historically within a specific culture of family life that had shaped gender characteristics, approaches to parenting, and so on. This openness to history and culture was made apparent in the course of my own psychotherapy, undergone during the 1980s, which was based on post-Kleinian object-relations theory and stimulated my interest in Klein.[11] Like Carolyn Steedman's testing of the limitations of the 'normative' family romance of Freudianism against her own family circumstances, my experience of therapy produced insights that did not fit the Chodorow model and called in question its orthodoxies.

Paradoxically, Klein's own writing came to seem more interesting than post-Kleinian orthodoxies because she places greater weight than any other object-relations analyst upon a pre-social human constitution. Following Freud, Klein posits a neonate torn by powerful conflicting impulses or drives, which she terms 'love' and 'hate'. Unlike Freud, she posits, too, a primitive ego with the capacity to feel pleasure and anxiety and to develop primitive psychic defences against the effects of its own destructive impulses as well as the shocks bestowed from 'outside'. Located halfway between the emphases of a fully developed object-relations model and those of the classical Freudian theory of drives, Kleinian theory has been argued to be marred by the resulting contradictions between 'biological' and social determinations of psychic development.[12] This charge is especially pertinent in any consideration of gender and sexual difference, which is displaced from a central problem to be elucidated into a given human reality. Gendered subjectivity, for Klein, itself exists from birth and is rooted in physical difference. As Hanna Segal, a leading exponent and teacher of Kleinian analysis, puts it:

> Little girls, like little boys, know their sex. . . . For Klein, both little boys and little girls are aware from very early on of the mother's body, of the wish to explore it, of the wish to be inside it, and both have the competitive desire to be like the mother.[13]

Unlike Freud's theory of the asymmetrical relation of boys and girls to the castration complex, this is a parallel structure for children of both sexes,

involving competing identifications with and desire for both parents. It is resolved for each through the development of what Segal calls 'the reality sense, healthy development meaning that you recognise your internal reality . . . the reality of your sex, your actual physical sex'.[14] Despite Klein's continual emphasis on the symbolism of sexual difference, this can seem a retreat into the gender essentialism based on physical difference from which Freud had originally rescued psychoanalysis. Among the undoubted normative dangers of this position, the Kleinian attitude to homosexuality as a perversion and a 'repudiation of reality' stands out.[15]

On the other hand, the contradictory position of Kleinian theory within psychoanalysis may be turned to advantage. Retaining a strong emphasis on the internal and pre-social determinants of a psychic life that is also profoundly transformed through social existence and yet never completely malleable or settled, it opens up the possibility of a productively dialectical model of interplay between the social and the psychic.[16] Taken together with the Kleinian interest in symbolization – in what it *means* to be a woman or a man – this allows the theorizing of a less fixed, more historically fluid conception of masculinities and femininities. The key to this lies, I will argue, not in Klein's explicit views on sexual difference, but in her conception of 'phantasy' – a conception that is readily compatible with the arguments about narrative, subjective composure and social recognition that I advanced in the previous chapter. Kleinian theory provides an analytical vocabulary to describe the various psychic scenarios that are staged in soldiers' stories. Distinguishing between qualitatively different modes of composure in terms of the conflicting investments of desire and anxiety that underpin them, a Kleinian approach can help to explain the specifically psychic attraction of idealized heroes as figures of identification; thus contributing to the theorization of imagined masculinities as at one and the same time psychic and social forms, constituted in the interaction between fantasies and cultures.

Phantasy and the social world in Kleinian psychoanalysis

Kleinian theory, in common with other psychoanalytic traditions, relates fantasy to the mind's *'unconscious* mental content', which may or may not become conscious itself, but which structures conscious experience and understanding. In Kleinian use, unconscious 'phantasy' is given a scope far beyond that of Freud's notion of wish-fulfilment as a response to external frustration. Instead, it is equated with his broader concept of the 'dynamic psychic reality' of the mind, which has 'a continuous living reality of its own, with its own dynamic laws and characteristics, different from those of the external world'.[17] This conception of phantasy is explicitly opposed to any straightforward dichotomy of real/unreal, where the real is equated with an external, material or objective reality, and phantasy with the unreal, as

something 'merely' or 'only' imagined. It also refuses any restriction of the term to particular consciously registered forms (daydreams, fictions etc.). It suggests, on the contrary, that phantasy is constitutive of psychic life, subjectivity, the very texture of experience: 'all that we do, think and feel depends upon it'. This difference is registered by the Kleinians' alternative spelling of the word.[18]

As such, phantasy is also the medium of the subject's experience of itself in relation to a real external world and real other people: 'Phantasy is not merely an escape from reality, but a constant and unavoidable accompaniment of real experiences, constantly interacting with them.'[19] Where Freud saw the making-sense of external reality – the reality-testing operations of the ego – as an alternative to wish-fulfilling phantasies, the Kleinians see reality-testing as profoundly affected by them. 'The outside world is always perceived and related to through a screen of the child's internal drives and phantasies, which may alter its impact dramatically.' Objective social reality is, however, given a central role within the Kleinian model, which posits an interaction and mutual influence between phantasy and 'reality experiences', beginning at birth. 'If unconscious phantasy is constantly influencing and altering the perception or interpretation of reality, the converse also holds true: reality impinges on unconscious phantasy. It is experienced, incorporated and exerts a very strong influence on unconscious phantasy itself.'[20] The Kleinian conception of phantasy therefore offers a powerful relational model of the psychic economy, allowing a far greater role to external reality than in Freud's system, where the external environment is only relevant to the extent that it supports or opposes the satisfaction of the individual subject. For Klein, an encounter with a specific external reality – the nurturing environment created and represented by 'the mother' (or under other childcare arrangements, the primary carer or carers) – is built into psychic processes from their very beginning in earliest infancy, as one of their conditions. This has important implications for attempts to understand phantasy as a social process informed by culture. It enables the theorizing of subjective experience in terms of an 'inner world' of the imagination, governed by both psychic and social determinants, which is simultaneously distinct from the real 'outer' world of social relationship and yet constitutes the mode of subjective insertion within it.

In Kleinian theory, the mutual interaction of inner and outer worlds is governed by universal mental processes of introjection and projection. Through projection, the 'ego', or self, invests in the social world (including other people) its own impulses and feelings that originate within the psyche. Through introjection it incorporates and internalizes within the psyche, as parts of itself, aspects of the social world. Since the latter is already invested with significance – it is seen in particular aspects, as threatening, comforting, stimulating and so on – introjective and projective processes constitute a complex, spiralling circuit of psychic exchanges, in the course of which an

internal world is established and built up in connection with the external, social world.[21]

Klein describes this inner world as being made up of internal phantasy figures or 'imagos' (also known as the 'inner' or 'internal' object, as distinct from the 'external object' or real person). These are imaginative constructs which mediate the psychic and the social: the product of continual inter-action between elemental psychic impulses and wishes, and social reality. They are derived partly from the various qualities and aspects of the social world (and prototypically, from the parents and their bodies, experienced in infancy as, for example, benevolent or punitive, and felt to be alive and active within the psyche), partly from conflicting internal impulses of aggression and libido, hate and love. The self registers, relates to and handles these impulses through omnipotent phantasies in which it does things, both beneficial and harmful, to its imagos, and invests them with the capacity to do things back.

> Hostile feelings are [felt as] an attack on the internal object [imago], which is thereupon expected to punish . . . in kind. . . . Since the child projects his own impulses on to his objects . . . , he expects his objects to do to him what he has done (or imagines he has done) to them. The internal object, attacked and injured by the aggressive wish, returns the attack immediately.[22]

Phantasy, then, is an ongoing process, a kind of narrative in which the self is imagined doing and being-done-to, as taking in and investing psychic ma-terial. In turn, these narrative phantasies organize a screen through which the social world appears and social relations are experienced.

For Klein, the rudimentary subjectivity existing from birth is continually transformed and developed through the 'object relations' established in the inner world between the self and its various imagos. The self as such is constituted by means of introjective identification with a multiplicity of different imagos, derived initially from the mother and subsequently from the father and other people of both genders, as encountered in social life. Through introjection, certain of these imagos 'become assimiliated into the ego [self] and . . . contribute to its growth and characteristics'. A child learning to wash itself, for example, both acquires the actual caring skills used by its parents, but also identifies with their nurturing qualities and characteristics, which it makes part of itself.[23] Another kind of identification takes place in relation to the projection of the self's own impulses and needs into real others, whom it imagines as being like itself. It may then, in turn, 'become like the object which it has already imaginatively filled with itself', giving rise to empathy, to the experience of losing the self in another, or, crucially, to identification with an idealization of what the self would like to become and has discovered, as if by chance, in the external world. If reintrojected, this kind of idealized imago derived from projective

identification forms the basis for an idealized self-image.[24] Klein distinguishes the wishful character of these identifications from those based on introjections of actual qualities and capabilities, by locating them in a distinct zone of the self – the super-ego. As will become apparent later, the distinction between ego and super-ego is at the centre of Kleinian thinking about gender.[25]

Psychic splitting, integration and composure

The diverse and fragmentary quality of these various identifications, related as they are to a heterogeneous set of imagos, engenders incompatibility between them, and leads to psychic conflict. The self attempts to reconcile and resolve this conflict in an endless endeavour 'to form a whole out of these various identifications'.[26] Psychic life is conceived of in the Kleinian account as a continual struggle, unconscious in the first instance, for a narrative phantasy capable of reconciling conflict and subsuming differences. This occurs in the face of a countervailing tendency to fragmentation, which Klein terms 'psychic splitting'. Chief among the factors that provoke splitting of the self and its imagos are the disintegrating effects of anxiety and the defences developed in self-protection against it. These 'ego defences' work to prevent anxiety from undermining the self by containing it within a limited zone of the psyche. 'Resistances' are established between anxiety-producing and anxiety-free imagos (and thus, also, between parts of the psyche), resulting in 'the different identifications becoming cut off from one another'. The self's defences against anxiety therefore produce narrative phantasies that exacerbate the existing fragmentation of the internal world: splitting interferes with more inclusive processes of integration, and ensures further psychic conflict will occur.[27]

Klein's account of efforts towards greater 'integration' of the imagos, and thus towards the greater coherence of the self, points to a specifically psychic dimension to the struggle for subjective composure that I outlined in the previous chapter. In one of the most useful contributions that Kleinian theory can make to cultural studies, this analysis is developed a stage further, through the distinction between this more open, integrative mode of composure and the more limited and defensive mode enabled by psychic splitting. In the former case, a more integrated self, open to its own contradictions and more tolerant of painful experience, confronts and strives to transform its anxieties, in efforts to reconcile the conflicting imagos. In the latter case, the self achieves a degree of coherence based on a denial of destructive and painful aspects of its own experience and of the anxieties to which these give rise. Refusing its own conflicts, it assumes a highly defensive formation where imagos that embody these aspects and threaten its composure are expelled beyond tightly policed borders.

The fluid and complex geography of connected and separated psychic spaces established by splitting and integration constitutes the terrain on

which the self struggles for composure in response to its own contradictory and conflictual formation. In Kleinian theory, this shifting psychic terrain, and the various modes of composure that may be established upon it, is mapped in terms of alignments between the self and its imagos. In Klein's analyses of these alignments, they are organized within two distinctive psychic 'positions' occupied by the self, each involving characteristic configurations of anxiety and the defensive strategies used to contain it. These affect in turn the investment of significance in the social world, including the way real other people are experienced. Klein's analyses explore how self-composure is always established on the basis of an imaginative positioning of others: as they are drawn into the internal psychic world, and allotted parts in the narrative phantasies that are played out within it, our sense of relatedness in social life becomes imbued with attractions and repulsions, fears and desires that neither self nor other can fully control. The search for psychic composure therefore has a profound effect upon possibilities for social recognition.

In Kleinian theory, the two psychic positions open to the self – the so-called 'paranoid-schizoid' and 'depressive' positions – are conceived of initially as developmental stages. They originate in earliest infancy, when the foundations of the inner world and all psychic life are established, growing maturity being marked by the increasing capacity for integration that becomes possible in the second position. But the Kleinians also see them as psychic possibilities available throughout adult life, to which we repeatedly return: they 'reflect different patterns of organizing experiences', involving 'the structuring of relations with others on the basis of characteristic anxiety situations'.[28] It is nevertheless important to retain Klein's insistence that both are constituted within the social relations of infancy and bear the imprint of those primary inequalities in power pertaining between a child and its 'mother'. Indeed, for Klein, the primal narrative phantasies through which object relations are first registered and worked through in infancy continue to exist in the unconscious, where they underpin and structure the psychic life of adults.[29]

Dealing with adults and children alike, Kleinian psychoanalysis of object relations typically begins with the psychic material expressed in stories of everyday life, or dreams, or play, and reinterprets it in terms of an internal landscape peopled with imagos in interaction with the self. Relations to the earliest objects may be discerned, for example, structuring many taken-for-granted expressions used in everyday storytelling, as when someone claims to find difficulty in 'taking in' information, or finds it 'goes in one ear and out of the other', or experiences a feeling of being 'drained' by the emotional demands of others. In Kleinian interpretation, a narrative scenario is read as a metaphorical guide to the primal phantasies that structure psychic reality and, through this, the experience of social relations.[30] Three scenarios are given prime importance in the Kleinian schema: the first two describe modes

of defensive composure in the paranoid-schizoid and depressive positions respectively, while the third describes the more integrative mode that becomes an alternative possibility only in the latter position.

Modes of composure 1: paranoid splitting

Efforts towards composure in the less coherent 'paranoid-schizoid position' can be traced back to the infant's earliest experiences of its own impulses and feelings as oscillating between black and white extremes of love and hate with no intermediate tones.[31] It is marked by splitting processes which make use of introjective and projective mechanisms to fragment the self, its imagos and its entire social world along this fault-line, into positive/pleasurable/benign and negative/painful/malign aspects. To take the prototypical case discussed by Susan Isaacs in an influential exposition of the Kleinian theory of phantasy: an infant feeding at the breast imagines it as perfectly meeting its own needs, a utopian source of plenitude and fullness without end. When frustration occurs, it might be experienced in aggressive phantasies of biting the breast and tearing it to bits. Anxious at thus having destroyed, in omnipotent phantasy, the source of its nourishment, and unable to tolerate the fears aroused by the imagined effects of its own aggression, the infant might next project this impulse onto the breast or the mother herself, in persecuting phantasies of being attacked, cut and bitten by her. When the infant experiences these attacks, through introjection, as the mutilation and disintegration of the internal world, yet another phantasy might expel the breast-in-pieces, denying all relation to it. Oral aggression towards the mother's body might also be a response to hunger experienced as inner emptiness, in phantasies of having sucked the breast dry, or scooped out its contents; provoking envy of an imagined plenitude withheld, and phantasies of entering the mother and robbing her of the contents of her body.[32]

To preserve from destruction in this conflict the necessary relationship with the loved 'external object', the mother herself is split into two distinct aspects: an idealized, benign breast which can again be introjected and a malign breast which can now be safely expelled through projective disavowal. Klein characterizes early psychic life as a continual struggle to manage conflicting impulses by keeping them apart in this way. Projective disavowal of aggression towards the mother's body, however, exacts a heavy price in exposing the infant to paranoid anxieties of being persecuted 'from outside', since this is now imagined to be the source of all aggression. The internal landscape of imagos produced by severe splitting, as described by Klein, resembles a fairytale world of benevolent wish-fulfilling fairy godmothers, malevolent and threatening witches, and other 'helper' and 'persecutor' figures. In its efforts to defend and preserve the pleasurable and benign impulses necessary for any well-being and psychic composure, the self establishes an affirming relationship to the idealized 'helper' imagos who

36

can do nothing bad or harmful. Through its identification with them, they are mobilized against the hostile and threatening imagos into which aggressive and destructive impulses are projected and disavowed. Anxiety generated by these aggressive impulses, and the prospect that they might come to dominate or even destroy the internal world, is experienced in narrative phantasies of attacking and being attacked by terrifying, persecutory imagos (and thus, by aspects of the imagined social world). The more extreme are the threatening imagos, the greater is the need for idealized helpers in response.[33]

While defensive splitting is most prevalent and necessary in early infancy, when the self has no other resources at its disposal for the management of anxiety, Klein suggests that the appearance of this characteristic linked opposition between ideal and persecutory figures can be identified throughout adult life in a variety of social and cultural phenomena. In her writing from the 1920s, she gives as one example 'the phantastic belief in a God who would assist in the perpetuation of every sort of atrocity (as lately in the recent war), in order to destroy the enemy and his country'. Here, narratives that compose a sense of national identity in a moment of crisis are found to draw their psychic energy from a defensive idealization involving projective disavowal. This enables 'our' atrocities to be recoded as righteous and divinely sanctioned, whilst 'theirs' – and only theirs – are named *as* atrocities. In this scenario, war becomes a metaphor for the sharply contrasting imagos produced by psychic splitting: their very existence provokes 'phantasies of internal warfare', so that 'we cannot be at peace with ourselves'. Indeed, the contours of the paranoid-schizoid landscape are repeatedly likened by Klein to a battlefield, in imagery strongly reminiscent of much literary adventure.[34]

As this example demonstrates, however, psychic splitting also has powerful effects within the social world. Under its influence, it is impossible to acknowledge the full complexity and contradictory character of social realities, since they too will be experienced in terms of these simple oppositions between benign and malign imagos. In this case, the 'outside' appears to confirm the dichotomies of a divided internal world. In Kleinian terms, when real other people are used in defensive splitting, as the vehicles for projections and projective identifications, then the possibility of relating to them as differentiated from the self – of social recognition in full awareness of their actual social circumstances – has been overridden by strategies for the management of psychic conflict. The struggle for inner peace and composure is linked, for Klein, with the struggle to recognize otherness and one's own social relatedness to others, within a complexly constituted social world. Both these impulses generate efforts towards further integration.

Successful paranoid splitting may, according to Klein, have a beneficial psychic effect. It enables a relative integration and coherence of the self against that which is split off from it, and thus helps to secure the conditions

that are a psychic necessity for a more open, less defensive mode of composure. Too much splitting, provoked by excessive persecutory anxiety, can produce an ever-increasing range of imagos and fragment the self into numerous unintegrated bits. Too little splitting can make it difficult to achieve and preserve the positive imagos, without which the entire inner world would be experienced as a dystopia of persecuting and destructive elements, rendering effective composure impossible. Where 'successful', however, this kind of splitting opens the way to the more coherent of Klein's two psychic positions – the 'depressive position', with its alternative modes of composure.

Modes of composure 2: manic splitting

Narrative phantasy in the depressive position is characterized by the infant's increasing ability to tolerate its own painful and anxious experience and to acknowledge its own internal conflicts.[35] This enables a lessening of defensive projection, whereby hostile, persecutory imagos are defused of some of their power and the imagined threat of destruction is reduced. New, less extreme imagos, which integrate a number of previously dichotomous aspects in a more complex whole, now enter the psychic landscape. Given the circuit of exchanges between internal and external worlds, these more integrated imaginings also enable a more coherent conception of the social world. Indeed, Klein argues, the process of psychic integration is fundamental to the self's capacity to recognize the separate existence of a social world 'outside' the inner world and its radical 'otherness' from the self. Imagos can more readily be distinguished from real other people, and social events discerned as such, through the screen of phantasy. This psychic process of differentiation is experienced initially in infantile relationship to the mother. Instead of finding in her a reflection of its own fluctuating needs and impulses, the infant discovers the existence of a more complicated person of many aspects, who may act in ways previously unimaginable: in responding, say, to aggression not by retaliation but with comfort and understanding. Such new and unexpected qualities discovered in the social world provide resources that may be drawn upon in the infant's internal struggle for composure. Their introjection into the inner world makes possible the transformation of its existing imagos into more helpful and complex figures with which the self can identify. This in turn promotes further integration.

However, these linked realizations – that the social world might be other than imagined, and that its own impulses and feelings are themselves contradictory – also expose the self to new kinds of psychic conflict and anxiety. In giving up defensive projection of its own 'negative' impulses into the social world, the infant now begins to feel that it is itself responsible for them, and for their painful, destructive consequences, which it now imagines to have

been wreaked upon itself and other people by its own activity. Anxieties about being destroyed by hostile imagos give way to new anxieties about having destroyed, and thus lost, the helpful imagos with which the self is identified. This not only threatens to undermine the coherence of the internal world, but also affects the infant's experience of a social reality that it has now discovered to be differentiated from itself. The prototypical experience of loss, in infancy, is that of the breast, which is now seen to come and go, and may be imagined as having been driven away or destroyed by the self's own attacks upon the mother's body.

Growing acknowledgement by the self of its own aggressive and destructive impulses gives rise in the depressive position to an experience of ambivalent love and hatred for the same real other. In narrative phantasies where it finds itself attacking imagos that are simultaneously loved and valued, the self strives to cope with acute loss and mourning for the valued-but-destroyed imagos, guilt at its own destructiveness, and depressive despair and hopelessness. The legacy of guilt at the damage it imagines it has done to others is compounded by the experience of its own internal world in pieces. If the internal landscape in the paranoid-schizoid position resembles a battlefield at the height of the struggle, in the depressive position we inhabit a psychic landscape of broken ruins, mutilated bodies and other fragmentary figures of the aftermath.

One possible response to this situation is for the self to abandon its difficult efforts towards integration and to reassert its omnipotent control over the internal world. Depressive anxiety, loss, guilt and despair may be countered by a series of denials: that the self's own impulses are at all ambivalent; that its internal world is in any sense dependent upon a separate social world beyond its control; and that the destroyed imagos are indeed of any value to it. The intolerable destruction of valued imagos is warded off in narrative phantasies characterized by renewed splitting, idealization and projective disavowal. Unlike those of the paranoid-schizoid position, however, these phantasies involve positive idealization rather than projection of the threatening and destructive imagos with which the self is now identified; and denigration, rather than paranoid fear, of the disavowed 'bad object'. Phantasies of contempt render the latter into a safely *deserving* recipient of destructive attacks, for 'an object of contempt is not an object worthy of guilt, and the contempt that is experienced in relation to such an object becomes a justification for further attacks on it'.[36] In these so-called 'manic' phantasies of uplifting triumph over the omnipotently defeated and worthless 'bad object', the self is enabled to own, justify and enjoy the aggressive and destructive aspects of its own nature, without arousing feelings of loss, guilt and mourning on behalf of the destroyed imagos. The difference in emotional quality between idealized object relations in the depressive, as compared to the paranoid-schizoid, position, can be suggested by developing Klein's own analogy between idealization and nationalism: the defensive

splitting that is mobilized, according to her analysis, against a hostile, threatening enemy such as Germany during the First World War, is in striking contrast to the chauvinistic superiority and ready denigration of the enemy that is evident in nineteenth-century British imperialism or in the Falklands expedition of 1982.

The cost of manic pleasure, however, lies in the reciprocal effect upon the self of the phantasies that it holds about its objects. Untransformed hostility and aggression that is directed in this way towards the other, and that is felt to exist only because of the other, continues to have reciprocal but unconscious consequences that impact back upon the self. In effect, certain of its own aspects are split-off and repeatedly attacked as worthless by other, idealized aspects felt to be superior. In infancy, the very establishment of a connection between internal world and social reality may be put at risk; in adult life, the experience of difference between the self and other people may become imbued with an overriding sense of superiority and contempt towards them. The damage done to the imagos in manic, triumphalist phantasy also damages the self and threatens its potential to relate meaningfully to others.

Modes of composure 3: reparation

A more hopeful alternative to renewed splitting, that acknowledges this reciprocity in object relations, is also available to the self in the depressive position. Manic defence may be eschewed in favour of a more difficult and painful process of working through internal conflict and coming to terms with its consequences. This search for a different foundation upon which to establish psychic composure is characterized by the wish to make good the damage the infant imagines it has inflicted (on itself as well as its objects), by repairing and restoring the destroyed and lost imago. 'The infant's longing to recreate his lost objects gives him the impulse to put together what has been destroyed, to recreate and to create.'[37] Whereas projective identification with an idealized aspect of the self enables an expulsion of pain and damage into the social world, narrative phantasies of 'reparation' mobilize the self's potential to tolerate and ameliorate its own painful experience. The devastating effects of loss, for example, may be countered by nurturing, life-enhancing phantasies where the valued imago (prototypically, the 'good breast' and 'good mother') is rediscovered, restored to the internal world and protected from further destructive activity. This concern for imagos that it wishes to secure from damage helps the self to control its destructive impulses, which may be displaced onto safely symbolic substitutes, such as the toys used by children in play, or the characters in novels.[38]

Assistance in developing the subjective qualities required in making reparation comes, not from imaginary, idealized helpers associated with the self's own desires, but from an increasing openness to the social world and the

attendant possibility of drawing from real relationships the imagos necessary to sustain this new endeavour. This involves a fundamental shift in the kinds of identification composing the self. Whereas in manic phantasy the self identifies through projection with punitive and persecuting imagos in order to counter anxiety, reparative phantasy is based on the actual qualities of tolerance, nurturance and creativity found in others and introjected into the inner world, where they provide the focus for introjective identification in which anxiety may be transformed.

In effect, Klein's concept of reparation establishes the psychic necessity of positive social recognition. This can be seen to be a two-way process. The efficacy of the self's attempts at composure evidently depends upon its recognition *of* real others as the focus for projective and introjective phantasies. In projecting imagos onto a real other, the self recognizes aspects of the other – as friendly and supportive, frightening or worthless, etc. – on the basis of its own efforts at composure. Similarly, the introjection of imagos into the internal world depends upon a moment of recognition that the other possesses necessary and desirable qualities. Where, in defensive splitting, recognitions are overlaid by highly charged disavowals projected into the other, the theory of reparation posits an interplay between this recognition of real others on the basis of currently dominant imagos, and the reciprocal, transformative effect on those imagos of what Klein calls the 'reality experiences' of social interaction. Existing imagos, which are themselves the product of continual cycles of projection and introjection, establish a set of narrative expectations that are brought to each new social encounter. Where attempts are made 'to establish danger situations to represent internal anxieties', real others may be approached in anticipation of finding enemies, or conversely, in anticipation of finding helpful figures to introject, capable of allying with the self in its internal conflict. To the extent that real others 'accept' these recognitions and play these parts, whether wittingly or otherwise, confirmation will be found in the social encounter for internally derived anticipations. In this sense, projection and introjection also involve an imagined recognition of the self *by* the other, and are fuelled by wishes to be recognized in particular ways (as lovable, powerful, deserving of attack and so on).[39]

Social interaction, however, is never fully under the control of the imaginer. Within any social encounter lies the possibility that a challenging discrepancy might open up between anticipations and recognitions that are derived from imagos, and the complex characteristics, feelings and responses of real others. Perception of such discrepancies may 'allow something new to happen' in the internal as well as the social world. Recognition of this surprising otherness is what makes possible the introjection of the new imagos that are necessary for any integrative transformation of narrative phantasy. The Kleinian prototype of this kind of 'benign' discrepancy – where the social world proves to be other than imagined, enabling phantasies

of destruction to be modified – is the 'good mother'. The infant's successful primary reparation of damage done in phantasy to the parent and the internal world is predicated on the continuance of loving care and affirmative recognition by a real mother who has neither actually attacked the infant nor herself been destroyed by its attacks, as feared. Proving to be more resilient than had been imagined, her continuing existence places limits on the effects of infantile omnipotent phantasy. This helps the infant to 'contain' its anxiety in the internal world, to come to terms with its existence there, and to offset its shattering effects by developing its own 'parental' qualities such as nurturance and patience, toleration and courage. The amelioration of pain depends, then, upon affirmative recognition in a social world where these qualities exist and are valued, and upon the capacity to benefit from them by introjection.[40]

However, this emphasis on the necessarily social conditions for reparative transformation of the inner world is not consistently sustained in Klein's writing. Frequently, her accounts of the 'circumstances' that help or hinder reparation concentrate almost exclusively on internal determinants (the strength of destructive impulses, for example); and her case studies demonstrate a marked lack of interest in analysing the specifics of different kinds of parenting or particular family structures so as to establish the most conducive social dynamics.[41] Even where the possibility of reparation is held to be contingent upon 'social circumstances', it remains the case that these are not commonly benign, and must be considered in a fuller sense than Klein's rather restricted interest in the mother–infant dyad and the immediate family circle. As Klein's own work has helped to show, the family itself is a site of manifold conflicts of interest, and parenting and growing up are both deeply shaped by transactions of power that frequently result in the emotional, physical and sexual abuse of children. Family transactions take place in the context of wider social conditions that encompass famine, unemployment, war and the many kinds of abuse of human rights. Far from being always affirmative, social recognition may be imposed through the exercise of power – by parents over children, men over women, rulers over ruled, one nation over another – generating a whole series of resistances and desires in its wake. Anxieties and fears originate not only in the internal world, but in the gamut of social conflicts and contradictions that impact on psychic splitting and integration and are carried of necessity into the depths of the psyche, by introjective processes that must use whatever is available from social life as resources for composure.

The repercussions of psychic conflict can certainly be traced throughout social life, in modes of political identification as well as in the intimacies of family relationships. But the really radical potential of Kleinian theory lies in its conception of the reciprocal contingency of psychic life upon social contradictions. It brings the full range of complex, conflictual social relations into dynamic interaction with the struggle for greater psychic

wholeness and integrity, not as a once-and-for-all process occurring in infancy, but as an ongoing process throughout all social life.[42] In this wider perspective, the determining pressures exerted by a divided social world upon any effective psychic wholeness are apparent, so that the purchase of split and idealized phantasies becomes much easier to appreciate. Indeed, the very idea of reparation may become caught up in them: idealization of the mother as a fully integrated source of boundless love and care, or of the self as capable of making 'everything all right again', both reproduce a wish-fulfilling, nostalgic phantasy in which an imagined wholeness is perfectly 'restored' in a world without pain. In the more realistic Kleinian conception, reparation and integration are always partial outcomes, never fully achieved, which bring about various ways of living with the damage. Our subjectivities are founded upon the reproduction of brokenness and the repetition of defensive strategies involving many kinds of splitting and idealization, countered by efforts towards integration and reparation under the stimulus of 'something new'.[43] This is the context in which Kleinian thinking about gender can best be understood and developed and its potential to throw light on the connections between gender and national identities explored.

Gender identity, psychic conflict and cultural forms

Gender identity, for the Kleinians, is not in itself a problem to be elucidated. It is a given reality, the result of anatomical difference, and readily recognized in an infant's knowledge that 'I am this; I am not that'.[44] The problematic character of gendered subjectivity resides rather in the question 'What does it *mean* that I am this rather than that?', when the attempt at an answer is necessarily embroiled in both the psychic struggle for integration and the social struggle for recognition. The gendered self of boy and girl, woman and man is founded upon the psychic reality of an internal world of conflicting imagos, brought into being by projective and introjective processes and derived from both masculine and feminine identifications. The attempt to form a whole out of these elements is at the very same time a struggle for a mode of composure as 'a girl' or 'a boy', 'a man' or 'a woman'. It is a struggle for a narrative phantasy that can be lived with, psychically and socially.

The relative strengths of the ego and super-ego have a crucial bearing on this struggle, since they embody the distinction between introjections based on actual capacities and qualities (to act, experience and relate in particular ways) and those derived from projective idealizations of wished-for capacities and qualities. While the former are not necessarily gender-bound (men and women both have the capacity to nurture, dominate, endure, reject), the latter embody the ideal characteristics of 'a good boy' or 'a real woman' and come to represent simplified social norms or gender stereotypes that become figures of 'what I am supposed to be'. Identification with these idealized

imagos involves an attempt to discover and imitate what is socially expected: a process that Margot Waddell has called 'searching for the secrets'. Identity, in this mode, is an external form assumed through projection: an off-the-peg narrative that is worn 'as if' it fitted the self comfortably and gave unproblematic shape to 'who I am'. The driving force behind it is a wish to secure without effort a painless and coherent (gendered) self. This operates as a defence both against the necessarily painful recognition of oneself as a multi-faceted and contradictory subjectivity with damaging and – in that significant cultural metaphor – 'dark' aspects, and against the hard necessity of working this through to a more complex, open and provisional composure founded upon the realities of the internal world.[45]

For the Kleinians, the problem of gender identity is resolved in the course of the struggle for psychic integration. Being 'a man' or 'a woman' in this more integrated mode becomes less a matter of location on one side or another of a polarized split, and more a question of connection between the so-called 'masculine' and 'feminine' internal qualities that make up the self, freed from the anxiety that any particular quality is 'unmanly' or 'not really feminine'. The shift in object relations from defensive projection to reparation allows the renunciation of 'acting a part' in favour of a sense of self that is emotionally grounded in the actual resources of psychic reality. The test of a desirable identification becomes, to paraphrase Waddell, a matter of the capacities for feeling that these various identifications carry, and how they serve you. Acceptance of the supposed 'destiny' of manhood and womanhood is conceivable at the moment when the externally derived significance of these categories no longer wields such terror over the internal world, and it becomes possible to be a man or a woman in one's own way: when it becomes possible, that is, to tell your own story. For Waddell, this properly 'psychological' process of integration involves psychic release from the determining pressures of masculinity and femininity, these being understood as 'sociological' categories.[46]

This is in many respects an attractive argument that opens up useful critical distinctions between different modes of gender identification and theorizes the possibility of transforming defensive forms of masculinity and femininity along more open and dialogical lines. But difficulties reside in its tendency, apparent in Waddell's use of the epithet 'sociological', to derive unhelpful gender stereotypes from the wider social domain and impulses towards reparation from interpersonal interaction within the immediate social relationships of the family. Indeed, in much Kleinian writing, the social domain as such appears to be conceived exclusively in these narrow terms, or even as the locus of internally derived phantasies. What is often lacking is a more sophisticated understanding of the complexly structured social relations within which these 'personal' relationships are located, and a more nuanced account of the less direct, more mediated processes whereby the one impacts upon the other within a culture.

This pulling-back from the most original element in the Kleinian account of phantasy marks an important limitation in Kleinian analyses of gender identities. The dangers inherent in this are tellingly evident in Klein's argument about the psychic significance of adventure. Here, she uses the example of 'explorers who set out for new discoveries, undergoing the greatest deprivations and encountering grave dangers and perhaps death in the attempt', to illustrate how impulses and interests originally derived from the infantile relationship to the mother may be transferred to other scenarios. 'Phantasies of exploring the mother's body, which arise out of the child's aggressive sexual desire, greed, curiosity and love, contribute to the man's interest in exploring new countries.' Far-off lands function 'in the explorer's unconscious mind' as metaphorical substitutes for the lost mother, expressing a reparative wish 'to re-create her and to find her again in whatever he undertakes'. As such, the conflicting impulses of the original ambivalent relationship – an aggressive drive to possess and rob her of her riches and a countervailing drive to restore and make good the damage caused thereby – are reproduced in the new context, merging into 'the later drive to explore'.[47]

Klein's intention here is to illustrate how the early triumph of reparative over aggressive wishes in relation to the mother underpins creative and constructive activity in later life. But her insistence on the reparative component of the drive to exploration leads, in effect, to an extraordinary complacency about colonialism and genocide.

> These wishes to make good merge into the later drive to explore, for by finding new land the explorer gives something to the world at large and to a number of people in particular. In his pursuit the explorer actually gives expression to both aggression and the drive to reparation. We know that in discovering a new country aggression is made use of in the struggle with the elements, and in overcoming difficulties of all kinds. But sometimes aggression is shown more openly; especially was this so in former times when ruthless cruelty against native populations was displayed by people who not only explored, but conquered and colonized. Some of the early phantasied attacks against the imaginary babies in the mother's body, and actual hatred against new-born brothers and sisters, were here expressed in reality by the attitude towards the natives. The wished-for restoration, however, found full expression in repopulating the country with people of their own nationality.[48]

Here, the real effects on others of national actions fuelled by unconscious phantasy are subordinated to a concern for the inner drama, to the point where the native populations of colonized countries are rendered entirely dispensable. Nor does Klein offer any suggestion of how the real relations of dominance and subordination established in the colonial encounter might

have impacted upon, or indeed helped to constitute, phantasies of this kind. Failure to relate phantasy to the current (rather than original) social circumstances in which it is invested leads, in this case, not only to a backgrounding of the native experience of colonialism (which is cast firmly in the past), but to an effective apology for it in colonialist terms.

It is noteworthy, too, how Klein's discussion remains curiously unconscious about gender. Her concern is with 'the *man's* interest in discovering new countries' and with his aggressive drive to conquer and colonize, but this is never located explicitly in terms of masculinity. Symptomatic here is the text's recourse to that common linguistic strategy of using masculine terms to refer to the generality, as in its sliding, elsewhere in the passage, between 'the child' and 'the little boy'.[49] This obscures the extent to which Klein is analysing a specifically masculine form of reparation and composure, and thereby conceals the constitutive effects of colonialism upon gender identity.

A further, related absence in Kleinian thought also becomes evident here – that of a developed concept of 'culture'. Interest in 'exploration' is not a purely individual matter, to be related exclusively to 'the unconscious of the explorer', but the cultural practice of a collective grouping or national community. While focused on the activities of the explorers themselves, it attains a general cultural salience through forms of discourse. Narratives of exploration and conquest are instrumental in forming 'interest': they organize a particular kind of imaginative investment in the activities of which they speak, according to the recognizable structures and conventions of the adventure tradition. They also organize imaginative investments in the gendered heroes whose deeds they relate and make available, as public representations which in turn may invite identification.

In her own analysis of the phenomenon of hero-worship, Klein describes it as:

> the peculiar position in the minds of people generally of idealized figures such as famous men and women, authors, athletes, adventurers, imaginary characters taken from literature – people towards whom is turned the love and admiration without which all things would take on the gloom of hate and lovelessness, a state that is felt to be dangerous to the self and to others. . . . Together with the idealization of certain people goes the hatred against others, who are painted in the darkest colours. This applies especially to imaginary people, i.e. certain types of villains in films and in literature; or to real people somewhat removed from oneself, such as political leaders of the opposite party. It is safer to hate these people, who are either unreal or further removed, than to hate those nearer to one – safer for them and for oneself.[50]

Here again we see a developed understanding of the hero as a psychic phenomenon, in terms of splitting, idealization and projective identification,

but no interest in its cultural dimensions. Fictional characters exist not only as the focus of projective phantasies, but are public representations given textual form through the use of specific signifying conventions, and accessible only through acquisition of the cultural skills of reading and interpretation.[51] Similarly, projection into public figures is unlikely to establish a relation with real other people, but will most commonly involve an engagement with representations of them circulating in the public media.

Klein's point, of course, is that unconscious phantasy does not differentiate between real people and representations of people. This is a perfectly legitimate psychoanalytic argument stemming from therapeutic practice. In analysis, interest is directed through the manifest form of imagos, towards the unconscious phantasies underlying projective investments in them.[52] But the elaboration of ideal and hated phantasy figures within the inner world needs to be distinguished as a process from the production and circulation of public representations bearing complexly coded cultural meanings that are collectively shared within a community. The psychic investments made in these hero-figures and narrative forms can not only be traced back to the internal world from whence they derive their psychic impetus, but also lead outwards into the wider culture with its conventional representations of the world and of the gendered self who inhabits it.

The idealized norms and stereotypes of gender, described as 'sociological' by Waddell, can more accurately be seen as *cultural* forms, the outcome of a cultural production of meaning that provides historically specific ways of inhabiting social relations and securing recognition. Gendered imagos are derived not only from interpersonal relationships with real others, but from a cultural repertoire of images and narratives. These representations of 'masculinity' and 'femininity', and the social identities established on their basis, never exist in a 'pure' form, but are always embedded within wider patterns of meaning and the broad collective identities of subgroup and class, ethnicity and nation. Klein's writing demonstrates no developed interest in culture, language or representation, an absence that seriously weakens the explanatory power of the Kleinian theory of phantasy and mars its claim to have taken account of social determinations. Given her insistence that introjective processes (whereby the self takes in and internalizes aspects of the outside world as parts of itself) always accompany projection, the introjection of cultural forms can be seen as a crucial missing link in Klein's argument about the impact of the social world upon unconscious phantasy.

To be fully dialectical, this requires a theorization of how the various phantasy imagos projected into cultural representations are in turn re-introjected into the internal world; of how they become the focus for renewed processes of identification with selected 'positive' imagos and renewed processes of projection whereby unwanted 'negative' imagos are rejected and expelled; and of the social consequences of these investments in terms of recognition. The qualities descriptively referred to by Klein as

'positive' and 'negative', 'good' and 'bad', themselves encode cultural evaluations. Heroes and villains may well be a psychic requirement, but their *form* matters very much. The available culture furnishes them with specific qualities and attributes, and these cultural forms become attached to and absorbed into the invested imagos themselves. The imago must, by this account, be understood as a fully Janus-faced imaginative construct, existing both as a cultural form, through the investment of imaginative significance derived from the psyche into the social world, and as an aspect of the self, inhabiting the internal world as a result of the internalizing of that form within the psyche. The forms matter, because their introjection is how culture gets into the self. Projection, on the other hand, is how the self gets into culture, since the investments made in particular forms such as adventure also confer on the self a position within the wider cultural field, from which the social world is rendered interesting and 'inhabitable' in specific ways.

From psychic imagos to cultural imaginaries

Adventure phantasies of exploration and conquest cannot be understood simply in terms of the direct social encounter between colonizers and natives, to which they are in one sense a response. Rather, they must be seen simultaneously as imagos and cultural forms, and located in terms of those systems of imagination that already invest social relations, making them significant and rendering them inhabitable for a given community according to historical meanings that are reproduced independently of any particular imaginer.

I describe these systems as 'cultural imaginaries', designating by this term those vast networks of interlinking discursive themes, images, motifs and narrative forms that are publicly available within a culture at any one time, and articulate its psychic and social dimensions. Cultural imaginaries furnish public forms which both organize knowledge of the social world and give shape to phantasies within the apparently 'internal' domain of psychic life. By their means, knowledge becomes implicated in the handling of psychic anxieties and conflicts while efforts towards subjective composure underpin and shape the acquisition of knowledges. The cultural imaginaries of British colonialism furnished the ways of seeing and making sense of colonized worlds such as Ireland, British India or Africa, available to explorers and other British people at any given historical moment. In mapping the significant features of these worlds, and finding them variously attractive or threatening in qualitatively distinct ways, the Irish, Indian and African imaginaries provided the cultural forms that enabled British people to inhabit them and to know themselves in relation to their other inhabitants. They constituted what it meant to 'be British' in these contexts. In bringing to social circumstances precise and historically shaped imaginative orien-

tations, which both determine the kinds of possible relation to those circum-
stances and are themselves confirmed or shaped anew by the encounter, the
forms of a cultural imaginary demonstrate the characteristics of the Kleinian
imagos, grasped now at their moment of existence as public forms.

I am not proposing this category of 'cultural imaginary' as a replacement
for comparable existing concepts in cultural theory, but for its strategic
utility in developing a cultural reading of Klein. As an analytic tool, it is
similar in reach to 'discourse', sharing its emphasis on the production of
meaning through the connections established between linked elements in a
signifying system. The discourse of Orientalism as analysed by Edward Said,
for example, demonstrates many of the features of a cultural imaginary.[53]
Said describes Orientalism as 'a tradition of thought, imagery and vocabu-
lary' in European culture that constitutes an 'imaginative geography' of the
area to its east as 'the Orient'.[54] In this articulation of social and psychic
space, the forms of knowledge produced for the Westerner about 'the
Orient' are 'governed not simply by empirical reality, but by a lottery of
desires, repressions, investments and projections'.[55] The historical formation
and 'genealogy' of the Orientalist imaginative repertoire can be mapped
across novels, poetry and the literature of travel; extends into sciences such
as linguistics, phrenology, ethnology, anthropology and geography; recurs
not only in written texts but in forms of painting and architecture; informs
modes of colonial administration, and economic and military organization.
This archive of narratives, images and other representations structures
the framework of possibilities within which Westerners in 'the Orient'
can locate themselves and their experiences, such that any encounter with
actual 'Orientals' is likely simply to reproduce historically predetermined
expectations.

Where Klein's analysis discovers in Western narratives of exploration and
conquest the integration and hope of reparation, Said proposes that
Orientalist imaginings be read as 'a form of paranoia' which functioned to
legitimate Western colonial expansion and became deeply implicated in
colonial rule. From the mid-eighteenth century, 'the Orient had [become]
both what Britain ruled and what Britain knew about'.[56] Underpinned by
paranoid phantasy, Orientalist knowledge was transformed into a mode of
power, a weapon to be wielded in colonial conquest which was felt to be, not
an act of aggression, but a necessary mastering of the dangerous and the
unruly. Its tropes can best be understood, argues Said, as a defensive
response to anxieties provoked by the encounter with cultural difference.
Western explorers, conquerors and administrators in the East encountered
in its landscape and the customary ways of its inhabitants a disorienting
strangeness that threatened their composure. The unmapped real terrain
evokes within the psychic landscape the terror of an infinite world without
boundaries (a description redolent of infantile separation anxiety), that is
projected into the Orient in 'feelings of emptiness, loss and disaster'.

Orientalism offered protection from such threats: it supplied the imaginative means 'to cancel, or at least subdue and reduce, its strangeness', by rendering it knowable in recognizable terms.[57]

Where a Kleinian-informed concept of cultural imaginary differs from discourse in either its Saidian or its Foucauldian usages is in its abandoning of their emphases on discursive coherence, regularity and unity in favour of a less monolithic, more complexly structured and contradictory formation. Using the Kleinian schema, other kinds of phantastical object relations besides the paranoid can be identified at work in the Orientalist cultural imaginary. In triumphalist phantasies that project a denigrated rather than a threatening other, subjective composure of an impregnable 'Western' identity is achieved through a binary splitting where the Westerner's power, strength and virtue, his potential for mature and civilized behaviour and for rational, articulate discourse, are all secured by contrast with the Oriental's weakness, servility and corruption, his childlike dependency and lack of discipline, his fundamentally irrational and uncivilized nature.[58] In Western reparative phantasies, cultural contact with the East is variously imagined as 'regenerating' a jaded European civilization or as the means whereby the West 'revives' and 'redeems' the dead world of the Orient through a transfusion of Western energy and cultural values.[59] When compared to Klein's dynamic, relational concept of phantasy, Said's produces a static analysis that collapses everything into one mode of object relation: Oriental*ism* in the singular; in which Western identity is reified as a simple unity, '*the* West', counterposed to another simple unity, '*the* Orient'.[60]

By 'cultural imaginary', then, I want to suggest a more fluid imaginative connection between patterns of linked associations, similar to Freud's sense of 'psychic pathways', which traverse a terrain by innumerable overlapping byways.[61] This both allows for internal plurality within a particular discursive archive like Orientalism, and also opens it up to the networks of other cultural imaginaries. The subjectivities of 'Britishness' were never constituted exclusively through the encounter with the Oriental as its other, but in relationship to a multiplicity of 'external' others, both colonial and European, besides being 'internally' fractured by social relations of class, gender, ethnicity and generation within Britain itself. Far from constituting a discrete, internally coherent archive, any particular imaginary such as Orientalism necessarily enters into intertextual relations with the many other imaginaries that register and map out these complex social relations.[62]

The pathways within and between cultural imaginaries, being historical as well as psychic products, can be traced across cultural representations both in textual form and as these have been institutionalized into the practical arrangements that govern activities and social relations within the social world. As Freud suggested, the links between some pathways may be facilitated by common elements. For example, colonial motifs of many kinds became increasingly central to the British national imaginary from the mid-

nineteenth century, while the imaginative significance of 'the soldier' has long been derived from, and helped to sustain, the linkage between national and military imaginaries. Facilitated by constant use, some imaginative connections may become so heavily naturalized that they can be immensely difficult not to make. Other connections may be hard to achieve, may have been neglected and forgotten, or may evoke fierce resistances that actively hold imaginaries apart. These imaginative fusions and lacunae function as the cultural correlate of psychic splitting and integration, establishing articulated zones and defensive borders across the imaginative geography of cultural as well as psychic life, and deeply informing the possibilities for subjective composure.

The imagining of masculinities occurs, not within the terms of discrete cultural imaginaries, but in and through these fluid links and splits. To the extent that connections between particular imaginaries are facilitated, it becomes possible to imagine forms of masculinity, like the national soldier hero, integrated in these particular ways. Where imaginaries are split off from each other, masculinities, too, will be fragmented along these particular lines: this occurs notably, as I will argue, in the split between domestic and military worlds. Since these available cultural forms are also introjected as imagos into the 'inner worlds' of living boys and men, and there provide the focus for identification and object relations, they in turn contribute to and exacerbate psychic splitting.[63]

The scope for integration or fragmentation within and between cultural imaginaries is itself contingent, not just upon psychic defences, but upon historically formed social relations. Anxieties that threaten the self are the product of real social encounters as well as fears of the destructiveness within, and the self's defensive responses are shaped by the need to maintain composure in social as well as psychic life. Conversely, opportunities to mobilize constructive and reparative impulses are also to be found in the social world. Phantasy does not exist in a separate domain of its own, divorced from the social; rather, psychic and social are abstracted levels of a single process,[64] articulated by cultural imaginaries that become the repositories, through projection and introjection, of historically and culturally specific forms of anxiety, defence and reparation. In this process, both cultural forms and the motivating wishes of phantasy are constantly being transformed in the fashioning of imaginative figures – imagos – capable of taking on and sustaining the powerful investments that bring both psychic and social worlds to life, while eliciting the social recognition necessary for composure.

Whether in the reproduction of defensive formations, or in efforts towards new insight, reparation and integration, the emergence and life of these imaginary forms has both social and psychic determinations. If their moment of existence as imagos depends upon psychic configurations of anxiety and defence that construct the social identities of self and other, their

moment of existence as cultural forms occurs under specific conditions of cultural production and consumption that are themselves shaped by configurations of economic, political and social circumstances. These material conditions govern not only the forms as such, but their availability and possible use by particular publics within existing patterns of social identity and recognition. It is only by supplying this full range of determining conditions that a fully historical account of the imagining of masculinities like the soldier hero becomes possible.

This is the framework in which I now wish to place the historical forms of adventure narrative and the idealized soldier heroes imagined in them. In the next chapter, I locate the British adventure hero as a specific historical form of masculinity, in relation to shifts in British national and colonial imaginaries and in the context of what is perhaps the most fundamental social division shaping modern gender relations – that which splits the world into distinct 'public' and 'private' spheres. Rooted in the early-nineteenth-century development of industrial capitalism, and rapidly transforming the social relations of politics, leisure and sexuality, the public–private divide established a contradiction at the centre of social life which all modern masculinities must negotiate. The adventure hero, in his complex and variable relations to the cultural imaginary of domesticity, will prove to be no exception.

3

THE ADVENTURE QUEST
AND ITS CULTURAL
IMAGINARIES

The quest structure of adventure

The essence of adventure resides in risk that gives rise to an experience of novelty and excitement. As a modern cultural practice, this is closely associated with pleasure intentionally sought out (as in an adventure holiday or a sexual adventure), but can also involve a chance occurrence (as the result of a car breakdown, perhaps, or getting lost in a strange place). This ambiguity between chance and human intention is evident in the etymology of the word itself, and a history of human relations to the world can be traced within its semantic tensions.[1]

In Middle English usage, *adventure* was closely associated with *fortune*. This signified both the luck (good and bad) 'which falls or is to fall to anyone', and the universal cause of events which brings about such 'changes in men's affairs'. *Adventure* also carried the more active connotation of a trial of chance – a soliciting of good fortune with uncertain outcome – and, in a significant extension, a hazardous enterprise. *Enterprise* connoted a form of active human endeavour, 'a bold, arduous or dangerous undertaking'. Where the notion of fortune suggests a world where human beings are determined by circumstances felt to be arbitrary and substantially beyond their own capacity to influence, the deepening association of *adventure* with *enterprise* marks the developing confidence of attempts to control and shape the world according to human desire and design. Circumstances that can be called 'adventures' in this more active sense provide a challenge to assert human will and test human capabilities against the vicissitudes of a world that remains deeply uncertain. A paradoxical tension between risk and control remains at the heart of adventure, and this explains the ambiguities of the word in modern usage. Without risk, there can be no adventure; but since both gain and loss remain possible outcomes, excessive risk may cause the experience of excitement to give way to anxiety. Adventure in the modern sense is balanced between anxiety and desire.

This structural tension is intrinsic not only to the experience of adventure, but to its narration. According to J. G. Cawelti in his analysis of popular

53

genres, the adventure story offers 'an imaginary world in which the ..ience can encounter a maximum of excitement without being confronted with an overpowering sense of insecurity and danger that accompanies such forms of excitement in reality'.[2] Narrative pleasure derives from the contrast between the conserving familiarity of well established generic conventions made stable through endless repetition and offering the comfort of a known reading experience, and the stimulating and unsettling material that is the very stuff of formula stories, carrying an intense charge of interest and excitement.

For example, in Alistair MacLean's adventure thriller *The Guns of Navarone*[3] the reader is involved in a world in which the hero – hanging by his fingertips to a slippery cliff top over a sharp drop to rocks several hundred feet below, where his comrade lies injured – is in immediate danger of being discovered by the enemy sentry; only to be saved by another comrade, who leaps over the cliff top in one bound, to plunge his knife into the sentry's body. The story is designed to generate an intense psychic interest, which can flip over at especially heightened moments into an actual physical experience of excitement or fear, disgust or arousal. Yet *The Guns of Navarone* is also a rather predictable tale, replete with conventional situations, characters and motifs, recognizable from innumerable other war thrillers: the dangerous mission behind enemy lines; the small group of soldiers, including the 'good' leader and his reliable right-hand man; the treacherous ally; capture by the enemy; exploding enemy installations; and so on. Recognition of these conventions will carry with it definite expectations about, say, the kind of things that are likely to happen while climbing a cliff in the dark, or the likely behaviour of the frightened soldier whose 'testing' will endanger the whole group. Expectations also develop about the likely (indeed, desired) pleasures that the story will produce. These include identification with the imaginary adventure hero, who provides the reader with 'an idealized self-image', and the certainty that the story will bring about a predefined desirable end: the successful destruction of the enemy guns and the final escape from the island. This anticipated moment of predetermined closure, where the protagonist both triumphs and regains a place of safety, is the crucial mechanism of pleasure. It enables the position of risk, danger and uncertainty 'within' the adventure text to be enjoyed imaginatively from the position of security 'outside' it, through a narrative movement that both produces excitement and suspense, and guarantees its pleasurable release and resolution.

Cawelti argues that the pleasures to be had from reading adventure depend upon a common narrative structure that underlies any particular story. According to the influential structuralist critic, Northrop Frye, the generic structure of adventure is that of a 'quest', involving a 'perilous journey' followed by a 'crucial struggle, usually some kind of battle', that brings to a head the conflict between the protagonist and his enemy. Victory

54

makes possible the recognition of the protagonist as a hero. The fictional world and the events taking place in it function entirely in terms of the protagonist's growth and are presented exclusively from his perspective, as a series of external obstacles to be overcome in the pursuit of his desired ends.[4] The key structural feature of the quest is that it be sufficiently risky to provide the necessary kind of challenge upon which this growth depends, without becoming so challenging that defeat is incurred, in which case adventure would give way to some other narrative mode.[5] Adventure, argues Frye, is a mode of romance, closely related to wish-fulfilling fantasies and dreams. It imagines a utopian world more exciting, benevolent and fulfilling than our own, in which the ordinary laws governing real existence are suspended to allow human experience to be suffused with the marvellous, the miraculous and the magical. The adventure hero himself is an idealized figure whose actions render him superior to other characters and to the environment in which he moves. 'Prodigies of courage and endurance, unnatural to us, are natural to him', and he is hindered neither by fears, scruples and doubts, nor by ambivalent needs and loyalties.[6] These qualities enable his overcoming of all obstacles to the successful completion of his quest.

The adventure quest therefore provides a powerful metaphor for the human capacity to endeavour, risk and win through; for the prevailing of human purpose in the world. Alternative narrative structures produce the possibility of investing any given material with other kinds of imaginative significance. The contrast between adventure stories and the narratives of working-class soldiers discussed by Steedman, for example, can be accounted for in terms of the differences between the quest structure and the narrative modes of irony and tragedy. In the latter, the reader has a sense of looking down from a position of ironic distance and insight at a world where desire is systematically blocked and frustrated, or at a hell where human life is precarious and exists in 'largely unrelieved bondage'.[7] Narrated in these modes, war becomes the very figure of horror and the soldier's story a dystopian nightmare of human suffering. Narrated as romantic adventure, war stories may come to embody the imaginative charge of wish-fulfilling idealization, replete with utopian possibility.[8] Powerful, superior and triumphant, the soldier heroes of adventure move through the fields of battle without incurring serious harm, becoming the figures of an exceptionally potent and pleasurable form of identity that corresponds closely to the promptings of desire. While irony and tragedy evoke the depressive scenario analysed by Klein, the structure of the adventure quest as described by Frye corresponds closely to the split forms of manic, triumphalist phantasy mobilized in defence against it. Given textual form in public narratives such as formula stories, novels or histories, it invites projective identification with the powerful, idealized figure at its centre, and projective disavowal and denigration of the qualities displayed by the defeated enemy.[9]

The adventure quest can also be seen to furnish imaginative resources and a mode of subjective composure that may be drawn upon in a living engagement with real circumstances of risk and challenge. While these are necessarily provisional and, unlike a text, offer no guarantee of closure, the adventure hero as a mode of lived subjectivity exists in continual hope and anticipation of victory. Where in practice such an 'adventure' ends in disaster and defeat, it will not be narratable as an adventure quest, but will give way to the narrative pattern of irony or tragedy. Paul Fussell, in his classic study of First World War literature, *The Great War and Modern Memory*,[10] uses Frye's categories in this way, as alternative cognitive frameworks that invest real-world circumstances and relationships with a specifiable imaginative significance and enable qualitatively distinct modes of engagement with them. Identifying the pervasive use of romance motifs in pre-1914 writing about war, Fussell shows how these narrative tropes were used in patriotic rhetoric and came to colour popular anticipation that the coming war in Europe was going to be an adventure. The felt tensions between this available language of utopian heroism and the realities of trench warfare provoked an ironical deconstruction of heightened romantic rhetoric, with its elevation of the soldier into 'a warrior', the battlefield dead into 'the fallen' and the blood of young men into 'the red/Sweet wine of youth'.[11] Eventually, this brought about a wholesale shift in narrative paradigm away from romance and towards a prison-like world of nightmarish horror.

According to Fussell, Frye's two modes of narrative assumed historical form in two different kinds of discourse that came to contest the significance of the Great War and constructed alternative identities for the fighting soldier: on one hand, the heroic, patriotic masculinity of the adventure stories, associated by Fussell with British popular imperialism; and on the other, those more complex, ironic narratives derived initially from trench literature but associated later with the anti-nationalist peace movement of the post-war years.[12] Frye's structuralist analysis of narrative, with its emphasis on the cultural conventions that organize meaning and identity, provides here the grounds for a powerful critique of nationalist claims that heroic storytelling simply gives textual embodiment to the real heroic impulses and qualities of British soldiers. It shows that, on the contrary, the heroism and virtue of the patriotic soldier is secured, not by his actions, but by their narration in terms of the quest structure. The very possibility of the soldier hero is shown to be a narrative construct, and nationalist mobilization to be dependent upon particular kinds of representation and fantasy.

Frye's description of the narrative structure of adventure has provided an indispensable tool for my own analyses of British soldier heroes. Yet, from the point of view of any argument about the historical formation of narrative imaginings, Frye's concept of the quest must appear deeply and problem-

atically ahistorical. His quest structure may organize a means of imaginative engagement with socio-historical realities, but these are given no constitutive role in explaining its own emergence: the quest itself is not seen as a product of history. Frye's structuralism – for all the sophistication of its formal descriptions of narrative, and despite its challenging emphasis on the narrative construction of human experience – paradoxically reaffirms an essentialist conception of narrative imagining in which the determining factors are located exclusively within the psyche. The mobilizing power of adventure is derived, not from specific cultural circumstances, but from an archetypal psychic structure, a universal given that corresponds to a primary cognitive impulse of human beings. This structure is expressed by different forms in different historical contexts, but in essence remains unchanged.[13]

My own project requires a conception of the modern adventure hero as a plurality of forms rather than a singular, abstract figure. These are brought into being, not as so many expressions of an essential adventure quest, but as the outcome of reciprocal interactions between the structured forms of the adventure genre and the broader cultural imaginaries in which they participate. Indeed, to avoid reification of 'the form' as an ahistorical archetype, the generic structure of adventure narrative – and not just the specific cultural materials that any particular adventure draws upon – must itself be seen as a product of history. The very notion of a 'quest' encodes values and assumptions about the possibility, importance or necessity of journeying away from the familiar into the unknown in pursuit of a desired goal or state of being. The significance of this structure, and the character of the risks and anxieties involved, changes according to the nature of the various motifs – the precise goal, conflict, adversary and so on – in which it is embedded.

In theorizing this historical relationship, Fredric Jameson's notion of 'sedimented content' is useful.[14] Jameson suggests that any particular adventure story will incorporate within itself aspects of the prior generic tradition, which have become embedded into the structure of the genre. These inherited forms of adventure quest constitute a range of possibilities that define what 'an adventure narrative' is, and the parameters beyond which a story ceases to be an adventure and becomes something else, at any particular historical moment. The sedimented content that defines this inherited tradition can be seen as the record of past connections with and between specific cultural imaginaries. Developments in the generic tradition occur when its inherited forms are activated within new social conditions and draw on the imaginaries currently investing them, to produce new kinds of quest. Any adventure text therefore involves an encounter between the historically formed motifs and sedimented structure of the genre and new developments in the cultural imaginaries resonant at the moment of its production. While this encounter poses a formal problem that the narrative must resolve in one way or another, there is nothing inevitable about the

outcome. Why generic restructuring takes this direction rather than that is, precisely, an historical question to be investigated.

The cultural imaginaries of modern adventure

Investigation of the historical development of adventure, like that of its structure, can begin from its etymology, where the impact of social circumstances upon the very idea can be traced. Modern usage allows that any undertaking felt to be hazardous, novel and exciting can be experienced as an adventure, and conversely, that the conditions of adventure can be sought in many kinds of circumstance that are both sufficiently risky and potentially rewarding to the subject: a new job or relationship, for example, or a visit to the big city, the site of Lucy Snowe's 'adventure' in *Villette* (1853).[15] Historically, however, powerful connotations have attached the imaginative resonance of the word to certain kinds of circumstances. The *OED*, for example, illustrates one usage of the verb, 'to risk the loss of, to imperil', with the phrase 'to adventure themselves abroad'. 'Abroad', as a generalized location for adventures, originally meant 'out of one's house', before its extension (*c*.1450) to 'out of one's home country'. This shift catches perfectly the widening thresholds of the unknown beyond which increasingly perilous adventures may occur, their engulfing conflicts taking place in locations safely distant from 'home' and family.

During the sixteenth and seventeenth centuries, the notion of enterprising adventure became very tightly associated with specific circumstances in which *men* could journey 'abroad' in search of their fortunes. From the mid-sixteenth century, *an adventurer* was a soldier: a volunteer who enrolled for military service of his own free will (rather than one who fought because of bondage or due), especially a 'soldier of fortune' or mercenary who risked death and injury in battle or through the numerous other hazards of campaigning life in anticipation of material reward. In the early seventeenth century, the particular combination of risk and fortune in commercial undertakings within a developing capitalist economy, especially those involving overseas trade, had produced the *merchant adventurer*, who either took part in trading expeditions or had a share in their financing. A specialist sense of *adventure* as a pecuniary venture or a financial speculation dates from this time and came to acquire a specific relation to colonial enterprise. The historical importance to British national development of the acquisition of an empire can be seen here to have become deeply embedded in the English language, giving the cultural significance of 'adventure' in Britain explicitly militarist, capitalist and colonialist connotations that run right through to the present. Adventures happen in other peoples' backyards, the other people in question usually being those linked historically with Britain by its 'adventures' overseas.

In the later seventeenth century, these connotations were extended to

include broader kinds of hazardous activity requiring subjective qualities of 'enterprise' and cleverness in order to succeed. A third sense of *the adventurer* then became 'one who lives by his wits', carrying strong class connotations of one without fixed social place, certainly lacking gentle birth or inherited fortune, and therefore somewhat disreputable. This sense could be extended, by the mid-eighteenth century, to *the adventuress*, carrying similar connotations but tying them much more closely to the manipulation of sexual favours in order to secure a social niche and way of life in polite society. These gendered connotations of *adventurer* and *adventuress* register the historically limited opportunities for women to become involved in adventures and their close association with sexual forms of risk, excitement and disreputability. The wider opportunities for adventure – in socio-economic as well as imaginative terms – fell to men, in a masculine world of risk and enterprise in the pursuit of fortune. These 'more adventurous' circumstances have given the concept its intimate (but not exclusive) association with masculinity.[16]

This gendering of adventure and its imaginative connection with empire is also evident in literary narratives. Martin Green, in *Dreams of Adventure, Deeds of Empire* (1980) argues that 'adventure narrative [is] the generic counterpart in literature to empire in politics', and points out that many writers have understood empire to be 'a place where adventures took place, and men became heroes'.[17] Green's principal interest is in modern adventure, produced under the conditions of 'the modern world system' established by mercantile and industrial capitalism, and epitomized by its founding text, *Robinson Crusoe* (1719). The hero of pre-capitalist adventure – the knight of chivalric romance – had relied on the chivalric code of honour to guide his actions, and on Fortune and other magical helpers to assist him against fantastical enemies (often monsters, giants and suchlike) in a world steeped in the atmosphere of the marvellous. By contrast, the paradigmatic modern hero is a figure constituted from the mercantile imaginary: the rational, prudent and calculating Crusoe 'defeats the challenges he meets by the tools and techniques of the modern system'. Crusoe on his island uses guns, compasses, scientific knowledge, diary- and account-keeping, Puritan spiritual techniques and other 'rationalized and systematized and de-mystifying habits of thought', to create order and value out of the wilderness in which he finds himself, and to subdue its native inhabitants to his will.[18]

If the very form of the modern adventure tale is imbued with the imaginative resonance of colonial power relations underpinned by science and technology, Green also emphasizes the reciprocal impact of these fictional imaginings upon the emerging reality of empire. In celebrating the opportunities that it offered for deeds of manly heroism, the adventure tales that began with Crusoe were, argues Green, 'the energizing myth of English imperialism':

They were, collectively, the story England told itself as it went to sleep at night; and in the form of its dreams, they charged England's will with the energy to go out into the world and explore, conquer and rule.[19]

As energizing myth, adventure helped to bring into being the emerging imaginaries of empire and the new historical forms of 'English' national identity and masculinity figured in them. These in turn charged the adventure quest with a specific imaginative quality which sedimented into its structure.

Drawing motifs from, and feeding new material back into the cultural imaginaries in which they participate, adventure narratives either reproduce or help to transform their character, and in the process are themselves shaped by their changing connections and the splits that exist between them. When in 1827, for example, Scott (in his preface to *The Surgeon's Daughter*) summarized the possibilities for a romantic story located in India, his interest clearly derived from the traditional repertoire of the Indian colonial imaginary, in which 'India' appears as 'a realm of imaginative licence . . . a place where the fantastic becomes possible in ways that are carefully circumscribed at home'.[20] This India was a perfect setting for chivalric adventure: a land 'where gold is won by steel; where a brave man cannot pitch his desire for fame and wealth so high but that he may realize it, if he had fortune to be his friend'.[21] An existing corpus of adventure stories, told by returning East India Company employees, soldiers and other travellers dating back some two hundred years, contributed to this imaginary topos ruled by wish-fulfilment. Circulating in both polite and popular culture, in oral as well as written form, these stories fuelled the excitement and desire that could stimulate others to make the journey to a place where these wishes might apparently be realized. They also provided writers like Scott (who had no personal experience of the subcontinent as a real geographical space) with a ready-made landscape of excitement and danger to test the wits and courage of British heroes.[22]

Sharing common elements of an Indian imaginary that extends into many other forms, the adventure story selects and reworks these motifs according to their potential for 'adventure interest'. The quest proposed in Scott's preface imagines a journey towards, and then within, this fantastic imperial landscape and an encounter with its inhabitants. These are envisaged as friendly 'Man Friday' figures, who side with the hero in his conflict, or enemies of the quest, to be fought and overcome. Scott is clearly drawing from Orientalist ethnography in his recognition of a rich variety of helper and enemy types: 'the patient Hindoo, the warlike Rajahpoot, the haughty Moslemah [*sic*], the savage and vindictive Malay'. Intrinsic to the adventure potential that he finds in India is the scope it offers for Western fascination with other cultures, in 'the various religious costumes, habits and manners of

the people of Hindostan'. Retaining many emphases from an older chivalric tradition of adventure, these imaginative elements are subordinated to the winning of fame and wealth, and it is in their acquisition that he imagines the social recognition of the hero. The wish-fulfilling idealization shaping this imagining is betrayed by the presence of that other necessary ingredient of romantic adventure – Fortune, the hero's magical helper who sets all to right.[23]

The Indian adventure that Scott actually wrote was rather different. Historically, of course, the success with which, 'in India, Europeans lorded it over the conquered natives with a high hand', so that 'every outrage may be committed almost with impunity', owed less to 'fortune' than to the structures and mechanisms of British colonial power as exercised by the East India Company. While Scott finds exciting the idea that British soldiers in India were 'like Homer's demi-gods' and their leaders, such as Robert Clive, 'influenced great events like Jove himself', the writing of such a story in the early nineteenth century would have had to face the disapproval of such a stance emanating from what Green calls the 'morally-serious' reading public.[24]

Prior to the late eighteenth century, the men who ran the Indian Empire under Company rule had been attracted primarily by the opportunities afforded for money-making and the pursuit of sensual pleasures. They adapted traditional forms of British masculine virility to these new conditions, with tolerance and even enjoyment of Indian culture. With the advent in the 1790s of evangelical interest in Empire and the emergence of the Christian missionary movement, these customary imaginings were challenged by an alternative image of India as 'the quintessence of depravity'. A new form of colonialism was promoted, based on the superiority of Christianity and Western science over indigenous religions, and designed for the 'improvement' and salvation of the colonized peoples whose decadence, cruelty and wickedness now required redemption and reform. A public campaign launched by the evangelicals to further this new conception of Britain's moral responsibility was directed in the first instance against those traditional conceptions of India that supported existing British rule. A moral critique of the old imperialism expounded against its characteristic forms of masculinity: the Empire had attracted 'the wrong kind of Englishmen . . . and brought out the wrong tendencies in them'. Training for the Company service began to propound the virtues of a new kind of 'Christian Englishman' – a righteous, energetic reformer who would be dedicated to the establishment of a virtuous and rational Raj.[25] While a writer like Scott might not directly subscribe to the evangelical re-imagining of India, its public pressure helped to create a moral climate that militated against the writing of narratives glorifying conquest in the old way.

Cultural imaginaries are not unified phenomena but conflictive, their forms being contested and refashioned by social movements pursuing

interests that are themselves construed in terms culled from existing imaginative traditions. A continual process of exclusion, incorporation and exchange is at work, in which imaginative connections and splits are reconfirmed or modified. Adventure narratives about the British in India were a principal vehicle for connections between the colonial and military imaginaries which changed the imaginative significance of 'India', 'the soldier' and 'war', making possible new kinds of soldier's stories. Macaulay's – and later, G. A. Henty's – interest in the Clive story indicates that India continued to be imaginable in these terms during the nineteenth century (a theme to which I return in Part II).[26] As Green argues, however, the earlier evangelical challenge to these imaginative connections helped to generate a different kind of soldier's story, as Scott's readers were treated instead to the multiple displacements of a *Waverley* (1814). Here, chivalric excitement is transferred to a colonial periphery located at an historical rather than geographical distance – the Scottish Highlands of 'Sixty Years Since' – and partially contained within a moral structure that circumscribes and qualifies its attractiveness and ultimately condemns it as unrealistically 'romantic'.[27]

The spiritual quest for the holy grail, Clive's imperial quest for power and wealth, and Waverley's journey towards self-discovery are not different forms of one universal quest structure, but different forms of quest with different kinds of hero. Transformations in the generic form of adventure can be charted in terms of the historically variable relations established between adventure narratives and cultural imaginaries. These relations are shaped by social and psychic forces far removed from the adventure landscape itself. Differentiated public audiences, that make different kinds of imaginative investments and are prepared to recognize different qualities of gendered subjectivity, exert a determining effect upon the kinds of heroes produced for their consumption, mediating the extent to which these become publicly available and recognizable forms. Captain Waverley, a fictional soldier who goes in search of romance, is a very different kind of modern hero from Crusoe, or from that most popular of nineteenth-century heroes, Lord Nelson, whose life and death were celebrated in the broadside ballad and the chapbook as well as in the romantic history and biography. These different forms of adventure hero co-exist in the early nineteenth century alongside other forms of imagined masculinity ranging from the methodist working-man to the Byronic hero, from the Jacobin radical to Cowper's domestic contemplative.[28]

Perhaps the most interesting of all the imaginaries related to modern adventure, bearing important implications for the masculinity of the adventure hero, is that of domesticity. To argue this is to challenge something of an orthodoxy in recent critical debate, that adventure and domesticity have little to do with each other. Martin Green, for example, considers an imaginative distance from the domestic sphere to be a structural requirement of the adventure quest as such: this takes place in 'settings remote from the

domestic and probably from the civilized'.[29] Green recognizes the existence of a domestically oriented mode of masculinity, whose desirable (and undesirable) qualities were imagined in the gentleman-protagonists of the mainstream domestic novel from Richardson and Austen to George Eliot and E. M. Forster. Domestic manliness, however, is presented as a totally separate alternative to the adventurer, the product of a profound split that occurs within the novel genre.[30] Other writers have proposed a particularly tight equation between masculinity and adventure: according to one account, this is founded upon the defensive need of men to distance themselves from ostensibly feminine interests in narratives of domesticity and romantic love, so as to preserve their masculinity from the threat 'of being unmasked, in an unguarded moment, as a cissy, a pansy, or a weed'.[31] From the later nineteenth century, when the form of adventure most familiar to the late-twentieth-century reader was first produced, through to contemporary action thrillers like *The Guns of Navarone*, *Who Dares Wins* or *The Heroes*, the absence of domestic material of any kind is indeed remarkable.[32] A convincing argument can be made that adventure in the expanding Victorian Empire provided opportunities for a veritable 'flight from domesticity' on the part of British manhood – a flight celebrated in Allan Quatermain's infamous boast, in *King Solomon's Mines* (1885), that 'there is not a petticoat in the whole history'.[33]

Yet, from an historical perspective that sees the adventure genre as a plurality of forms, there is evidently nothing intrinsic to the quest structure that insists on a linear narrative movement away from the domestic sphere. In pre- and early-modern romantic adventure of the Arthurian or Spenserian kind, for example, the quest is organically connected to the domestic space from which it begins and to which it often aspires to return, in a circular narrative trajectory. The notion that all adventure featuring a masculine protagonist must echo Quatermain's boast is belied by quests in which the hero encounters forms of feminine sexual temptation that are explicitly juxtaposed, structurally and symbolically, to domestic femininity and that test his manhood just as surely as armed combat.[34] Renaissance romance that encompassed both 'adventure, quest and trial' and 'the private sphere of the nuclear household' was instrumental in the late sixteenth and seventeenth centuries in propounding the case for romantic love and imagining new conceptions of gender, marriage and domestic responsibilities. By the late nineteenth century, however, these twin concerns could no longer be readily held together in one narrative genre, which split into two distinctively gendered types of narrative, both addressed to broad, sexually differentiated 'popular' readerships. 'Masculine romance', from *Boys Own Paper* to James Bond, now became exclusively concerned with adventure scenarios of 'male camaraderie, rivalry and contest', in an imagined world quite distinct from that of 'domestic femininity' constituted by 'feminine romance', which was now exclusively preoccupied with the search for fulfilment through

heterosexual love.[35] The appearance of this disjunction between the manly world of adventure and a domestic, romantic world of male–female relationship has historical as well as simply structural significance. Investigation of the relation between these two imaginative worlds, and of the masculinities that inhabit them – a relation that the disjunction itself renders invisible – must lie at the very centre of any historical analysis of the adventure hero.

If this splitting-off of domestic and romantic interests assumed a pervasive and enduring form during the course of the nineteenth century, the process can be seen to have begun with the modern tradition of adventure initiated by *Crusoe* and to have been held in check by countervailing tendencies associated with evangelicalism and 'moral seriousness'. Scott's fiction, for example, written under the influence of the late-eighteenth-century movement for the 'reform of manners', brought together adventure and domestic motifs and explored their interaction. Evangelical championing of moral reform and alternative social values, including codes of masculinity, had an impact in every nook and cranny of British public life as well as in the colonial service (where it forms the wider context for reform in India); affecting, for example, the pursuit of traditional manly recreations, men's conduct in the public street, and attitudes towards civic responsibility. Traditional codes of masculine behaviour came under criticism as being 'vulgar' and 'coarse', and new standards were set for '"improvement", a value which had many faces: refinement of manners, "rational" tastes, the cultivation of moral sensibilities, restraints imposed on some forms of personal indulgence . . .'.[36] A new ideal of 'domesticated manliness' centred on the home and family was propounded in a proliferating domestic imaginary fed by sermons and religious tracts, practical handbooks on the management of domestic life, gardening books, poetry and other discourse.[37]

Sustained by a Christian imaginative geography rooted in the dichotomy between Home and World, the impulse behind reform was to transform the public world according to the moral yardstick of private domestic life. As Leonore Davidoff and Catherine Hall have shown, 'Home', by association with 'the Heavenly Home' and its promise of peace and rest in the life hereafter, came to signify a 'sacred refuge' from the tribulations of a fallen and amoral World. Given worldly 'pollutions' and strife, the truly religious life for middle-class evangelicals came to centre in household domesticity, since it was only within the bounds of the private home that the requisite habits of a godly and morally pure life could be secured and maintained.[38] By the early nineteenth century, this imaginative geography had taken on tangible shape in the desirable figure of 'the White Cottage', typically with thatched roof, a porch hung with honeysuckle and roses and set in a garden surrounded by a hedge, fence or wall, within which 'all was humility, comfort and peace'. The garden, a crucial feature of the domestic landscape, bore powerful connotations of paradise and the proper cultivation of virtue, in sharp contrast with the turbulence beyond:

We are a garden walled around,
Chosen and made peculiar ground
A little spot enclosed by grace
Out of the world's wide wilderness.

On the other side of that wall, a threatening public world of political unrest, poverty, brutality, sexuality and disease posed constant dangers on many fronts to the godly and, as domestic imaginings spread in a more secular form, to the 'genteel' and respectable of all classes.[39]

Into that turbulence, moral manhood ventured to do 'God's duty in the world'. This, together with the financial support of his family, was man's distinct responsibility according to the evangelical doctrine of 'separate spheres', which allocated woman a reciprocal sphere of influence at the centre of the household, as 'the godly wife and mother', overseer of the practical and spiritual welfare of the family.[40] The nineteenth-century domestic idyll figured 'a rose-covered cottage in a garden where Womanhood waited and from which Man ventured abroad – to work, to war and to the Empire'.[41] The impulse behind evangelical reform can be seen as an attempt to extend the boundaries of 'home' and transform more of the wilderness, through enlightened cultivation, into a garden, an imaginative association that is most clearly evident in the forms of colonial settlement throughout the Empire.[42] A vigorous pursuit of moral reform and the regeneration of corrupt worldly society – the taming of the wilderness – required a particular kind of courage, initiative and authority, as well as 'active energy' (for which evangelicals entering the Indian service were renowned).[43] While the ideals of domestic manliness established standards to be sought in these public endeavours, their demands necessitated the fashioning of an effective public identity. New kinds of adventure hero were one imaginative response to this need.

The ideal of Christian manliness imagined a 'gentleman' equally at home in the public as well as the private sphere. A 'manly sensibility' – integrating 'robust manliness with refinement' and tempering moral authority with a solicitous regard for dependants – would guide his conduct to the lower orders and the colonized as surely as to his wife and children.[44] In practice, the discord that is part and parcel of any social relationship rendered elusive the attainment of this harmonious integration, while the ideal itself was constantly challenged by the conflicting demands of public work and private domestic life. These often required contradictory qualities of character and conduct, and generated a tension that men struggled to resolve in their constant movements back and forth across the frontier of domesticity. As Davidoff and Hall have shown, many a middle-class man made a 'powerful investment in domestic harmony': its worldly rewards – a peaceful and contemplative existence centred on his wife, children and the simple pleasures of fireside and garden – could furnish (as one manufacturer wrote) the

'utmost ambition of the desires of my whole life'. To attend to work with too much zeal, for example, was to risk neglecting the attractions as well as the responsibilities of fatherhood. On the other hand, the new values and qualities associated with domesticity risked recognition, according to traditional codes of manliness, as insufficiently virile: particularly where an 'excessive' attachment to the home was apparent, they tended to an unmanly feebleness of character and dependency upon women.[45] The intensity of feelings evoked by a wife and children might well undercut a family man's interest and competence in public life, and separation anxiety could transform the world into 'a barren desert without them'.[46]

There is no structural reason why adventure should not relate to these contradictory flows of desire, drawing the domestic imaginary into connection with those other imaginaries (such as the colonial and the military) that furnish the adventure landscape and the themes of the quest. Creative connection of this kind remained a possibility in early-nineteenth-century adventure, as the fiction of Scott testifies. Taking *Waverley* (1814) as an example of a circular quest that begins from and returns its hero to domesticity, I propose to investigate how an adventure narrative may work with these contradictions, and to explore the phantasies that structure this particular quest and its imagining of a desirable masculinity.

Scott's Waverley: the splitting and integration of adventure and domesticity

Scott's *Waverley: or 'Tis Sixty Years Since* is an adventure set during the Jacobite Rebellion of 1745.[47] While Green suggests that this historical retrospective represents a displacement of adventure interest away from the Indian Empire, *Waverley* can be seen as a colonial text in a more immediate sense. Written in the wake of the 1801 Act of Union that created the 'United Kingdom of Great Britain and Ireland', and at the height of the long war with revolutionary France, one of its main problematics was the forging of a common British identity capable of integrating differences between Scotland and England. Scott's aspiration was to introduce the natives of Scotland 'to those of the sister kingdom in a more favourable light than they had been placed hitherto', so as 'to procure sympathy for their virtues, and indulgence for their foibles'. In this, Scott 'attempted for my own country . . . that which Miss Edgeworth so fortunately achieved for Ireland', which 'may truly be said to have done more towards completing the Union than perhaps all the legislative enactments by which it has been followed up'.[48]

In its harking back to the 'Forty-Five' – the moment of victory for British colonial policy over Jacobite resistance to the Hanoverian state, which paved the way for the massive depopulation of the Highlands – the novel establishes the perspective of modernity to position the Highlands as a backward, peripheral region of intense romantic interest. Finding a picturesque quality

in the poverty and discomfort of a traditional, feudal way of life, carried on without the 'improvements' brought by modern techniques of production, *Waverley* contributed to the invention of the now-familiar Highlands imaginary, with its kilts, clans, tartans and bagpipes, that first made the region a centre of attraction for tourists and ethnographers in the late eighteenth and early nineteenth centuries. Scott himself was president of the Edinburgh Celtic Society, founded in 1820 to promote the use of ancient Highland dress, and a prominent researcher into the social history and customs of the Highlanders. In a strategy closely linked to that of Orientalism, this knowledge was utilized in *Waverley* to construct an adventure world, with strong claims to documentary authenticity, that celebrated Highland otherness while ultimately justifying its subordination. 'We would recommend this tale', wrote Lord Byron, 'as faithfully embodying the lives, the manners, and the opinions of this departed race', which constitutes 'a very large and renowned portion of the inhabitants of these islands'.[49]

The most interesting aspect of the novel is the way that these political and ideological oppositions – England–Scotland, Lowland–Highland, Hanoverian–Jacobite, modernity–antiquity – are established in terms of a pattern of conflicting characters and motifs drawn from different narrative genres. Elements of the domestic novel of sensibility, assimilated from Scott's reading of Fanny Burney and Jane Austen, are fused with those of romantic adventure.[50] The tensions between them are worked through to a synthetic resolution in the course of a quest which takes Scott's young protagonist, Edward Waverley, on a circular journey from his home in the south of England northwards into the Scottish Highlands and back. Interweaving public and private domains in this way, the narrative fore-grounds the conflicts of identification experienced by Waverley as he oscillates between competing conceptions of desirable masculinity in a journey of self-discovery.

This bridging of genres proved immensely popular on its first appearance, and Waverley's transformation evidently figured a mode of masculinity appealing or at least acceptable to a wide range of readers. The novel 'overshadowed everything else' published that year: gaining a warm critical reception; selling six print-runs within the year, soon increasing to some 12,000 copies; stimulating intense public speculation about the identity of its still-anonymous author, 'which occupied every company, and almost every two men who met and spoke in the street'; and winning many new, serious readers to the novel.[51] Even evangelicals were 'seduced into novel-reading' by Scott, despite long-established religious opposition to a practice con-sidered even more 'pernicious and alarming' than theatre-going.[52] In a sense, the novel brought about a further integration in speaking to, and imagin-atively pulling together, components of the reading public with otherwise conflicting values and investments.

67

The initial motive for the quest in *Waverley* derives from disturbances in the domestic environment during its hero's childhood. His mother dies when he is 7, while from an even earlier age, he has been brought up between two very different households: that of his father, a supporter of the Whig government, and that of his Jacobite uncle and aunt. Here, his withdrawal into daydreams excited by romantic stories is indulged, with 'evil consequences' which 'long continued to influence his character, happiness and utility'. Although Waverley has a clear place to occupy in social relations, being heir to the comfortable domestic life of a landed gentleman, he has failed to acquire the necessary masculine habits of 'firm and assiduous application', of 'controlling, directing and concentrating the powers of his mind'; and shows a marked disinclination for 'field sports and country business'. Instead, romantic fiction has stimulated a dangerously feminine excitability of imagination and a 'deep and increasing sensibility', apparent in 'the dainty, squeamish and fastidious taste acquired by a surfeit of idle reading'. As a result, when Waverley 'mingled with accomplished and well-educated young men of his own rank and expectations, he felt an inferiority in their company'.[53]

Torn between conflicting identifications – which have their origin both in the 'public' world of politics (Jacobite versus Whig) and in the internal world of the psyche (reason versus imagination, masculine versus feminine), each standing as a metaphor of the other – Waverley is unable to occupy securely the social role mapped out for him. His opportunity to resolve these conflicts arises not within the domestic sphere but by moving away from it into the adventure world, where imagination can be given free play whilst also carrying consequences. Responding to his Aunt Rachel's suggestion that he should 'see something more of the world' before settling into marriage (with an English woman of whom she disapproves), he accepts a commission in the British Army, and 'the transient idea of Miss Cecilia Stubbs passed from Captain Waverley's heart amid the turmoil which his new destinies excited'.[54] The quest is thus explicity coded as Waverley's search for a coherent and effective masculine identity. It is a quest for manhood.

The adventure landscape it takes him into is the Scottish Highlands, via the 'half-way house' of Tully-Veolan, the lowland seat and home of the Baron of Bradwardine, an ex-Jacobite comrade of Waverley's uncle, Sir Everard, and his daughter Rose. Narrative interest is closely bound up with romance motifs and intensifies as the quest gets underway, but Scott also retains his critical perspective towards Waverley's yearning for excitement and romance, provoking an ambivalence in the reader. His fascinated attraction to the Highlands and their inhabitants is first evoked by Rose Bradwardine's description of a Highlanders' raiding party. This, 'a story which bore so much resemblance to one of his own dreams', stimulates Waverley to seek out for himself experiences which he had hitherto only

read about in books: he felt himself to be in 'the land of military and romantic adventures'.[55] Delaying the journey to his regiment at Stirling, and leaving behind the pleasures of Rose's company in the domestic haven of Tully-Veolan, Waverley travels on into the ever-grander mountain scenery accompanied by a Highland guide, towards the camp of the Highland chieftain, Fergus McIvor.[56]

The splendour of the Highlands landscape provides an apt location for Waverley's encounter with the 'other' masculinity of the Highlanders, in which his own masculine identity is explicitly thrown into crisis. This occurs first when his guide, Evan Dhu, castigates 'the effeminacy of the Lowlanders, and particularly of the English'; and later, more substantially, at Waverley's meeting with Fergus, whose 'martial air' and 'manly appearance' suggest an epic military virility.[57] Waverley's admiration for what he perceives as Fergus's superior manhood leads to an intense friendship, marked primarily by Waverley's identification with Fergus. At the same time, he falls in love with Fergus's sister Flora MacIvor and, with his encouragement, courts her hand in marriage.[58] Waverley's desire to live the life of a Highlander, characterized for him by the passionate intensity of romance, is enmeshed from the beginning in the polarities engendered by his own flight from self. In finding in the Highlands everything that is desirable, Waverley rejects (at least by default) his own Englishness and its associated qualities and tries to locate himself anew on the terrain of the other. The distance he has travelled from his English self becomes clearly apparent when he agrees to support the Jacobite Rebellion by fighting in the army of the Young Pretender, Prince Charles Edward Stuart, against the very British forces he originally came to Scotland to join. Having become a Jacobite, the outcome of his personal quest is now fused with the outcome of the political conflict in which he intends to fight, and his identification with Fergus is complete. Waverley now dons the dress of a Highlander. He attempts to become his own imagined other.[59]

The story of Waverley's encounter with the Highlanders, resulting in this new phase of the quest with Waverley as a soldier marching to battle against a British army, is interwoven and complicated by other themes centring on romantic love and domestic happiness. His attraction to Flora is seen from the beginning in the comparative light of Rose Bradwardine. Where Flora is characterized above all by her intense commitment to the public cause of Charles Edward, to the exclusion of interest in the private sphere of the domestic, Rose is described in terms of the ideal embodiment of domestic femininity. Waverley himself articulates a strong desire for domestic security and intimacy during his first visit to Tully-Veolan and this introduces the discordant note of likely unfulfilment into his courtship of Flora. She resists his vision of their future life together, and continues to contrast him with Fergus, whom

she considered as dangerous to the hopes of any woman who should found her ideas of a happy marriage on the peaceful enjoyment of domestic society and the exchange of mutual and engrossing affection. The real disposition of Waverley, on the other hand, notwithstanding his dreams of tented fields and military honour, seemed exclusively domestic.[60]

Until he has made his complete identification with the Jacobite cause, Waverley can believe that his national identity as an Englishman is the sole impediment to their union, and he continues to imagine that his yearning for excitement and intensity (which attracts him to Flora in the first place) can be compatible with ordinary domestic happiness. When Flora continues to reject him despite his joining the Jacobite army, the incompatibility is exposed, and Waverley is shown to be pulled between conflicting impulses. The narrative can now pose the question of what Waverley wants.

Waverley's choice to remain committed to the public cause even though his personal hopes have been dashed constitutes a moment of major growth in his moral stature and marks the hinge upon which the story turns. For if the narrative up to this point has been motivated by Waverley's flight from contradiction in his denial of his Englishness and desire to attain the idealized values he finds in Highlander Scottishness, the final rejection by Flora initiates the contrary process of his facing-up to the contradictions and their implications. For the first time, Waverley overcomes his vacillating temperament and begins to exhibit 'a manly and decisive tone of conduct'.[61] The first important consequence of this emerges when he is forced to confront the destructive implications, for once-valued others and therefore for his own integrity, of the enterprise upon which he is embarked. Meeting by the road an English soldier dying from wounds received in a skirmish with Jacobite forces, he recognizes the man as one of his own family retainers with whom he had first journeyed to Scotland. When the man asks, 'Squire why did you leave us?', Waverley is struck with guilt at having abandoned his dependants and his duty.[62] During the battle of Prestonpans, he is dismayed to come face to face with Colonel Gardiner, the respected commander of his own regiment, and is later mortified to learn of his death. This remorse prompts a questioning of where his values and commitment lie, and forces him to seek a resolution to the conflict of his own desires.[63]

A helper in this further stage of Waverley's quest appears in the figure of Colonel Talbot, an English officer whose life he saved during the battle and who now becomes his prisoner and eventual friend. Talbot, the voice of reason, duty and 'Englishness', tells Waverley of Gardiner's death and confronts him with the destructiveness of his betrayal. While a professional soldier, Talbot is devoid of the charisma associated with the Highland soldiers. He is also, crucially, a settled domestic man who confides in Waverley about his own wife and children. Talbot provides, then, a source

of positive identification for Waverley to pit against Fergus, with whom he is explicitly compared. As their friendship grows, so Waverley's fascination with Fergus begins to wane. The friendship with Talbot is also associated with Waverley's gradual transfer of affection from Flora towards Rose. At this point, then, Waverley's choice between competing desires is figured in these two associated pairs of opposites, Talbot–Fergus and Rose–Flora, both representing the conflict between domesticity and romantic adventure. When Fergus declares himself a suitor of Rose, Waverley is able to acknowledge the strength of his own feelings for her, and his cooling friendship with Fergus is transformed into open conflict and rivalry.[64]

In this penultimate stage of the quest, Waverley begins to recognize and confront his conflicting desires and to establish new goals. The exhaustion of his impulse towards adventure is marked by the turning-back of the Highlanders' advance into England at Derby. Waverley becomes separated from the Jacobite army during an engagement with the British in which Fergus and his closest companions are captured. After a period in hiding, he travels to London disguised against arrest to meet Talbot, where he simultaneously renounces being a soldier and declares his love for Rose.[65] His subsequent return to Scotland is doubly motivated by his wish to see her and his desire to avoid arrest and trial as a traitor. Arriving at Tully-Veolan once again, however – in a chapter appropriately entitled 'Desolation' – he finds it destroyed by British troops and its occupants scattered.[66] The resolution of the quest is enabled by a letter from the King procured by Talbot, granting Waverley's pardon – in effect, a recognition of his fundamental loyalty and a forgiveness of his lapse from it. Marriage with Rose is agreed upon immediately after receipt of the pardon, and together they establish a new and more secure realignment of public and private identities, with Waverley now on the side of established political authority rather than rebellion: the necessary condition of that domestic happiness which he is now able to choose unambiguously for himself.[67]

This does not represent a return to the circumstances at the beginning of the novel. Waverley has gained much of value as a result of the quest, which has transformed him into a hero who integrates the competing identifications at play in the text. The successful resolution of his conflict incorporates these newly won 'Scottish' values into his re-asserted Englishness. Rose, of course, is Scottish, and retains those associations of romantic proximity to the risky Highlands which cluster round Tully-Veolan more generally. Marriage into the Baron's family likewise cements a new alliance of English and Scottish gentry. Similarly, the destructive aspects of the quest, in the shape of the now-defeated Scottish Jacobites, must also be faced. Despite Waverley's intercession, the State refuses to pardon Fergus. Waverley attends his trial and visits him during his final hours in prison. His execution fills Waverley with horror and prompts a new sense of responsibility and obligation towards the Scots, realized in his assumption of Fergus's feudal

responsibilities towards the remnants of his clan. The key figure of this reconciliation is the repairing of Tully-Veolan, the 'halfway house' between England and Scotland, effected by Waverley with the help of Talbot. His return to establish home there with Rose brings the quest to its resolution and the narrative to its closure.[68]

Waverley is an adventure quest predicated upon a divided and contradictory domestic situation which is complexly bound up with the public world of politics. The quest takes its protagonist into that public world where his efforts to resolve his own personal conflicts between modes of masculinity and femininity become articulated to those public conflicts between Whig and Jacobite, England and Scotland, that helped to engender them in the first place. The resolution of the one is shown to be dependent on the resolution of the other. Imagined masculinities and imagined nations intersect in Waverley, who comes to figure a representative national subjectivity. If the wish-fulfilling pursuit of this new identity initially takes the form of an identification with the Highland masculinity of the national other, the narrative holds this foray into colonial space together with Waverley's problematic relation to domesticity, thus qualifying the wish-fulfilling escape and foregrounding the tension between the two spheres of life and their alternative modes of masculinity. As in Renaissance chivalric romance, masculine identity is worked out in the movement across the border and back, which foregrounds conflicting desires in the hero. On the one hand, he wishes for romantic adventure and the opportunity to become a soldier hero; on the other, he wishes for domestic happiness, love and tranquillity. This enables the narrative to problematize and explore the nature of Waverley's identification with the other in the adventure landscape. While adventure is initially pursued at the expense of settled domesticity, in itself it does not generate a solution to the narrative's motivating contradictions. Rather, adventure provides the conditions under which those contradictions can be clearly identified as such, so that the hero can develop the resources necessary to confront them.

A Kleinian analysis can identify the structure of phantasy underpinning Waverley as a defensive splitting leading to a new integration accompanied by reparation. The initial splitting of 'domestic' and 'adventure' imagos introduces movement into the narrative, with Waverley's abandonment of 'domestic Englishness' producing a compensatory projection of value into the adventure world of the Highlands. Through projective identification, the qualities now felt to be lacking are rediscovered in the admired other whom Waverley first makes into the figure of his own desire, and then incorporates into himself by becoming like it. These introjected qualities of Highlander virility strengthen Waverley's own sense of masculine selfhood, to the point where his 'wavering' fluctuations give way to a new-found integrity and sense of commitment. This new strength enables him to survive rejection by Flora, but remains dependent upon the splitting-off and denial – as the 'bad

object' – of that part of himself invested in Englishness. The effects of this are experienced by Waverley initially as the unprovoked hostility of the British state, when he is arrested for treason.[69] Waverley does not realize (is unconscious of) the way his own actions have produced these attacks on him; they seem to stem from unprovoked aggression, which in turn comes to justify Waverley's own assumption of aggression as in one sense retaliatory and defensive.

His commitment to the Jacobite army is a moment of significant integration, and thus the hinge of the story, insofar as it marks the narrative shift in phantasy to the depressive position. Waverley himself assumes responsibility for aggressive and destructive actions against the no-longer-feared-but-now-denigrated, British authority; and his projections onto the Highlanders (his reliance on maintaining them as his idealized imago) begin to weaken as his own confidence grows. But he is now also exposed to depressive feelings of loss and guilt in his encounter with the once-valued-but-now-destroyed negative imagos of the English soldier and Colonel Gardiner. These positive imagos reappear in restored form as Colonel Talbot, a figure of reparation who now replaces Fergus as the repository of projected values that Waverley feels himself to lack, as a result of his splitting and introjection of Highlander qualities.

This is the moment when Waverley becomes conscious of the complex nature of social conflicts, of his own ambivalence, and of its consequences. He is poised between contradictory desires for Flora and Rose, identifications with Fergus and Talbot, and loyalty to English and Scottish peoples and their political representatives. As Waverley is drawn back towards Talbot and Englishness, the danger of renewed splitting arises, in a mirror reversal where Waverley is now drawn into conflict with Fergus. The latter loses his idealized qualities and increasingly appears in either a hostile or a denigrated light. When they quarrel, 'his eye flashed fire, and he measured Edward as if to choose where he might best plant a mortal wound'; and he is twice described as 'unreasonable', as well as 'haughty' and 'domineering'.[70] At this stage, then, the narrative is poised between triumphalist destruction of the Highland force, with Waverley in the position of destroyer or destroyed, and the possibility of further integration and reparation.

The narrative effects the latter by investing powers of retribution and forgiveness, not in Waverley, but in a 'higher' authority – that of the British State and particularly the King.[71] Waverley, separated from the Highland force, is forgiven, while the Highlanders meet with great dignity what the narrative presents as the thoroughly justified punishment of the law. Waverley's attempts at intercession, while failing to mitigate the sentences of death for treason, divest them of triumphalism, since he experiences horror and remorse at Fergus's execution. Destructiveness and its effects are hereby integrated into and contained by what now appears as a benevolent State. Waverley's task is then to repair the damage to both sets of imagos, English

and Scottish, caused by the war and his own involvement in it. Marriage with Rose, the assumption of responsibilities towards both English and Scottish retainers, and above all the physical reparation of Tully-Veolan, are its figures.

In renouncing his challenge to an authoritative father-figure, identifying with him and securing positive recognition from him, Waverley achieves the Oedipal resolution upon which a (relatively) secure masculinity depends. The novel is especially interesting, however, in its explicit treatment of the splitting in masculine identity across the public–private divide and its efforts to imagine a resolution that 'repairs' the damage caused by this split. This is brought about by an imagined integration of imagos in which triumphalist victory in the quest is tempered by aspects of domestic manliness. Significantly, this resolution depends upon the narrative imagining a new and more harmonious configuration of public and private spheres. A new political settlement based securely within the parameters of the existing State is felt to be deeply bound up with the fashioning of new kinds of subjectivity. In this, the reparation envisaged in the figure of Waverley is a potential held out to the various components of the novel-reading public.

<center>*</center>

As the public–private divide deepened from the early nineteenth century, and the contradictions it posed to masculinities intensified, so the potential lessened for the kind of imaginative integration found in *Waverley*.[72] With the domestic sphere now marked out as 'woman's place', the difficulty for men of integrating domestic and public identities became acute, the pressure of the divide rendering them competing alternatives in uneasy tension. As movement between these worlds became more problematic and acquired a powerful psychic charge, the public–private frontier itself increasingly came to be assumed rather than explored, in order to fix one or the other sphere as a coherent and self-contained imaginative space. The resultant split between cultural imaginaries along this cleavage reinforced the divide and helped to naturalize the different gendered worlds that were its product, in the very form of imaginative significance invested in – and excluded from – each.

This 'gendering' of cultural imaginaries is evident throughout nineteenth-century British culture. It breaches class differences through the widening take-up of modes of respectability and gentility by the working class and through the extension of state regulation across public and private domains. Military life, for example, was purged of women through their physical exclusion from the battlefield: from the 1840s, officers' wives could no longer attend as spectators, while women 'camp followers' were prevented from touring with the army, rendering the domestic and sexual routines of military life less publicly visible.[73] The effects of splitting are also evident in the links facilitated between these separated domestic and military imaginaries and the imagined nation. While fatherhood never became the preferred

form of expression for the patriotism of men, the patriotic virtues of motherhood were extolled in paeans to the family as the basis for national stability; the existence of domestic femininity became a measure of the advanced development of civilization in Britain; and the importance of the home and garden was claimed as a peculiarly 'English' characteristic. On the other hand, the imaginative encoding of 'Empire' as a part of the public world, a sphere of masculine activity in commerce, politics and war, tended to remove colonial domestic life from the public gaze.[74]

With the historical splitting-off of domesticity as the feminine domain, and the fragmentation of the reading public along gendered lines, a far-reaching generic restructuring of adventure and a transformation of its imaginative possibilities becomes evident. Attempts, like *Waverley*, to resolve the contradictions between public and private worlds and to repair their psychic effects by means of imaginative integration, become increasingly difficult and unlikely. Where domestic motifs are drawn into adventure, they now tend to appear in the text in less coherent, more troubling ways that resist formal integration. Alternatively, they may disappear entirely from view as a structured absence, leaving the adventure world as an imagined space free from the contradictions engendered wherever the form admits men's investments in the domestic sphere. With the sedimentation of these generic shifts, adventure narrative is restructured into a form of split and idealized wish-fulfilment, resolving in phantasy the contradictions in masculine identities that still have to be lived out as such in reality.

Fredric Jameson has suggested that unrealized elements absent from the manifest structure of any narrative constitute a significant subtext which he calls its 'political unconscious'.[75] The relation between manifest structure and subtext is produced by 'strategies of containment', the formal mechanisms whereby a narrative attempts to manage and dispel contradictions, dilemmas and anxieties derived from real structures of opportunity and responsibility in everyday experience. These mechanisms operate in such a way as to enable what can be registered consciously to seem internally coherent in its own terms, while repressing what cannot be incorporated without radical incoherence. Generic structures founded on these strategies produce the 'political fantasies' through which a social group imagines its own collective identity.[76] In these terms, the adventure hero founded upon splitting can be seen to imagine a form of masculinity that is ideally coherent and powerful because free from any such conflict.

Where Jameson conceives of the unconscious in Freudian-Lacanian terms as the site of repression, accessible only through a symptomatic analysis of the absences and contradictions immanent within any particular text,[77] a Kleinian conception of unconscious splitting and disavowal suggests a method whereby the political unconscious of one genre may be discovered within the material present in another. If adventure and domestic narratives

are seen, not just as simple alternatives, but as dynamically inter-related through the splitting of cultural imaginaries, then the domestic imaginary may be read as adventure's political unconscious, and the adventure quest as a strategy of containment for underlying anxieties and contradictions, the key to which may be sought not only in the public world, but in the masculine relation to the domestic sphere. The disavowal of domesticity, by this account, can be seen as constitutive of a particular historical type of adventure hero. Returned in this way to the historical conditions to which it is a response, what appears as a self-contained and coherent whole can be shown to be merely one aspect of a more complex and contradictory formation.

In the rest of the book, as I trace changing forms of adventure from the mid-nineteenth-century Victorian Empire to the post-colonial world of the 1950s and 1960s, I will be equally concerned to chart their heroes' complex relations to domesticity and sexuality, as to explore their more evident involvement in Britain's colonial imaginaries.

Part II

The hero-making and hagiography of Havelock of Lucknow

Imperialism and military adventure
in the nineteenth century

It is said by Mr Canning that India is a land fertile in heroes; but the fact is that India is a land fertile in those events which give to British subjects the opportunity of displaying those great and heroic qualities which abound so much among the inhabitants of that nation to which we have the happiness to belong, and among those who have of late had an opportunity of distinguishing themselves, few have been more fortunate than Sir Henry Havelock, and none have better availed themselves of that fortune.

<div align="right">Lord Palmerston in Parliament, December 1857[1]</div>

Their fate sent them to serve in India, which is not a golden country, though poets have sung otherwise. There men die with great swiftness, and those who live suffer many and curious things.

<div align="right">Rudyard Kipling, 'The Incarnation of
Krishna Mulvaney' (1891)[2]</div>

There are few terms in the language around which cluster so many blissful associations as that delight of every English heart, the word HOME. The elysium of love – the nursery of virtue – the garden of enjoyment – the temple of concord – the circle of all tender relationships – the playground of childhood – the dwelling of manhood – the retreat of age; where health loves to enjoy its pleasures; wealth to revel in its luxuries; poverty to bear its rigours; sickness to endure its pains; and dissolving nature to expire; which throws its spell over those who are within its charmed circle; and even sends its attractions across oceans and continents, drawing to itself the thoughts and wishes of the man that wanders from it at the antipodes.

<div align="right">John Angel James, <i>Female Piety or the Young Woman's
Friend and Guide through Life to Immortality</i> (1856)[3]</div>

4

THE IMAGINING OF A HERO
Sir Henry Havelock, the Indian Rebellion and the news

Introduction: the making of a hero

On 7 January 1858, when the press announced the death of Major-General Sir Henry Havelock, hero of the Relief of Lucknow, there began a period of national mourning on a scale not seen in England for fifty years. 'Never since the death of Nelson has the removal of any commander been so deeply and universally deplored. . . . For two days, in every circle from the Palace to the cottage, there was a national lamentation.'[1] As with all claims about national unity and universality, this needs to be qualified; but there can be no doubt that Havelock's contribution to the defeat of the 1857–8 Indian Rebellion (or the 'Mutiny', as it is commonly known) earned him a legendary reputation. Among a batch of military commanders to win popular recognition during the Rebellion, only Havelock became 'a major national hero': comparisons with the greatest of all British military heroes, Nelson and Wellington, were common even before his death.[2] In memorium, the Government agreed to a proposal to erect in Trafalgar Square a full-length statue, paid for by national subscription (see Figure 1). Although the statue stands there to this day, Havelock's name, unlike that of Nelson, has failed to become permanently inscribed in popular memory. Few of the tourists who might laugh at the pigeons perched on Havelock's head before crossing the road to the National Gallery will know who he was, how his name became a 'household word' in mid-Victorian England or why it was honoured in this extraordinary way. Nor will many remember that, for two generations of Victorians, he was 'a paragon to be emulated, who could symbolize "the goal towards which men strove"'.[3]

Havelock the hero was forged during the excitement and anxiety generated throughout England in the autumn of 1857 by the enormity of events in India. The Rebellion began with the mutiny of Indian regiments at Meerut on 10 May 1857 and the subsequent seizure of Delhi. The revolt quickly spread to other regiments and was taken up by the populace in the towns and countryside of the Northern Provinces. By the end of May a national uprising had developed in Oudh, and by mid-June 'the British had lost their

authority in most of the central provinces, a slab of country extending from the borders of Rajasthan in the west to Bihar in the east'.[4] Throughout this area British communities had been destroyed, and isolated garrisons remained under siege in Agra, Cawnpore, Lucknow and elsewhere. Havelock, fresh from the charge of a division during the Persian expedition earlier that year, was appointed Brigadier-General commanding a small flying column with orders to proceed from Calcutta to relieve the garrisons at Cawnpore and Lucknow and to re-establish British authority in Oudh. After winning a series of victories against the rebels, news stories in the English press hailed him as the saviour and avenger of British India.

A 62-year-old man on the brink of retirement after thirty years as a career officer, and a practising Baptist who proselytized among the rank-and-file in the Indian Army, Henry Havelock was an unlikely hero. During the last weeks of his life, whilst he fought fatigue and disease as well as Indian rebels, the hitherto 'unknown' Havelock became the focus of intense public interest as his story took root and proliferated in newspapers, pamphlets and public meetings across the country. After his death he was eulogized in a plethora of sermons, elegies and book-length biographies. Numerous rewritings for the burgeoning late-nineteenth-century publishing industry ensured the continuing, wide circulation of the legend and its reproduction to the eve of the Great War and beyond. Havelock remained a popular public hero for over fifty years after his death before apparently falling victim, along with much else from the adventure culture of late Victorian and Edwardian Britain, to the machine-guns, the artillery and the wire along the Western Front. Thereafter, his story has steadily been forgotten and his name consigned back to the obscurity from whence it arose.

In this second part of the book, I develop my arguments about masculinity and colonial adventure in the nineteenth century through a case-study of the Havelock phenomenon, exploring the production of the Victorian soldier as national hero. Havelock's national significance placed him on a par with the Napoleonic heroes, who were an established part of the pantheon and remained key emblems in state definitions of Britishness throughout the nineteenth century.[5] Yet Havelock was acclaimed in the late 1850s as a national soldier hero of a significantly new kind.

These differences can be located in terms of the new configuration of cultural imaginaries brought about by the 1857 Rebellion. Havelock was a soldier of the Empire, who fought in markedly different campaigns to those of the European theatre of war against enemies who, unlike the French or the Russians, were invested with the racial significance of colonial relations. The Rebellion had a decisive impact upon popular imaginings of India and the ways in which Britishness was defined against Indian others, drawing colonial and national imaginaries into an increasingly close association. According to Francis Hutchins:

The English national excitement over the Indian Mutiny was an important episode in the development of popular interest in England's overseas enterprises, which provided the political basis for the imperial adventures of later years.

The Indian Rebellion (like the Crimean War before it) evoked jingoistic sentiments in literature and the press long before the term 'jingo' was coined in the music halls. One outcome of the Rebellion was an enhanced interest in the government of 'our' Empire, including 'a ringing endorsement of the justness of India's subordination and an insistence that it be made more firm and effective through Crown rule'. The latter was established in 1858 with the abolition of the East India Company, whose rule of British India since the days of Clive 'had always been something of a closed preserve, a vested interest, a field of service and enrichment for one segment of the population only', rather than a public concern of the nation as a whole. As Hutchins puts it, 'India had been in a sense annexed psychologically because of the popular interest which now followed its reconquest. India "belongs to us", Miss Martineau stated confidently, speaking the national mind.'[6]

This psychological annexation was tightly bound up with military imaginings stimulated by the suppression of the Rebellion. National excitement took the form of a

> sudden growth of popular interest in the activities of these small bands of Englishmen overseas and an inclination to consider their exploits a reflection of the will and intentions of the nation, and their victories thus a creditable achievement, reflecting honourably upon every Englishman.[7]

The Indian Rebellion could be described as the first 'national-popular' colonial war fought by Britain in its Empire. It generated popular excitement and interest of a kind that had signally *not* accrued to previous military exploits in India, from the days of Clive to the more recent Afghan War (1838–42), Sir Charles Napier's annexation of Sind (1843) and the Sikh Wars which resulted in annexation of the Punjab (1845–6, 1848–9).[8] Heroic adventure stories about the deeds of the British generals who effected the 'reconquest' of the rebellious provinces produced fresh and psychically powerful connections between the national, colonial and military imaginaries of mid-Victorian Britain, which would give imperialist adventure its special resonance throughout the second half of the nineteenth century.

The stories told of Indian Rebellion heroes also established a further articulation by bringing this entire formation into contact with Christian imaginings. As Olive Anderson has shown, the years 1854–65 saw the notion of 'the Christian soldier' gain widespread currency beyond narrowly evangelical circles, in a movement promoting conversion among the ranks and the moral reform of the Army. She identifies this as the 'decisive shift'

that transformed popular perceptions of the military from the 'brutal and licentious soldiery' of Wellington's early-nineteenth-century army to the 'unprecedented adulatory attitudes towards Britain's professional soldiers' (and the wide diffusion of military sentiments and rhetoric) characteristic of the heyday of popular imperialism.[9] The 'pantheonization' of Havelock 'played a significant part in these developments', generating a substantial hagiographical literature in which he was represented as a soldier-saint:[10] a figure that can be read precisely as a trope linking two hitherto discrete imaginaries and rendering the elements of each available for use in the other.

But an adequate account of the emergence of this qualitatively new kind of soldier hero cannot rest on the analysis of cultural imaginaries alone. The very possibility of Havelock's existence, in 1857–8, as a nationally recognized public hero was contingent upon the mid-century revolution in the public media of communication, especially in publishing, and the massive proliferation in printed discourse that ensued.[11] A fuller explanation of Havelock's public significance requires the tracing of these changing configurations in the cultural imaginaries of adventure as they were mediated by this mid-century development in national-popular culture and its further extension and mutation throughout the second half of the nineteenth century.

Havelock is such an interesting figure because of his unique position within these cultural transformations. The constituent elements in his production harked back to an earlier evangelical formation, which was already breaking up by the 1850s, and anticipated the ever-accelerating developments in the media of communication which underpinned the 'New Imperialism' emerging in the 1870s and 1880s.[12] His name was trumpeted alike in those traditional forms, the pulpit sermon and the tract, and in reports in the one-penny press made possible by the most modern news-gathering technologies. The themes of a traditional popular patriotism, mobilized by the pamphlet and the local orator, encountered a new imperialist ethos generalized outwards to the provinces by sophisticated, centralized methods of modern organization. The Havelock story had no existence outside these varied conditions of cultural production and consumption. They were constitutive of, not one, but many different versions of the hero, constructing him for, and delivering him to, a variety of different public audiences, each of which invested particular qualities in his image. What interests me in this case-study is not the actual life and achievements of Havelock the real man, but how his story was told and retold, and the imaginative significance invested in these different renderings.

The mid-century recomposition of cultural imaginaries, together with new conditions of cultural production and consumption, combined to generate the most substantial – and influential – of all the various forms of heroic storytelling about Havelock: that which fused military adventure with the evangelical genre of the 'exemplary life'. From mid-century, stories

of the lives and adventures of pious soldiers were increasingly used as a vehicle for evangelical propaganda, the adventures functioning as a sugar-coating for the moral example presented by their characters and achievements, highlighted by the narrative so as to invite emulation. These biographies of great military leaders constitute an important and little-studied genre of Victorian popular literature. In the earliest 'Lives of Havelock', the convergence of the national military pantheon with the Christian soldier tradition, and the fusing of the imaginings available in each into one composite figure of ideal and exemplary moral manhood produced a new form of British masculinity: one characterized by a potent combination of Anglo-Saxon authority, superiority and martial prowess, with Protestant religious zeal and moral righteousness. In this, Havelock can be seen as a prototype of the popular soldier heroes of the later Victorian and Edwardian Empire, such as Wolseley, Gordon, Roberts and Kitchener. These figures constituted a new tradition of exemplary imperial masculinity which remained at the heart of the British national imaginary right up to 1914.[13]

Where the Havelock legend of the 1850s and 1860s differs from this later tradition is in its interest in the domestic life of the hero. Telling the story of an early-nineteenth-century 'serious Christian' and family man, these exemplary life representations of Havelock's masculinity also involve an engagement with domestic imaginings not readily compatible with the life of a campaigning soldier. Havelock's biography is especially interesting amongst Victorian soldier heroes in that its mid-century forms provide an opportunity to explore the contradictions between the conflicting identifications of adventure hero and domestic manhood, as these were negotiated in the narration of a particular life. This, and the subsequent reworkings of the Havelock legend in the years up to 1914, will be the focus of Chapter 5. First, though, I investigate the primary basis of the legend in the unfolding news stories of Havelock's adventures, which first introduced his name to an anxious and admiring reading public during autumn and early winter of 1857–8.

The news stories about the mutiny that appeared in England from May 1857 claimed, as responsible, modern news stories do, a truth-status as documentary reporting on events. Yet the news report, like any other form of narrative, does not simply record the realities about which it speaks, as if passively registering their imprint, but actively shapes its 'raw material' according to an investment of imaginative significance. As a public form, the news is complexly determined by both social and psychic factors that intersect in the particular historical circumstances of its narration.[14] The reporting of Havelock's mobile force can be seen to be mediated by two specific sets of conditions: contemporary developments in the gathering, relaying, publishing and distributing of 'the news' from India, and the prevailing imaginative forms governing the sense that British people, both in India and England, could make of these astonishing events.

'The news' from India in 1857

In 1857 the English press was in the early stages of a communications revolution that was expanding the quantity of available news and speeding up its transmission to ever-increasing audiences. The recent repeal of the 'taxes on knowledge', having removed governmental control of the press and opened the way to a cut in cover prices, stimulated a massive extension in the market for newspapers. The rapid emergence of a cheap, daily provincial press and the continuing growth of the mass-circulation popular Sunday press – both phenomena of modern, urban, industrial England – posed a challenge to the political pre-eminence of the powerful London-based dailies led by *The Times*. Both catered for readers who could never have afforded the price, and heartily disapproved of the politics, of the established metropolitan press, which spoke to, and on behalf of the dominant mercantile and industrial elite. By contrast, the popular Sunday papers – notably *Lloyd's Weekly Newspaper*, *Reynolds' Newspaper* and the *News of the World* – catered for the bulk of the working- and lower-middle-class reading public, largely located in the traditional Chartist and radical heartlands of the industrial Midlands and North; while the provincial dailies were mostly organs of the educated middle class in those same areas, building on liberal and non-conformist traditions that also flourished in parts of the West and East Anglia. By the late 1850s, the major Sundays each boasted weekly sales of 150,000, while circulation of the provincial press was far in excess of that of the metropolitan papers; the actual readership multiplying these figures several times over.[15]

This expansion of the press created the conditions for a sustained national-popular interest in the Empire, an interest that the press was able to cater for by means of the modern, trans-imperial communications network that had been developed in the thirty years prior to the Indian Rebellion. The impetus behind this had been commercial rivalry between the major London dailies, which had generated a capital- and technology-intensive modernization of the Indian news service designed to increase its speed of delivery. In the early nineteenth century, England and India were separated by a vast gulf. The sea-route by steamer, carrying passengers and the Mail from the south-coast ports to Calcutta via the Cape, generally took four months, sometimes longer. By 1836 a new 'Overland Mail' route, that linked steamer-stages in the Mediterranean and the Red Sea by land travel across Egypt from Cairo to Suez, had reduced the Calcutta journey to sixty days. Among the first institutions to take advantage of this halving of journey time was *The Times*, which established its own network of steamers, forwarding agents and special couriers at massive expense, in order to secure its reputation in the City for news of Eastern markets. Further paring of hours and minutes reduced the journey time to thirty days and ten hours in 1841; and so efficient was *The Times*'s organization that its editor, J. T. Delane, often

received important news from India by 'Extraordinary Express' ahead of the Government. By 1847, when *The Times* and three other London dailies reached an agreement to share an Indian Express Mail service, railway connections and the telegraph had been installed, the latter superseding the Overland Mail as the 'Extraordinary Express' in the form of terse messages or 'telegrams' which briefly summarized the most important points in the oncoming Mail, where they were developed in more detail.[16]

The success of this modernization in communications inaugurated the transformation of time and space that is so remarkable a feature of the modern world. By the late 1840s, news was arriving in London 'from distant parts of the world in times that appeared unbelievable': feats of news transmission such as the appearance in the afternoon edition of *The Times* one 31 July, of news from Bombay dated 29 July, created 'much astonishment' amongst readers.[17] Speed created a heightened excitement in the news, which had become hot property by mid-century. According to one contemporary account: 'Before a foreign mail packet comes alongside the Southampton dock wall hundreds of persons in London, eighty miles distant, are reading from the public journals with breathless interest the news she has brought.'[18] As the world became a smaller, more accessible place, Britain's overseas Empire was brought closer to home as an imaginable reality.

While internally differentiated along the fracture-lines of political and cultural conflict, the British news public participated as a whole in these developments in the national culture. Foreign news formed a substantial component of the provincial and Sunday newspaper as well as the metropolitan daily, whose dearly bought overseas copy – being readily piratable and able to be distributed around the country by train and telegraph immediately after publication in London – would often appear in the provincial papers without acknowledgement or fee, before the London papers themselves arrived. By 1855 the metropolitan dailies had moved to institutionalize this general reliance on their services by licensing the Electric Telegraph Company to sell to the provincial papers copies of all the news telegrams it received between each daily edition, to be published with acknowledgement of their source.[19] The popular Sunday papers, being less dependent on speed, published the Overland Mail that had arrived during the week, reproducing not only the full summaries of the main events found in the British-Indian press, but also on occasion the commentaries upon them made by *The Times* itself. *Reynolds' News*, for example, frequently betrayed its source of news from India by articulating its own editorial stance, in substantial disagreement with *The Times* on many points, through critique of that newspaper's comments.[20] The newspapers which together delivered the primary national public for the Havelock legend, whilst articulating distinctive editorial stances on the news of the Rebellion, nevertheless relied on substantially the same reports, delivered at the same time to an English

reading public newly excited by the very phenomenon of 'news' of this kind. These circumstances were to have an important bearing on the development of the Havelock heroic image.

The communications revolution, while less advanced in India, also bore directly upon news-gathering there. Under Dalhousie's modernization policies, the 1850s saw the beginnings of a railway system and the achievement, by 1854, of a telegraph network linking all the major cities, including Allahabad, from whence news of Havelock's flying column would later be wired to Bombay and Calcutta.[21] By the time of the Rebellion, a well-established system of news-gathering was in place, centring on *The Times*'s own regular correspondents based in Calcutta and Bombay, who telegraphed the headlines and later forwarded the Mail (now sent via the British Post-Master General's office at Marseilles and direct rail link to Boulogne).[22] This reached the offices of the major London dailies about one month later. Besides the correspondents' own regular letters of summary and comment, the Indian Mail during the Rebellion included statements released by the British authorities and other public agencies, dispatches from commanders in the field, eyewitness accounts from soldiers and civilians by letter from all over India, and information from private sources within British-Indian society. Copies of the local British-Indian newspapers, whose own reports were compiled from a similar range of sources, were also included.

This was not a system designed for war-reporting. Unlike W. H. Russell's famous dispatches for *The Times* during the Crimean War, which first established the value of a civilian special correspondent reporting directly to the newspaper's editor from the heart of the campaign,[23] reports of the Indian Rebellion were irregular, uncritical and unreliable. Effectively, the English press was universally dependent upon these few individuals who were comfortably situated in the British-Indian capital cities some hundreds of miles from the scenes of revolt, and whose source material was furnished for them by the British-Indian community.[24] These limitations were exacerbated by the effect of hostilities upon internal communications in India. If the first word of the outbreak of mutiny 'was flashed 824 miles from Agra to Calcutta . . . before it [the telegraph wire] could be severed by rebel sepoys', thereafter the collapse of British rule throughout the Northern Provinces and the ensuing isolation of the besieged communities introduced days of waiting for any news at all.[25] Where news was scarce, an alternative and faster source was rumour, though often this could not be confirmed or denied for several days or even weeks. These circumstances of news-gathering and transmission meant that the news stories that appeared in England functioned predominantly to generalize British-Indian responses to the Rebellion – responses which were, at best, partially informed of events – as an imaginative framework for English readers. In this process, a set of specifically psychic determinations came into play.[26]

The British colonial imaginary and the Indian Rebellion

The phantasy material invested in press reports of Havelock's column on its mission to rescue, relieve and re-establish colonial order needs to be related to the specific anxieties generated in British culture by news of the 'Mutiny'. This came as a profound shock to the public in England. The possibility of losing India – so important to the British economy, but also to its reputation as a world political power – had never before been seriously entertained. Now, 'our empire in the East' was felt to be 'imperilled', and with it, British 'prestige' and 'supremacy' among the European nations.[27] The imaginative impact of the Rebellion, however, was not registered primarily in geopolitical terms, but took the form of outrage and a sense of insult and degradation at what had apparently been done to the bodies of British people.

In the press reports published in autumn 1857, and written without the benefit of hindsight, readily verifiable atrocities committed by the rebels were compounded with phantastical rumours like the following:

> The history of the world affords no parallel to the terrible massacres which during the last few months have desolated the land. Neither age, sex nor condition has been spared. Children have been compelled to eat the quivering flesh of their murdered parents, after which they were literally *torn asunder* by the laughing fiends who surrounded them. Men in many instances have been mutilated and, before being absolutely killed, have had to gaze upon the last dishonour of their wives and daughters previous to being put to death.[28]

The veracity of such rumours was apparently endorsed by eyewitness evidence in correspondence sent to the British-Indian press, much of which was reproduced in full by the English papers. *The Times* also eagerly published the private letters of British-Indian civilians and soldiers written to families and friends elsewhere on the subcontinent or back in England. Ostensibly, these added further details to what was only ever a very sketchy picture of events. One notorious instance of rumour centred on Lord Shaftesbury, an important and well-respected public figure, who claimed to have received a letter

> from the highest lady now in India [Lady Canning, wife of the Governor-General] stating that day by day ladies were coming into Calcutta with their ears and noses cut off, and their eyes put out . . . children of the tenderest years have been reserved . . . to be tortured in cold blood with the utmost refinement of imagination before the eyes of their parents, who were made to witness the cruelties and who were made to swallow portions of the flesh cut from the limbs of their children, and afterwards burnt over a slow fire.

Shaftesbury addressed public meetings on this theme, which received wide and detailed attention from the press, but he was later forced to admit that he had never seen this letter himself, and there is no evidence that it was ever written.[29]

Whether subsequently corroborated or refuted, these stories articulated the shock, fear and anxieties of the British-Indian community from which they originated and within which they first circulated. As personal narratives, they can best be read as efforts towards subjective composure. Addressed not to a general news-reading public, but to the particular public of immediate families and friends who were affected by common anxieties about what was happening to themselves and their loved ones, they attempted to make sense of horrifying events and to manage the terror of their psychic repercussions. Once publicly amplified and condensed together in press reports claiming to be documentary 'truths', for which they furnished the eyewitness evidence, these stories took on an altogether different significance. As sources for more generalized and powerful public narratives, they helped to establish the imaginative frame within which the impact of the revolt could be grasped by English readers in the summer and autumn of 1857. Their details were further retailed in histories and fictions long after its suppression, despite being exposed as groundless in numerous enquiries published from 1858 onwards. Clearly, the continuing imaginative resonance of these rumours could not be dissipated even when they were found to be empirically untrue. If we are to understand the impact of the Rebellion in England, we need to consider not so much the 'truth value' of these stories, as their role in organizing the imaginative relation of English people to events in India. In this, they ensured that the public gaze remained fixed from the outset of the Rebellion upon a spectacle of massacres, atrocities and other sufferings inflicted upon the British in India by the mutinying sepoys.[30]

Attempts by Victorian writers to define their reactions to the reports are striking for their ambivalence, at once repelled and fascinated. This is aptly illustrated by *The Times*'s guilty apology for publishing details of the Cawnpore massacre, as 'painfully interesting'.[31] If the Rebellion stimulated new popular interest in India, then it did so by means of horror stories that compelled a particular kind of 'interest', or psychic investment, in a scene that was, of necessity, imaginary. 'India' was rendered a nightmare landscape peopled by figures straight out of evangelical Orientalism. The mutineers – whether 'the Cruel Hindu' or 'the Mahomedan [who] is a ferocious animal, and made so by his creed' – are commonly described as devils and fiends, whose 'wickedness' and 'malignity' are so total as to make them 'lose everything human and behave like demons'.[32] India itself is ascribed a demonic character, attributable either to 'the superstitions that they call religion which provides the licence of an excuse for their horrible passion';[33] or, in that more fundamental discursive strategy analysed by Said, to the

eternal, unchanging nature of a country where, in every state prior to British rule,

> men like today's mutineers [made] it a policy to strike terror by every imaginable cruelty . . . it was an ordinary thing to attack villages reposing in the utmost security and, without a quarrel, to burn them, slaughter the inhabitants indiscriminately, and to acquire the soil.[34]

The readers of these reports, at a safe distance of some thousands of miles, were invited to imagine 'cruelties at which the heart shudders and the blood runs cold, and the ears of Christians tingle with the horrid tale'.[35]

The imaginative energy behind the intense ambivalence of this scenario derives from psychic splitting and projective disavowal. Patrick Brantlinger, referring primarily to historical and fictional writing on the Rebellion, describes the atrocity rumours as 'the projection of "devilish" sexual impulses onto Indians' in phantasies characterized by extreme sadism. 'The violence and lust of the Mutineers are repositories for feelings and impulses that [the writer] cannot attribute to his English characters.'[36] In Kleinian terms, sadistic phantasies of cannibalism and the dismembering of human bodies derive from early infantile phantasies of oral aggression against the body of the mother. Fear of this aggression prompts its projection onto others, giving rise to persecutory anxieties of being attacked, 'eaten up' or dismembered by these other beings, who assume a terrifying and threatening aspect as a result.[37] In Mutiny narratives, the positions of attacker and victim, derived from these aggressive and sexual components of the phantasy, are invested in the forms of a cultural imaginary that organizes the relative positions of British and Indian subjectivities in terms of colonial power. The demonic mutineers are therefore experienced as profoundly threatening to the colonial subjectivity of the British as 'master-race' and to the Anglocentric imaginings that underpin it. The cruelty of the subjected races is this time being turned upon their British masters, with disturbing implications.

The imaginative significance of this violation of bodies disrupted the colonial order on several levels. The brutalities committed against British-Indians, argued *The Times*, 'pass the boundaries of human belief, and to dwell upon them shakes reason upon its throne'; for in committing them, the mutineers 'have broken the spell of inviolability that seemed to attach to an Englishman as such'.

> There is something quite new to English minds in hearing of the dreadful outrages committed upon the persons of English men and women.
>
> We thought we were lifted above such a dreadful risk, that our higher than Roman citizenship would shield us, that some Palladium

would protect one of English blood from the last indignities. It seems we are mistaken.

With previous certainties overturned, the nightmare landscape has a peculiar, shifting, unbounded quality: anything might happen next, for now

> there is no knowing how far they will go. . . . The more cringing and servile they were before – the more they crouched under the commanding eye which controlled them then – the more boundless is their insolence now. . . . Having once torn away the veil, [they] rush with voracious relish to the pollution of the sanctuary . . . to soil the marble surface of the temple with the vilest filth.[38]

In the very profusion of metaphor it is possible to detect the discourse of colonial power working overtime to re-establish a coherence which has been shattered by the Rebellion, just as the focused gaze of that 'commanding eye' is now forced to scan the vastness of a territory over which British rule no longer holds sway.

Nor were British reason and knowledge alone threatened by this transformation of imaginative space. The language of the temple soiled, the sanctuary polluted, the inviolable violated, indicates that the sacred is also at risk. In another, constantly recurring metaphor, the Rebellion is seen in terms of a long-gathering storm: as 'that thundercloud, the breaking of which has deluged the land in the blood of England's best and bravest sons and fairest daughters, and children cruelly slain at their mother's breasts'.[39] This storm metaphor, suggesting the build-up and sudden, unexpected release of elemental forces, can be read in a number of ways. Its implicit contrast between the dark cloud – a black, all-engulfing mass which rains blood, like the 'swarming' Sepoy regiments – and the sunlight which it has temporarily quenched, evokes the evangelicals' 'civilizing light' against the darkness of barbarism. The Biblical reference to the deluge that is falling on the sons and daughters of the chosen race, however, also smacks of divine punishment for sin. The atrocities were widely interpreted as such, and whilst, for evangelical opinion, this prompted intensified faith in the providential support for British rule in India, for others, this sanctity (as distinct from the rationality) of British rule in God's name was called into question. The Christian Socialists, Charles Kingsley and F. D. Maurice, among others, suffered a crisis of faith: 'What troubled [them] was how God could have allowed his "Christian" people to be massacred by "heathens".'[40]

The image of the polluted sanctuary suggests another level to interpretation of the psychic charge investing the atrocities. As a figure for the transgression of boundaries between purity and corruption, the sacred and the profane, the spiritual and the carnal, it is deeply rooted in the Victorian domestic imaginary. Queen Victoria herself articulated this in her lament that 'the whole is so much more distressing than the Crimea – where there

was *glory* and honourable warfare and where the poor women and children were safe'.[41] Atrocities committed on women and children in India were found particularly horrifying given their especially close association in imaginative geography with the domestic 'sanctuary' of the home. The threat to their safety implied an absolute transgression of the imaginative demarcation between 'our space' and 'their space', whereby the safe, the familiar and the homely was rendered hostile and then hellish, in a complete dystopian reversal.

Once again, the 'private' writings of British-Indians expressed these anxieties most acutely. In the period immediately before actual violence erupted, women registered their disquiet in terms of the disruption of order within the domestic space by newly 'insolent' native servants, and of the transformation of the areas around their homes from safe colonial space into dangerous enemy territory. As the imaginative boundaries shifted, these people found themselves, all of a sudden, deep within that hostile zone with utterly inadequate physical protection. So began, at least for those with sufficient foresight, the task of turning their homes into military defences. In the garden of the Lucknow Residency, 'trenches scarred the flower beds and lawns'.[42] In England, the nature and seriousness of the Rebellion was 'brought home' through domestic geography. *Lloyd's Weekly* contradicted governmental assertions that the Indian people remained loyal, by reference to private letters telling how, for example, 'at Agra, the very servants of the Europeans plundered the bungalows of their masters and then set fire to them. . . . Everywhere the story has been the same; the rising of the sepoys followed by disaffection and dishonesty of even domestic servants'.[43] 'Interest' in the besieged British garrisons quickly came to focus on the women and children isolated, so to speak, 'behind enemy lines'. Much of the excitement and anxiety generated in England by the five-month siege of Lucknow derived from the spectacle of their suffering the hardships of the frontier soldier, whilst simultaneously remaining within the domestic space which the very name of their fortress – the Residency – evoked.

The 'polluted sanctuary' also refers to the bodies of women and children 'violated' by the sepoys. Many writers have commented on the significance of Victorian ideas about the 'spotless innocence of women and children' in responses to the Rebellion.[44] In the idealization of womanhood encapsulated in the notion of 'the angel in the house', the respectable wife 'brings a more than mortal purity to the home that she at once creates and sanctifies, for which her mate consequently regards her with a sentimental, essentially religious reverence'.[45] Her purity was guaranteed primarily by the innocence of her own sexual nature, carefully cultivated in genteel girls by parents anxious 'to shield their daughters from a reality which [they] perceived to be sexually contaminated', and thus as liable to contaminate and corrupt the nature of any woman who yielded to sexual desire.[46] Her best defence against this possibility was the assumption of 'an essential passivity,

a lack of any desire to strive or to achieve', and a corresponding adoption of the 'feminine' virtues of patience, resignation and self-sacrifice.[47] The passivity and innocence of ideal womanhood were qualities invested also in the idealization of childhood, reinforcing the imaginative connection between the two. The violation of British women and children struck at the heart of this Victorian reverence, most powerfully in accounts of the 'crowning atrocity' of the Rebellion: the 'massacre of innocents' committed after the surrender of the Cawnpore garrison. This 'exceed[ed] in magnitude anything hitherto reported from these scenes of wickedness', and 'will set the blood of every Englishman boiling in his veins'.[48]

In these stories, an intense pathos is generated by the imagining of the innocents as entirely helpless victims of unbridled Oriental passions; a pathos compounded by the sullying of an ideal and its immediate reinvestment in the telling, as a defence against its loss. This scenario threatened to breach the imaginative boundaries that fixed social identities, shaking the very categories which held in place civilized relations between the sexes. The reluctance of some writers to 'pollute my pen' – and with it, readers' imaginations – with specific details of this atrocity expresses this anxiety.[49] So, too, do the many rumours about the daughter of General Wheeler, commander of the Cawnpore garrison: she was variously reputed to have been killed and cast into the well, to have been carried off by a sepoy for sexual favours, to have killed her abductor before committing suicide, and to have run off with and married him, although the most arresting version of all tells of her shooting dead five 'ruffians' in defence of her life and honour (which the writer considered to be 'among the most remarkable instances of female heroism'.)[50]

More than virtuous femininity was at risk here. For Klein, the idealization of femininity is rooted in the infant's defences against its own phantasied attacks on the mother's body. Reverence for 'the angel in the house' can be seen as a form of this same defence, guarding here against taboo masculine sexualities evoked in the Mutiny scenario.[51] It provides a defence, too, against the split in masculine identity between domestic virtues and the duty to act and achieve in the world. According to Carol Christ, the masculine idealization of domestic femininity can be understood as an effort to resolve masculine ambivalence both about the desire to achieve (which can lead to failure, anxiety and despair) and about the value of 'active' virtues. She, who is pure and passive, 'represents an ideal freedom from those very qualities he finds most difficult to accept in himself'. Christ points out that this projection nevertheless places the man in 'the position of sole actor and sexual aggressor. Thus the very idealization through which he had sought to escape his ambivalence compels him to re-enact the domination and sexual aggression that create such a conflict'.[52] From this perspective it becomes possible to see the atrocity stories as activating the contradictions in British masculine identity in a peculiarly potent and troubling way. They confront it not only

with the pollution of the sanctuary, evoking renewed idealization of the suffering innocents, but also with a failure to adequately protect that sanctuary, provoking a renewal of ambivalence, anxiety and despair, which in turn impels the resumption of an active and aggressive role with renewed vigour.

The disturbing implications of this eruption of the unconscious within colonial relations were countered by a swift re-assertion of aggressive masculinity, fuelled by the wish to re-establish British rule and authority and transform the nightmare landscape back into safely colonial space. The form this took was an astonishing public clamour for revenge.[53] It is hardly surprising to discover that this desire originated in the British-Indian community.[54] It was widely shared by British troops, who were licensed to satisfy it by the colonial authorities in their first reactions to the Rebellion. One soldier, in General Barnard's force marching on Delhi from Kurnaul in May, recorded that: 'We burnt every village and hanged all the villagers who had treated our fugitives badly until every tree was covered with scoundrels hanging from every branch'. Summary executions by shooting and hanging became commonplace throughout the Northern Provinces. In Benares, Colonel Neill – who would soon be serving under Havelock – 'restored order' by the enthusiastic use of 'hanging parties', using mango trees for gallows and elephants for drops. At Allahabad, under his orders, 'European volunteers and Sikhs descended upon the town, burning houses and slaughtering the inhabitants, old men, women and children as well as those more likely to be active rebels who were submitted to the travesty of a trial'.[55] In the Punjab, appalling reprisals were perpetrated against deserting mutineers and suspected leaders of the Rebellion, to complement the disarming of sepoy regiments and other defensive arrangements aimed at deterring an uprising in their own area. In one incident, 192 sepoys of the 51st Regiment were shot by firing squad. In another, at Peshawar on 10 June, forty mutineers from the 55th Regiment were paraded publicly before the garrison and thousands of spectators, prior to execution by 'blowing away' from the mouths of cannon. One soldier who witnessed this wrote to his father, 'It was a horrible sight but a very satisfactory one. . . . The pieces were blown about in all directions.'[56]

News of British reprisals caused considerable satisfaction back in England too. Thomas Macaulay remarked that:

> The cruelties of the sepoys have inflamed the nation to a degree unprecedented in my memory. Peace Societies, and Aborigines Protection Societies, and Societies for the Reformation of Criminals are silenced. There is one terrible cry for revenge. The account of that dreadful military execution at Peshawar – forty men blown all at once from the mouths of cannon, their heads, legs, arms flying in all directions – was read with delight by people who three weeks ago were against all capital punishment.[57]

This cry for revenge can be traced across almost the entire spectrum of the mid-Victorian press: from, for example, the popular Sunday *Lloyd's Weekly* ('vengeance upon the fiends') to the influential metropolitan dailies, *The Times* and *The Morning Post* ('the extermination and rooting out from the face of the earth the Mohammedan and Brahminised demons who have committed crimes on British women and maidens too horrible to name') to the radical *Newcastle Chronicle* ('vengeance . . . sharp and bloody, . . . [They should be] exterminated as if they were so many wild beasts').[58] The poet Martin Tupper wrote sonnets, widely published in England and India, calling for the complete destruction of Delhi and the erection of 'groves of gibbets' for the mutineers. The call for revenge was echoed at public meetings of the Indian Relief Fund and at religious gatherings such as the 20,000-strong crowd at the Crystal Palace in October 1857, to whom that 'nonconformist spellbinder', the Revd Spurgeon, 'preached blood'.[59] Many private individuals among the literate middle class testified to private wishes for revenge, including Dickens and Mrs Flora Annie Steel, who remembered in her memoirs how 'I burnt and hanged and tortured the Nana Sahib in effigy many times'.[60]

This widespread wish for revenge can be read as a defensive response to anxieties generated by the loss of psychic control over a hated and feared other and by the threat this poses to subjective coherence. With reason and faith put at risk, and the psychic boundaries between us and them, known and unknown, home and wilderness transgressed, the triumphalist revenge phantasy countered the threat by imagining the longed-for annihilation of its source. In this paranoic reassertion of control, self-legitimated punishment is fused with an omnipotent denial that control has ever been lost. In the case of the British in India, however, the power to 'realize' such phantasies actually existed on the ground. The agents of an all-too-real retribution were to be the British Armies of the East India Company and the Queen. The satisfaction and delight generated by news reports of their activities derived from the fulfilment of a wish – the pleasurable release of psychic energy attendant on the gratification of revenge desires. By the autumn of 1857, the major vehicle for these phantasies of national revenge was the flying column led by Brigadier-General Henry Havelock.

The adventures of Henry Havelock

On 20 June 1857, five weeks after the Meerut mutiny, Havelock was appointed Brigadier-General in command of a mobile column, with orders to quell all disturbances at Allahabad, to lose no time in moving to the relief of the besieged garrisons at Cawnpore and Lucknow and to 'take prompt measures for dispersing and utterly destroying all mutineers and insurgents' (see Figure 2). Arriving at Allahabad to assume command ten days later, he found Neill's 'Bloody Assizes' underway. On 7 July, the column – 'a

pitifully small force consisting of about a thousand British infantry from four different regiments, less than 150 Sikhs, six guns, a detachment of native irregulars, and twenty volunteer cavalry' – left Allahabad on the journey to Cawnpore and Lucknow. 'Soldiers!', said Havelock, in one of those rhetorical addresses to his troops which would be quoted so often in the future, 'There is work before us. We are bound on an expedition whose object is to restore the supremacy of British rule and avenge the fate of British men and women.'[61]

The military conditions of this expedition were in many ways eminently conducive to the imagining of war as adventure. Reflecting on the discrepancy between the responses of the English public to the Indian Rebellion and the Crimean War, Edward Spiers has pointed out that, in the Crimea, the campaign rapidly resolved itself into that stasis of large armies, endurance of appalling conditions and large-scale but ineffective slaughter, most usually associated in popular memory with the First World War. In India, by contrast, the campaign fought to suppress the Rebellion was a war of movement: 'the vast terrain, isolated garrisons, and scattered enemy offered scope for a multitude of independent initiatives by the various generals, commanding relatively small bodies of men'. As Lord Palmerston noted, such a field of activity provided fertile opportunity for the display of heroic conduct.[62]

In the narration of any military campaign as 'an adventure', its heroic aspects are foregrounded at the expense of less exciting motifs. The peculiar conditions of news-gathering and communication that pertained during the 'mutiny war' facilitated this process in two important respects. First, the absence of an on-the-spot reporter like Russell made unlikely the emergence of a more critical narrative mode. Russell's reports from the Crimea had not only included eyewitness accounts of the realities of combat but had also drawn public attention to the poor living conditions and ill-health of the soldiers, especially during the winter of 1854–5, and exposed the logistical weaknesses and strategic errors of the British campaign. The presence of 'negative' motifs of this kind undercut heroism with an ironic discourse of human errors and suffering. His swingeing attacks on the aristocratic generals' incompetence helped to transform the initial popular excitement and support for the 'Crimean adventure' into the public anger and concern that eventually brought down the Government. There is evidence in abundance that the Indian campaign shared all these features – 9,000 of the 11,000 British soldiers who perished were the victims of sunstroke and sickness – but critical attention was not drawn to them, at least in the early stages.[63] The absence of negative motifs of this kind made possible the foregrounding of 'positive' opportunities for initiative and heroism in the stories that did reach England about the activities of Havelock's flying column. Second, the fragmentary and uncertain quality of the news service affected the very form of narration, with unfolding events in India being reported in England in

blocks of news that appeared in irregular instalments some six or even eight weeks after they had occurred. Serial narration of this kind tended to heighten British anxieties while investing adventure motifs with the countervailing charge of wish-fulfilling assertiveness.

The small size of Havelock's force, and its emotive mission to rescue British women and children from their expected fate at the hands of savages, generated keen interest in England. For most of the summer, however, the general anticipation of military revenge was concentrated on the recapture of Delhi. Reports of Havelock's arrival in Allahabad did not reach England until 15 August, and nothing more was heard of him until the Mail of 31 August delivered in a single instalment the news of sixteen eventful days, catapulting Havelock into public consciousness as the avenger *par excellence*. His dispatches from the column described how, between 7 and 16 July, his small force had marched 126 miles in the full heat of the Indian summer, fighting and winning four battles against numerically superior rebel forces at Futteypore, Aong, Pandoonuddee and Cawnpore. The enemy had been 'routed', twenty-six guns captured, and after the fourth battle against an army nearly four times its size led by Nana Sahib, Havelock's column had recaptured Cawnpore on 16 July. The absence of any details of combat lent to reports of the march and battles the instantaneous, omnipotent quality of wish-fulfilment, giving the impression that victory had been won at the waving of a wand: at Futteypore, 'in the twinkling of an eye, [Nana Sahib] was routed, pursued, caught again at Cawnpore, driven out of the town, and pushed into his entrenched camp at Bithoor'.[64]

By quirk of the Mail, news of this string of heroic victories reached England at the same time as news of the first Cawnpore massacre. After a pledge from Nana Sahib of safe conduct down the river in boats, the garrison of men, women and children under General Wheeler had surrendered, only to be ambushed at the riverside:

> The story may not be – probably is not – true in all its details, but that Nana Sahib ordered and executed a general massacre of the prisoners who, whether by surrender or capture, had fallen into his hands, is unquestionable. We cling to the hope that the story is untrue which devotes the women of the force to a yet direr fate than sudden and violent death, which avers that the miscreant disposed of them to his men by open sale in the Cawnpore bazaar.

Havelock himself had intelligence of the surrender and massacre of the Cawnpore garrison before leaving Allahabad. In the English press, the juxtaposition of the two time-scales and their interweaving in a single report brought about an imaginative fusion of the two events – victory and massacre. This heightened already intense associations of revenge investing the British forces, shifting their focus to the very place that Havelock had 'just' recaptured (in historical time, six weeks earlier). 'Already, indeed, the

van of the avenging host has appeared. Two thousand British bayonets [have] flashed in the faces . . . of Nena [*sic*] Sahib , with his cowardly crew of miscreants [who have been] driven headlong into flight.' It was as though no sooner had the massacre been perpetrated than vengeance was distributed.[65]

The imaginative investments in Havelock's column were deepened still further by its association with the second Cawnpore massacre at the Bibighur. This went untold in England until 17 September. On the day after the battle of Cawnpore – and after Havelock's dispatch announcing victory was on its way to join the mailboat leaving Bombay on 30 July – Havelock's troops had entered the town to learn that:

> A large number of women and children, who had been 'cruelly spared after the capitulation for a worse fate than instant death', had been barbarously slaughtered on the previous morning – the women having been stripped naked, beheaded and thrown into a well; the children having been hurled down alive upon the butchered mothers, whose blood yet reeked on their mangled bodies.

Eyewitness accounts, by the British soldiers who discovered the path leading to the well, evoke a mix of almost unbearable pity and anger provoked in them by the scene and by the sense of having arrived just a few hours 'too late'. Havelock, inciting his troops to further endeavour, twisted the knife by confronting them with the idea that the massacre had been incited by the very victory that they had hoped would ensure the safety of the prisoners. Soldiers now swore personal and collective vows of vengeance.[66]

Developed in stories that circulated widely in England from mid-September, this 'oath of vengeance' motif lifted the narrative of Havelock's campaign to an epic pitch and rendered his army into Homeric proportions. In one version, 'the brave men who had not quailed before the 13,000 enemies', arrive in Cawnpore 'panting, hot, dusty and thirsty', to find 'the ground sanctified by the blood of gentle women and children'; they turn pale, tremble, weep, and think of their own families in England. Discovering the dead body of General Wheeler's daughter, they cut off her hair (carefully saving a portion for relatives). Then

> they divided the blood-stained locks amongst them; each washed his portion; dried and counted the hairs composing it; and then with a great loud oath they swore to kill and lay low as many of the murderers as they had hairs of the poor girl's head – and they *will*. They have already partially carried out their oath, and now the war cry is
> 'Remember the ladies,
> Remember the babies'.[67]

The emotionally charged language of Victorian melodrama splits the scene into a black-and-white world of absolute evil and absolute virtue.

As Brantlinger has argued, the impact of this event surpassed all others in the intensity of pathos it generated. The Well of Cawnpore became 'the primary focus of all popular [British] accounts' of the Mutiny in nineteenth-century histories and fictions. The rebel leader held to be responsible – Nana Sahib – was popularly imagined to be the 'Satanic locus of all Oriental treachery, lust and murder'.[68] It is my argument that, conversely, the name of 'Havelock' was invested with idealized projections of positive value, his heroization being a product of the same psychic splitting that demonized Nana Sahib. Just as Nana Sahib became a synecdochal figure condensing all the most shocking and threatening aspects of the Rebellion, so Havelock became an imago of omnipotent, triumphalist energy and power:

> Nothing surpasses, and few things can equal, his eight days' incessant march to Cawnpore, his winning four victories in twice as many days, his terrific strides across a swampy region, blistered by the heats of the Indian midsummer, his succession of rapid and over-powering blows.[69]

In accounts like this, it can appear as if Havelock alone was single-handedly responsible for achievements that were actually won by a force of hundreds.

The wishes invested in, and constitutive of the image of Havelock the conquering hero operated precisely as a defence against unbearable loss, grief and anxieties of destruction. Consider, for example, this panegyric to Havelock (in *Lloyd's Weekly*):

> In the midst of the blood, and outrage, and disaster – in the worst darkness of the storm, towering as a giant above all other fighting men, stands gallant Havelock! His cheering voice, his keen sword, his dashing generalship, make up, for us, a figure of radiant hope. His name becomes a 'household word'. Men who have lost sons; mothers who have children and husbands to mourn; and those broken-hearted men and women who live to think always of foul outrages committed upon their own flesh and blood – all hail the name of Havelock. People begin to talk more confidently of our fate in India, seeing that a second Clive has appeared. [Other] brilliant deeds pale before the forced marches and hourly battles of Cawnpore's lion-hearted hero.[70]

Not only is the omnipotent power of this imago grounded upon specifically masculine virtues and qualities, but the investments of the reading public in the 'avenger of his countrywomen' are also imagined to be significantly gendered. As *The Times* put it: 'Not a wish will have been conceived by husband or father in his moment of unutterable agony which the vengeance of his countrymen will not amply realize'.[71]

The Havelock image simultaneously became the focus of collective national imaginings. The idea of Havelock as the saviour of British India, and thus the restorer of British supremacy and prestige, rapidly gained

ground. In the *Bombay Times*, he was hailed as the first 'to stem the wild torrent and turn the tide':

> Under God, this heroic captain, with his brave Englanders, has saved India. His march has been so triumphant, his success so marvellous, as to impress even the public mind with the conviction that he has received his mission from a higher than earthly rule.[72]

Since his victories (suggested *The Times*), the result was not in doubt:

> India will be British, and the British will be its lords, established in greater strength and dignity than ever. . . . That we are the same nation as before has now been proved beyond question. The relative superiority of our race is as incontestable now as it was a century ago – indeed, even more so. . . . General Havelock's march is the very expression and type of our position in Hindustan. He advances, he fights, he conquers – everything goes down before him.[73]

An imagined national identity is here being strengthened by introjective identification with military victories that are taken in as psychic nourishment, becoming 'our' victories. The discourse of British power underpinned by reason and faith can once again be confidently sustained, as the energizing cycle of introjection and projection brought about by news of the victories works to re-invest the myth of Britishness. 'Havelock' comes to embody this wish-fulfilling projection of an idealized and omnipotent national identity founded upon racial and religious superiority, as the very figure of the nation.

The generation of phantasy investments in Havelock's victories owed much to the English press narration of his column's progress on the basis of the serial and fragmentary reports emerging from India. The delay between the occurrence of events in India and their narration in England directly affected the character of Havelock's quest. In each instalment of the English news, it is possible to identify how the available material has been worked into a narrative shape capable of managing the anxieties current at that moment. In the case of the 31 August instalment, for example, temporary closure was established by foregrounding the hero's successful achievement of a part of his original quest: his defeat of Nana Sahib and entry into Cawnpore. These reports of his first successes are deployed in such a way as to completely frame the news of the Cawnpore atrocities, so containing their dread within a triumphalist narrative of revenge and retribution lifted directly from the British-Indian press. Similarly, both of *The Times*'s reports of 17 September, first introducing the story of the well, actually begin with promises of their 'decidedly cheering character'. This astonishing phrase was possible because, once again, news of these nightmare scenes had arrived by the same Mail as that of another Havelock victory, at Onao on 29 July.

Since the narrated conflict is only a part of a larger and as yet unresolved

conflict, the closure achieved by each instalment is necessarily incomplete and anticipates further activity in the future. Havelock's triumphal entry into Cawnpore reveals only the extent of the task to come: the renewed imperative of revenge, the danger to the Lucknow garrison, and beyond that Agra and Delhi. At the moment of narration, there is no guarantee that, in the future, the obstacles to be encountered will be overcome and the quest successfully completed. The time-delay therefore produces a narrative tempo of serial instalments punctuated by pauses of some days or weeks without further news, while the basic outlines of already reported events are being constantly embellished with further details. This results in suspense: the heightening of dramatic impact brought about by serial narration and its withholding (however unwittingly and unwillingly) of authoritative knowledge necessary to the managing of anxiety, and to eventual narrative closure.

As well as managing its 'own' material, each successive instalment must also relate to narrative expectations inherited from the previous one. News of the Cawnpore massacre is perhaps the most striking instance of a major *failure* of the quest to accomplish the desires with which it was originally invested, namely the relief by Havelock of the Cawnpore garrison. This disappointment, far from providing the crux of the report, is displaced and managed in a narrative that reinvests Havelock as the embodiment of a wish-fulfilling defence against the psychic impact of such failure. In order to effect its own partial closure, this instalment necessarily generates in turn fresh desires concerning the future development of the quest: that complete revenge will be achieved, that Lucknow will be relieved, that Delhi will be recaptured and British rule re-established. While the unpredictability of unfolding events means that the news report cannot achieve such full control of its material as narratives fashioned with the luxury of hindsight, the wished-for resolution is all the more intense. After Cawnpore, wishes of this kind fixed upon the Relief of Lucknow, seeking in its achievement an end to anxiety. It is the tension between these expectations and desires and the possibility that the next instalment will show the quest to have failed that produced such intense interest in the arrival of the next Mail from India in the weeks after 17 September 1857.

The narration of events during the following weeks oscillated wildly between confidence and anxiety. For some, Havelock's victories seemed to promise a speedy end to the conflict. British-Indian optimism in the providential design that had brought forth such an avenger led the *Bombay Times* to anticipate that Havelock would swiftly arrive in Lucknow and meet little resistance there. Letting its imagination rush triumphantly on ahead, it anounced that, after relieving Lucknow, Havelock intended 'to press on to Delhi, a distance of about 170 miles'. The *Bombay Telegraph* predicted that 'long before Christmas the whole of India will be lying at our feet'.[74] This manic triumphalism was endorsed by *The Times*, but other English news-

papers, less sanguine about the prospects for British forces, foregrounded the obstacles facing Havelock's quest. *Reynolds' Newspaper* described the late-August Mail, bringing first news of Havelock and Cawnpore, as 'disastrous . . . the worst yet received'. September's news was 'chequered', with the bad greatly predominating. Pointing out that Delhi had not yet been retaken, it contrasted its own early-August warnings about the strength of the rebels with *The Times*'s misplaced confidence that they would be unable to hold out much longer, and compared the situation to the Crimean débâcle of Sebastapol. Now, mutiny had broken out in Bombay. Havelock's column had failed to save Wheeler's garrison, and while his 'energy and decision' had 'told with tremendous effect', he now had 'a foe in his camp more deadly than the Hindoo – cholera'. While 'dribblets' of reinforcements reached the British, 'thousands' flocked to the enemy. 'Meanwhile, *The Times* brags and vapours and appeals to Heaven.' *Lloyd's Weekly*, while more optimistic about the superiority of 'English pluck' ('No sane Englishman believes that the Hindoo is strong enough to counter the Saxon'), also stressed the obstacles in the way of Havelock's quest to relieve Lucknow. Travelling in the rainy season without transport, the column faced an army ten times its own size; and even if Havelock did manage to relieve the 'remains' of the garrison, 'it is hardly to be thought that he could retain that great city of 300,000 inhabitants in a country the population of which is altogether hostile'. Anticipating the advance on Lucknow down a road where 'the enemy must be swarming . . . like hornets', even *The Times* began to express renewed anxieties: 'it is desperate work to make head against twenty to one'. Thoughts began to turn to Lucknow where, if Havelock failed, the probable fate of men, women and children under siege in the Residency now seemed all too imaginable.[75]

The next Mail brought news of a check. Far from entering Lucknow, and despite winning two more victories at Busseerutgunge (5 August) and Boorhiya (11 August), Havelock had been forced to fall back again on Cawnpore. Further news of Havelock's ninth victory in five weeks (at Bithoor, 16 August) could not dispel the sense of intensified threat. Havelock himself was

> threatened with attack on three sides . . . the probability is – and the English public must be prepared for the sad news – that this gallant soldier with his handful of men will find himself shortly in no better condition than poor Wheeler was, in the same place. And this while Nana Sahib besieges Lucknow!

With Agra also unrelieved and Delhi not yet secure, 'even the capital of British India [Calcutta] is not safe from assault'. At the centre of this 'gloomy picture', Havelock was at once the locus of anxieties and the means of their wished-for resolution: 'We want to see Havelock before Delhi!'[76]

There now began a period when 'the arrival of each Overland Mail from

India' was expected with 'feverish anxiety', and 'people do not generally consider what they may reasonably expect, or within what limits their anticipations may range'. For two weeks there was nothing but waiting, with 'Havelock still at Cawnpore', cholera raging in his camp and reinforcements under Sir James Outram making slow progress. When the reinforcements arrived at Cawnpore, and Havelock together with Outram was again set to advance on Lucknow, the release of anxiety and strengthened hope took the form of renewed triumphalism in England, this time more widely shared. 'The worst horrors of the Indian revolution are over', crowed *Lloyd's*, 'and now dawns the day of triumph and the avenging sword flashes in the light.'[77]

This optimism was apparently confirmed when, on 11 November, news arrived of 'an event that will carry a feeling of joy and thankfulness into every household in the kingdom. Lucknow has been relieved!' Havelock and Outram had fought their way into the city after winning two more victories (at Mungulwar, 21 September; and The Alumbagh, 23 September), and they were now installed in the Residency (25 September). Their arrival had occurred 'just as it was mined and ready to be blown up by its besiegers'.

> Undismayed by the aspect of a kingdom in arms against them, General Havelock and his comrades once more crossed the river to fight their way to Lucknow, and this time victoriously. They carried every hostile position by storm, hewed their passage through the rebel masses up to the very wall of the Residency, and snatched their countrymen from the indescribable horrors of their impending fate. For the whole work they had but 2,500 men, and of these one-fifth were struck down in battle.

Adventure motifs abound in this narration of the Relief of Lucknow: the heroes' combat, heavily outnumbered, with the 'hostile enemy masses'; their active masculine virtues (they 'storm' and 'hew' the passage to their goal); their heroic masculine sacrifice in aid of 'the weak, delicately bred women and the sickening helpless children who saw every day dusky swarms surrounding them and thirsting for their blood'; their suspenseful salvation, not 'too late' but only just in time.[78]

In these reports, the Relief was narrated as the successful completion of Havelock's quest, establishing narrative closure on his adventures and enabling, precisely, a general 'relief' from the narrative tension that had gripped press audiences since the summer:

> After five months of suspense and anxiety we may again breathe freely. The victory has come at last – won by almost superhuman endurance, by heroism never surpassed, by energy, activity and skill, which reflect honour on all engaged. . . . It may now, indeed, be said that the Indian Mutiny is at an end.[79]

The crucial importance of the closure established by Havelock's Relief of Lucknow to his public reputation can be easily gauged from this comment of *The Times*:

> If fortune had denied him the happiness of saving his countrymen from a dreadful death he would have been not the less deserving of the highest honours which the state can bestow upon courage, skill and enterprise. We should, however, have deplored the fact that his little column was unable to penetrate into the thick mass of the insurgents, and, honouring the effort, should have pardoned the failure. But now there is nothing to allow for or to forgive. The campaign has been crowned with complete success.[80]

Fortuitously coinciding with reports of the re-occupation of Delhi, the Relief made possible a symbolic 'putting back in place' of that which had been disturbed. Under a front-page headline, 'Reconquered India', *Lloyd's Weekly* drew the inevitable comparisons with Clive and reasserted British superiority:

> It must be clear now – even to the Frenchman – that the Anglo-Saxon, and the Anglo-Saxon alone, is destined to carry civilization to the Hindoo. Only the Saxon could carry a calm front in the midst of savage hordes; give daily battle against fearful odds, and be the victor always; and, with a mere handful of armed men, subdue a revolted nation.[81]

In this moment of unqualified triumphalism, recognition of the hero as the very embodiment of national pre-eminence was invested with a heightened, idealizing charge of emotional energy. The powerful imaginative impact of this closure fused for posterity the association between Havelock and Lucknow.

Yet narrative closure was far from being established on the Lucknow story. The 11 November news report of its relief turned out to be just one more instalment in a narrative that ran and ran. On 8 December further reports described 'severe fighting' in Lucknow; and on 12 December a second relief force, under Sir Colin Campbell, crossed the river at Cawnpore claiming 'all right in Lucknow'. Havelock's force, it transpired, had been of insufficient strength, and the opposition so fierce, that an evacuation of the Residency had proved impossible: in effect, it had simply joined the beleaguered garrison. The actual relief was left to Campbell's force, which was reported successful on 25 December. By then Havelock's final dispatch had been received in England. This described the vicious fighting and high price in lives of his own troops' entry into Lucknow, and announced the assumption of command by Outram.[82] Amid these further obstacles, renewed threats, and confusions over the structure of British command and responsibility, there existed numerous possibilities for the hero to become 'unfixed' from the position of idealized success in which the Lucknow

closure had placed him. The reason this did not occur was that, on 24 November, two weeks after the Relief was reported in London, Havelock was dead. His story, at least, had come to an end.

The telegram that arrived in London on 7 January 1858 announced bluntly that 'General Havelock died on the 24th November from dysentery, brought on by exposure and anxiety'.[83] Press reports strove to fit the actual circumstances of Havelock's death to the idealizing conventions of a final, heroic closure: a deathbed scene was imagined in terms of those static tableaux beloved of heroic painting, in which the hero is depicted 'falling at his post'. *The Times*, for example, suggested that, 'if Havelock did not actually fall under the death-shot of the enemy, he perished from disease aggravated by unsparing exertion'. To achieve the active death required of the hero, it recommended that: 'We must think of him upon his deathbed . . . as we think of Wolfe on the heights of Abraham, of Abercrombie on the Egyptian sands, of Moore on the cliffs of Corunna. Never was there a more glorious death.' *The Daily Telegraph* found it more convenient to omit the dysentery from the telegram altogether, and focused exclusively on the 'fatigue and anxiety'.[84] Another Victorian death convention could then be brought imaginatively to bear: 'Draw up the sheet over that pale-worn face! Havelock is dead.'[85] The complexities of an unfinished and bloody struggle in India can here be displaced by the simplicity of death, imagined as ideally peaceful and dignified, the end of worldly strife. This vision was confirmed by Havelock's 'last speech': 'For more than forty years', he is reported to have said to Sir James Outram, 'I have so ruled my life, that when death came I might face it without fear.'[86]

The memory of one 'so illustrious' would be fixed (it is imagined, for eternity) in lyrical language that transfigures suffering and loss:

> As long as the memory of great deeds, and high courage, and spotless self-devotion is cherished amongst his countrymen, so long will Havelock's lonely tomb in the grave beneath the scorching Eastern sky, hard by the vast city, the scene alike of his toil, his triumph, and his death, be regarded as one of the most holy of the many spots where her patriot-soldiers lie.[87]

By such means was a final resting-place established for the hero in the imaginative landscape of his adventures, and those adventures brought to a close. Havelock's death made the perfect end to the story – and ensured that his image would live on.

Contesting the Havelock heroic image

In the four months after the news of his first victories, Havelock had already become far more than an ordinary adventure hero. His representation proliferated in a veritable explosion of discourse, further fruit of the mid-

century communications revolution, with its attendant growth of the print market and the reading public. Besides the news stories themselves, the expanding press proved thirsty for any information about the life and military career of the new public hero and the Havelock heroic image also featured in pamphlets and ballads, engravings and paintings. His name became a 'household word' circulating throughout the national culture in a plethora of different forms, each with its own familiar conventions, in which different public audiences were able to hear the 'same' story and come to recognize the 'same' hero. The simultaneous existence of these various forms – from the middle-class newspaper to the evangelical tract and the melo-dramatic popular pamphlet for 'the millions' – coupled with the beginnings of a national print-distribution system (and thus a national market) points to the 1850s as a key moment in the emergence of a national-popular culture: a unified culture of 'the people', organized within national boundaries by a common system of cultural production and distribution, and centred on shared cultural forms and knowledges.

In the making of Havelock into a nationally popular figure, additional connotations became attached to his primary significance as idealized revenger. His image became a valuable cultural commodity, inflected this way and that according to the various political and cultural projects with which it became associated, from reform of the State to the sale of sheet music or to the spreading of the gospel.[88] In this sense, Havelock can be seen as a prototypical media star, whose heroic image was the product of devel-opments in the modern technology of mass communications in ways that bear comparison with the film stars analysed by Richard Dyer. Despite the significant differences in the culture industries at the early and relatively primitive stage of mass cultural production pertaining in mid-Victorian England (by comparison with twentieth-century film culture, or indeed with the conditions that produced Wolseley, Roberts and Kitchener later in the nineteenth century), the Havelock heroic image, like a 'star image', is a construct that embodies 'ideal ways of behaving'. While actually the fabrica-tion of a sophisticated industry, encompassing not only the production of the public narratives that are its primary vehicle, but also a wide range of other media agencies concerned with its promotion and circulation, the star's apparent rootedness in the authentic existence of a real person effec-tively conceals these processes. Like a film star, Havelock was at once both a real person and a character in a story: the ideal value embodied in the conquering hero of the news reports was apparently guaranteed by the documentary authenticity of real events.[89]

Once established in the public domain, a star image is constantly embel-lished by any and every scrap of new knowledge about the star, published to cater to the interests of particular public audiences. In the process, the star image becomes more complex and multi-faceted, the focus of competing investments. Dyer suggests that audiences themselves contribute directly to

the star-making process, for in consuming the image constructed for them by the public media, they are actively selecting from its complexity those aspects that 'work' for them and they can appreciate and identify with, thus establishing a dialectic of production and consumption with its primary producers.[90] Comparable developments in the Havelock heroic image can be identified in autumn 1857. It is apparent that, from the earliest days in September, the 'Havelock' constructed by the pro-revenge press came about in direct response to public pressure; being in effect a mouthpiece for the popular movement that mobilized a cross-class majority in support of reconquest and reprisals, marginalizing radical opposition. This mobilization was based on the Indian Relief Fund Committees.

The Fund itself was an offspring of that burgeoning of popular philanthropy during the Crimean War, associated most commonly with the name of Florence Nightingale. It was established in London on 31 August 1857 to provide 'for the relief of sufferers by the Mutiny': specifically, to raise regular instalments of money to be distributed by Lord Canning, the Governor-General in India, 'without distinction or nationality, to every person of whatever rank, who has a just claim upon the sympathy and assistance of the British people'. Supported and amplified by a substantial cross-section of the press, from *Lloyd's Weekly* to the *Manchester Guardian* to *The Times*, 'the sympathetic movement has rapidly extended throughout the country. Our provincial contemporaries record the proceedings at almost innumerable local assemblages', and sizeable collections were made 'even in places of minor importance and comparatively scanty population.'[91] These local Committees also formed a focal point for the consolidation of the new popular alliance in support of Lord Palmerston's Liberal premiership that had also emerged during the Crimean campaign. Like this previous popular mobilization, they articulated vigorous demands for a more energetic prosecution of the war effort, for the destruction of the 'aristocratic monopoly of power and privilege' which was impeding it, and for greater efficiency and democracy in the conduct of the nation's affairs.[92] The Relief Fund Committees adopted Havelock as their own. According to his biographer, J. C. Marshman, they used Havelock's name 'to stimulate exertion', and 'never was it mentioned without eliciting rapturous applause'.[93] It seems likely that they were responsible for the vociferous campaign that put pressure on the Government to bestow a fitting reward on Havelock for his patriotic services.

Within the Committees, however, two distinct versions of Havelock the hero were vying for dominance. These different investments derived immediately from the wider field of national politics, but also drew their energies from deeper cultural roots. Although the pro-revenge lobby promoted a patriotic national unity, rooted in the assertion of British national identity through conflict with other collectivities external to the nation, significant internal differences existed within this hegemonic project. Class

conflict over the organization and function of the British State cut across, and came to be realigned in relation to, this freshly reasserted imperial supremacy. In 1857, class conflict was still articulated predominantly in the traditional terms of an 'aristocratic' ruling bloc against 'the people'. According to Dyer, 'contradictions in ideology' of this kind have a crucial effect in structuring the multi-faceted image of the star. Efforts to stabilize the image either bring about 'the suppression of one half of the contradiction and the foregrounding of the other', or alternatively 'the star effects a "magic" reconciliation of the apparently incompatible terms'.[94] Where the popular Sunday newspaper, *Lloyd's Weekly*, in its championing of Havelock, foregrounded 'the popular' in direct opposition to 'the aristocratic', *The Times* was attempting to reconcile the two by making Havelock and other Indian generals into champions of the middle class in its mid-century challenge to the prestige and symbolic power that shored up aristocratic hegemony within the ruling bloc. Class conflict came to be expressed and fought out in alternative images of the hero.[95]

In *The Times*, Havelock – along with those other Indian generals, Nicholson and Neill – appears as the self-made man, product of the career open to talent, who typifies the virtues and authority of a middle class that believed its time had come:

> The middle classes of this country may well be proud of such men as these, born and bred in their ranks – proud of such representatives, such reflections of their own best and most sterling characteristics, – proud of men who were noble without high birth, without the pride of connexions, without a breath of fashion, and without a single drop of Norman blood in their veins.

'Imbued with the whole tone, temper and ethics of middle class life', these impeccably 'Anglo-Saxon' heroes were contrasted favourably with the unworthy aristocratic generals of the Crimea – and, indeed, with the great Duke of Wellington himself. Their achievements proved that:

> The middle classes now produce that type of mind which may be called the governing one – that character which rules mankind, which accomplishes great objects, which marshals means to ends, gives life to a nation, and produces the great events and the noble achievements of the day. . . . There is not one single feature of energy, or self-sacrifice, or daring – not one single solid, not one single brilliant trait, which belongs in history or romance to the deeds and careers of aristocracies in public, civil or military life, which does not belong to the careers of Neill, Nicholson and Havelock.

No longer could it be claimed that the nation was 'wholly depend[ent] upon its aristocracy for all the great and brilliant feats which are required for maintaining its supremacy or rank in the family of nations'. Such 'ancient'

and 'obsolete' assumptions, derived from 'the language of old romance', might be used to justify the iniquities of the purchase system and so to sustain continuing aristocratic domination of the army, but were dangerously out of touch with contemporary realities, as the Crimean disaster had demonstrated. Appropriating the romance of heroic adventure, this articulation of a new kind of national hero was one component of the middle-class bid for cultural authority and state power in the shifting political territory of mid-nineteenth-century Britain.[96]

Growing public curiosity about Havelock's background and character fuelled this image of the previously 'unknown' middle-class hero. Character sketches and career biographies detailed Havelock's lengthy and distinguished active-service record prior to the Rebellion. These were fleshed out with anecdotes, considered of sufficient public interest to warrant national publication, told by 'those who remember the residence and early life of this hero, of the courage and daring which foreshadowed the man in the boy'.[97] Besides stories of Havelock's martial prowess, information concerning his character as a serious Christian was found especially interesting. A Relief Fund meeting at Bloomsbury, for example, debating the responsibility borne by missionaries for provoking the Mutiny, heard one speaker assert that:

> On the contrary . . . had there been more missionaries there would have been less probability of those misfortunes (hear). Many taunts at first had been uttered against preaching colonels and Christian officers in India, but those scoffings had ceased now that it was known that General Havelock . . . was also a pious and God-serving Christian (hear).[98]

Anecdotes began to surface about Havelock's religious work in the army, where he had preached to prayer-groups of converts among the rank-and-file (nicknamed 'Havelock's Saints') and survived the hostility of fellow-officers who considered him to be 'a methodist and a fanatic'.[99]

Stories like these quickly became apocryphal legends. Fused with news reports that Havelock ascribed all his victories to God, they produced the image of Havelock as 'a Christian warrior of the right breed – a man of cool head and resolute heart, who has learned that the religion of war is to strike home and hard, with a single eye to God and his country'.[100] This imagery of a specifically Christian militarism circulated within evangelical and Christian Socialist publics, but also overlapped with a more secular middle-class cult of Cromwell in which the Puritan soldier was held to embody self-discipline and fearlessness. The Havelock image also acquired further connotations from the Gothic Revival and the fashionable cult of chivalry, the latter being especially influential in constructing idealized conceptions of the contemporary officer. 'By stressing the essentially chivalric nature of such "military virtues" as discipline, dedication and self-sacrifice it was possible

. . . to interpret colonial skirmishes as Christian crusades.'[101] Such representations furnished an idealized masculinity that could be aspired to in everyday life, and the chivalric hero became the virtuous (and asexual) masculine counterpart to the middle-class 'angel in the house'. Here, the chivalric code itself became a primary site of class conflict and reconciliation between middle-class and aristocratic manhood. Such images and motifs from the wider middle-class culture organized the investments made by these particular publics in the stories of Havelock's adventures that they read in the press. Drawn upon and incorporated within further press reports, they added further layers of significance to the Havelock heroic image produced there, in a circuit of production and consumption a good deal tighter and more enclosed than Dyer's film-star culture.

The popular Sunday press shared some common ground with the critique of aristocratic exclusivity and incompetence launched by *The Times*. Havelock, a 'solid Anglo-Saxon' hero, 'is the man of the day; a glory to us, to add to the Wellesleys, the Nelsons, the Napiers. But then, unfortunate man! he is in no degree related . . . to the Cowpers, the Greys, or the Gowers.' Even *Reynolds' Newspaper*, a staunch opponent of British rule in India, praised 'the successful gallantry' and 'wondrous deeds' of Havelock, in order to damn 'the eternal blunderings committed by our aristocratic incapables in the Crimea. . . . Why this contrast? Because Havelock is a real and not a sham soldier.' Where the popular Sundays parted company with *The Times* was in their championing of a 'plebeian Havelock' who had 'sprung from the people'.[102] Middle-class efforts to distinguish itself from this wider constituency were mocked as 'snobbish', and the hero was claimed for the cross-class political radicalism that had produced limited reform in 1832, as an exemplar of the democratic reforming impulse:

> If the people would . . . have men really honest in their sympathy with the wants and sufferings of the poorer classes raised to power; if they would see . . . a Havelock considered equal to a Lord Robert Grosvenor – they must convince Her Majesty's government . . . that they are really and truly in earnest in their desire for a new Reform Bill.[103]

The popular press also went much further than *The Times* in extending its critique of aristocratic misrule to the current governance of India. While *The Times* explained the outbreak of the 'mutiny' in terms of the innate depravity of the Indian people, the popular Sundays, alongside much of the provincial press, located responsibility for the 'rebellion' firmly on the shoulders of the East India Company and the British Government. In the pages of *Reynolds' Newspaper*, the legitimacy of Empire itself was called into question. Its language of radical patriotism linked events in India with the extinction of liberty at home: 'Our sympathies are with the

insurrectionists . . . with the oppressed struggling with their tyrants – with the tortured, plundered, enslaved and insulted natives of India', who are 'virtually, slaves to a haughty and incapable aristocracy comprised of some twenty families' who hold sway over Britain too. Their rebellion was no mere 'mutiny', but a just war for national independence against British 'turpitude' and the tyrannous 'yoke of foreign domination'. Havelock and his column were seen as 'heroes in an unjust cause', whose great endeavours were misplaced and futile: 'all the individual energy and heroism that would have retrieved or overcome disaster is alike thrown away, and will be, while the "system" continues . . . Better not to fight . . . better let India be lost at once . . . if we might then impeach the losers.'[104]

In *Lloyd's Weekly*, by contrast, an attack on the Government's mis-handling of Indian affairs went hand in hand with an enthusiastic identifi-cation with the Empire. 'Leadenskull-street and King Smith' (satirical euphemisms for the Company HQ at Leadenhall Street and its chairman, Vernon Smith) were blamed directly for the rise of Nana Sahib, their 'pet prince'. Besides demanding vengeance against the insurgents, *Lloyd's*, along with provincial papers such as *The North and South Shields Gazette*, required that 'the men who have imperilled our empire in the East' be called to account. Wish-fulfilling investments in the hero ('we yield to none in our admiration of men of the stamp of Havelock and Neill') were qualified by worries about further governmental bungling: 'how many of his victories in the field have been tarnished or lost in the closet; and how shall we obtain an assurance that India, regained by English valour, shall not be once more imperilled by an English bureaucracy?'[105] Indeed, at one point the image of the hero itself was at risk of tarnishing, as *Lloyd's* sought to blame the Government for the Cawnpore massacres. Questioning why the advance on Cawnpore of British troops under Neill had been delayed pending Havelock's arrival to assume command, the paper suggested that Neill 'was kept waiting by Havelock because the Government was jealous of letting a Madras officer have the honour and glory of the thing, and because Havelock had personal influence to secure it for himself'. This identification of Havelock with those held responsible for the massacre underlines the extent to which the hero's reputation was not at all fixed in this early stage, but was subject to conflicting pressures and articulations.[106] That the criti-cism was dropped can be attributed to the greater utility of the Havelock heroic image as a vehicle to bolster the campaign for a more robust response to the crisis. This contrasted the 'apathy' of government ministers holiday-ing on the grouse-moors with the 'sympathy' and 'vigour' of the people, as epitomized by the Indian Relief Fund, the Volunteer Movement and the energy of professional career-soldiers like Havelock and Neill.[107]

Havelock the popular hero was also constructed for a plebeian and working-class reading public in street literature such as the eight-page pamphlet, *Who and What is Havelock?* Priced at 1*d.*, at least six thousand

copies of this were published during the autumn of 1857, probably soon after the news of Havelock's Relief of Lucknow on 11 November, at the time of condemnations in the French press about British atrocities in India.[108] Besides acclaiming the 'wonders' performed by Havelock and his force ('a great and magnificent chapter in the history of blood and steel'), the pamphlet offered a spirited defence of British reprisals against the French charges. 'A portion of the profits' was intended for the Indian Relief Fund. This evident patriotism coexists, however, with a thoroughly burlesque treatment of Havelock the hero. Indeed, the pamphlet provides a classic example of this long-established popular tradition in street literature and theatre, whose characteristic 'double consciousness' is at one and the same time deeply invested in an idealizing mode and ironically distanced from the form in which that investment is organized.[109] The burlesque is directed here at those public forms – the exemplary biographical anecdote; the heavily condensed military memoir – that are key building-blocks of the middle-class image of Havelock, and exposes this image *as* image, by controlled mockery of its idealization.

The pamphlet begins by admitting that 'very little is known of his early life', which is 'a pity' because of the 'interest of his admirers', but then goes on to offer a series of anecdotes, as a 'clue to his character', in the very pattern of the conventional sketch. One of these retails how Havelock, as a 7-year-old, fell from a tree whilst bird-nesting, but was more concerned with the eggs than with his own safety, showing how he was 'born fearless'. 'We do not vouch for the truth of it, for it bears a close resemblance to a tale told about Lord Nelson'; however, 'with us it is so good a clue that we believe the story', whose point is borne out by 'current events'. Another anecdote, 'illustrative of his judgement, calculation and forethought', tells of how the 12-year-old Havelock once dealt with a dog that was worrying some sheep, as evidence that 'he who could rout one Savage could rout fifty thousand'. The source of all these stories is 'a doubtful source, we are sorry to admit – sorry because the whole anecdotes are so kindly, evidence of such manliness and gentle courage, that we regret we have not the assurance of their truth from the general himself'.

This ludicrous exaggeration and debunking of the conventional use of anecdote, as illustrative of exemplary character in the man prefigured in the boy, is not made to stand in the way of narrative pleasure in the Havelock story. The pamphlet takes evident delight in Havelock's martial character and exciting exploits. Indeed, he is represented in a thoroughly conventional manner as one 'who had been born a soldier'. His early attempt to make a career in the law is humourously handled: 'Think of that – the fearless boy, the champion of little ones, and the brave overcomer of savage dogs, to be tied down to a dull desk before dull books in the dullest of dull temples.' Inspired by Waterloo, Havelock is unable to bear such 'thralldom' any longer and, in less than a month, he had 'flung away those odious books and

buckled on the sword'. Then follow accounts of Havelock's 'first daring military exploit', his 'narrow escapes' (a shipwreck; having horses shot from under him) and other stock-in-trade adventure motifs. This Havelock is an old-style, dashing Peninsular War soldier of the Sir Charles Napier type, far removed from the earnestness of the middle-class soldier hero.[110] Even here, though, the mockery remains:

> Indeed, it would be useless to follow the thread of the General's battles. It would seem, *as you read the memoir of his military life*, that no battle could take place without Havelock – wherever danger was, there he was too; fearless, dauntless, he seemed to bear a charmed life. From 1841 to 1845 his sword was continually in his hand, his brain was continually as hard at work as sword, and indeed his promotion seems but slow business seeing the hard work he was ever at. [*My emphasis*]

Once Havelock's story has been brought up to the Rebellion, however, the pamphlet undergoes a remarkable shift in tone. Burlesque gives way to the melodramatic adventure of the march and early victories, the pathos of Cawnpore and the epic revenge oath. Melodrama is clearly the form that organizes a fully serious popular investment in the Havelock narrative. Its strong moral contrasts and heightened intensity of response produce a specific kind of idealized adventure hero, giving popular form to the process of psychic splitting that also produces the middle-class chivalric adventurer.[111]

Significantly, the pamphlet gives no truck to Christian soldier motifs and eschews the religious justification for British reprisals offered by *The Times*: 'If ever a nation was made the instrument of vengeance of an insulted Deity, that nation is England. . . . This country is armed by PROVIDENCE with power for the punishment of evildoers, and this punishment is at this particular time a high and sacred duty.' Where *The Times* distinguished the righteous violence of British reprisals from the mutineers' atrocities by evoking divine sanction, *Who and What is Havelock?* advances a firmly secular rationale that rests on the moral superiority of a civilized and peaceful nation over the forces of barbarism and war.

> When the English [*sic*] brought India under their dominion, from north to south, east to west, it was a bloody field of unceasing murder and destruction – to the land we gave peace – as each province has been added, the inhabitants – the millions have dropped the sword for the spade; so are we justified in our possession, as civilized nations in this day may justify conquest *if they will*. Our crusade is the restoration of peace, in which the mass of Indians place their hope – the English go on doing a good act, and if the sound 'avenge' is heard, who shall wonder? Were there ever such awful deaths, such tortures? Why, in the very palace of Delhi our men found a woman crucified and naked;

what passed between the crucifixion and her death we do not know if we may guess.

The reprisals, while they may 'appear horrible', are in fact 'MERCIFUL', and by deterring further rebellion, will even 'save lives'.[112]

To point to the significant differences between these competing versions of Havelock the hero must not obscure what they share in common. Centrally, both deny any equivalence between the sufferings inflicted upon Indian communities (including women and children) by British soldiers with those inflicted on British-Indian communities by the rebels. In each case, fears provoked by triumphalist revenge phantasies – fears of becoming like the hated other in the very act of destroying it – are assuaged by idealizations that deny the full horror of British vengeance by splitting it off and projecting it onto the 'cruel and treacherous' Sepoy.[113]

These idealizations are apparently grounded in the person of Havelock. Reluctant to engage in reprisals, Havelock's own merciful character comes to epitomize that of the imperial mission. Being a Christian, his own moral qualities, rather than those of his decidedly unchristian column – besides the British rank and file, never noted for their religious temper, it included a large contingent of Sikhs – come to embody the justice of the national cause. While the Havelock heroic image, like that of the film star, is extensive, multimedia, intertextual and ultimately composed of any number of different versions of 'who and what' the hero is and stands for, its potential to figure an idealized and powerful British national identity remains a common and unifying element. If 'Havelock', in the autumn of 1857, was a complex amalgam of many different motifs and meanings, holding these various investments together in one unified, heroic image had become vital for those promoting the politics of national unity during the Indian Rebellion. In a symbolic sense, that politics depended upon achieving and maintaining the hegemonic unification of a range of competing investments and interests in the idea of 'the nation' and its empire.[114] By the close of 1857, the figure of Havelock was at the centre of this project.

Pressure had been mounting on the Government, brought to bear by the Relief Fund Committees, to ensure that the State deployed appropriate public forms to recognize Havelock as a national hero. Following the news of Havelock's fifth victory at Onao, the military authorities had announced as his reward a good-service pension worth £100 a year. This drew complaints as being an 'inadequate remuneration which it was declared at public meetings would in France have been honoured with a marshal's bâton'. The Government responded by announcing, in late September, Havelock's knighthood and his promotion to Major-General. *Lloyd's Weekly* welcomed these as concessions 'extorted from our aristocratic governors by the vigorous voice of the people' and the campaign continued, with demands being raised to a new pitch after the Relief of Lucknow. In November, Havelock

was awarded a KCB and the Queen recommended that he be made a baronet with an annual pension of £1000 for life. These announcements were welcomed by *The Times* as 'instalments' on the road to 'the highest honours'. When Lord Palmerston introduced the Queen's recommendation in Parliament with 'a glowing speech' in praise of Havelock, he was rebuked by a Mr J. White MP, a merchant, who argued that this niggardly reward was due to the fact 'that General Havelock had not the honour of belonging to any very noble family'. Correspondents to *The Times* agreed: Havelock, Nicholson and Neill were being 'fobbed off' simply because 'they happen to be men unknown in fashionable circles'. *Lloyd's Weekly*, on this occasion, quoted *The Times* approvingly: 'Lord Havelock, the English public will insist upon saying – LORD HAVELOCK OF LUCKNOW.'[115]

The death of the hero

The news of Havelock's death, whilst it put an end to the public clamour over his reward, provided a catalyst for unifying processes of a rather different kind. Now, the newspapers reported, 'a whole nation mourns his loss'. According to the Revd W. Owen, an early biographer: 'Seldom has an event been received by the nation with a more bitter feeling of regret than the death of Sir Henry Havelock at the close of his wonderful campaign. . . . Everywhere friends met each other with the sorrowful news that HAVELOCK IS DEAD!'[116] Extraordinary mourning activity did indeed take place nationwide. Havelock's widow, Hannah, received hundreds of condolence letters from perfect strangers. Public tribute was paid in Sunderland, his home town, where the minute bell of the parish church tolled throughout the day and the Union Jack flew at half-mast on the tower. Tribute was also paid by the City of Liverpool, and by 'the most eminent statesmen of the day, without distinction of party'. Most remarkable of all, 'on the succeeding sabbaths' in the pulpits of 'hundreds' of churches and chapels throughout the country, 'ministers of every denomination' preached funeral sermons on Havelock's life, merits and worth. One such was preached at Westminster Abbey. Another, at Bloomsbury Baptist Church, attended by Havelock during his leave in England in 1849–51, attracted such a massive congregation that one thousand were turned away and the sermon had to be repeated the following Sunday. Even some Establishment churches were hung in black.[117]

In their reporting of this 'nationwide' mourning, the papers transformed it into a 'national' ritual. In this, as in its articulation of a national response to the Indian Rebellion, the mid-nineteenth-century press provided the imaginative links that forged a national public. As Benedict Anderson has argued, the newspaper has been a key cultural form in the historical emergence of 'the *kind* of imagined community that is the nation' – one in which a great number of people, for the most part anonymous and even invisible to each

other, imagine themselves to be bound together through participation in a shared, collective ritual based on a modern conception of simultaneity in time. In the newspaper, a collection of juxtaposed stories about events that have no necessary or intrinsic connectedness are held together by an 'imagined linkage' derived from the 'calendrical coincidence' of measured time: the date at the top of each page guarantees that events unfolding in geographically distant locations all share the same temporal continuum and are thus part of the same imaginative space. This space is the 'imagined world conjured up by the [newspaper] in [its] readers' minds', the connections between events being supplied by their shared imaginative interest in them. This is activated in a 'mass ceremony' characterized by 'the almost precisely simultaneous consumption' of that imagined world with each consecutive edition of the paper, 'by thousands (or millions) of others of whose existence [each communicant] is confident, yet of whose identity he has not the slightest notion'.[118]

Two caveats must be borne in mind when deploying this general argument in relation to the English press in 1857–8. The simultaneity in time imposed on events by their inclusion under a dateline depends upon the instantaneous, global news-gathering service of the age of broadcasting and satellite communications, and cannot be read back with quite this confidence into the slower processes of the 1850s, with their notable temporal disjunctions. Nor, as Alan Lee has argued, should the English press be considered properly 'national' in scope and function until at least the end of the nineteenth century, given the variety in types of newspaper and patterns of readership.[119] It nevertheless helps to explain how press reports of mourning events taking place all over the country enabled these to be both represented and experienced as the simultaneous, collective mourning of the whole nation. The face-to-face mourning shared among friends or in a Sunday service could be thereby enhanced and extended in the knowledge that unseen thousands of others were also mourning the same man at this very same time. Participation in mourning rituals on this scale, focused on a shared 'national' figure, involved and developed a consciousness of belonging to the national collective.

National mourning demanded national recognition and commemoration. Besides conferring upon Havelock's widow and eldest son the baronetcy and pension that he did not live to receive (thus absorbing the family of this middle-class and popular hero into the ranks of the landed aristocracy), the Government also granted 'most cheerfully' a request from the Havelock Memorial Committee for a statue on the west side of Trafalgar Square, 'corresponding to that of Sir Charles Napier' to the east. To pay for the statue, the municipal boroughs of all the chief provincial towns were asked to raise subscriptions 'with a view to afford to all classes the opportunity of doing honour to the memory of that great man'. That this was to be a national memorial was left in no doubt by the committee's adoption as its

motto Havelock's Order of the Day after the battle of Bithoor: 'England shall sweep through the land. Soldiers! in that moment, your labours, your privations, your sufferings and your valour will not be forgotten by a grateful country.' In March, a national Memorial Fund was launched at a crowded meeting in the Theatre Royal, Drury Lane. The Duke of Cambridge himself – the Commander-in-Chief of the British Army – agreed to become President, and 'subscriptions flowed in rapidly'.[120] In commemoration, state and nation were apparently at one.

This statue of Havelock, beneath Nelson's Column in Trafalgar Square, marks the zenith of Havelock's rise to national prominence and remains the most visible sign of public recognition for his services. The statue itself, however, has nothing to say about the significance of the life, or the death, that it honours. This remained a product of the discourse that surrounded it. In the further explosion of public storytelling stimulated by Havelock's death, a more stable heroic image was shaped, secured and passed down to posterity.

5

COMMEMORATING THE
EXEMPLARY LIFE
The Havelock hagiography

Mourning, reparation and commemoration

In unravelling the significance of Havelock's death for the English national
public, a starting-point can be found in the sharp contrast between the
national mourning it caused and the renewal of British triumphalism that
followed the Relief of Lucknow: 'The sad tidings reached us when all
tongues were speaking of his wonderful march, and recounting his daily
battles, and when all hearts were swelling with grateful feelings to the
patriot-warrior'; when, indeed, 'the nation was eagerly expecting some fresh
achievements from the great hero. . . . The national hopes were at once
quenched in death, and one common feeling of grief pervaded the whole
land, from the royal palace to the humble cottage.'[1]

Such direct registering of feelings of loss was unprecedented in the entire
narration of Havelock's campaign. In these new public imaginings, the
intensity of sadness, grief and bitter regret was felt in direct proportion to
the prior idealization of a hero whose name had become synonymous with
'the national hopes', with wonder, expectation and gratitude, and with the
triumphal denial of loss, death and defeat. According to Klein, this kind of
sudden juxtaposition of idealizing, omnipotent phantasy with the very
psychic material it has worked to deny can be a profoundly disturbing
experience, in which not only the idealized imago as such, but all the value
invested in it, can easily be felt as under threat of complete destruction.
Havelock's death, we are told, 'seemed to dash down every satisfaction, to
dim every triumph'. As in earlier stages of the Havelock story, intense and
widespread 'private' investments are concentrated upon a single figure of
collective importance, but one who has now become a 'depressive' imago,
the focus of phantasies of loss, guilt and reparation.[2]

This ironic reversal is captured most poignantly in a dominant motif of the
time, which invested intense pathos in the perception that Havelock's
reward for his services had arrived 'too late':

Then the British heart began to ponder how to reward her brave
children. How unexpected and bitter at that moment was the news,

117

that the man whose deeds had fixed our chief attention, and whose preservation appeared so sure, – that *Havelock* . . . was stricken, . . . that *he* would lead his devoted troops no more, – would return no more to a loving family, or a grateful country, – that he died before the news reached him of earthly honour and distinction so freely and worthily bestowed. Oh, there is something intensely touching in this event! We all feel we have lost a friend. We are all in mourning today. [*Original emphases*][3]

Havelock had died before receiving his honours, not only because of the time-lag in the news between England and India, but also because they had been bestowed 'too late'. Social recognition of the hero, involving the expression of collective appreciation and gratitude through projective identification with the hero's image, had been rendered incomplete by governmental delay. In effect, the circuit of psychic exchanges – between the subjects of projective investment and their object, the repository of idealized value – had been broken. A world that required the existence of the hero in order to appear bright and hopeful was rendered dark and meaningless by his death. In this depressive moment, when 'the honours conferred by his sovereign and the applause of his countrymen, only served to render his loss more deplorable', even the memory of what was valued had become unbearably painful. This irony was heightened by the sense of news literally 'crossing in the post' because of the time-lag: 'While parliament was voting inadequate rewards to this brave and triumphant soldier, his admiring country little dreamed that he was already gone where the voice of honour, though never louder or more universal, will not reach him.'[4] The English public's own imaginative valuing of the hero, and even human endeavour itself, are rendered potentially futile by this retrospective perception, in which all the emotional energy appears to have been expended in vain.

In the fluctuations of depressive phantasy, the dominant feeling of loss can give way to a sense of responsibility and guilt, as if those suffering from loss have brought it upon themselves. Marshman writes, 'It seemed as if all men felt a self-reproach that he had not been known before, and now, when he came back, how they would make it up to him! But this was not to be.'[5] Here, the self-reproach can be interpreted as a phantasy that 'we' have destroyed Havelock by 'our' ignorance in failing to recognize the merit of the previously 'unknown' soldier, as if knowledge would have averted loss. A further source of these destructive phantasies, and a clue to the intensity of feelings attached to them, is suggested by the presence elsewhere in the Relief of Lucknow narrative of the 'too late!' motif – namely, Havelock's arrival at Cawnpore 'too late' to save the women and children massacred at the Bibighur. Like Havelock, they too died before they could be reached by those who had invested intense significance in their life, and this news also reached England late, intensifying the sense of powerlessness, that English

readers could do nothing to help or comfort the sufferers. After Cawnpore, however, feelings of guilt and loss had been displaced into a desire for revenge focused on Havelock the destroyer. The intensity of emotion now aroused by his death is surely derived from its association with Cawnpore: the 'too late' motif expresses a displaced grief, previously contained and denied in phantasies of Havelock's triumphal adventure and now released by the breakdown of defensive triumphalism on the sudden downfall of the avenger. Behind the guilty sense that recognition of Havelock had come too late, it is possible to identify a national guilt at the Indian massacres and the wish that, had the English public taken an earlier interest in India and been less ignorant of Indian affairs, then the Rebellion itself might have been averted.[6]

In Kleinian thinking, such experiences of disintegrating loss and guilt, associated with the depressive position in psychic life, provide the necessary conditions for reparation activity.[7] Fuelled by the wish to restore the lost imago by introjection to the inner world, bringing it back to life and preserving it from further harm, reparative phantasies can be identified in the earliest responses to the death of Havelock: even the imaginary deathbed scene itself is replete with renewed idealization of the hero at the very moment of loss. Social recognition of the hero, thwarted by his untimely death, is displaced into the form of symbolic acts and objects that repair and 'put right' the damage done ('when he came back, how they would make it up to him!') and 'keep alive' the memory of his name and value. This is the phantasy that underpins the phenomenon of commemoration.

Various forms of commemoration were adopted by different publics. At local level, 'streets, babies and public houses were named after him' throughout the country, and subscriptions for local, public monuments were established in Birmingham, Sunderland and London. Among the nonconformist community, Havelock was honoured by the promotion of 'those great objects to which his life was devoted': the Soldier's Friend and Army Scripture Readers' Society launched a special 'Havelock Scripture Readers Fund' to establish Temperance rooms in army barracks in India, and to send out 'a band of Havelock Scripture readers'.[8] At national level, the desire for state recognition of Havelock as a major, national hero was now fuelled emotionally by apparently universal reparative wishes.

Participation in this national-public ritual of mourning and reparation, however, was to divest the heroic image of its more subversive traces of radicalism. The very impulse behind reparative phantasy is profoundly conciliatory: in desiring the repair of what has been damaged and the drawing-together of what has been split apart, it prompts the mourning community to bury not just the dead, but its own differences. Where, back in the autumn, a strident refusal of national responsibility for the outbreak of rebellion had accompanied the popular assault against Government incompetence, in the winter, acceptance and atonement for, precisely, 'our'

collective responsibility and guilt had become the very foundation of commemorative activity. The ascendancy of the middle-class, Christian image of Havelock was secured on this basis.

Eulogies to a dead hero

Reparation phantasies fuelled a vast range of commemorative discourse published in 1858. Sketches and evaluations of Havelock's life were featured in all sectors of the press, including specialist nonconformist publications such as the *Baptist Magazine*. Tennyson, the Poet Laureate, published a poem, 'Havelock', moved by the 'sad news'. Funeral 'Odes' were published in pamphlet form and in magazines such as *Punch*. 'A spate of tracts and leaflets appeared, most of them based on the flimsiest material', and the publishers of Paternoster Row also responded to demand by printing many of the pulpit sermons, at prices of one or two pence for the popular market to one shilling for a readership with deeper pockets.[9] The shared impulse behind this writing was the reparative wish to pay 'to the memory of one so illustrious . . . the tribute of a national elegy'.[10] Whereas the original hero-making of Havelock had been intimately related to the specific anxieties generated by the Rebellion and to the part played in those events by Havelock, the real, concrete individual, in the further stage unleashed by his death, a series of abstractions were performed upon Havelock's character and actions. These made of him an exemplary figure, the bearer of abstract qualities and values for which anecdotes and episodes from his life and adventures provided the illustration.

In these narratives of Havelock's exemplary life, earlier episodes of the unfolding story were reworked in relation to its later development and closure. Since the narration no longer related to a complex, changing field of uncertainties and anxieties, it could now proceed teleologically towards a known outcome that bestowed a retrospective significance. Some events and motifs, important in early tellings, were found to be uninteresting within this new structure of meaning, and were discreetly edited out, whilst others were reinvested with a significance more sharply defined, more fixed than before; for example:

> Who was more fearless than Havelock? With forces few and weakened by disease, in a burning clime, against incredible odds . . . he flung himself into the weak post, hemmed in by myriads of enemies, swarming and bloodthirsty, conscious that health and strength were failing, and that he would have to pay the sternest penalty. . . . Doubtless, the whisper of caution came to him, – Beware lest you perish and never see England and sweet home again. . . . But the despairing shriek of the woman and the child was in his soldier's ear and he must save them if

he could. He turned a deaf ear to delay; the emergency required every
sacrifice. He was not the man to refuse, cost whatever it might.[11]

There is no sign here of those weeks of anxious delay while Havelock's
soldiers died by the dozen from the cholera whilst awaiting reinforcements
in Cawnpore, nor of the real possibility that the column might never reach
Lucknow. Instead, the 'Relief' and Havelock's own illness and imminent
death are read back into the earlier episodes, transfiguring the motif of
Havelock's martial valour with the additional sense of conscious self-
sacrifice. In this reshaping of events the adventure hero is now located as the
product of a much longer and more coherent story of heroic character-
building, into which diverse anecdotes about Havelock's life are integrated
as 'preliminary adventures' that lead inexorably towards the successful
completion of the quest.[12]

In eulogies published in the press, Havelock was imagined predominantly
as an exemplary soldier whose character represented an ideal integration of
qualities. *Blackwood's Magazine*, for example, pictured the hero in terms
that echo contemporary, middle-class versions of the good father: he was
'severe in discipline', 'rigid in command', expected all who served under him
to endure hardships 'without a murmur', and yet 'ever strove to alleviate
their sufferings and improve their condition'. Being 'a true soldier',
Havelock 'was able to combine the greatest daring with the greatest
prudence' and made his decisions according to 'the principles of military
science'. His greatest moment, by this measure, was not the Relief of
Lucknow but his prudent decision to retreat to Cawnpore, which displayed
'greater moral courage'. *The Times* considered 'that ideal which his country-
men conceived of his character' to rest on Havelock's 'blameless character,
inoffensive manners' and, most especially, his 'strong sense of duty'.
Havelock is celebrated as a professional soldier who has worked hard to
acquire a 'consummate skill' and an 'intimate knowledge of the duties of his
profession in the highest and in the minutest points'. Duty, rational knowl-
edge, attention to detail, prudence, moral courage: these are the middle-class
keys to self-help and success, and make deliberate contrast with the dashing
courage of the traditional, aristocratic military ethos. 'Exercizing at once
foresight, vigilance, promptitude, unwearying strength, and indomitable
courage', Havelock (according to *The Daily Telegraph*) 'gave example to the
soldiers of British India.'[13]

The exemplary moral of Havelock's life was found to inhere in his whole
career, not just the pinnacle of his success. 'His career is certainly a lesson to
those who come after him', argued *The Times*: 'The point which it is most
profitable to note is the long and patient service of this accomplished
soldier.' At sixty-two years of age and after thirty-four years of service –
after 'campaigns in the swamps of the Irawaddy, in the plains of Central
India, in the passes of Cabul, and on the parched shores of the Persian Gulf,

– after fever, and shipwreck, and long years of fatigue' – Havelock still 'lingered in comparative obscurity, and must have consoled himself only with the thought that he had done his duty'. The merit of Havelock's final campaign is found to lie in its revelation of a life of virtue that had hitherto lain hidden from public view.

> His suddenly gained reputation in the very evening of his life is, perhaps, more instructive than if he had been famous in the prime of manhood. It teaches the soldier not to despair of his profession because promotion and honours are slow in coming, nor to think, because he remains unknown to fame till his course is nearly run, that therefore his has been a useless and undistinguished career.

This celebration of the 'unknown' hero, whose success did not come by 'favour' or 'fortune' but who 'worked his way with ordinary men', rendered the exemplary virtues of his life widely applicable beyond the ranks of the army, as a potential energizing myth to inspire countless thousands of other unpretentious and unrecognized lives, from the 'improving' middle class and the 'self-made' working class alike.[14]

In the abundance of sermons preached from Anglican and nonconformist pulpits throughout the country after the news of Havelock's death, we find exemplary abstractions of a different kind.[15] While registering some unease at speaking about soldiers from the pulpit, these sermons make use of the deep public excitement at Havelock's adventures and the intense mourning for his death as a unique opportunity to 'draw religious lessons', to enunciate a great truth and 'to illustrate that truth by a great example'.[16] The grounds for these exemplary lessons are found in the Christian metaphors of the 'good soldier' and the 'good fight'. In the Gospel of St Paul, these are used as figures for the conflict inherent in both worldly and spiritual existence and for the 'enduring hardness' required of the godly. The earth is regarded as 'a battlefield, upon which the ranks of good and evil were for ever marshalled against one another', in a spiritual war for eternal salvation or damnation that is mirrored in those 'other battlefields, of which the scene was the soul of each one'. When 'some of our best and bravest soldiers, specially in India', are themselves Christians, the metaphor assumes a literal embodiment: having 'endured hardships for the Cross' and epitomized the superiority of 'courage inspired by Christian faith', they become 'a type of, and an example to, every Christian man'.[17]

Havelock, above all others, is 'representative of the virtues which we believe God has himself specially endowed many a Christian soldier of this land'. By analysing these virtues and illustrating them with examples from the life and character of Havelock, 'we may compare ourselves with this standard, acknowledging our defects, and seek the grace we need'. In the sermon preached by Leopold Bernays, for example, Havelock's religious faith is seen to be 'the secret of that foresight and promptitude, that never-

tiring strength, that dauntless, almost reckless courage. He was a strong, God-fearing man, cast in the old mould of scriptural heroes', whose achievements rested on an unswerving dedication to duty, a confidence in victory that brooks no doubts or hesitations even in apparent defeat, and a capacity for 'patient waiting and endurance' of all 'difficulties . . . dangers . . . and privations'. As a Christian soldier, he 'served England better, because he served God first: in the Revd Aylen's sermon, Havelock is contrasted favourably with Nelson, since he is imagined as replacing that famous call to duty, 'England expects . . .', with 'God expects . . .'. For Aylen, '*Havelock was more than a soldier; he was a saint*' (original emphasis).[18]

Ultimately, these virtues resolve themselves into a preparedness on the part of the Christian soldier to undergo self-sacrifice 'even unto death'. The Revd Reed finds a 'noble self-renunciation' in Havelock's going 'eagerly' on dangerous missions, prepared to sacrifice his life 'to fulfil at all hazards what he regarded as his life's work'. The moral here, for we who look on, is that: 'Small are all hardships of ours compared with those of soldiers – of martyrs – of our crucified Lord.' This identification of the soldier-martyr with Christ himself sanctifies his death in war and fixes the ultimate significance of his story in terms of Christian faith in resurrection and the afterlife. In this narrative, Havelock's deathbed speech forms a closure only in worldly terms: for 'Havelock is dead, yet lives; we live, but must die'. Havelock's story is a reminder that death comes to us all, even those who survive 'a hundred battles'. Told in this way, it demonstrates the limit-mark placed on triumphalist heroic adventure by the facts of human mortality, and gives a religious twist to familiar, ironic motifs:

> The baronetcy and the pension were granted too late. Our sovereign sought to honour a conqueror, and behold in his stead a corpse. He for whom the nation would have celebrated an ovation, is dead. Verily man walketh in a vain show.

But it also demonstrates the means available in Christian narrative to transcend ironic closure. 'Havelock teaches me', writes Aylen, 'that I should be watching and waiting for the world's conqueror, Death' and endeavouring to order my life in such a way that, like Havelock, I die 'the death of the righteous', and achieve eternal life.[19]

If, in these sermons, Havelock's story is rewritten as a religious quest for faith, telling of the trials and obstacles encountered on the battlefield and their overcoming in the struggle against death and evil, the adventure landscape evoked in them is both a literal and a metaphorical one. As Revd Reed points out, in the stories of Christian soldiers, missionaries and martyrs, we encounter a narrative of 'Christian fearlessness' that has actually been lived out in other places, by other people. For Reed, Havelock's quest transfigures the literal battlefield in India with its specifically Christian imaginings. His sermon propounds a fervent Christian imperialism that

demands the renewal of British rule in order to perform 'the work of the Lord in India', and he prays that 'the death of Havelock be blessed' by increasing 'the desire of England for the conversion to Christ of the Indian race'. At the same time, as mere readers of these stories, 'we hear of such things, but we only hear of them. We ask, how we should bear such trials? But with us it is only a matter of speculation.' However, the task before us, too, is to pursue the path of 'Christian duty' across the battlefield of the world.[20] Reading Havelock's quest as a metaphorical conflict enables a transference of heroic virtues from the colonial frontier to the everyday situations of people living distinctly unadventurous lives in England.

With some 40 per cent of a total adult population of nearly eighteen million attending weekly services in church or chapel during the 1850s, sermons such as these reached a vast public audience, even before we take account of the relaying of their exemplary life themes through the Sunday Schools, the Ragged Schools, the YMCA and YWCA, the house-to-house visitation schemes and all the other institutions and practices organized by evangelical energy for the conversion of the working class.[21] The 'main weapon' in this cultural war was the cheap tract or broadsheet – 'the greatest single medium of mass communication in the nineteenth century'. Millions of copies of religious tracts, featuring stories of 'striking conversions, Holy Lives, Happy Deaths, Providential Deliverances, [and] Judgements on the Breakers of Commandments', were pumped every year around a sophisticated, national distribution system that reached deep into the countryside as well as to the towns and cities.[22] Among the most popular were 'narratives of the lives and deaths of pious individuals who had actually existed', often characterized by a morbid fascination with 'holy death', sensationalism, a heavy moralizing tone and intense earnestness.[23] The Havelock story, combining as it did the thrills of martial adventure and a good deathbed ending with a serious conversion experience and plenty of anecdotes of good works, fitted ideally into the popular-tract tradition.

These publications were responsible for consolidating the image of Havelock as a Christian as well as middle-class hero. In itself, however, the tract was too ephemeral a form to fix that image reliably for posterity. This occurred by means of a further stage of cultural production – the exemplary-life biography in book form.

The exemplary-life hagiography

Within three years of Havelock's death, four full-length biographies had been published, all by serious Christians seeking to sustain the evangelical momentum generated by the Havelock story and to give its advocacy of Christianity a weightier and more enduring form. Like the sermons, these narratives fuse the exemplary life with the exciting motifs of Havelock's military adventures to extend Christian soldier themes into a wider reading

public. The Revd Owen claims of his *The Good Soldier* that 'its price puts it within reach of THE MILLION, for whom it is written'; and, to judge from the advertisements (for *The British Workman and Friends of the Sons of Toil*) at the back of his volume, James Grant's *The Christian Soldier*, at one shilling, also appears to have aimed for a popular readership.[24] W. Brock's *Biographical Sketch* went to eight editions in 1858 alone, and sold 46,000 copies – 'an enormous sale for the mid-nineteenth century'.[25]

There was a further motive behind these texts. Among further details that arrived from India about Havelock's campaign, a number of aspersions were cast upon the quality and propriety of his leadership. These were fuelled by the often contradictory evidence emerging in histories and the military memoirs of other generals. Controversy focused on four main propositions: that, as *Lloyd's Weekly* had originally suggested, Havelock's original assumption of command had fatally delayed the march on Cawnpore; that his recommendation of his son, Harry, for the Victoria Cross after the Battle of Cawnpore had been unfounded and nepotistic; that his retreat to Cawnpore, after the first ill-fated advance on Lucknow, had been over-cautious; and that, being superseded in command by the higher-ranking General Outram, credit for the fall of Lucknow did not rightly belong to Havelock at all. In their mode of upholding the idealization of Havelock's heroic reputation in the face of public controversy, the Christian biographies warrant their description as 'hagiographies', a term usually used to refer to writings on the lives of the saints, but which catches perfectly the reverential respect bestowed upon Havelock by these, and most later-Victorian, biographers.[26]

All three of the 1858 versions were based substantially on material about Havelock's character, life and adventures that was already in public circulation. To this heady brew, Brock – the Baptist minister at Bloomsbury Chapel, a noted religious writer and friend of the Havelock family – added a few personal letters from Havelock to his wife, in what was otherwise 'little more than a somewhat frothy sermon'.[27] Owen went for the personal dimension by including 'personal communications to the Author by friends of Havelock', mainly reflections on his character by those who had known him. Grant relied for narrative effect upon his compilation of Havelock's official dispatches together with what appear to be contemporary news reports, all written from a present-tense standpoint within the unfolding events. Although little more than compilations of existing public material, these early hagiographies necessarily engaged in reworking the familiar motifs to the new, formal shape required to sustain a full-length narrative life.

The merits of John Clark Marshman's later (1860) version, *Memoirs of Major-General Sir Henry Havelock, KCB* – by far the most substantial and interesting of the four – are that, first, it introduces a body of new material by making extensive use of Havelock's private correspondence; and second,

that it incorporates this 'private' material into the story of the public man with considerable formal sophistication. J. C. Pollock described this book in the 1950s as 'one of the classic biographies of the age'. All subsequent biographers have noted their debts to it, and it achieved a huge readership. In 1867, noting 'the exhaustion of [two] former editions' – which he attributes to the 'esteem in which the character and services of General Havelock continue to be held by his fellow-countrymen' – Marshman issued 'a popular edition, with the view of placing [Havelock's Memoirs] within the reach of a larger number of the public'. This was to remain in demand for the next forty years. Here, if anywhere, is the definitive 'Life of Havelock'.[28] (See Figure 3.)

John Clark Marshman (1794–1877) was ideally placed to write that biography because of his close personal relationship to Havelock. The eldest son of Joshua Marshman, one of the first Baptist missionaries to join William Carey in Bengal in 1799, he accompanied his father to Serampore, the tiny Dutch colony sixteen miles from Calcutta, where the first mission based itself in order to be free of East India Company harassment. The missionaries established their own Baptist Church, engaging in widespread itinerant preaching of the Gospel, the translation, printing (on the mission's press) and distribution of the Bible in native languages, and the training of an indigenous ministry. Marshman himself played an active role from his eighteenth birthday and for twenty years held the position of secular bishop, responsible for a great body of missionaries, catechists and native Christians. Like his father, he was a distinguished Orientalist scholar, known especially for his pioneer history of Bengal. He was also a successful lawyer and journalist, who founded and ran with his father Bengal's first vernacular newspaper and the influential English-language journal, *The Friend of India*.[29]

Marshman is taciturn about his relationship with Havelock, merely mentioning the beginning of their acquaintance in 1823 when Havelock, fresh in India, first visited Serampore, and noting how, over the next three years, he was a 'frequent visitor' who 'cultivated the society' of the missionaries, himself included. Pollock, however, describes Havelock's fascination with Serampore, where he found many of his spiritual, intellectual and personal needs met, and emphasizes especially the 'intellectual companionship' he shared with Marshman. Pollock also describes how the Marshmans would read out, after dinner, letters from their 14-year-old daughter, Hannah, in England. In February 1829, a few months after her return to Serampore, Hannah and Havelock were married, and Marshman became Havelock's brother-in-law.[30] As well as sharing a community of faith and intellectual companionship with Havelock, Marshman was also privy to much of his most intimate family life, his closest confidant and a man whose own views on both spiritual matters and public affairs were much in sympathy with those of his subject.

Marshman's conception of his practice as a biographer was clearly minimalist. In the *Memoirs*, he is at pains to represent the man he knew so well in Havelock's own words, by making extensive use of their own lifetime's correspondence and of Havelock's letters to Hannah. Responding, in his preface to the 1867 edition, to the 'disparaging remarks' made about Havelock since his death, Marshman claims that: 'The simple, unvarnished narrative of his deeds during the appalling difficulties of the Mutiny, and the exposition of his familiar correspondence, will be found to furnish the best vindication of his character.'[31] Havelock's private letters are seen to complement the story of his public works, together rendering transparent the character of the real man, without recourse to Marshman's own interpretation of that character.

But this is to underestimate the active role of the biographer. Marshman's selection and editing of material for inclusion, his presentation of that material and the very form of the biography as narrative are all shaped by his own imaginative investment in the memory of Havelock. This, a product of their personal relationship, leads him to identify as a biographer in an utterly uncritical fashion with the man whose character he wishes to vindicate. Furthermore, since Havelock's letters to Marshman were themselves an aspect of their friendship and were shaped by the mutual recognitions that each gave to, and elicited from, the other, the personal relationship between the two men had a structuring effect on one of the primary sources of Marshman's text. In combination, these factors produce the narration of a Havelock whom the reader is invited to value in particular ways.[32]

Marshman's Havelock is also, inevitably, formed in relation to the heroic image produced for public consumption between 1857 and 1860. As Dyer has shown, the 'public' and 'private' lives of the star or hero feed off each other. Aspects of his private, 'authentic' character are drawn into the public domain and become components of a public image that in turn inescapably affects how the private person will in future be seen.[33] Marshman's appreciation – and later, vindication – of his friend's character cannot be divorced from the powerful public versions of Havelock as the middle-class, Christian soldier and national hero, for, as Marshman himself notes in his preface, it is this very public esteem that constitutes Havelock's character as an interesting and fit subject of biography in the first place, and to which Marshman's more nuanced and complex account is intended to contribute.

What makes Marshman's *Memoirs of Havelock* such a fascinating text is the insight it provides into this interaction. On one hand, the *Memoirs* is an adventure narrative telling the tale of the public works of a heroic Christian soldier. On the other, it presents, as of public interest, the spiritual, intellectual and emotional life of the 'private' man in his domestic as well as public relationships. This coexistence of adventure and domestic motifs adds greater complexity and depth to the public image of Havelock, but it also leads the narrative into an engagement with the profound contradictions

between public and private spheres that have structured British masculinities since the early nineteenth century. In Marshman's *Memoirs*, we can read how these contradictions cut across and complicate the making of the hero in a mid-century hagiography, but at the same time are contained and managed, through the biographer's selective incorporation of 'private' material into what remains an intensely idealized public hero.

'Every inch a Christian, and every inch a soldier': Marshman's adventure hero

Marshman follows the well-established contours of the Havelock story by structuring his own narrative as an adventure quest with the Rebellion at its climax. This is vastly more detailed than any previous version and draws its material from a variety of sources: not only Havelock's private correspondence, but also his official military dispatches and orders, other eyewitness accounts and memoirs, military histories, news reports and other biographies, as well as personal anecdotes and Marshman's own memories. For the most part, the narrative integrates many already well known, but hitherto fragmentary, anecdotes and motifs into a coherent shape. This familiar story is fleshed out in greater detail under the motivation of Marshman's wish to vindicate Havelock's reputation. While remaining silent about Havelock's conflict with Neill, conceding as 'a questionable point' the speculation that an earlier departure from Allahabad would have averted the Cawnpore massacre, and treating the charge of nepotism to serious and scholarly refutation, Marshman's preferred strategy is to undermine the charges against the hero by a narration of events in such a way that they appear to 'speak for themselves'.[34]

The *Memoirs*' narrative clearly identifies two distinct stages to the Lucknow expedition, punctuated by Havelock's retreat and wait in Cawnpore.[35] His greatest heroism is located by Marshman in the first stage, when he unequivocally holds independent command and acts on his own initiative, in classic adventure mode, to surmount the enormous obstacles to his quest. The Indian terrain is rendered in Biblical terms as a hostile environment where climatic extremes weigh upon human endeavour. Exposure to the intense heat of the 'broiling sun' at its midsummer zenith, traditionally regarded as fatal to the British in India, rapidly weakens the column, while the 'deluges' of torrential rain frequently make progress on the roads impossible.[36] Forced marches and fighting under these conditions quickly lead to fatigue, exposure and sunstroke, besides casualties in the field, and, within two weeks of setting off, to cholera and dysentery as well.[37] Beyond Cawnpore, the obstacles intensify. Crossing the river at all poses serious logistical difficulties and is seen to represent 'one of the boldest moves' executed by Havelock. Danger 'teemed', not only from the superior forces of the devilish Nana Sahib, now in his rear, but also from the hostile

and martial population encountered as the column enters the province of Oudh. Advancing without the aid of maps, it now has to carry its increasing numbers of sick and wounded.[38] According to Marshman, Havelock's inspirational leadership was decisive in holding the morale and encouraging the 'valour' of his troops under such difficulties, especially after the 'gloom' of their entry into Cawnpore.[39] Havelock is nevertheless 'a prey to conflicting anxieties', and eventually takes the 'most painful decision of my life', that his position is now so weak that the enterprise has become 'a gainless sacrifice of lives'. For Marshman, this decision epitomizes Havelock's greatness, since 'it demanded more moral courage to relinquish the advance on Lucknow than it required personal courage to encounter the greatest dangers in prosecuting it'.[40]

The arrival of Sir James Outram in Cawnpore to assume command terminates Havelock's 'freedom of acting on his own individual and unfettered judgement'. Although Marshman endorses the popular perception of Outram's great 'chivalry' in waiving his rank to Havelock and offering to serve under him until the Relief had been effected, he also attacks the appointment and argues that Havelock was nevertheless inhibited by Outram's presence:

> It was impossible for General Havelock, when placed under the control of another, to act in the same spirit of daring enterprise which he had exhibited when acting on his own responsibility. [It] . . . necessarily neutralized those qualities which had given so peculiar a character of mingled boldness and caution to his career.[41]

Although Marshman does not say so explicitly, it is clear from the narrative that he believes Outram's arrival to have brought about a confusing situation of dual command. We learn, for instance, that the difficult choice about which route to take into Lucknow was made when 'Sir James resolved to enter the city over the bridge, and then turning to the right, to advance to the Residency'. We read, too, of Havelock and Outram arguing over crucial tactical decisions: whether to take the heavy guns into the city and whether to halt at nightfall or continue to push forward until contact with the Residency had been established. That Havelock remained in formal command is confirmed by his dispatch from the Residency reporting on the operation, signed 'Brigadier-General, Commanding Oude Field Force', which ends by announcing that Outram has 'now assumed the command'.[42] As such, the responsibility – and the ensuing censure or commendation – rested firmly on Havelock's shoulders. That he was not free to execute that responsibility entirely in his own way, it might be inferred from the narrative, only increased the praise due to him.

The grandeur of Havelock's death is enhanced by Marshman's descriptions of the vicious street-fighting occurring in Lucknow, first at the bridge defending the entrance to the city, and then in the final three-quarters of a

mile to the Residency, where 'the strength of the enemy was concentrated'. Over the last 500 yards,

> The Highlanders and the Sikhs, with the two commanders at their head, pushed on to the Residency through an incessant storm of shot. The loopholed houses on either side poured forth a stream of fire as they advanced. Every roof sent down a shower of missiles on them. Deep trenches had been cut across the road to detain them under the fire of the adjacent buildings. At every angle they encountered a fearful volley. Seldom have troops had such a gauntlet of fire to run, but officers and men, animated by the Generals, sternly moved on.[43]

Havelock himself confirmed that a total of 535 officers and men of the British force had been killed, wounded or were missing that day, out of 2500 who set out from Cawnpore. The *Memoirs* completes the story of the further blockade and defence of the Residency and the equally fierce fighting and even heavier losses sustained in Sir Colin Campbell's Second Relief, before the famous 'Meeting of the Generals' episode when Havelock learns of his knighthood.[44] The horrors of this street-fighting are contained, as in other contemporary military writing, by the language of 'gallantry' and 'intrepid exertion', used here in all seriousness to dignify mortal risk, self-sacrifice and death.[45]

The pathos of Havelock's death, in Marshman's account, lies in his survival of all these trials, only to give way to illness after the final rescue, by evacuation from the city, of the Lucknow women and children. Havelock is carried out with them. Despite his 'emaciated figure', he has endured exposure and fatigue 'to the verge of human endurance' but has long 'dreaded the recoil on his constitution when rest should succeed to labour'. Symptoms of diarrhoea steadily worsen, and 'he was removed at nightfall . . . to the Dil-koosha, where a soldier's tent was pitched for him'. Surviving yet one more narrow escape (enemy bullets 'fell around his tent'), Havelock lives to face death in peace and composure, 'his mind . . . calm and serene, supported by the strength of that Christian hope which had sustained him through life'.[46]

Episodes of the hero's life prior to the Rebellion are incorporated into the *Memoirs* as preliminary adventures that prepare Havelock – and the reader – for the ultimate trial of his march to Lucknow. Identification with Havelock is invited through the first-person voice of his letters and dispatches, reinforced by Marshman's narrative commentary in which the constant, reflex use of the pronouns 'we' and 'our' binds together narrator, Havelock and readers in an easy assumption of community.[47] However, rather than elicit an intense imaginative merging with Havelock, Marshman's narration encourages a more distanced, controlled but still unqualified admiration for him. This opens up the space for that comparison between self and hero which makes the hagiography morally profitable. The known outcomes of

the Relief, Havelock's recognition as a hero and the closure of his death, render each prior narrative component retrospectively meaningful in terms of its position within a teleological structure. The entire quest is pointed towards that moment of closure in Dilkoosha Park, and is written to demonstrate the truth of Havelock's famous deathbed speech: 'I have so ruled my life, that when death came I might face it without fear.'

Anecdotes of Havelock's schooldays, like those in the earliest press sketches, are found interesting 'as exhibiting the germ of those qualities, by which his character was subsequently distinguished'. The full development of those qualities follows from his initiation as a soldier and as a Christian. The eldest son of a family from the commercial and professional middle classes, Havelock has originally embarked upon a legal training and only takes up a military career when his father loses the family fortune and, after an 'unhappy misunderstanding', withdraws financial support. With the aid of his brother William, Havelock manages to obtain a commission in the army, and in 1815, 'at the age of twenty, became a soldier'. In a one-page elision of the first eight years of Havelock's military career as a lieutenant stationed in the British Isles, Marshman concentrates on his acquisition of 'that fund of professional knowledge which contributed so largely to the success of his military operations in India'. Seeing 'no prospect of active service in Europe', Havelock learns Persian and Hindustani before following his two brothers to India in 1823.[48]

Havelock's initiation as a Christian is located as a conversion experience on the journey to India. Havelock is described engaging in 'religious conversation' with one Lt Gardner, who becomes his 'evangelical instructor', and leads him by degrees from a weakened faith and doubts about the divinity of Christ to 'public avowal, by his works, of Christianity in earnest'.

> Before the voyage terminated Havelock had added to the qualities of the man and the soldier the noble spirit of the Christian; and thus was he accoutred for that career of usefulness and eminence which has endeared him to his fellow countrymen. Vital religion became the animating principle of all his actions, and a paramount feeling of his duty to God rectified and invigorated the sense of his duty towards man.[49]

Landing thus in India, in May 1823, the first stage of Havelock's quest is completed. In its further stages, Marshman narrates the testing and further development of those qualities.

In this, a retrospective hierarchy of significance is established between the various episodes of Havelock's life. This can be demonstrated by considering the time-scale of the narrative's telling in relation to the time-scale of the events narrated.[50] The *Memoirs* can be broken down into five relatively discrete blocks of time, as follows:

(1)	50 pages	(pp. 1–50)	44 years	(1795–1838)
(2)	84 pages	(pp. 51–134)	5 years	(1838–42)
(3)	96 pages	(pp. 135–229)	14 years	(1843–56)
(4)	35 pages	(pp. 230–64)	6 months	(January–June 1857)
(5)	177 pages	(pp. 265–441)	5 months	(July–November 1857)

In block one, over two-thirds of Havelock's life is condensed into one-ninth of the narrative. This covers his first years in the army in England, his journey and early life in India, his first experience of active service in the First Burmese war (1824–6: 12 pp.), his marriage and his routine army career before being called to serve in Afghanistan. Block two concentrates exclusively on Havelock's five-year involvement in the Afghan War, in which he serves as captain on the General Staff. In block three, a little under a quarter of Havelock's life occupies roughly the same proportion of the narrative. This recounts the resumption of Havelock's routine career, interspersed with shorter periods of active service at Gwalior (December 1843, 2 pp.) and in the Punjab (First Sikh War 1845–6, 17 pp.; as well as details of the Second Sikh War, 1848–9, 24 pp., that Havelock, withheld from active service, could only write about). It also includes a two-year visit to England on leave (1849–51). By contrast, the final year of Havelock's life – mostly composed of active service in the Persian War, when he commanded a division, and in the Rebellion – is allocated almost one-half of the narrative.

This selective distribution of narrative time works to foreground Havelock's relatively short periods of active involvement in military campaigns (approximately one-seventh of his total service record is given 350 out of 450 pages), thus rendering his routine military career and other aspects of his life relatively less interesting. An alternating rhythm between periods of active and routine service begins when Havelock joins his first campaign, the British invasion of Burma (May 1824). This 'opportunity' fulfils Havelock's 'long cherished' and 'ardent hope'.[51] In the narration of this campaign, a whole batch of adventure motifs are introduced. These include Havelock's first engagement with the enemy; first responsibility of command, resulting in the capture of an enemy position and casualties among his own men; and first encounter with 'very distinguished gallantry' (in the person of a lieutenant who is simultaneously hit by three musket-balls in the side and speared in the back, and is found 'expiring, his sabre yet clenched in his hand, fallen and lying over a dead Burman, in whose skull was a frightful gash').[52] In stark contrast to the excitement of war, is Havelock's twelve-year wait to repeat the experience. According to Marshman: 'This long period of repose from the active duties of the field presents *few incidents of interest* in Havelock's career', and he returns to 'the *monotony* of a subaltern's life', 'the *drudgery* of the cantonment, or the office' (my emphases). The contrast is repeated throughout the *Memoirs*. His appointment to the Afghan expedition in 1838, for example, 'rescued'

Havelock from 'the *uninteresting* duty of commanding sixty men', while at its return in 1843, 'after four years of active service amidst the most *animating* scenes, in which it had fallen to his lot to devise and execute *important* military operations', he was '*doomed* to return to regimental duties' (my emphases).[53]

Active service not only is more exciting, animating and interesting than regimental routine, but also furthers the acquisition of those qualities necessary to the ultimate success of the quest. At the fiercely fought battle of Maharajpore, for example, 'Havelock was in the thickest of the engagement by the side of the Commander-in-Chief, and the cool intrepidity with which he moved on amidst the balls which ploughed the ground around him was especially remarked.' The number of horses shot from under him comes to be proverbial, as does the belief that Havelock himself bears a charmed life.[54] Similarly, Marshman's detailed treatment of Havelock's central involvement in the Afghan War serves to demonstrate how 'Havelock's practical knowledge of the science of war had been greatly enlarged, and his military judgement matured, by the conflicts in which he had borne a share'.[55] The *Memoirs* takes a keen interest in the historical background of the various campaigns, the military qualities of the generals, their strategies and tactics and the course run by particular battles. Much of this derives from Havelock's own extensive commentary and critique (some of it published) on the campaigns of his day, and establishes his credentials as a brilliant military strategist and an advocate of bold initiatives.[56] A qualifying note is introduced into the excitement of combat stories by Havelock's own caveat, that 'war is not romance, but always a matter of nice calculation, of fluctuating chances; a picture not seldom crowded with vicissitudes, and oftentimes a season of patient waiting for small advantage'.[57] Through his narration of the preliminary adventures, then, Marshman shows Havelock acquiring the traditional military virtues of dash and gallantry, tempered by calculation, patience and caution deriving from the professional study of military science, and tested by practical experience in the field – the very combination of qualities that would check the Rebellion.

By contrast, Havelock's periods of routine service appear dull and uninteresting – a state of enforced 'repose', even when he is actually hard at work.[58] In narrative terms, they come to be associated almost exclusively with obstacles to the quest, as Havelock's career is stymied through lack of promotion. His long wait for active service between the Burmese and Afghanistan campaigns is described by Marshman as 'the eleven years of neglect he was doomed to experience from this time', and Havelock's own phrase for himself – 'the neglected lieutenant' – becomes a recurring motif in the narrative.[59] Havelock is described desperately searching for promotion, frustrated by the iniquities of the purchase system and obsessed by the spectacle of his contemporaries and juniors constantly being promoted over his head. In 1854, Marshman finds Havelock, now 59 but still struggling for

a colonelcy, lamenting: 'I have soldiered with my heart and soul for thirty-nine years, and my country's generals neglect me . . .'.[60] In developing this theme, of the waste of Havelock's superior talents by the ineptitude of the General Staff, Marshman aligns his narrative with the campaign in England to reform the army and other branches of the state, but also confronts the reader with the possibility that Havelock might not have been promoted to a sufficiently high rank to assume command during the Rebellion.

A similar irony is at work in a second major obstacle, which Marshman shows to have very nearly brought the quest to an absolute and premature end. Back in Burma, not two years after his arrival in India, Havelock becomes seriously ill with a rare liver complaint and is ordered to return to England as the only sure way to save his life: 'To return home at such a period, however, was to relinquish all prospect of taking an active share in the campaign, at a time when he was panting for professional occupation.'[61] Havelock risks remaining in India, and within six months has rejoined his regiment in Burma; but the illness continues to haunt the rest of his career. In 1849, an especially serious attack again threatens his life.

> His constitution, which was feeble when he landed, had been shattered by six years of severe military campaigning. Indeed, the marvel was, that with the seeds of disease in him, he should have been enabled to survive the wear and tear of the Sikh and Afghan Wars.[62]

The harsh climate and conditions of work that eventually killed him in 1857 are shown to have nearly done so eight years earlier. His doctors order Havelock to England, on a leave which lasts for over two years, and from which he nearly does not return.

The 'leave in England' episode occupies a key structural position in the *Memoirs*. As the culminating point in the alternating rhythm of active service and repose, it is also the moment when both sets of obstacles to the quest – Havelock's illness and his sense of neglect and disenchantment – cohere into a major personal crisis. To appreciate why, we need to trace the presence within the *Memoirs* of a second narrative trajectory intercut with the adventure quest, in which the 'career and illness' motifs are invested with a rather different significance: the story of Havelock's search for domestic fulfilment.

'A sad houseless wanderer': the adventure hero, domestic manhood and Christian composure

In this second narrative strand, Havelock appears, not as an adventure hero, but as a family man and a career soldier. It tells of his deep emotional investments in his wife and children, and his efforts at promotion in order to provide comfortably for them and to secure their future in the event of his

own death. The status of this narrative is ambivalent, for although it presents its own motifs in sufficient detail to give them an interest of their own, far in excess of a simple narrative function as 'obstacles' within an adventure, yet they are not given the same intensity of interest, not developed in such detail, as the central military themes of the narrative. This means that their presence – within what is otherwise an adventure structure – very powerfully suggests, without actually articulating as such, an alternative narrative perspective on the story of Havelock's life. This creates palpable tensions which Marshman works hard to contain. These narrative tensions, or 'troublings', can be interpreted in terms of the contradictions (between 'public' and 'private' masculine identities) produced by the gendered separation of spheres, of which the mid-Victorian, middle-class career-soldier affords perhaps the most extreme instance.

Havelock was married to Hannah Marshman in 1829. Almost immediately, they conceived the first of eight children, of whom three boys and two girls survived infancy. Marshman leaves no doubts as to the quality of Havelock's feelings, claiming that his marriage was the source of 'unalloyed happiness' to him for twenty-nine years:

> It was delightful to witness a man of Havelock's strong character, unbending himself amidst the endearments of domestic life, and exhibiting the great soldier and the stern disciplinarian, as the most affectionate of husbands and the most exemplary of parents.[63]

Yet virtually no detailed substance is given to these bare statements. In ordinary circumstances, the narrative does not even register the births of these children, or their names. Marshman gives no information about the characters of Hannah and the children, nor of Havelock's relationship to them, nor of their everyday life together.[64]

What information there is largely concerns the impinging of military life on the possibility of achieving a settled domestic haven. The first detail of the couple's domestic life together finds Havelock, in 1831, forced by military duties 'to exchange a comfortable residence at Chinsurah for two shell-proof dungeons on the ramparts of the fort [Fort William, Calcutta], to which he removed with his wife and child'.[65] These difficulties are suggested, without being explored, in the string of factual detail about Hannah's movements around northern India with her family and her regular separations from Havelock. Later in 1831, for example, Havelock's regiment moves again, this time to Agra. While travelling there, 'a second son was born to him on the river'. In 1834, Hannah moves to 'the sanatorium of Cherra-poongee for the health of his third and infant son, Ettrick', while Havelock takes a language examination at Calcutta and then wins an interpreter's appointment at Cawnpore. On arrival there, he learns of the baby's death in his absence.[66] The very discontinuity of this narrative, and

the impossibility of reconstructing from it a clear sense of the movements of Havelock and family in relation to one another, is itself significant.

Nor is there any exploration of the implications for Havelock himself of a family life that is full of goodbyes and long separations. Prior to 1851, there is almost no indication in the *Memoirs* of the loneliness, sadness and anxiety these must have caused him. In Marshman's campaign narratives, once Havelock has entered active service and moved across the frontier, it is as if his domestic attachments simply disappear, leaving in their place an unalloyed adventurer. There is no suggestion of his experiencing either any difficulties on returning and readjusting to domestic life after active service, or any emotional intensity on being reunited with his wife. During the Afghan War, for example, Havelock did not see Hannah for over two and a half years, one of which she had spent in England. On his return, Havelock's 'desire to go down to Allahabad to meet my wife' is noted by Marshman, but the prospect of renewed domestic life is not apparently exciting enough to offset the narrative's subsequent 'dooming' of Havelock to regimental duties, and the intense relief of their reunion is all ascribed to Hannah.[67]

The importance of the family in this rather fragmented, discontinuous domestic narrative lies in its function as the primary focus of Havelock's anxieties about loss and failure. Narrative interest in Havelock's children is mostly registered at moments when they are placed in danger and pose the threat of loss to Havelock himself. His first son enters the narrative as an infant suffering from teething-pain and fever whilst travelling on the Ganges some forty miles from medical aid: 'The danger seemed imminent, and our distress was not trifling'. Havelock describes in a letter how he himself operated with a makeshift lancet to relieve the child: the story would be 'tedious' to anyone 'who did *not* know how the human heart, even the heart of one who has passed through many scenes of suffering and danger, attaches itself to these little ones in their years of helplessness' (original emphasis).[68] On the death of his third son in infancy, Havelock writes of 'the feeling of desertion and loneliness which with me has supervened on the first shock of the bereavement'; and in 1836, we learn of the death of Havelock's baby daughter in a fire that sweeps the family bungalow and also endangers his wife (again in Havelock's absence). On this, the only occasion prior to 1851 on which the intensity of Havelock's own feelings for Hannah is described, news reaches him that 'his wife was lying at the point of death. He was astounded by the blow, and it required all the strength of Christian principle to sustain his mind.' He 'hastened to the scene of desolation' to find that the doctor gave 'no hopes of Mrs Havelock's recovery. . . . For three days during which he never left her couch, it appeared as if every moment would be her last.'[69] These instances, of loss and threatened loss of his loved ones, function in the *Memoirs* as a synecdoche into which all Havelock's domestic affections are condensed: they are the means by which the narrative both registers an intensity and limits its development, contain-

ing Havelock's domestic sensibility within an adventure narrative that is not interested in foregrounding and exploring it, but nevertheless admits its existence.

Further domestic anxieties are provoked by Havelock's lack of financial security. This was endemic for a man of his impoverished family background in the army, where it was still assumed, on the basis of the aristocratic officer-gentleman ethos, that service was undertaken 'for honour and not material reward'; and that officers would support themselves 'in the manner and style of a gentleman, largely upon the basis of private means or parental support'.[70] Officers' rates of pay were abysmal – less than half that of clerks at equivalent grades in the War Office. For a man in Havelock's position, who was entirely reliant on his army pay to support his wife and family, this was compounded by the difficulties placed in the way of his promotion by the purchase system, which favoured the wealthy above the meritorious. Promotion was necessary to financial well-being, not only during his working life, but also to secure provision for his dependants in the event of his retirement and death. The service awarded no retirement pensions as of right, and only those who had been severely wounded or had performed with especial 'gallantry' in battle could apply for the few that were granted. Promotion without purchase was most likely in regiments on active service or posted in unhealthy tropical stations, since the commission of any officer who died through wounds or disease would revert to the Crown, whence it might be bestowed upon the officer next in seniority within the regiment. Such vacancies were less common in peacetime, although an ambitious officer could transfer between regiments to seek promotion by serving in as many campaigns as possible. This was the course pursued by Havelock. His opportunities both for promotion and a pension therefore depended primarily on the display of valour in battle; that is, on exposure to those very dangers of death by wounds and sickness against which security was sought in the first place. The paradox of this most risky of routes to domestic security lay in the threat that, should he die in service, the financial investment in *his* commission, too, would revert to the Crown and be lost to the family. These circumstances both explain the reasons for Havelock's domestic anxieties, and suggest a more mundane motive than pure, heroic 'joie du combat' behind the alacrity with which he sought out active service.

Marshman's narrative treats Havelock's financial worries at great length. Time after time it finds him fretting about his lack of promotion, endeavouring to enter the purchase lists by borrowing money and anxious about falling into debt. His promotion to captain in 1836 is a relief welcomed 'for the prospects of a better provision for my family during my life-time and after my death'.[71] His constant efforts to boost his salary by winning special appointments to the HQ staff, made on merit by Commanding Officers, meet with consistent success. But in the longer term, such positions are no

substitute for active service and promotion, and during the long stasis in Havelock's career that begins in 1846, his domestic anxieties become acute. They are exacerbated by recurring ill-health.

In 1847 Havelock – now aged 52, a major with five children to support and educate, and desperate for further advancement – is once again laid low, first by fever, and then by his chronic liver complaint.

> I have felt during some portions of this sickness a longing for a Christian rest, relying on the Christian's hope; but then sight and thought of my unprotected wife and children makes me wish for life, though with labour and vexation, until their lot is satisfied.

The doctors diagnose the illness as 'serious, if not fatal': 'hard work, great exposure to the sun, or any untoward accident of climate, would soon finish the story in ruptured abscess and death'. Again the prescription is convalescence in England. Havelock admits that 'both will and duty' point his way to England; 'but as for the means of going, difficulties accumulate around me every day'. The ensuing dilemma lies at the heart of Marshman's domestic narrative. Were Havelock to remain in India, he could continue to support his family in moderate comfort, pay for his boys' education and be available for further promotion; but he would run 'the greatest risk of leaving poor Hannah and my five boys and girls without a sixpence in the world but my major's pension, £70 per annum and a thousand pounds in the [purchase] funds'. Were he to go to England, the doctors thought that 'a year's absence would entirely restore my health, and that two would make me as good a man for Indian work as I have ever been', but the expense of the visit would eat up his savings, making it impossible to educate his children, and would mean 'finally sacrificing my prospects in the army by purchase'.[72]

Having resolved to make the trip in November 1847 (after 'the worst attack of liver I have ever experienced', brought on by 'sleeping in wet tents' in poor conditions whilst on tour), four months later he has recovered sufficiently to be able to stay 'without much risk' but on constant readiness to leave 'at a fortnight's notice'.[73] In April 1849, however, the illness of his eldest daughter forces Hannah to take her and the two younger children to England in order to save her life. In October, after a further deterioration in his own condition, Havelock follows them, confronted with failure: 'I have returned from India as poor, the increased claims on me considered, as I went to it.'[74]

The leave-in-England episode[75] represents the single greatest obstacle to be overcome before Havelock can achieve heroic stature: it is the point where the obstacles he has faced previously – ill health, blighted career and, behind them, family commitments and domesticity itself – come nearest to creating the conditions in which the quest cannot continue. As such, it is also the moment where the *Memoirs* articulates most clearly the underlying contradiction between work and family, public and private lives, the soldier

and the domestic man, and introduces the greatest complexity into its image of Havelock.

During the episode, Havelock is placed firmly in domestic space and the public man is least in evidence. Convalescent, confronting his own public obscurity and lack of success, he comes to desire repose. After two years of this, and with his health restored, further rebuffal from the army has become intolerable.

> The horror of an old soldier on the point of having his juniors put over him is so sensitive, that if I had no family to support, and the right of choice in my own hands, I would not serve one hour longer.[76]

This prompts 'very serious thoughts of retiring altogether', to a quiet, contemplative life couched in terms of desire for a cottage – the very hallmark of the early-nineteenth-century domestic idyll. As Davidoff and Hall have shown, dreams of retirement were a classic product of the frustration engendered in middle-class career men unable to reconcile the demands of their public life with their domestic investments. But here Havelock's dilemma of 1847 returns in reverse. To retire, renouncing all further hope of promotion or active service, smacks of 'prematurely throwing up the game'. Furthermore, the best retirement arrangements he can hope for would provide a barely sufficient income and enable only a partial realization of the dream: not a flower-strewn cottage with a garden in the suburbs, but 'a Swiss or Tyrolese cottage', while 'of England I must never venture to think'. To return to India in the hope of betterment would incur 'considerable expense' and the risk of immediate recurrence of his illness.

> The result might be, I will not say, death in harness in a few months, but the even more appalling alternative, so far as the interests of my family are concerned, of being compelled to return once more to England by absolute inability to work.

Besides these considerations, Havelock also feels that it would be 'imprudent' for his family to return with him before the younger children had completed their education in England. The decision whether or not to return to India comes to represent a choice between the unsatisfactory fulfilment of a dream of retirement and the prospect, at the age of 56, of another lengthy separation from his wife and children.[77]

Marshman handles Havelock's decision to return alone to India, and the personal crisis that this provokes, in a manner consistent with his treatment of domestic themes throughout: the strength of Havelock's feelings is at once registered and somehow understated, with their fuller implications left unexplored.

> It was, therefore, determined that Mrs Havelock should remain for some time in Europe. To a man of Havelock's warm domestic

139

sympathies, this separation was a source of the most poignant regret; *but* he submitted to it with resignation, as a matter of Christian duty. With a heavy heart he quitted Bonn . . . [*My emphasis*][78]

During his journey through Germany to Trieste in October–November 1851 (thence to catch the boat to Bombay), Havelock writes to Hannah every day. Marshman quotes from three of these letters, which tell of Havelock's attempts to enjoy the sights of Frankfurt, Leipzig and Vienna, his emotional condition, and his struggle for composure:

> [I] have really lost all desire to see anything, or inquire about anything, for I have no-one to whom I can communicate my feelings of pleasure or pain. I ought not to write thus, however, because it will grieve you. I have commenced this journey under God's guidance, and not an effort on my part shall be spared to do something for you and my little ones. If you knew what I have endured since I parted with you, I fear it would give you pain, *but* my God will support me. Remember, I am not the only one who sinks thus when separated from those dearest to him. Read the account of the great Marlborough under such circumstances. *But* I have Jesus Christ to trust to, and His presence to comfort me; *yet* in this mortal state we do feel keenly.

> The bitterness of parting, my position after so many years, which renders it unavoidable, and I fear, not a few doubts about the worldly future, passed in rapid succession through my brain, which . . . was so wrought upon that I never slept a single second. *But* I did indeed find sweet relief in the thought of meeting you in that better kingdom, for all earthly meetings are uncertain, and only terminate in longer or shorter separations. . . . I know not what lies before me, *but* I *do* feel that we are both in the path of sacred duty.

> Now – though the word tears my heart-strings – adieu! May God grant us a happy meeting sooner than we expect! *but* if never on earth, in the presence of Jesus I trust we shall meet. [*My emphases*][79]

In Marshman's presentation of the separation, these quotations from Havelock's letters picture a man in the depths of loneliness, distress and bitterness at parting, yet drawing on his faith in a struggle to manage these feelings. Both in the letters themselves and in Marshman's gloss, it is notable that the expression of distress is always held in check by the conjunctions, 'but' and 'yet'. This brings about a repeated conjoining, within the sentence structure, of the disturbing element and that by which it is contained: 'poignant regret' by 'resignation and duty'; 'what I have endured' by 'God's support'; 'keen mortal feelings' by 'trust in Christ'. Havelock's conflicts and contradictions are resolved within the narrative by Havelock's recourse to Christian transcendence. Faith and duty work to unify a divided masculinity

by integrating public and private identities within an overarching religious narrative, in which the poignancy of Havelock's temporal loss of Hannah is more than compensated by their anticipation of eternal reunion.

The condition of this composure is, of course, Havelock's submission to the will of God, and here we find the central meaning of the *Memoirs*. The trial and anxieties of Havelock's domestic life and career both function to test and develop his Christian fortitude and trust in God's purpose. In surmounting the obstacles in the path of duty, Havelock is fashioned – at whatever personal cost – into a tool of providential design. Providence preserves him alike from danger on the battlefield, ill-health, demoralization and neglect, and prepares him to play his allotted part in the Rebellion.[80]

This emphasis on providential design places the *Memoirs* firmly in the tradition of Puritan 'pilgrimage' narratives, traceable back to the seventeenth century, where the pilgrimage is used as a metaphor for the human journey through life. According to Isabel Rivers, this metaphor assumed a new resonance in the eighteenth-century autobiographies of the Methodist travelling preachers. In embracing actual itinerancy, they lived their own lives in a literal sense according to the pattern of these inspirational narratives and subsequently cast them in turn into stories capable of inspiring others. Renouncing all earthly love, comfort and security, the wandering preacher becomes 'a *pilgrim* and a *stranger* here below; that nothing may divert me from pressing through the lonely desert, till I arrive at my Father's house'. Given the imaginative dichotomy between the world as barren wilderness and 'the quiet settlement, the certain place of abode, the tender friendship' of the domestic space, Rivers's claim, that often the most difficult task facing the itinerant was to leave his wife and home, is unsurprising. The deprivation and suffering undergone in his travels give rise to 'the temptation to give up this arduous life and return to his home, his family, his trade. In resisting temptation he learns the symbolic nature of his experience: his sufferings are providential.'[81] Middle-class evangelicalism attributed a rather different significance to the home–wilderness dichotomy, seeing domestic life not as the antithesis but as the very focus of the spiritual life. Unlike the settled existence of other middle-class lives, however, that of the soldier on active service reproduced almost exactly the conditions of hardship, exposure, danger and ceaseless movement that characterized the life of the itinerant pilgrim. The *Memoirs* imagines Havelock as one such in telling how, in the last year of his life, 'when all further expectation of active duty had vanished from his mind, he was suddenly called into the field', and at the age of 62, attains 'the summit of his wishes' in his first independent command.[82]

In celebrating Havelock as 'the great hero whom God has raised up at a great crisis', Marshman's adventure narrative offers itself as the means to trace the pattern of providential design.[83] From its small beginnings, through the various trials and tests that fit the hero for his victory, it builds to the moment of closure in the tent at Dilkoosha Park, when the pattern

stands fully revealed and the hero achieves the ultimate reward of peaceful death and eternal life. It nevertheless remains the case that the inspirational composure imagined by the *Memoirs* is dependent upon the narrative's prior subsuming of Havelock's domestic desires and anxieties within the triumphal adventure of the public hero. Although, in one sense, the structural primacy of adventure over domesticity is qualified (since both are branches of the path of Christian duty), the *Memoirs* is founded upon and reproduces the belief that *men's* duty to God can best be fulfilled through public works. Hence the making of Havelock as a paradigmatic Christian hero is secured, not by his early retirement to an obscure Tyrolese cottage and family life, but by his return to India, the land of adventure. To achieve its figure of ideal Christian manliness, the narrative operates a strategy of containment to 'resolve' the contradictions it has evoked, by reworking or excluding important aspects of Havelock's domestic investments. This can be demonstrated by turning briefly to Havelock's private correspondence, as read by a later (twentieth-century) biographer, J. C. Pollock.

Pollock critiques the *Memoirs* as over-protective towards Havelock's public reputation so as to give his readership what they recognized and desired – 'a presentation of their hero in pure white marble', at the expense of all controversy or any sense of Havelock's 'human foibles and weaknesses'. Partly out of respect for the widow and family, partly through following current conventions of biography, Marshman treated Havelock as 'a public man whose private life should be discreetly veiled'.[84] In Havelock's letters, however, marriage and domesticity appear at the very centre of his life, which is narrated by Pollock as a dramatic love-story. According to Pollock, Havelock joined the army unwillingly, believing that his father's failure, which plunged the family into penury and genteel poverty, had blighted the careers of himself and his brother; and that there would be opportunities for promotion without purchase through active service in India.[85] His love for Hannah – 'a sprightly young miss . . . a little too wild for a missionary's daughter' – emerges organically out of his strong domestic attachments to Serampore. Pollock explores their mutual affection and courtship in some detail, including the obstacles to their marriage: the lengthy absence of Hannah's father in England and Havelock's financial prospects. Immediately before their marriage, Havelock's already precarious financial position is worsened when he is held responsible for the large debt amassed by his 'dashing' brother William, and ruined. He offers to break off the engagement from necessity, afraid of committing Hannah to a life of poverty and misery.[86] After settling into married life at Agra, during Marshman's 'uninteresting' period, 'their home was renowned throughout the cantonment for happiness'. Pollock details their time spent together, and brings out the tensions and jealousies surrounding work and family commitments, as well as the support Havelock drew from his wife to sustain him in his painfully slow career.[87]

Placing Havelock's marriage at the very centre of his life necessarily renders him a more contradictory figure. During their period of settled domestic life at Agra, for example, Havelock's illness and a tendency to depression (unremarked by Marshman) both disappear under the influence of Hannah's 'kind heart, on which I entirely rely for affection and sympathy in every circumstance and condition of life'. This emotional dependence makes Havelock's own anxieties about separation and loss a tangible presence in the narrative. On his return from Afghanistan, Pollock tells of Havelock eagerly anticipating his reunion with Hannah after nearly four and a half years apart; while on the occasion of her serious illness after the birth of her fifth child in 1845, Havelock writes to her from amidst the fiercest fighting of the Sikh War: 'The last six months have been to me a time of harassing anxiety such as I never endured within the walls of Jellalabad or in any other of my adventures.'[88] Neither this illness (clearly as critical an event as Hannah's injury in the fire), nor Havelock's assessment of it, is mentioned by Marshman – a clear measure of the extent to which he excludes important domestic material and shapes what he does include to fit his preferred narrative trajectory. Within this differently centred narrative, the relative significance of military adventure and domestic happiness is reversed, as when, prior to the Afghan campaign – his great opportunity to excel – Havelock fervently assures Hannah that 'I would rather spend one hour in your dear society than win a battle'.[89]

Placed within this context, Havelock's return to India can be recognized as a shattering personal crisis. Pollock emphasizes the 'heart-ringing bitterness' of Havelock's farewell to Hannah and describes how, on the journey to India, 'the full force of his desolation nearly submerged him'. So desperate was his need of Hannah that he could barely cope with the travel arrangements without her. Pollock restores to Havelock's lonely letter about his sleepless night in Leipzig one sentence edited out by Marshman ('Oh how hardly I desired to turn back and rejoin you at Bonn as I lay in my bed') and his assessment that this was the worst night he had experienced 'since Ferozeshuhar', site of one of the hardest battles of the Sikh War. Havelock draws here on imaginative geography to capture his sense of emotional distance and estrangement from domestic security and simultaneously expresses his sense of spiritual crisis: 'I feel for the present a sad houseless wanderer. But I must not repine: God is with me. That ought to be enough.' Only once on board the ship to Bombay is a more composed Havelock able to articulate the full extent of the crisis, in another letter to Hannah:

> During a part of my late journey my nervous excitement has been such that to use poor Colonel King's phrase before he destroyed himself, I have for many hours been 'scarcely a responsible being'. To such a state have care and sickness reduced one, to whom in former days men were wont to point as a pattern of hope in time of public danger. But

we are poor inconstant creatures at the best. The cross of Christ is my support.[90]

This Havelock is a man whose powerful public identity and achievements are underpinned by an equally powerful attachment to, and emotional dependency upon, a woman.[91] Caught in the contradictions between the two, he is thrown into emotional turmoil and struggles to compose himself by recourse to a properly Christian resignation and acceptance of separation. From this perspective, we can read the *Memoirs* against the grain and identify the exclusions performed upon Havelock's correspondence by Marshman in his efforts to sustain the heroic image of Havelock as adventurer and Christian soldier. The *Memoirs* foregrounds Christian duty, not as a composure to be struggled for in the 'dark night of the soul', but as an achieved fact. This strategy depends in turn upon the power of Havelock's domestic attachments being minimized in the narrative. By contrast, what we glimpse in Havelock's figure of himself as 'a sad houseless wanderer' is a masculinity caught in a kind of psychic no-man's-land, exposed at the moment of transition across the border between imaginaries. The possibility of domestic composure has been renounced, but not the desire for it, which renunciation depends upon a reinvestment of the wilderness as an imaginative terrain for the quest. Meanwhile, the sad, houseless wanderer has to inhabit that wilderness in all its disintegrating terror, the very figure of loss induced by psychic splitting. Paradoxically, this glimpse intensifies the resonance of that deathbed scene in Dilkoosha Park. Dying in a tent thousands of miles from the loved ones he had hoped for six years to be reunited with, we are invited to witness the wanderer now at peace with himself, the world and his God. Realizing the irreconcilable conflicts to which this composure is a response renders it, strangely, all the more poignant.

Splitting Havelock:
the soldier hero in the era of popular imperialism

Marshman's attempt to fix the heroic image of Havelock met with considerable success. All subsequent biographies, while uniformly far shorter than its 457 pages, were to rely on his as their definitive source of information. For one hundred years, the only serious alternative as a book-length 'Life' for adult readers was that of Archibald Forbes (1890). Although this draws on more recent published sources supplemented by eyewitness accounts of the Rebellion, apart from challenging Marshman's version of Havelock as the 'neglected lieutenant', Forbes is recognizably treading in his footsteps.[92] The *Memoirs* itself remained in print for fifty years after its first appearance, a new impression appearing for the last time in 1909, the same year as the publication of Baden-Powell's *Scouting for Boys*.

Yet by then, as this juxtaposition suggests, the imaginative landscape had changed around it. The appearance of that Havelock celebrated by Marshman had been contingent on an historical conjunction of cultural imaginaries at a particular moment in the formation of a national-popular culture. As these conditions underwent further transformations, so the Havelock heroic image was necessarily reworked into new shapes and significances. Up to the 1870s, all surviving, published retellings of the Life of Havelock were Christian hagiographies.[93] But from the mid-1880s, new versions began to appear, heralding a further extensive proliferation of the Havelock image during the late-Victorian and Edwardian era of popular imperialism.

The conditions for this were brought about by the accelerating development and diversification of the culture industries from the 1870s, itself a component of the more general shift in capital investment into production for a popular consumer market. John MacKenzie has shown that, in the last quarter of the century, profit-based enterprise transformed patterns of consumption, utilizing new techniques of production, distribution, marketing and advertising that created new tastes and new publics. These were predominantly focused on products, representations and practices concerned with the Empire. The 'phenomenal growth' of the music hall, popular theatre and other forms of commercial entertainment; the increase in giant exhibitions 'run by commercial interests, and securing large attendances'; the arrival of brand images on product packaging, and the increase in commemorative bric-à-brac; the boom in visual images, particularly in the form of picture postcards and cigarette cards, and in the making and consumption of music; the development of board-games, toys and other forms of children's culture; and 'the vast expansion in the publishing trade': all contributed to the diffusion of imperial imaginings into every corner of late-Victorian culture.[94]

Images of British soldier heroes and stories of their colonial adventures assumed a new importance at the very centre of these imaginings. This was very much an imperial tradition in the making, since new soldier heroes were regularly being produced during these decades in a lengthy sequence of colonial 'small wars' that steadily expanded the boundaries of Empire. As James Morris points out, 'Anybody over thirty, say, at the time of the Diamond Jubilee [in 1897] had experienced a period of British history unexampled for excitement. . . . The events of the past twenty-five years had swept the people into a highly enjoyable craze of Empire.'[95] These new adventures were eagerly featured in an increasingly fervent popular press driven by competition to secure the quickest reports, the most exciting descriptions, the most vivid visual images of the 'glamorous or tragic spectacle' of war, from growing numbers of correspondents and war artists. Eyewitness accounts, together with articles from the press and the inevitable character sketches, were reproduced almost immediately as small books or

cheap pamphlets, such as the 1*d*. collections of *Lives and Adventures of Great Soldiers in the British Army* (1885).[96]

The most famous soldiers followed Havelock in becoming 'household names', with four in particular standing out. Generals Wolseley, Roberts and Kitchener became public heroes following their famous imperial victories won variously in Canada, West Africa, Afghanistan, Egypt and the Sudan. In the case of General Gordon, his martyrdom in the imperial service at Khartoum ensured the canonization of an already popular, Christian soldier hero into the most renowned of all exemplars of imperial virtue.[97] A 'hero industry', far more extensive and better organized in 1885 than in 1857, responded with 'the production of anti-Gladstone, pro-Gordon materials ranging from medals to bookmarks, jugs to scraps for children's albums', as well as the increasingly ubiquitous commemorative plates, cups and busts. The Havelock image took its place alongside the new heroes on products like these, in the war heroes sets of cigarette cards and postcards, and even as a brand marker: 'Havelock' cigarettes featured a picture of the hero before Lucknow.[98]

Crucial to these developments was the 'revolutionary expansion of publishing and popular readership', brought about from the 1880s by modern, commercial production and marketing methods, which constructed new public audiences differentiated no longer so much by class, education or political and religious persuasion as by age and gender. The emergence of a gender-differentiated, specifically juvenile literature can be traced back to mid-century, but enjoyed its most dramatic expansion with the rise from the late 1870s of the new kind of high-circulation journal typified by *Boy's Own Paper*. Promoted first by the evangelical publishing houses, these presented 'imperial ideas in all their nationalist, racial and militarist forms', in adventure stories and historical romances that increasingly featured secular and more exciting adventure heroes. Taking the lead, publishers like Blackie, Nelson and MacMillan began to specialize from the 1880s in 'simple, direct adventure fiction' for boys, much of it (notably in the case of G. A. Henty's novels) set in imperial locations and feeding off the narratives about real soldiers.[99]

While the boundaries between 'fiction' and 'history' began to blur, the latter was also increasingly in demand. Compared to the original emphasis on Havelock as a special and exemplary individual, in the later nineteenth century the hero became one of an expanding pantheon. The Havelock story was now being marketed alongside (and to some extent in competition with) the narratives of more contemporary soldiers and events, in a far more systematic organization of hero-worshipping by the publishing houses. 'Hero-publishing' – a 'considerable industry' by the end of the century[100] – tended to produce books in one of two forms: either a series of 'famous lives' about imperial soldiers, administrators and missionaries, past and present; or a collection of several, highly condensed lives within one volume.

In Eliza Looker's 'Life' (1885), Havelock appeared alongside Sir Colin Campbell; F. M. Holmes (1892) grouped him with Clive, Warren Hastings and Henry Lawrence as *Four Heroes of India*; and George Barnett Smith included him in volume three of his *Heroes of the Nineteenth Century* (1901). Havelock also featured in MacMillan's 'English Men of Action' series, and Nelson's 'Stories of Noble Lives'.[101] Leakage between history and fiction through the shared form of adventure is also evident in the 'great sea change in the writing of popular and school history' that took place towards the end of the nineteenth century. Commonly taught in elementary schools from 1895, and compulsory in secondary schools from 1900, history was 'brightened up' by narratives of great men and women, with pride of place going to war stories. These became 'a prime staple of English and history readers' such as those published in 1911 by the Cambridge University Press. Twenty-four out of forty lives for study were war heroes, with Havelock taking his place alongside Clive, Nelson, Wellington and Gordon, each forming a chapter in a still-developing national epic defined fundamentally in terms of military achievement.[102]

The publishers' conception of gender-specific literature was echoed elsewhere in the culture. 'Aggressive, individualistic adventure for the boys, submissive domestic service and child-rearing for the girls':[103] this was the formula inscribed not only within narratives, but in the wider field of recognitions and misrecognitions within which texts were distributed and read. MacKenzie points out that the juvenile book market, including heroic biography and adventure fiction, was aimed primarily at adult purchasers, being designed to supply suitable birthday and Christmas presents for children and prizes to be bestowed in Sunday schools, National and Board schools and other improving institutions.[104] Here, parental approval of the themes of a commercially produced children's culture – itself expanding to encompass toys, games and dressing-up materials – intersected with evangelical and state concern about the propagation of gender-specific moral virtues. As well as educational practice, the activities of gendered (often paramilitary) youth organizations such as the Boys' Brigade and the Girls' Patriotic League, and the expanding intervention of the state into childcare and family life within the home, all instituted a comprehensive separation of the worlds of boys and men from those of girls and women.[105]

The gendered splitting of cultural imaginaries was both cause and effect in these developments. Colonial adventure contributed to that ever-tightening fusion of colonial and national imaginaries that gave British national identity its imperial expansiveness, but this imperial imaginary was split into complementary parts along the fault-line between the domestic and military imaginaries. Towards the end of the century and into the Edwardian period, desirable masculinities and femininities increasingly came to be imagined and recognized predominantly in terms of their gender-specific contributions to the imperial mission. As Anna Davin has shown, the State's

interest in the moral and physical health of the working class came to be redefined, from the 1880s, in terms of the responsibilities of motherhood in turning boys into healthy and virile men, 'the future colonizers and soldiers, not to mention the traders, who hold the Empire together'.[106] Official fears about the degeneration and decay of the imperial race, now engaged in competition with other colonial powers, became focused on the condition of the manly body, particularly that of the soldier, as its most visible sign. Amidst continual invasion scares, and especially in the aftermath of that profound shock to British national confidence, the Boer War (1899–1903), the argument gained ground that 'no nation was ever yet for any long time great and free where the army it put into the field no longer represented its own virility and manhood'.[107] As Michael Blanch has argued, in Edwardian Britain 'the military became a metaphor for national destinies in general', and in the gendered division of labour, war and military manhood came to be associated with the highest mode of masculine service to King and Empire.[108]

This is associated with a further 'remarkable shift' located by Anne Summers around the turn of the century, away from evangelicalism and nonconformity towards military and patriotic allegiance to the Imperial Crown. The moral underpinnings of imperialism, originally derived from the Christian imaginary, became subsumed into an all-embracing concept of service in the imperial mission: 'the Empire itself had become a kind of faith'.[109] The effects of this shift upon the imagining of the soldier hero can be traced in the contrasting images of Generals Gordon and Roberts, who were both the focus of a vast hagiographical literature.

Gordon's martyrdom at Khartoum, perhaps even more than the death of Havelock, was invested as the ideal type of Christian forbearance in the face of suffering and death. Even before Khartoum, A. Egmont Hake's *Story of Chinese Gordon* (407 pp. and already in its fourth edition) had represented Gordon in explicitly evangelical terms as a 'perfect' man, Christ-like in his 'conquest of self'. Eva Hope, in her *Life of General Gordon* expressed the sentiment that continued to underpin writing in the genre in 1885: '[Gordon's] conduct throughout is an illustration of the way in which the Christian should fall in with the designs of Him who is the ruler of the universe, and the guide of the individual.'[110] The pages of Violet Brooke-Hunt's *Lord Roberts* (1901) are similarly peppered with moral lessons drawn from Roberts's exemplary conduct. Yet despite his own Anglican piety, Christian zeal is conspicuously absent from this narrative, being displaced by an emphasis on 'the spirit of Imperialism', and 'the thought of England's Queen and England's honour which had made men brave to suffer and to do'.[111] It remains, nevertheless, an improving narrative of a soldier 'whose whole life has been devoted un-grudgingly to the service of that Empire of which he has ever had so lofty a conception'. In writing it:

my desire has been to give to boy readers the general idea of a career, successful in the highest degree, rich in adventure and experiences, fortunate in many respects, yet unmistakably built upon the sure foundation of honest work and single-hearted devotion to duty.[112]

Aside from this important shift in moral emphasis, these exemplary lives were all telling essentially the same story. As Eva Hope writes of Gordon:

And therefore his biography is a lesson. We may get from him, as from all good men and women, light to guide us in the formation of our characters, and the direction of our actions. To the young especially, who desired to make the best of their lives, an account of Gordon and his work cannot be other than useful; and if they will stop to ask what has made him great, they will be able to discover in him the qualities out of which all heroes are made.[113]

Paradoxically, the greater variety of heroes there were to be learned from, the more their adventures became illustrative of a single, uniform masculine type.

These shifting cultural imaginaries and the re-positioning of readerships in relation to them provided the context in which the Havelock story was read and retold during the period from the 1880s to 1914. The new Lives, written for juvenile or popular readerships, all differ from Marshman in three important respects. First, they adopt an expressly educational stance towards Empire. Revd J. S. Banks offers his character sketches 'in the hope of interesting young readers in our Indian Empire', while F. M. Holmes, while noting the 'fast passing away' of 'popular ignorance and indifference concerning India', still doubts whether 'even now, the great mass of the British public is fully acquainted with that history'. Lucy Taylor, clearly addressing boy readers, suggests they find India on the map, and lectures them matter-of-factly on the basic political realities of the Eastern Empire.[114] Second, in their selection of episodes, reduction in the volume of detail and employment of a livelier writing style, they produce far punchier, more sharply pointed narratives. Taylor's, for example, retells the old anecdote of Havelock as a boy bird-nesting in a tree, but employs a first-person literary device to invite identification: 'I've nearly got it! Here goes for the next bough!'. Her description of the Highlanders' victorious charge at Cawnpore similarly draws on the developing conventions of adventure fiction: 'Nothing could stand against those fellows when their blood was up. Down went the Sepoy gunners, ramrod in hand, dead at their post; down went the regiment behind them, for there was no time to fly; away scampered the rebels in the rear in wild, headlong confusion.'[115]

Third, these narratives decisively foreground Havelock's military adventures at the expense of other aspects of his life, and concentrate predominantly on the Rebellion itself.[116] While some attention is given to

Havelock's religious faith and works,[117] his domestic life virtually disappears from view. In all these texts, Hannah is referred to only as 'Mrs Havelock' or 'his wife', except by Taylor, who misnames her 'Harriet'. Their marriage is remarked upon in the briefest possible fashion, mostly in a single sentence which, if any comment is given, defines the marriage as 'a source of unalloyed happiness till the last day of his life', without mention of any of the anxieties and separations that it entailed.[118] The treatment of Havelock's leave in England, and return alone to India in 1849–51 is equally cursory, being accomplished in some cases in a couple of sentences, and nowhere giving any sense of the conflict and distress evoked by Marshman.[119]

In the one exception to this pattern, George Barnett Smith recognizes that, on his departure, 'Havelock could not suppress his own sorrow, for his affections were very deep, and the separation weighed heavily upon him. But he went forth committing his loved ones and himself into the hands of [God].' Uniquely among the later biographies, this one also refers to Havelock's letters 'giving impressions of these famous cities' as he travelled across Europe, but without mentioning his personal crisis. Significantly, this is displaced onto Hannah. The decision that Havelock would return alone 'involved a terrible struggle for Mrs Havelock. She wanted to go out to India with her husband, and yet the children must not be deprived of the maternal care'; and the hours before the final farewell 'were very painful, but the soldier's wife summoned all her fortitude to her aid, and thought of her duty, and love for, her children'.[120] Hannah is the one torn by conflicting needs, while Havelock – feeling sorrow but trusting in God – remains emotionally intact and unproblematically set on course for his great adventure. In these rewritings of the Havelock story, we can trace the splitting-off from exemplary life adventure of domestic concerns, the wishful resolution of the contradictions that this interest introduces into the image of the soldier hero, and the emergence of a conception of 'moral manhood' oriented exclusively towards the public world of action and combat.

What the turn-of-the-century versions continue to share with Marshman are the idealizing projective investments in their hero as the embodiment of desirable, British masculine composure in the face of adversity. In the early twentieth century, the opportunities to attain this, previously located in the imaginative geography of an expanding Empire, are recoded in terms of service in defence of the nation as feminine Homeland; as in this National Service League pamphlet:

A lad . . . knows that he stands between his mother and his sisters, his sweetheart and his girlfriends, . . . and the inconceivable infamy of alien invasion; . . . And he learns, as he can in no other way, the supreme lesson of physical cleanliness and self-respect, for has not his body, with its faculties – its endurance and its lithesomeness and its

proud contempt for pain – become one of the bricks that form the living wall of the land he loves?[121]

This is nowhere more apparent than in Baden-Powell's Scouting movement, where we see the transference of masculine skills and virtues identified with the imperial frontier to the English countryside (itself transfigured into adventure terrain in the process) and their enlistment in national defence that is both imaginative and literal.[122] Here, the link between the heroic fantasies of boyhood and political mobilization of the nation achieved a new and institutional form.

Introjected into the psychic landscape of a generation of British boys, we can read these emergent imaginary forms as the energizing myths of a war that would prove quite different to that fought by Havelock's flying column. The Havelock story and others like it offered Victorian and Edwardian readers alike a utopian heightening of the everyday, a wish-fulfilling figure of 'something [they] want deeply, that [their] day-to-day lives don't provide . . . the sense that things could be better, that something other than what is can be imagined and may be realized'.[123] Ultimately, it is the presence of this quality – and the subsequent loss of it – that marks Havelock as a hero of his era.

Decathecting Havelock: the hero since 1914

The decline in Marshman's *Memoirs* as a widely read text after 1914 parallels the withdrawal of interest in the Havelock heroic image as such. Thereafter, the only new treatments of the story have been Pollock's and Cooper's centenary biographies in 1957 and Charles Wood's fascinating poetic drama *'H': Being Monologues at Front of Burning Cities* (1970), one of a series of his plays debunking the British tradition of military heroism.[124] This 'decathecting' of the Havelock story – its lack of psychic resonance for modern readerships – itself provokes some important questions.

The First World War is widely considered to have sounded the death-knell of imperialist adventure, detaching the cathexis (or charge of emotional excitement) from the idea of war and rendering the soldier a figure of irony. Yet, as we shall see in the following chapters, colonial adventure remained an attractive and exciting narrative form well into the twentieth century in war stories about Lawrence of Arabia, the Desert Rats or the SAS. Even Havelock's story continued to circulate, in school history text-books produced in the 1920s and 1930s which followed the 'new history' of the late nineteenth century in their insistence that 'pupils should be taught to admire such personalities as the Lawrences [Henry and John, not T. E.], Nicholson, Havelock, and Outram'.[125] Indeed, MacKenzie argues that:

The imperial and patriotic mould, formed at the end of the nineteenth century, was not broken until at least the late 1960s and 1970s. Even

then, financial constraints ensured that texts whose approach was formulated in the 1930s remained basic school material in an era when their message bore little relationship to the real world.[126]

This is a salutary reminder that the public audiences for particular forms of narrative are not transformed uniformly and that residual forms may persevere in some sectors of a culture alongside emergent forms that appear elsewhere.

A vast gulf is nevertheless apparent between Victorian adventure and the interests and sensibilities of the mid-to-late twentieth century. This is brought out, not only by the paucity of new interest in Havelock since 1914, but also by the efforts of those few retellings. Pollock, offering the first rereading of Havelock's personal correspondence nearly one hundred years after Marshman, brings to it distinctly mid-twentieth-century interests in the 'real' man behind the public image. The impetus behind this stems directly from modern unease with the idealized public hero, and a wish to recover a lost contemporary relevance:

> Had he been as Marshman portrayed, of forbidding moral perfection, Havelock could have little meaning for a later age which has no patience with unreality. Havelock was not an angel but a Christian . . . human, and therefore a sinner to the end.

By telling the story as one of suffering, conflict and the struggle for faith, Pollock – himself an Anglican – hopes to demonstrate that 'in a world so different, the values and beliefs for which Havelock stood still stand'. Pollock's discovery of a 'lovable' private self behind the public mask – Havelock's 'warm and attractive humanity', his good sense of humour, the passionate bond with his wife – is informed by ideals of domestic manliness and married love current in the 1950s. Leonard Cooper, in a parallel move, also gives weight to domestic themes in telling the story of Havelock's 'unceasing quest for security'.[127]

Despite these modern re-emphases and the light they throw upon the Victorian construction of the public masculine hero, neither of these projects is convincing in its claim that Havelock has contemporary relevance. The reason can be located in their implicit reproduction and re-endorsement of the imperialist assumptions that are sedimented into the adventure motifs of the Havelock story. The imaginative focus for both these retellings remains the Rebellion, rendered in what remains fundamentally a heroic adventure narrative.[128] Pollock's retains the Anglocentric perspective of the earlier versions and differs from them only insofar as it strives to present Havelock as a humane, even pro-Indian, man, who stops short of the excesses of his colleagues.[129] There is no questioning of Empire here: indeed, Pollock even applauds Havelock's qualities as those that 'made England'.[130] While a pro-imperial stance was not untenable in the year after Suez, a serious imagina-

tive re-engagement with the Havelock narrative would have needed to recognize that the colonial imaginary had now become a site of powerful conflicts; that its fusion with the very idea of the national could no longer be upheld; and that military intervention in the Empire could not in future take the form of triumphalist retribution.

The First World War did not bring about the end of adventure, but it is indeed a watershed. It marks the break-up of that powerful, interconnected configuration of cultural imaginaries in which Havelock was first constituted as a hero in 1857 and which underpinned the subsequent tradition of the national soldier hero. Declining national confidence in the imperial mission, exacerbated by the post-war shift of international power away from Britain towards the USA and the rise of liberation movements among the colonized peoples, led to a new tentativeness in deploying the military expedition. The 'illusion-destroying' experience of the Great War confirmed a longer-term 'estrangement' of the Churches from 'a slowly secularizing wider culture', and called in question the moral legitimacy of nationalism.[131] Havelock, a hero who embodied, abstractly, a cluster of virtues with their roots in early-nineteenth-century evangelical imperialism, survived the permutations of this configuration in later-Victorian and Edwardian culture, but not its break-up and the acceleration into 'modernism' brought about in 1914–18.

In my own, rather paradoxical, encounter with Havelock, I have been surprised by the extent to which this old story of struggle, faith and the overcoming of anxiety and fear has the power to move. But, saturated as it is with the imaginings of confident, Christian imperialism, this power remains muted, a half-seen glimpse of a story that might have been told but has not been – to date. I find myself speculating about the form such a modern, post-colonial retelling might take and the possible public that could sustain it. To be truly relevant in our era, it would need to focus, as does Charles Wood's stimulating play, not on the similarities but on the differences between Victorian and contemporary imaginaries and the subjective forms composed by them. It would need, too, to explore the contradictions produced in the hero by splitting and to bring his story into dialogue with those others originally marginalized and silenced by it: Hannah's narrative and Indocentric accounts of the Rebellion.

This is not an academic speculation. One question that it poses very sharply is, how might the Indian Rebellion be remembered in Britain today? Unlike the years before partition and independence in 1947, the nineteenth-century Raj has not been extensively treated by Western film and television, and remains largely invisible in recent popular memory. In 1938, a proposal for a British film called *The Relief of Lucknow* was proscribed for fear that it might inflame the tense relations between the British Government and its Indian subjects in what was to be the last decade of British rule.[132] In the 1990s, when Indians constitute the largest 'ethnic minority' in Britain, the

problem of how to retell stories like Havelock's has an important bearing on the significance that 'we', the British people, can make of 'our' imperial past; on our understanding of the way that past has shaped what we imagine it means to 'be British' today; and on any possibility of our transforming the projective disavowals of otherness that remain inscribed within British national identity. The complete disappearance of the Havelock story is not something to be celebrated, but the mark of a forgetting with profound implications.

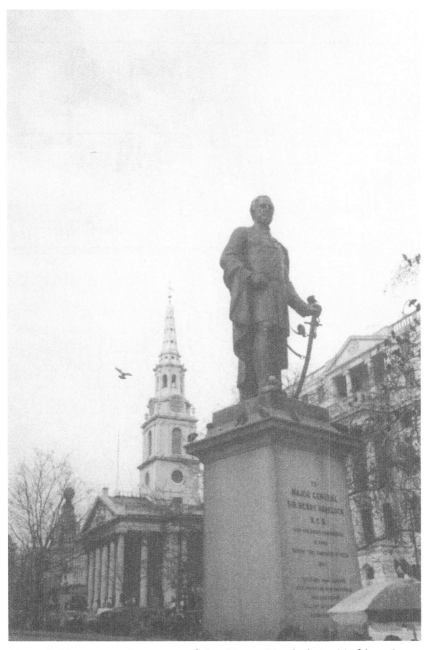

Figure 1 Commemorative statue of Sir Henry Havelock in Trafalgar Square, London. Photo: Graham Dawson.

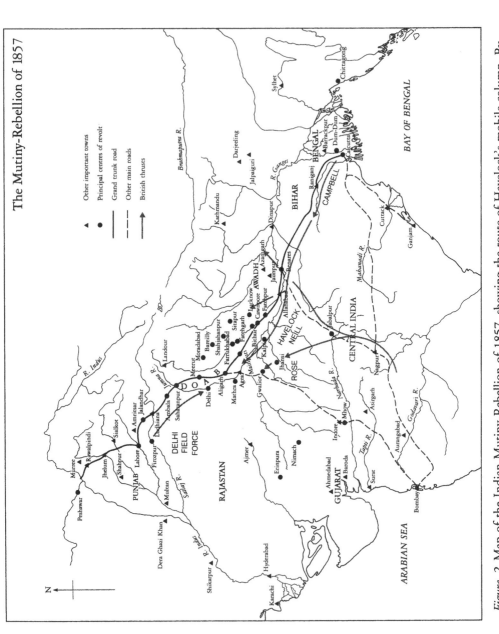

The Mutiny-Rebellion of 1857

▲ Other important towns
● Principal centres of revolt
—— Grand trunk road
--- Other main roads
→ British thrusts

Figure 2 Map of the Indian Mutiny-Rebellion of 1857, showing the route of Havelock's mobile column. By courtesy of the National Portrait Gallery, London.

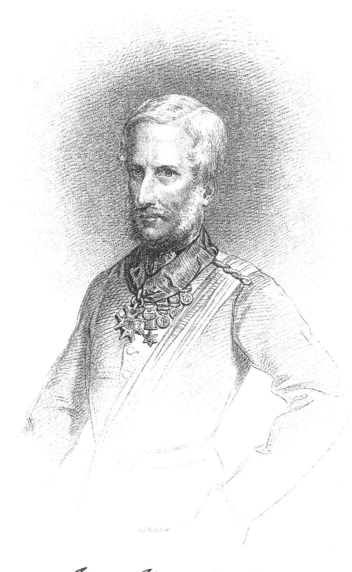

Figure 3 Engraving of Sir Henry Havelock by H. Adlard: frontispiece to John Clark Marshman's *Memoir of Major-General Sir Henry Havelock* (1909), London: Longmans, Green and Co.

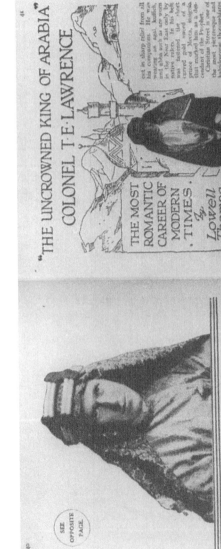

Figure 4 The first instalment of Lowell Thomas's romance, which introduced Lawrence of Arabia to British readers, appeared in *The Strand Magazine*, January 1920. By courtesy of IPC Magazines Ltd.

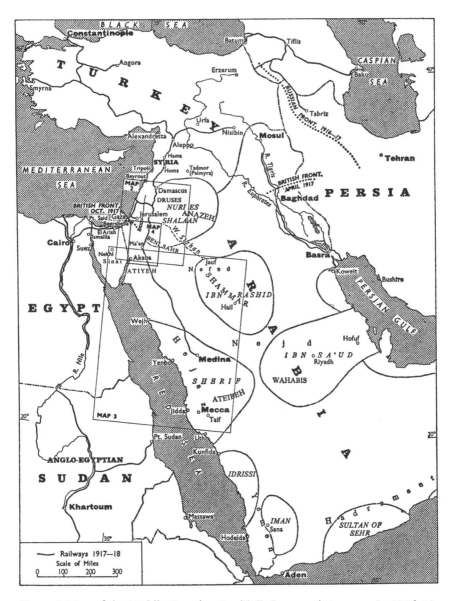

Figure 5 Map of the Middle East showing T. E. Lawrence's journeys in 1916–18.
From T. E. Lawrence, *Seven Pillars of Wisdom* (1962), Harmondsworth: Penguin.
© Penguin Books Ltd.

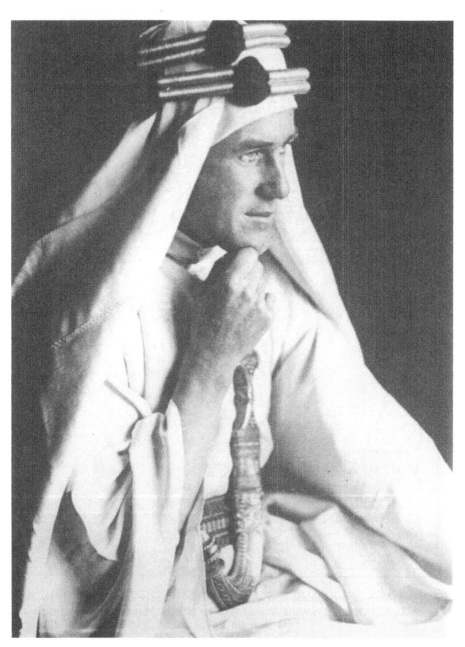

Figure 6 'The dreamer whose dreams came true': Lowell Thomas's caption for this unattributed photograph of Lawrence posing for the camera in Arab robes, 1918, in *With Lawrence in Arabia* (1925). From S. E. Tabachnick and C. Matheson, *Images of Lawrence* (1988), London: Jonathan Cape.

Dean's Patriotic Pinafores for Children.

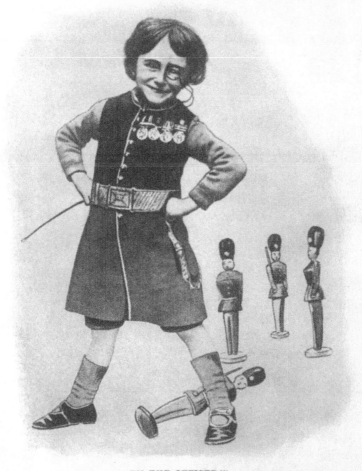

"I'M THE OFFICER!"

This little officer is wearing one of "Dean's Patriotic Pinafores".

Photographed from life.

AWARDED A GOLD MEDAL, FESTIVAL OF EMPIRE EXHIBITION, 1911.

Figure 7 Selling patriotic fantasies: an award-winning Edwardian advertisement (*c.* 1911) feeds off military imaginings in pre-1914 boyhood culture. By courtesy of Weidenfeld & Nicolson Archives.

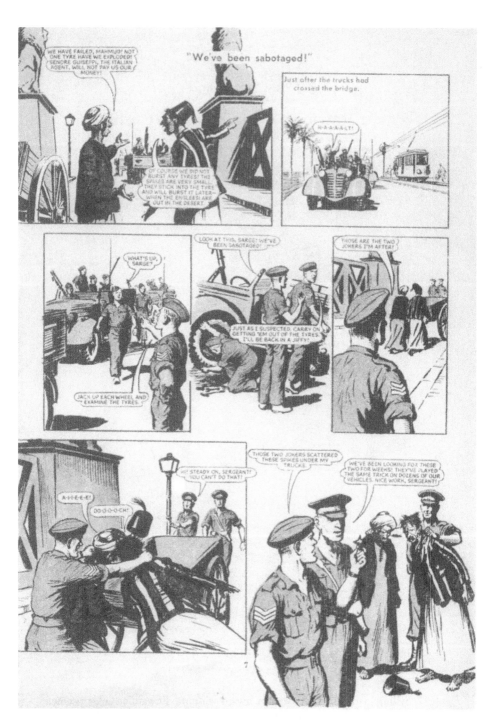

Figure 8 An excerpt from the comic-strip story 'Attack on Marzuk', in *The Victor Book for Boys 1967*. Sgt Miller's smartness is more than a match for the denigrated other, represented here as Egyptian nationalists.

© D. C. Thomson & Co. Ltd.

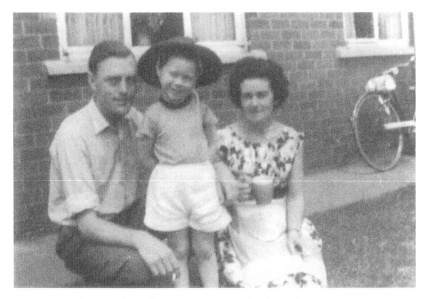

Figure 9 Family snapshot of me at age 3, our back garden, Doncaster, 1959: my parents' approval of my hat wearing, and their recognition of me as a cowboy, made an important part of the cowboy hat's meaning for me. By courtesy of Mr and Mrs F. A. Dawson.

Figure 10 Family snapshot of me at age 3, Scarborough, 1959: being a cowboy also gave me a public identity. By courtesy of Mr and Mrs F. A. Dawson.

Figure 11 Family snapshot of me at age 3, our back garden, Doncaster, 1959: the Lone Ranger on Snowy. Imagining myself as television and comic heroes, I was making my own sense of self and assuming the shape in which I wanted to appear in the world. By courtesy of Mr and Mrs F. A. Dawson.

Figure 12 Family snapshot of me at age 4 with my friend Janet, our back garden, Doncaster, 1960: the hats and guns are 'realistic' accessories in play fantasies where imagined identities can be recognized and shared with others. By courtesy of Mr and Mrs F. A. Dawson.

Part III

The public and private lives of T. E. Lawrence

The imperial adventure hero in
the modern world

The image of the post-Enlightenment man [is] tethered to, not confronted by, his dark reflection, the shadow of colonized man that splits his presence, distorts his outline, breaches his boundaries, repeats his actions at a distance, disturbs and divides the very time of his being.

Homi Bhabha, 'Foreword' (1986)
to Franz Fanon's *Black Skin, White Masks*[1]

In my case, the efforts of these years to live in the dress of Arabs, and to imitate their mental foundations, quitted me of my English self, and let me look at the West and its conventions with new eyes: they destroyed it all for me. At the same time I could not sincerely take on the Arab skin: it was an affectation only. Easily was a man made an infidel, but hardly might he be converted to another faith. I had dropped one form and not taken on the other, and was become like Mohammed's coffin in our legend, with a resultant feeling of great loneliness in life, and a contempt, not for other men, but for all they do. Such detachment came at times to a man exhausted by prolonged physical effort and isolation. His body plodded on mechanically, while his reasonable mind left him, and from without looked down critically on him, wondering what that futile lumber did and why. Sometimes these selves would converse in the void; and then madness was very near, as I believe it would be near the man who could see things through the veils at once of two customs, two educations, two environments.

T. E. Lawrence, *Seven Pillars of Wisdom* (1935)[2]

6

THE BLOND BEDOUIN
Lawrence of Arabia and imperial adventure in the modern world

Introduction: the blond Bedouin

In contrast to Sir Henry Havelock, Lawrence of Arabia remains a name to conjure with. The story of the British intelligence officer who lived among Bedouin Arabs, became a commander of their guerrilla army, and led them to freedom from Ottoman tyranny during the latter part of the First World War, has proved to be one of the enduring myths of military manhood in twentieth-century Western culture. In 1988–9, one hundred years after his birth and seventy years after his Arabian adventure was at an end, two major new biographies appeared, together with an exhibition in London.[1] The contemporaneous re-issue, in a painstakingly restored version, of David Lean and Robert Bolt's 225-minute epic film *Lawrence of Arabia* (first released in 1962) 'attracted extraordinary attention' when released in the United States: 'Pictures of a youthful Peter O'Toole, resplendent in white robes, have emblazoned newspapers and magazines across the country.'[2] This success, repeated in Britain and elsewhere, suggests the continuing fascination of the Lawrence legend, and perhaps most especially, the arresting visual iconography of the 'white Arab'. As a marketing hook provoking curiosity about the film, this image establishes the motivating enigma of its narrative as one concerning the identity of the hero. With its intimations of cross-dressing and disguise, it promises the pleasures of narrative play with cultural difference in an exotic 'Oriental' setting; but also of the spectacle of that most masculine of men, the soldier, elaborately arrayed in flowing skirts, in transgression of gender fixities.

This enigma of identity was foregrounded, too, at the originating moment of the Lawrence legend, when in August 1919 Lowell Thomas brought to London his New York 'travelogue', 'With Allenby in Palestine'. Thomas, an American journalist, had met Lawrence in Jerusalem in January 1918, and was allowed by General Allenby's British Army HQ in Cairo to visit him at his base camp at Akaba, on the Red Sea coast, provided he published nothing until after the war. In the course of celebrating Allenby's overall campaign in the Middle East, Thomas's multi-media show used film and slide material

accompanied by a narrative commentary to introduce audiences to Lawrence. A report on the show in *The Sphere* was subtitled 'A Remarkable Film Lecture telling the Strange Story of Colonel T. E. Lawrence, the leader of the Arab Army', and carried photos of Lawrence in Arab dress. As the popularity of the Lawrence material gradually became evident, Thomas changed the name of the show to 'With Allenby in Palestine and Lawrence in Arabia'. This performance, which played for several months to packed houses at the Royal Opera House, the Royal Albert Hall and other major London venues before touring the provinces and the British Empire, was eventually seen by audiences totalling over four million people. By November 1919, the public image that Thomas constructed for Lawrence had made him a world figure: 'the first media legend' and 'the most celebrated soldier of the First World War'.[3]

Although no text of Thomas's 1919 lecture survives, his Lawrence narrative was published in serial form in *The Strand Magazine* (1920), under the title 'The Uncrowned King of Arabia' (see Figure 4). Then as now, the hook was a fascination with the 'mysterious' hero of 'The Greatest Romance of Real Life'; all the more 'remarkable' and 'amazing' because, claims Thomas, it is not merely a story but a history of real events, the romantic hero a real man.[4]

> An Englishman was supposed to be in command of an army of wild Bedouins somewhere in the trackless deserts of the far-off land of the 'Arabian Nights'. . . . In Egypt and Palestine I heard fantastic tales of his exploits Lawrence became to me a new Oriental legend in the making, and until the day I met him . . . I had been unable to picture him as a real person. Cairo, Jerusalem, Damascus, Bagdad, in fact all the cities of the Near East, are so full of colour and romance that the merest mention of them is sufficient to stimulate the imagination of matter-of-fact Westerners, who are suddenly spirited away on the magic carpet of memory to scenes familiar through the fairy story-books of childhood. So I had come to the conclusion that Lawrence was the product only of western imagination overheated by exuberant contact with the East. But the myth turned out to be very much of a reality.

While Thomas's own interest in Lawrence is underpinned by the familiar Western imaginative geography of an exotic and romantic Orient, the truth of his story is authenticated by a bluff, matter-of-fact narrative voice which explicitly evokes, in order to deny, its improbable and fictional quality.[5]

The specific focus of fascination, in Thomas's opening description of his fortuitous discovery of Lawrence, is his very identity as 'an Englishman'. 'One day', not long after General Allenby had captured Jerusalem, 'I happened to be in front of a bazaar on Christian Street' when 'my

curiosity was excited [by] . . . a group of Arabs'. Among them was 'a single Bedouin who stood out in sharp relief from all his companions'. Not only Thomas, but the crowds in front of the bazaars turned to look at him. That this man 'must . . . have something extraordinary about him' to attract attention in such a way is reinforced by Thomas's description of Christian Street as 'one of the most picturesque and kaleidoscopic thoroughfares in all Asia Minor':

> Russian Jews, Greek priests in tall black hats and flowing robes, desert nomads in goat-skin coats like those worn in the time of Abraham, Turks with red tarbooshes, Arab merchants lending a brilliant note with their gay turbans and gowns – all rub elbows in that narrow lane of bazaars and shops and coffee-houses that leads to the Church of the Holy Sepulchre.

The colourful costumes function here as signs of the exotic richness of teaming Eastern life, timeless and unchanging since Biblical times; fascinating markers of cultural difference, rendered visible in this 'uncompromising meeting place of East and West', where 'the racial peculiarities of Christian, Jewish and Mohammedan peoples . . . are accentuated'.

The extraordinary Arab stands out, as supremely different amidst this throng of difference, by his contradiction of those 'racial peculiarities'. He is wearing the 'costume' of a native ruler, carries in his belt 'the short, curved gold sword of a prince of Mecca, insignia that marked him as a descendent of the Prophet'. He carries himself 'with majesty . . . every inch a king' and looks like he had 'stepped out of the pages of the *Arabian Nights*'. That he is 'real', however, and not a fictional character, is paradoxically attested by the most remarkable thing about him:

> The striking fact was that the mysterious prince of Mecca looked no more like a son of Ishmael than an Abyssinian looks like one of Stefansson's Eskimos. Bedouins, although of the Caucasian race, have had their skins scorched by the relentless desert sun until their complexions are the colour of lava. But this chap was as blond as a Scandinavian. . . . The nomadic sons of Ishmael all wear flowing beards, as their ancestors did in the time of Abraham. The youth with the curved gold sword was clean-shaven. . . . His blue eyes, oblivious to the surroundings, were wrapped in some inner contemplation.

This 'blond Bedouin' attracts the curiosity of Thomas's narrator (and readers), by his disruption of the signs of cultural difference, evident in the visible contradiction between his Arab costume and his 'Scandinavian' racial features. 'Who could he be?'[6]

This enigma of identity provokes Thomas's narrative search for the truth about 'my blond Bedouin' in the story that follows. That it should continue to fascinate seventy years later bears testimony to the continuing centrality

of racial conceptions of difference in the imagining of British (and 'Western') masculinities. But we are clearly dealing here with a rather different kind of 'Englishman'[7] than the adventure hero embodied in the imperial tradition prior to the Great War. Lawrence seems to break all the informally codified rules that, at least since the Indian Rebellion, had governed white colonial masculinity and upheld the authority of Empire.

Edward Said has described this masculine code – a lived form of subjectivity and not just one featured in texts – as 'Kipling's White Man':

> Being a White Man . . . was a very concrete manner of being-in-the-world, a way of taking hold of reality, language and thought. It made a specific style possible. . . . As an idea, a persona, a style of being, [it] seems to have served many Britishers while they were abroad It involved a reasoned position towards both the white and the non-white worlds. It meant – in the colonies – speaking in a certain way, behaving according to a code of regulations, and even feeling certain things and not others. It meant specific judgements, evaluations, gestures. It was a form of authority before which non-whites, and even whites themselves, were expected to bend. In the institutional forms it took (colonial governments, consular corps, commercial establishments) it was an agency for the expression, diffusion and implementation of policy towards the world, and within this agency, although a certain personal latitude was allowed, the impersonal communal idea of being a White Man ruled.[8]

The image of the blond Bedouin would appear to be deeply subversive of this stance. The overt femininity of the image in Thomas's romance is supplemented in later versions of the Lawrence legend by an aura of ambivalent, even transgressive, sexuality. A different relation to the other is evident in its apparent openness and comfortable ease with Arab culture, mediated by the forms of the Arabian imaginary which arguably facilitated a more 'respectful' cultural intercourse than was possible in the 'harder' imperial imaginaries of India and Africa.[9] Finally, it takes the form of an imagining about the winning of freedom from tyranny in which the hero ceases to be a colonizer and lines up instead with anti-imperialist forces (re-activating an older aspect of British national identity).[10]

I will argue, nevertheless, that the Lawrence legend is an imperialist fantasy and its hero a figure of British imperial masculinity, albeit one rendered confusing and contradictory by its undermining of the authoritative fixities of Kipling's White Man. Indeed, Lawrence is interesting precisely because of the complexity of his heroic image. Where Havelock embodied in a relatively straightforward fashion a cluster of virtues specific to the certainties of Victorian moral imperialism, and ceased to interest with the crumbling of this imaginary configuration, Lawrence has continued to fascinate over such a long period because he embodies contradictions and enigmas

that have remained potent and unresolved into late- and post-imperial Britain.

This argument can be focused by studying the Lawrence legend in relation to imperial adventure. On one hand, Lowell Thomas's blond Bedouin is clearly an imperial adventure hero. In arguing this, I take issue with an assumption in much of the critical writing on English literary adventure, that its heroic, military forms are to be associated primarily with the Victorian Empire, and that it never recovered from the horrors of the Western Front in 1914–18. Bernard Bergonzi, for example, argues that 'after the mechanized, large-scale slaughter of the Somme in July 1916 . . . the traditional mythology of heroism and the hero, the Hotspurian mode of self-assertion . . . had ceased to be viable'. Similarly, Paul Fussell also sees the Somme as the turning-point, where the heroic idiom of military adventure proved utterly inadequate to cope with the hitherto unimaginable experience of trench warfare, and gave way to irony in which war was no longer seen as heroic opportunity, but rather as the very figure of dystopian hell on earth.[11] Such accounts, built on a simple before-and-after model, seriously neglect the existence before 1914 of ironic, anti-heroic narratives. If the Somme is placed in the context of the Crimean winter as reported by Russell, or of the 'most appalling slaughter' of the Dervish army at Omdurman (1898) by Kitchener's Maxim machine-guns (reported by George Steevens), or of that same general's 'bludgeon methods' (which had 'taken the fun out of following the flags') during the latter part of the Boer War, it becomes apparent that we are dealing not so much with an historical supersession as with an ongoing tension between adventurous and 'anti-adventurous' modes of narrative.[12]

This is borne out, too, by evidence of a thriving adventure culture during the interwar years. John MacKenzie has demonstrated the 'striking continuity' between pre- and post-war boys' fiction and heroic lives biographies, and the adaptation of these stories for the cinema, 'which continued to rework the adventure, militarist and imperial traditions of an earlier popular culture'. He argues that, in the 1920s, 'warfare appears to have continued to be a popular subject for entertainment, particularly the aspects of it which could be romanticized in the true conventions of the adventure traditions'. At the cinema, 'war was certainly good box office'; and Thomas's film-show can be placed in the context of 'a series of semi-documentary films' that combined actuality footage with a 'boys' adventure stories' approach to war.[13] In constructing his adventure hero, Lowell Thomas clearly draws upon the traditional conventions of chivalric romance to narrate 'the strange story of Colonel Lawrence' and works to incorporate Lawrence's evident differences from the tradition within this idealized image. Lawrence remained 'England's . . . most famous adventurer' into the 1930s, later becoming associated with that other interwar cult (especially strong among boys) of the Royal Flying Corps and RAF.[14] This evidence suggests a

serious misjudgement by writers who have denied the continuing centrality of war adventure stories and their versions of heroic masculinity beyond the First World War and into the later twentieth century.

One reason for this is the tendency of end-of-adventure arguments to concentrate on 'serious' and 'literary' forms at the expense of popular narratives. MacKenzie has suggested that 'the difference between the pre-war and postwar worlds is that in the former high and popular culture to some extent converged, while in the latter they diverged', adding that 'in each case the "energizing myths" of imperialism were carried through popular cultural forms'.[15] More usually, however, recognition of such a split has resulted in the disparaging and dismissal of the popular forms. Andrew Rutherford, for example, argues that popular genres such as the western, the spy story and the war film 'form part of the heroic mythology of modern urban man' and celebrate 'heroic virtues' as necessary 'if the "normal" life we value is to be protected and sustained'. But he goes on to stigmatize their 'childish assumptions' and 'ethical and psychological simplicities', preferring instead to explore modern writing which 'treat(s) heroic themes and reinvestigate(s) heroic values' while taking 'full account of the complicated, contradictory nature of adult experience'.[16] Similarly, Martin Green suggests that after 1918, 'a serious literature of adventure' becomes impossible. He posits a renewed split in the reading public between the anti-imperialism of serious literary culture and popular adventure forms (exemplified for him by Lawrence and by John Buchan's fiction) which 'lacked the power to convince and dominate'.[17] Popular narratives, though, become rather more interesting when considered in terms of their representation of masculinities, for Rutherford's argument may then be taken to imply that they imagine forms of masculinity that are ideally free of any such complexities. This is the theme I wish to pursue in analysing Thomas's Lawrence of Arabia.

On the other hand, Rutherford uses Lawrence as an exemplar of precisely the complexity he sees lacking in adventure: 'Lawrence was both a brilliantly successful man of action and an intellectual – sensitive, scholarly, self-analytical and self-tormenting.' In Seven Pillars of Wisdom, Lawrence's epic account of his own involvement in the Arabian Revolt, and one of Rutherford's key texts, Lawrence represented himself in terms of an alternative tradition that increased in imaginative power towards and after the turn of the century. This is a tradition of ironic subversion and commentary upon heroic adventure epitomized most clearly by Conrad's Heart of Darkness.[18] It registers and explores both a fascination with, and fear of, the colonized other, including, specifically, those 'other' masculinities that possess, in their very subordination, qualities that may appear to be antithetical to the Englishman and exist within the narrative as a troubling, disturbing or even overtly desired presence. Undermined in this colonial encounter, the adventure hero is divested of wish-fulfilling psychic investments, and contradiction, disturbance and conflict are foregrounded in their place.

The omnipotent imperial masculinity fragments into its obverse, a masculinity haunted by an experience of otherness that is no longer other people, but is now lodged within the psyche; a masculinity torn and split by psychic conflict, and divided against itself.[19] This Lawrence of Arabia, confronting the horrors of war, torture and rape, physical exhaustion and guilt, is a modernist anti-hero struggling for composure without the succour of religion.

Taken up and probed by subsequent biographers armed with that other tool of twentieth-century modernism, depth psychology, Lawrence's fractured subjectivity is made into a symptom of a wider culture in crisis, not least because of the loss of Empire. Where Thomas's idealized hero can be read as an imperial figure, the telling and retelling of the Lawrence story in conflicting and contradictory versions has occurred over seventy years during which British imperial authority was first challenged and then eroded away. If Thomas's adventure is considered in relation to these later narratives, the Lawrence legend can be read as a site of conflict between these alternative imaginings of British masculinity.

In this third part of the book, I explore the imagining of Lawrence as an adventure hero and the inter-relation between this figure and the modernist anti-hero, both at the level of public narrative and in terms of Lawrence's own self-identifications. This does not imply a search for the 'real' Lawrence. The 'Lawrence of Arabia' exhibition in London claimed confidently that, as a result of the many representations, 'there were in a sense two quite different Lawrences in existence: the man and the legend'.[20] But it is my contention that separating the two is not such an easy task as this implies. One reason for this is T. E. Lawrence's own involvement in the process of myth-making about 'Lawrence of Arabia' and his own investment in the form of that myth. This intersected in equally complex ways with his own self-imagining, so that the ambivalences and lack of fixity that characterize the legend are reproduced in Lawrence's own accounts of himself. My investigation is not concerned with the question 'who or what was Lawrence and how can we know him?', but asks instead 'who has made what imaginative investments in the Lawrence legend?': a legend that has always been concerned with the making of identities and with the imagining and living-out of possible selves.

The irregular soldier and the flight from modernity

Lawrence was made into a hero at a time when the desired masculine qualities associated with the imperial tradition were palpably in contradiction with the actual social structures in which men were living and dying during and immediately after the Great War. Lawrence's Arabian adventure can be seen to meet a widespread desire for the reassertion of a heroic British identity to set against the destruction not only of life, but of meaning, values

and beliefs, brought about by the war in Europe. Even during the war, Lowell Thomas's own motives for visiting the Middle East were propagandist, stemming from efforts in Britain and the United States to produce heroic images capable of arousing American military intervention. Dispirited by the European fronts, Thomas and his cameraman Harry Chase had heard news of the capture of Jerusalem and sought permission to visit Palestine from Colonel John Buchan of the Department of Information in London. In the Middle East, they would find 'war stories more uplifting than any to be found in the Flanders quagmire'.[21]

Eric Leed has explained the European enthusiasm for war in August 1914 in terms of an imagined 'liberation' from modern economic activity into 'a field of freedom, uncertainty and risk, a field upon which a character and an identity would be realized – a character who was the antithesis of "economic man"'.[22] This belief in war as a means to escape the 'soul-killing mechanism of modern technological society' produced a profound disillusionment under Western Front conditions. While trench warfare could still be described in a 1919 boys' annual as a 'wonderful development . . . much fuller of interest and excitement than might seem possible',[23] several features of the Western Front campaign rendered it palpably inimical to adventure. Trench warfare was mechanized warfare: the mass slaughter of 'cannonfodder' by artillery, tank and machine-gun. It was static warfare, that trapped and immobilized soldiers in a nightmare landscape drained of life and beauty. It was bureaucratic warfare, conducted by means of a rigidly disciplined hierarchy and highly organized division of labour: designed to separate, on industrial lines, those who thought (and 'managed') from those who acted; to instil unthinking obedience in the latter to decisions made elsewhere; to orchestrate a uniformity and precision of effort.

The war in the Middle East, by comparison, was one of movement: in Allenby's main campaign, as well as his Arabian sideshow, much use was made of cavalry (which had been abandoned on the Western Front in 1915). Some scope was granted to traditional, heroic military virtues such as enterprise, initiative and bravery. The personal qualities of individuals in action counted for something, and soldiers had some chance of experiencing themselves as powerful and effective agents. Under these conditions, war could once again furnish opportunities to imagine and test desirable masculinities. This imaginative contrast, not only with the Western Front, but with the bureaucracies, the mechanization and de-humanizing division of labour in modern 'mass society' as a whole, marks the persistence of traditional investments in the adventure world as a space where a utopian intensity of experience remained possible. In this sense, the continuing impulse towards romantic adventure can be considered in terms of what Leed calls an 'escape from modernity', suggesting a flight into simplicity from the paradoxes and pressures of modern life, rather than a modernist engagement endeavouring to make that life habitable.[24]

The Lawrence story as told by Thomas foregrounds the wish-fulfilling features of adventure to an extreme degree and goes to considerable lengths to mark Lawrence's imaginative distance from the military culture associated with the British generals of the Western Front. His Lawrence is no ordinary soldier, but a reluctant hero made 'against the grain' from the most unlikely material:

> Fate never played a stranger prank than when she transformed Thomas Lawrence, the retiring young Oxford graduate, from a studious archaeologist into the world's champion train wrecker, the leader of a hundred thrilling raids, commander of an army, creator of princes and terror of Turks and Germans.[25]

Thomas's repeated designation of Lawrence as a scholar and student – his description of him as taciturn, shy, a loner and a recluse, more at home in the arcanities of books, and in the past, than in the political and military conflicts that are making the future – establishes a contrast between contemplation and the inner life, as against the public world of conflict and action. Later, while 'trekking across the desert' together, Lawrence tells Thomas 'that he thoroughly disliked war and everything that savoured of the military and that as soon as the war was over he intended to go back to archaeology'.[26]

This theme is developed through Lawrence's 'unmilitary' character. He 'hardly knew the difference between "right incline" and "present arms"', and he scorns the protocols of rank and military decoration and refuses to be 'correct' in uniform:

> I have seen him in the streets of Cairo without belt, and with unpolished boots – negligence next to high treason in the British Army. To my knowledge he was the only British officer in the war who so completely disregarded all the little precisions and military formalities for which the British are famous. Lawrence rarely saluted, and when he did it was simply with a wave of the hand, as though he were saying, 'Halloa, old man' to a pal. I have never seen him stand to attention.

As well as intensifying the marvellous quality of Lawrence's transformation into a soldier hero, these details suggest a contrast in modes of masculinity between traditional images of the military man of action and a more 'passive', contemplative masculinity which may even be inscribed as feminine or effeminate. Lawrence's otherworldliness is linked by Thomas to his aura of inscrutability, his perpetual faint smile as mysterious as the Mona Lisa. On first meeting Lawrence, Thomas is impressed by his 'serene, almost saintly' expression, like 'one of the apostles', as if he were a soldier-saint, or a Christian knight from the age of chivalry. The incongruity of this contrast is developed at length by Thomas, in an extended play upon conventional representations of military manhood. Attaching the connotations of chivalry

to Lawrence preserves continuity with the older tradition, but inflects it in a new direction.[27]

The pre-condition for enterprising initiative in adventure fiction, as Martin Green has shown, is often the escape by a younger man from the surveillance and control (but also protection) of an established and older authority, who may be coded explicitly as a father-figure. This relationship can, indeed, pose the most basic obstacle to the quest. Thomas's narrative, too, has Lawrence at General HQ in Cairo 'chafing under the red tape of Army regulations'. The quest begins with the General Staff granting his request for leave, 'delighted to have the opportunity of getting rid of the altogether too independent subordinate'. In military biography from Havelock to Kitchener, the heroes, being generals, tended to be older men. By foregrounding and exaggerating the significance of Lawrence's 'youthfulness' (two years are stripped from his age), Thomas distances his hero from the discredited 'old order of society, the father's order', responsible for the war, and identifies him instead as a symbol of the forces for change in the 'new England'.[28]

In Thomas's Lawrence, youth and sexual ambivalence are combined with more conventional associations of the soldier hero in an ideal integration of 'active' and 'passive' qualities, so elusive to most modern masculinities. Their imagined integration in Lawrence suggests, not merely a distance from the traditional British military establishment, but an alternative and superior mode of being a man.[29] At the same time, by depicting his Lawrence as rejecting and transgressing all the signs and rituals of military authority, hierarchy and discipline, Thomas is able to separate out the 'positive' and exciting qualities invested in military adventure and preserve them from contamination by the 'negative' qualities associated with trench warfare. This opposition is captured best by Thomas's description of 'the irregular way in which he [Lawrence] does everything', for after 1916, it would be the 'irregular' or guerrilla, rather than the regular soldier, who proved capable of sustaining adventure interest.[30]

There is something transgressive about Lawrence's freedom from established military authority in Thomas's story. It offered its audiences a fantasy of liberation. Thomas cuts his hero free of the modern world itself, imagining him as able to do as he pleases and fashion the world according to his own desires, far away from the cramped, regimented and soulless hierarchies, out in the limitless deserts of Arabia. Here, the maverick individual, the eccentric, by breaking all the rules, becomes an imaginative figure of the fully human. Paradoxically, however, it channels this utopian impulse into a reworked imperialist form. Liberated from the destructiveness of military authority, what Lawrence does with his own freedom is to reinvest one of the oldest of all British imperialist imaginings: that of bestowing freedom on a colonized people by the exercise of imperial authority.

The arrival of Thomas in Jerusalem, then, bears testimony to a continuing

Western desire for the excitement and inspiration provided by military adventures (both in books and in real life), and to the tendency to seek them out across the frontiers of one of those peripheral zones of the world inhabited by colonized (or colonizable) peoples. In turning away from the Western Front to the Middle East as an imaginative location of more inspiring military adventures, Thomas was projecting a romance world, designed to enable the heroic omnipotence of a (white, Western) ideal masculinity, onto a real geographical space inhabited by communities of real other people; the Arabian desert, where Bedouin tribes had made their way of life for centuries. In this, he was able to draw upon a rich Western imaginary of Arabia.

The Arabian peninsula, along with the whole area we now designate as the Middle East, had been a part of the Ottoman Empire since the early sixteenth century. Prior to 1908, when oil was discovered in Persia, British imperial interest in the region had focused, besides trade, on keeping open the route to India, by means of bases at Aden and along the Arabian coastline of the Persian Gulf, and – a few years after the opening of the Suez Canal in 1869 – by the effective rule of Egypt.[31] Contact with the Arabian interior had been minimal, being confined to Victorian travellers and explorers, most notably Richard Burton and Charles Doughty; but it was vividly evoked in their lyrical writing in praise of the desert:

> At last once more it is my fate to escape the prison life of civilized Europe, and to refresh body and mind by studying Nature in her noblest and most admirable form – the nude. Again I am to enjoy a glimpse of the glorious desert, to inhale the sweet, pure breath of translucent skies that show the red stars burning upon the very edge and verge of the horizon and to strengthen myself by a short visit to the wild man and his home.

Being in this natural landscape has the power to revitalize the modern sensibility dulled by civilized life:

> In the Desert . . . your lungs are lightened, your sight brightens, your memory recovers its tone, and your spirits become exuberant; your fancy and imagination are powerfully aroused, and the wilderness and sublimity of the scenes around you stir up all the energies of your soul – whether for exertion, danger or strife.[32]

The conception of the desert Arabs furnished by the Arabian imaginary was an idealized 'romantic fixation' which made them well liked for their picturesque, primitive but 'chivalric' way of life and their renowned fighting ability: between 1911–18, for example, an 'Arabs of the Desert' series was featured by the toy soldier manufacturer, Britains. On the other hand, critics have drawn attention to the negative inverse of this, in which Western

cultures have commonly imagined the Arab peoples as backward, duplici-
tous, cruel, bloodthirsty, servile, fanatical and destructive.[33] Thomas's
romance world evokes both this lyricism of the landscape and these ambiva-
lent, polarized forms of imagining the other, in an encounter with the
Islamic world of the Ottoman Empire at a moment when it was torn by the
internal conflict of the Arab Revolt.

The Arab Revolt had its origins in the resentment among some sectors of
Arab opinion at their subordinate position within the Ottoman Empire,
fanned by the resurgence of Turkish nationalism from 1909. When the Turks
declared war in support of Germany in November 1914, the long-standing
British policy of supporting the preservation of the Ottoman Empire was
replaced by negotiations to secure the support of Arab nationalists in the
war. The Revolt began under the leadership of Hussein ibn Ali, an influen-
tial Islamic figurehead who, as Grand Sharif of Mecca, claimed descent from
the Prophet Mohammed and had won wide acceptance as 'spokesman for
the Arabs', contingent on his securing suitable terms from the British. These
complex negotiations were still underway in June 1916 when, under pressure
of events, Hussein began the Arab Revolt in the Hejaz region by seizing
Mecca. In October 1916, Ronald Storrs, a senior British intelligence officer
from the Arab Bureau in Cairo, arrived in the Hejaz to help organize
support for the Revolt. Accompanying him was Captain T. E. Lawrence.[34]

The quest for freedom

In narrating the story of Lawrence's involvement with the Arabian Revolt as
an adventure, Thomas utilizes a particular selection, ordering and treatment
of events to place him at their very centre. Interest and attention are directed
towards Lawrence's personal quest and achievement of heroic stature at the
expense of other aspects of the Revolt, so that the reader is positioned by,
and invited to identify with, a thoroughly Anglocentric narrative. Thomas
recounts how:

> He brought the disunited nomadic tribes of Arabia into a unified
> campaign against their Turkish oppressors Lawrence placed
> himself at the head of the Bedouin army of the King of the Hejaz,
> drove the Turks from Arabia, and restored the Caliphate to the
> descendents of the Prophet Lawrence freed Arabia, the holy land
> of millions of Mohammedans.[35]

From an alternative perspective, Elie Kedourie has argued that:

> This simple story is in its simplicity quite deceptive. For the relations
> between the Ottoman state and its Arabic-speaking subjects cannot be
> described merely as those between oppressor and oppressed. The
> Ottoman state was an Islamic state, and Islamic loyalty was a strong

bond between rulers and ruled. Apart from the Sharif in the Hijaz (and the small number of Ottoman Arab officers who joined him), the Arabic-speaking provinces remained . . . faithful to the empire until the end.[36]

In order to sustain the idealization of Lawrence as hero and the Anglocentric fantasy of his fight for Arab freedom, Thomas's narrative splits the Islamic other into 'good' and 'bad' aspects (along lines dictated by British imperial interests and power). As in the Havelock story, British omnipotence is secured in contrast to colonized otherness, but here Arabness and Turkishness are constructed through different forms of projection in each case. Since, in common with the broad tradition of imperialist adventure since the later nineteenth century, Thomas's romance world is almost entirely devoid of women, Lawrence's encounter is with Turkish and Arab masculinities.[37]

In order to fix Lawrence rather than the Arabs as the focal point of the narrative, Thomas's narrative effects a curious structural displacement whereby the Arabs are imagined as lacking certain qualities that Lawrence will supply. 'At almost any time in those five centuries the desert people could have freed themselves had they been able to unite. But . . . no-one appeared in the Near East strong enough to bring the Arabs together.' While the current Arab leaders, King Hussein and Prince Feisal, are granted 'great credit' for building the Arab nationalist movement and initiating the Revolt, 'neither of them had the uncanny skill and masterly diplomatic ability to carry out their original plan'. These are the very qualities discovered in Lawrence. The Arabs come to recognize him as the leader without whom the Revolt cannot succeed, and make him 'an Emir and a Prince of Mecca out of gratitude'. Thomas suggests that their inability to unite under a strong, Arab leader – due in particular to their indiscipline and constant fighting among themselves – is largely responsible for their failure to throw off Turkish rule and their status as 'slaves' of the culturally inferior Ottoman Empire. In this Social Darwinist analysis, the qualities attributed to the Arabs signify British superiority, but also constitute the major obstacle to the quest.[38]

The theme of the quest itself is announced when Lawrence, surveying the Arab army, promises Feisal that 'his troops would be in Damascus within the year'. Confronting Lawrence, as Havelock, are formidable obstacles and 'overwhelming odds'. His greatest problem – and achievement – is to overcome the Arabs' tribal 'blood feuds' that in some cases had lasted for centuries, thwarting the efforts of 'scores of generals, statesmen and Sultans' to unite them in a single movement.[39] Rising to this challenge, Lawrence demonstrates existing qualities and knowledges and acquires new ones: 'magic powers of persuasion'; a 'masterly and convincing manner' whilst recruiting; skill and justice in settling disputes. All is underpinned by his

knowledge of Arab customs and dialects, for even before joining the Cairo HQ in 1914, Lawrence was already 'an authority on the geography of the Near East'.[40] He was able to advise the British generals' strategic plans on the basis of 'short cuts which he alone knew from his years of barefoot travelling'. As 'a student of peoples', he had 'adopted native costume and tramped barefoot over thousands of miles of unknown desert country, living with the various Bedouin tribes, and studying the manners and customs' of peoples throughout Turkey, Syria, Palestine, Mesopotamia and Persia; having 'a more intimate knowledge' of them 'than almost any other European'. Thomas claims that Lawrence spoke 'faultless Arabic' in five dialects and that he was 'one of the greatest living Arabic scholars'.[41]

As the Arab leader by dint of his own superiority, Lawrence now becomes the very centre of the Revolt. Thomas credits Lawrence alone with wiping out the blood feud, building up and inspiring the Arab army, masterminding the strategy of its campaign, outmanoeuvring the enemy generals, leading the Arabs into battle, and establishing a government in Damascus: 'In fact he was the moving spirit of the Arabian revolution'.[42] The results of this are often bizarre. For example, Thomas suggests that, because of Lawrence's extensive knowledge of explosives, about which the Bedouin were wholly ignorant, 'Lawrence nearly always planted all his own mines, *and took the Bedouin along with him merely for company* and to help carry off the loot' (my emphasis). On recruiting missions, 'the fact that *Lawrence was accompanied by Emir Feisal*, the most popular of King Hussein's sons [rather than, as might have been expected, the other way round!], assured him [not Feisal] of the heartiest possible welcome wherever he went' (my emphasis). The Arab army, instead of pursuing its own revolt by their own means with support from Lawrence, come to occupy the place of devoted helpers on his quest to become a hero.[43]

The Turks constitute an obstacle of a different sort. In their characterization, Thomas utilizes a similar Orientalist binary dichotomy. But while his picture of the Arabs, and of Lawrence's relation to them, is ambivalent and includes recognition of positive qualities, as enemies, the Turks become the recipients of all that is negative in a straightforward demonizing comparable to that of Nana Sahib and typical of much wartime propaganda. While more recent scholarship has favourably contrasted the 'authoritarian and deeply conservative but neither insensitive nor ruthless' Turkish Empire with the 'institutionalized racial discrimination' and cultural supremacism of modern European empires, in Thomas the Turks are 'tyrannical oppressors' who had managed to 'usurp the leadership of Islam' and 'governed the Arabs as though they were an inferior race' for 500 years. Turkish troops commit 'atrocities against [Arab] women and children' and practice gruesome methods of torture. They have absolutely no qualities worthy of respect, and so merit the 'utter scorn' of the hero.[44] They are also represented as powerless against him. In narrative terms, they exist only in order to be

defeated: to be outmanœuvred, tricked, surprised, captured, paralysed, shot and blown up.

Consistently 'outwitted', overwhelmed and eventually demoralized, the Turkish forces pose no threat to Lawrence in Thomas's story and function merely to be defeated by Lawrence's superior leadership and 'strategic genius'. Once exposed to military combat, Lawrence distinguishes himself by his courage (he always charged at the front of his troops, was 'in the thick' of every fight). He is casual about danger: 'strolling on foot through the Turkish lines', or inveigling Turkish soldiers to approach close in the hope of taking him prisoner before, 'with a speed that would have made an Arizona gunman green with envy, whipp[ing] his . . . revolver from the folds of his gown and [shooting] six Turks in their tracks'. He is, of course, 'a perfect shot'.[45] Where Lawrence is clever, the Turks are stupid. Lawrence's bravery is matched by the Turks' cowardice, his skill by their incompetence. All the heroic qualities discovered by Lawrence on the quest find their opposite, by implication if not direct attribution, in the Turks. As the devalued, contemptible and worthless 'bad imago', the Turks are deserving recipients of the punishment and destruction meted out to them by the hero. Moreover, since they deserve Lawrence's righteous violence, he is licensed to take pleasure in it, as 'sport', free from guilt or remorse at his destructiveness: 'Do you know, one of the most glorious sights I have ever seen is a trainload of Turkish soldiers going up in the air, after the explosion of a mine?'[46]

The third obstacle to the quest is the Arabian desert landscape itself in its sheer vastness of scale and difficulty of terrain: 'The distance from Damascus to Aleppo alone is greater than the distance from London to Rome, and great sweeps of desert separate nearly all the important points.' Thomas himself claims to accompany Lawrence on a raid which takes 'two days hard riding across a country more barren than the mountains of the moon, and through valleys that would make Death Valley look like an oasis'.[47] If his overcoming of the first two obstacles equips Lawrence with the leadership and martial qualities of the traditional British soldier hero, it is in his overcoming of this third obstacle that the imaginative resonance of the legend derives. For 'when Lawrence left the coast of Arabia and plunged into the desert he shed his European clothing and habit of mind and became a Bedouin'. He learns to traverse the desert Arab-style, by camel, acquiring a 'thorough knowledge' of their ways through 'exhaustive study', and becoming (according to one Arab leader) 'one of the finest camel-drivers that ever trekked the desert'.[48] He eats only the simple Arab food, and even 'worked out his problems in true Arab manner'. This can be seen as an extension of Lawrence's studious interest in, and appreciation of, Arab customs and culture, which he values as 'an entirely older civilization than his own'. Those very qualities that distinguish the Arabs from British military culture provide opportunities for an Englishman to experience a different way of

being. When Thomas visits him at Akaba, Lawrence had 'lived so long in the desert that it was more natural for him to act like an Arab nomad than a European'. He had been *'entirely successful* in transforming himself into a Bedouin' (my emphasis).[49]

Acquiring Bedouin ways in the desert enables Lawrence to lead the Arab army under his command in a successful guerrilla war behind enemy lines in Turkish-controlled Arabia (see Figure 5). The focal point for this is the Hejaz railway, connecting the Turkish garrisons at Medina and Maan with Damascus. Lawrence becomes an expert saboteur. His success lies in the Arab army's ability to take the Turks by surprise, due to its greater flexibility of movement and Lawrence's 'superior knowledge of the topography of the country'. Having 'wiped out' a Turkish post near Maan, for example,

> The young Englishman and his band of Bedouins disappeared in the blue, swallowed up in the desert so far as the Turks were concerned, until the evening of the following day, when they reappeared out of the mist many miles distant at another point on the railway. Here Lawrence merrily planted a few mines, demolished a whole mile of track, and destroyed a train.

So successful are these tactics that Thomas records only one unsatisfactory expedition, when Lawrence and sixty Arabs blow up a train carrying the Turkish Commander-in-Chief and one thousand troops near Deraa, and have to fight a 'pitched battle' against 'overwhelming odds', suffering twenty casualties before escaping.[50]

As well as guerrilla raids against the Turks, Lawrence marches his growing army 700 miles across the desert and along the coast; maintaining 'a perfect liaison' with the Royal Navy which results in the capture of the strategic coastal towns of Yambu and El Wijh, and building up his army to a force of 50,000 Arabs along the way. In a decisive move, he then leads a smaller force of about 1,100 northwards to Akaba, 'his most important objective'. After defeating 'a crack Turkish battalion' at the battle of Aba-el-Lissan for the loss of only two Arabs, and achieving numerous smaller victories, Arabs from the northern tribes come 'by the hundreds' to join him, while entire Turkish garrisons surrender without a fight. Finally, Akaba itself falls to the Arabs as a result of Lawrence's 'spectacular manœuvre', when he accomplishes 'what the Turks thought was impossible': leading 10,000 Bedouins over the King Solomon Mountains – 'high, jagged, almost impassable, arid mountains' – and down into the town; where 'the Turks and Germans were so paralysed by the feat . . . that they were ready to surrender at once'.[51]

The fall of Akaba marks the close of the penultimate stage in Lawrence's quest and opens the possibility of its successful completion: the invasion of Syria. It also brings the first public recognition of his achievement, from Allenby himself, to whom Lawrence communicates his news personally after an epic camel ride, 'continuously for twenty-two hours at top speed

across the mountains and deserts of the Sinai peninsular', undertaken 'to save his army from starvation'. Allenby promotes Lawrence to a colonelcy and sends him back to Akaba with 'unlimited power and resources' as the right wing of his allied army.[52]

In the final stage of the quest, Thomas has Lawrence planning the invasion of Palestine and Syria with Allenby, effectively doing the work of a lieutenant-general and powerful enough to insist on a starting-date for the campaign to fit the needs of his own force. Lawrence and the Bedouin army 'swept north across the deserts east of the Dead Sea', destroying their final railway bridge at Deraa, before pushing on ahead of Allenby to Damascus itself, where 'they drove the Turks out of the city after a hot hand-to-hand fight in the streets' and liberated the city. Thomas describes how Lawrence governed Damascus 'until he could organize the Arab leaders and turn over the government to them', and then how he and Allenby joined forces again to free Beirut and sweep the Turks from Aleppo (a claim that was entirely withdrawn from Thomas's book).[53]

But the fulfilment of the quest is Lawrence's 'official entry' as victor into Damascus, 'the city which was the ultimate goal of his whole campaign', along streets packed with 'hundreds and hundreds of thousands' of cheering Arabs.

> As Lawrence passed the gates of Damascus the inhabitants of that city, which was once the most glorious city of the East, realized that they had at last been freed from the Turkish yoke. . . . As they saw [the mysterious Englishman] come swinging along on the back of his camel, it seemed as though all the people of Damascus shouted his name in one joyful chorus. For more than ten miles along the streets of the city the crowds gave this Englishman one of the greatest ovations ever given to any man.

Other accounts suggest, more prosaically, that Lawrence drove quietly into the city in a car accompanied only by another British officer, to discover that 'Damascus had been freed, without fighting' on the previous day, as a result of 'an accommodation between departing Turks and resident Arabs'. But Thomas's version – of Lawrence's triumphal entry into Damascus to the acclaim and recognition of the Arabs as their hero and liberator – is the more fitting way to bring an adventure quest to its close.[54]

'Becoming an Arab'

'Becoming an Arab', in Thomas's narrative, is an essential component of Lawrence's transformation into an adventure hero. For if romantic adventure in the colonial peripheries has now become the means to acquire idealized masculine qualities felt to be lacking from the modern world, these very qualities appear to be those that enable the inhabitants of the peripheral

landscape to operate freely within it. Where a Havelock was imagined to be securely in possession of heroic qualities that defined his difference as an Englishman, in the Lawrence legend these are discovered in – or rather projected into – the world of the other, who now possesses that which is desirable and necessary for Western man to become a hero.

Thomas's Arabs are characterized in terms of a traditional, pre-modern chivalric masculinity. Unlike the Turks, they are the inheritors of an ancient civilization.

> 'The pure Arab of the desert belongs to a race which built some of the first civilization', he [Lawrence] said. 'They had a philosophy and a literature when the natives of the British Isles were savages. . . . [They] live as their forefathers lived thousands of years before Christ.'[55]

Devout and patriotic, they take great pride in their ancestry and abide (unlike the 'treacherous Turks') by an 'unwritten law of the desert', placing much emphasis on hospitality. Their Sharifian leaders such as Feisal have great dignity, their ceremonial is 'spendid and barbaric' and their characters are often passionate and colourful. Above all, their fighting capabilities are prodigious and include 'a headlong unreasoning dash and courage' and great powers of endurance.[56] These qualities are linked to a wild, primitive, anarchic masculine energy represented most powerfully by Auda abu Tayi: 'a born brigand', 'the greatest hero of modern Arabian history' and 'the most celebrated desert fighter for four generations'. He is an epic figure who recites epic tales, and claims to have killed seventy-five men in hand-to-hand combat (excluding Turks, whom he classifies in a derogatory fashion as 'women'), to have been wounded twenty-two times and to have married twenty-eight times. Auda's tribe, too, is larger-than-life:

> They cause more trouble, have more enemies and take part in more blood-feuds than any other tribe. They are the most obstinate and unruly and quarrelsome people I've ever met. They seem to have no fear. One small boy . . . will take a rifle and engage in battle against twenty men. No man in the tribe will recognize any other as a sheikh. . . . [They] are unable to unite among themselves even when attacked from outside.[57]

We can see here how the desired qualities of Arab masculinity are also the very qualities that mark Arab inferiority, and ultimately subordination, to Lawrence's Britishness. For Thomas's narrative is involved here in a complex negotiation whereby those Arab qualities coded as positive and felt to be lacking by British masculinity may be desired without, however, threatening imperial superiority. Thomas's constant insistence on the Arabs' boyish enthusiasm, innocence and indiscipline serves this end. He describes their pleasure in the thrills of raiding and winning 'loot'; their 'playfulness' and 'carelessness' on 'train-blowing' expeditions; their coveting of

Lawrence's robes. This combination of qualities – both epic and childish – inevitably renders the Arabs into figures of fun, out of a burlesque: Thomas actually describes Lawrence's devoted personal bodyguard – 'a select band of picked men . . . every one of them a famous fighting man' – as 'a comic opera crew'. The potentially threatening quality of their primitive anarchic energy (they parade around Cairo 'bristling with pistols and daggers, causing much uneasiness wherever they went') can thus be dissipated in affectionate laughter at their pranks.[58]

In a second, linked strategy, 'becoming an Arab' provides Thomas with the opportunity to prove Lawrence's superiority as an Englishman. Thomas imagines that Lawrence 'outdid them from camel riding to speaking their own language'. Apparently, 'only one Bedo among Lawrence's followers . . . could stand the pace when he extended himself to the limit' on camel back. On one journey, the pair are said to have ridden for twenty-two hours per day for three days, covering 300 miles, a distance which normally took twelve days and setting 'a record for camel-riding which will probably stand for many years'. Auda, 'the acme of everything Arabic', recognizes this as 'the secret of Lawrence's success': '"By the Beard of the Prophet", he roared, "this fair-haired son of Allah can do everything that we do even better than we do it ourselves".' Thomas emphasizes the importance of this to Lawrence's leadership of the Bedouin:

> Lawrence won the admiration and undying devotion of the Arabs because of his understanding of them, through his proficiency in their dialects, and his rare knowledge of their religion . . . and even more, perhaps, because of his fearlessness and reckless courage, his ability to outdo them in nearly everything in which they themselves excelled.[59]

'Becoming an Arab' in Thomas's narrative is the means whereby Lawrence's knowledge of Arab customs can materialize as power. Significantly, the meeting of cultures is not reciprocal. Lawrence, the European, can 'go native'; but the natives are not enabled to 'go civilized'.

> Although they frequently asked him questions regarding his own country, he invariably led the conversation back to local Arab affairs. He scrupulously avoided drawing comparisons between European and Arabian ways, and he seemed to have an insatiable desire to learn as much information about the peoples and parts of the country he was in as possible.

The flow of information is all one way, along lines dictated by relations of power, which implicate knowledge in power, and invest power in knowledge. This is evident, too, in another crucial withholding of knowledge practised by Lawrence: his decision 'not to instruct the Arabs in the use of high explosives'.[60]

Lawrence does not, in fact, 'become an Arab', if by that is meant to cease

being an Englishman. He does not renounce his superior Western knowledges, but rather lives according to them. His participation in Arab customs is calculatedly selective and designed to enhance his prestige. He 'never entered into competition with the Bedouins unless he was certain first that he could excel them' and 'he made it a rule never to speak unless he had something special to say' and could speak with knowledge and authority.[61] This personal authority is supported by the materiality of British imperial power: gunboats, explosives, machine guns and 'the unlimited financial support of the British Government'.[62] He was, says Thomas, 'like an actor playing a part':

> The Bedouin never saw him excepting when he was at top notch. He cultivated the character of a man of mystery. He usually dressed in beautiful robes of pure white. In order that his garb should always look spotlessly clean he carried three or four special changes of raiment on an extra camel. He also made it a point to shave every day, although frequently they were dry shaves due to the scarcity of water.

This detail about shaving is important, since attention to civilized toilette in remote and uncivilized parts of the Empire was one of the traditional attributes of the Englishman.[63] One of the most obviously contradictory signs of the 'blond Bedouin' – the absence of a beard – is no accident, but a carefully contrived sign of Britishness, which helps to establish the combination of 'mystery', purity and authority that distinguished him from the Arabs. The image Lawrence assembles for them involves a complex balancing of likeness and difference.

Traditionally, in the post-Mutiny empire, the superiority of white, imperial Britishness was guaranteed by a clear demarcation of difference policed by powerful fears about the moral and psychic effects of 'going native'. By contrast, the structure of phantasy in Thomas's narrative can best be explained as a projective identification.[64] Valued masculine qualities felt to be marginalized, excluded or even lost to Britishness are projected onto the Arabs. The British hero who empathizes with them, takes their side and becomes identified with them functions to repossess imaginatively those qualities. This identification with the other may then in turn be introjected into the Englishman's own identity as a part of himself, which is thus strengthened in imagination through a new combination of qualities. The Arab who is also clearly an Englishman, the 'blond Bedouin', incorporates all the desired qualities of Arab masculinity whilst simultaneously retaining his Britishness, evident in qualities and knowledges that the Arabs are unable to emulate. His reckless courage, his endurance, his ability to move at will in the desert landscape as an Arab, are combined with an Englishman's disciplined application of knowledges, an Englishman's access to finance and the modern technologies of war. Thomas's 'Lawrence of Arabia' is a hero who enjoys the best of both worlds.[65]

Thomas's adventure story, while displaying a fascination with alternative forms of masculine identity, ultimately imagines Lawrence resolving them into a new kind of ideal unity and coherence: an omnipotently powerful masculinity for post-1918 Britain. The figure of the blond Bedouin rejuvenates the soldier hero as an ideal by removing it from the dominant conditions of modern warfare and exposing it to conditions in the colonial periphery where adventure opportunities still abound. This new soldier hero offers an imaginary resolution to contradictions both within modern British masculinity (between the contemplative and the active), and between modern and traditional masculinities (whereby epic qualities can be imaginatively repossessed in a modern form). The very qualities in Lawrence that mark his difference from conventional military masculinity – his youth, his contemplative otherworldliness, his studious intellectuality – are recoded as essentially British virtues through Lawrence's encounter with the Arabs. By integrating these virtues with the epic qualities of the Arabs, Lawrence is equipped with an alternative form of martial valour that combines with his intellectuality to establish his superiority over regular British military manhood. But the blond Bedouin also represents the management in phantasy of the threat to British identity posed by Arab otherness. Integrating those threatening qualities within the soldier hero both divests the colonized and subordinated other of its disturbing power and reaffirms the unproblematic superiority of a strengthened Britishness. Neither the Turks who are triumphantly destroyed, nor the Arabs who become wild and childlike helpers, present any serious threat to Lawrence's superiority, either morally, physically or psychically.

The final twist to this phantasy of the omnipotent Englishman concerns the question of femininity. Given the absence of women in Thomas's Arabia, it is striking that many of Lawrence's own qualities – his boyishness and lack of a beard, his small size, modesty and shyness – have feminine connotations. On several occasions, Thomas explicitly describes Lawrence as feminine: 'He was so shy that when General Storrs or some other officer tried to compliment him on one of his wild expeditions into the desert, he would get red as a schoolgirl and look down at his feet.' At his first meeting with Allenby (the crucial first recognition of the hero), 'the youthful lieutenant' (who had just endured a camel-ride of super-human length and arduousness) is imagined 'look[ing] very much like a Circassian girl in Arab costume'.[66]

These evocations of a feminine Lawrence perform no necessary narrative function but add a further dimension to Thomas's investing of the blond Bedouin as a phantasy of psychic defence. Articulated with the racial phantasy that dissolves the threatening qualities of racial difference to sustain the power of Britishness, we find here the phantasy of a perfect man who is also womanly; a figure that, in dissolving sexual difference, manages the potential threat posed by femininity to a wholly masculine world from

which it has been banished, in order to sustain the power of masculinity. In the narrative of 'becoming an Arab', Lawrence can be imagined as the man with everything.

Popular adventure in modern times

Heroes are made, not by their deeds, but by the stories that are told about them. During his short visit to Arabia, Lowell Thomas grasped that, in Lawrence, he had discovered 'the stuff of which great legends are made'. As Lawrence himself put it, Thomas 'seems to have realized my "star" value on the film'.[67] Although in Thomas's narrative, Lawrence achieves recognition as a hero on his triumphal entry into Damascus, this recognition is actually dependent upon Thomas's own narration of the Lawrence story to British and Western publics in the metropolitan centres, which enjoy the spectacle of British power in the primitive and traditional Orient and find release in it. Although Thomas claims to be simply relaying the truth about Lawrence in his story, in narrating Lawrence's deeds as an adventure romance his story is shot through with specific forms of phantasy and actively imagines Lawrence as a British hero: 'a man who will be blazoned on the romantic pages of history with Sir Walter Raleigh, Sir Francis Drake, Lord Clive, Chinese Gordon, and Kitchener of Khartoum'.[68] His Lawrence is an idealized chivalric knight: the very title of his show and his later book recall Henty and the pre-war adventure tradition in which he situates his hero.

But important differences emerge when the 'Lawrence of Arabia' legend is compared with that tradition as exemplified by Havelock. The apprehension of providential design and the subordination of human will to that of God, deeply constitutive of Havelock the Christian soldier, has been replaced by a combination of blind fate, the naked imperial power of gold and gunships and the active agency of a secular hero whose identity as a Christian is merely nominal. The confident, imperial purposes of the earlier tradition are no longer manifest. Instead the actual imperial interests motivating Lawrence's presence in Arabia remain shrouded in the romantic mystery that Thomas wraps around his hero. The secret and highly manipulative diplomatic negotiations conducted by the British with Arab, French and Zionist leaders – including the notorious Sykes–Picot agreement between the colonial powers, which undermined Lawrence's promises to Hussein and Feisal of an independent Arab state and laid the basis for the post-1918 settlement in the Middle East – have no place in this adventure. Instead, British interest is displaced into an anti-imperialist fantasy of national liberation prompted by quite different impulses and attractive for different reasons, the excitement that was once invested in the operations of the regular British Army in the Empire being displaced onto the guerrilla soldier whose origins are to be found in the anti-imperial wars fought by Latin American, Boer and Irish people's armies.[69]

Consequently, the relation established to the colonial other in Thomas's narrative is strikingly different from that of 'Kipling's White Man' and somewhat subversive of it. While the Lawrence fantasy remains deeply imbued with power and imagines the continuing dominance of Britishness, the fiercely, almost psychotically defensive projections evident in the Havelock story have been replaced by a more complex, interactive projective identification. Where Havelock's heroic identity was secured through the denial of any common ground between the virtuous British and the depraved Indian (with even the loyal Sepoy troops giving cause for suspicion), the Lawrence story is comparable to *Waverley* in its impulse, not *only* to fix the meaning of difference (although it certainly does that), but also to integrate, and draw vitality and strength from, aspects of the subordinated culture.

While I have described Thomas's adventure as a flight from modernity, this in itself implies (as Martin Green has argued) a distinctively 'modern' form of adventure, the product of the modern world system.[70] The attractiveness of the 'primitive' arises at moments when confident belief in the progress and civilization brought about by modernity gives way to doubt and discomposure, which the experience of the natural landscape and traditional modes of subjectivity found in the backward peripheral zones of the system can be felt to dispel. The selective character of these imaginative investments can be clearly identified in Thomas's treatment of domesticity. His Lawrence story conforms to the splitting-off of the domestic themes from adventure that is characteristic of late-Victorian imperialism, effecting that imaginary liberation from the contradictory effects of the separation of spheres which I discussed in Chapter 3.[71] This situating of the domestic sphere as the antithesis of the public world of action is itself a central feature in the development of modern metropolitan cultures; yet we do not find in Thomas any interest in the forms of traditional 'domesticity' lived by the Bedouin, except insofar as this furnishes elements of the 'outdoor life' compatible with adventure. What we do find, again absent from the asexual chivalry of the pre-war tradition, is the suggestion of a troubling but fascinating sexuality and a transgressive fluidity in the imagining of gender, enabled by the encounter of modern with pre-modern.

The latent tensions and disturbances that these shifts introduce into the adventure form are contained by Thomas's narrative, which manages to work them into the pattern of a traditional generic quest and thereby helps to reorient the development of the popular adventure tradition in the twentieth century. The exploits of Lawrence and his fellow Arab Bureau agents were rapidly transformed into fictional adventures: in, for example, F. S. Brereton's *With Allenby in Palestine* (1919), whose hero enters Turkish-held Jerusalem disguised as an Arab; and in John Buchan's Sandy Arbuthnot, hero of *Greenmantle* (1917) and a subsequent series of thrillers, whose character and adventures become increasingly bound up with that of Lawrence and his unconventional military stratagems.[72] Several existing

currents of adventure interest fed into this development: the 'temporary soldier' of colonial fiction; the 'disguise' motif that runs through colonial adventure from *Waverley* through Sir Richard Burton to A. E. W. Mason's *The Four Feathers* (1902); the outdoor life and wartime surveillance responsibilities of Baden-Powell's Scouts and, beyond them, the *veldtkraft* and guerrilla tactics of the Boers.[73] After 1918 – and especially after 1940 – the imaginative resonance of the colonial periphery becomes condensed with that of the occupied territory. The guerrilla, the commando, the Special Operations forces, the secret agents, spies and saboteurs who operate 'behind enemy lines' or in the margins of the conflict: these become the characteristic soldier heroes of twentieth-century adventure. A direct line runs from Lawrence to the Second World War, in which his military thinking influenced the conduct of desert operations and partisan campaigns, themselves the source of many of that war's heroic narratives, which in their turn would become a staple of post-war adventure films and boys' comics such as *The Victor*.[74]

This new breed of soldier heroes – secular, irregular, firmly distanced from the domestic – was fashioned by the containment strategies of adventure into wish-fulfilling masculine figures, not for moral edification, but for pleasurable entertainment. Thomas's Lawrence of Arabia story stands as an exemplar of this modern trajectory. But the containment strategies of adventure that made possible the imagining of this idealized hero proved to be less efficacious at managing disturbances in the lived subjectivity of its originator.

7

THE PUBLIC AND PRIVATE LIVES OF T. E. LAWRENCE

The adventure hero and modernist masculinity

Lawrence of Arabia and the 'real' T. E. Lawrence

In October 1918, his military role in the Arab Revolt at an end, T. E. Lawrence returned from the Arabian desert to London, 'the great city of modernity', to confront the image of himself represented there. Stories of his adventures were already public knowledge in governing and intellectual circles, and from the moment of his return Lawrence found himself to be among the most sought-after men in the metropolis.[1] London was by this time

> the world's biggest city, still expanding with extraordinary rapidity, generating a remarkable cityscape and a fascinating technology [This] made for a sense of excitement and stimulus. London had now become the outright point of concentration for English national culture . . . ; through it and from it came the newspapers, the books and the ideas of the country at large. . . . It was the capital of Empire and the centre of world trade . . . a 'world city' with a world hinterland, an entrepôt for culture, publishing, finance and shipping, a magnet . . . for migration [It] teemed with suggestions of indefinite and sometimes outrageous possibility, of hidden but magnificent meanings.[2]

Expanding national and international publics increasingly looked to London for the lead in new tastes, fashions and fads. This was the metropolitan centre to which, in August 1919, Lowell Thomas brought his multi-media show 'With Allenby in Palestine', and launched the 'Lawrence of Arabia' legend.

The relation between the legend and 'the real T. E. Lawrence' is a remarkably complex issue. From one perspective, the legend can be analysed as the product of Thomas's imaginative investment in the living soldier whom he encountered at work in Arabia and represented as an idealized hero. In his narration of 'the Greatest Romance of Real Life', however, Thomas does not claim that his narrative will *make* Lawrence into a hero,

but that Lawrence is already a hero, whose exploits need only to be recorded. The fantasy works to background or censor out any features that contradict this idealizing investment, thus concealing its own existence as such, so that the romantic hero of Thomas's adventure narrative and the real Lawrence appear to fuse together into a 'living legend'. From another perspective, T. E. Lawrence's own contribution to the legend must be emphasized. His own fascination with the energizing myth of imperial adventure had brought him to the Middle East in the first place, in a series of journeys and sojourns made between 1909 and the outbreak of war. His admiration for the great traveller, Charles Doughty, and the inspiration of Doughty's *Travels in Arabia Deserta* on Lawrence's own journeys and writing, are well documented. Martin Green suggests that 'Lawrence's vision of himself as hero' derived from medieval chivalric romance, and quotes Lawrence's own claims that as a youth, he had harboured 'chivalric' fantasies of leading the great but fallen Arab people in a 'crusade' for freedom. These investments in the otherness of the Arabs were his personal appropriations of a common cultural imaginary shared with Thomas and his audiences.[3]

Lawrence's self-imagining clearly constitutes a significant dimension of the 'reality' which Thomas claims to record. While the adventure story plays free with the historical 'facts' of the Revolt and Lawrence's involvement with it, it nevertheless roots itself in that historical reality and produces a version of it that some later historians have continued to find broadly convincing.[4] Similarly, Thomas might have filmed Lawrence in Arab dress, but he did not ask him to put it on. As well as a form of 'power-dressing' to impress the Arabs, Lawrence's 'cross-dressing' can be located as a component of his homoeroticism in relation to both Arab and European young men.[5] It became an element, that is, in his own public self-representation, which he himself brought to the metropolis on occasions such as the party in January 1919 (on the occasion of the Emir Feisal's visit to London prior to the Paris Peace Conference), attended by Lawrence 'in full Sharifian white'. Taken out of the desert and placed in this context, the wearing of Arab dress becomes a form of 'aestheticism' and 'dandyism' identified by Martin Green as the mark of revolt by the younger generation against the 'seriousness' of their elders; and as Bradbury points out, 'the dandy is an essentially urban figure, a style-maker standing out in the general display'.[6] (See Figure 6.)

If Thomas's hero is produced out of an encounter with Lawrence's own self-imagining as 'Lawrence of Arabia', the latter is itself only one among many other of Lawrence's identifications: a single component in a lived masculinity that is necessarily more complex and multi-faceted, and is fashioned in the spheres of work, the family, friendship and sexuality as well as in the landscape of adventure. The legend is a result of Thomas 'recognizing' aspects of Lawrence in a particular and highly selective way. The storybook hero that he composes from this encounter then becomes a kind

of public mirror to Lawrence's own self-imaginings and necessarily impacts back upon the ways that Lawrence sees himself and the ways he is (and likes to be) recognized by others.[7]

It is unsurprising, then, that 'the real T. E. Lawrence' would appear to have held intensely ambivalent views about Thomas's version of Lawrence of Arabia. This is evident in the contradictory accounts that have emerged about Lawrence's original collaboration with the journalist. Thomas claimed to have enjoyed his full co-operation when they met in Jerusalem and Akaba; that, indeed, 'he arranged for my jaunt to Arabia'. Lawrence, on the other hand, complained that Thomas had made 'a sort of public mountebank' out of him. He publicly distanced himself from the Covent Garden show, refused to endorse its authenticity and insisted on a disclaimer in Thomas's book that he, Lawrence, was not the source of its material.[8] The ambivalence emerges again over the show itself, for Lawrence 'quietly attended the show several times while stating his disdain for it to his friends'.[9] This suggests a secretive private fascination with an image of himself produced for the widest public consumption, coexisting with a public disavowal, a reluctance or antipathy to being recognized publicly in such a form, as such a hero.

These contradictory responses of the real man to the heroic image have given rise to a great deal of research and debate among Lawrence's many biographers. Thomas himself incorporated Lawrence's 'modesty' into the image of a reluctant hero who preferred archaeology to war, emphasizing a charming discrepancy between Lawrence's 'public' and 'private' selves which reinforced the fascination of his 'mysterious' hero. Stephen Tabachnick, while broadly endorsing Thomas's positive view of Lawrence, considers it 'flawed' in parts, and attributes this to Lawrence having fed Thomas falsehoods: 'In many cases Thomas was clearly repeating tall tales and propaganda, sometimes in garbled form, that Lawrence himself had told him in a spirit of mischief and mockery or in order to garner political support for Feisal.' Tabachnick finds no difficulty in distinguishing the 'true' from the 'false', nor does he consider Lawrence to have had any. As these fictions subsequently assume a life of their own, Lawrence 'began to detest and hide from his own partially-created public image'. In sharp contrast, Desmond Stewart sees Lawrence as a champion self-publicist who 'used mysteries' in order to 'creat[e] a myth about himself'. Stewart's Lawrence is himself responsible for constructing the Lawrence of Arabia legend, before disingenuously distancing himself from its most public form. This poses real problems for a biographer concerned with the 'truth' about Lawrence, which Stewart resolves through his psychological interpretation of Lawrence's character as a charlatan.[10]

These interpretations underline the extent to which T. E. Lawrence was caught up in the developing legend in complicated ways. Yet all of them remain overly psychological in approach and fail to take full account of the conditions of cultural production that shape the telling of the narrative and

organize its relation to public audiences. Thomas's 'Lawrence' depended upon the popular technology of slide projection to display his many photographs of Lawrence, upon the crowd-pulling power of the exciting new medium of film and upon a growing sophistication in publicity and mass-marketing techniques. The popular newspapers which seized upon Thomas's image, and continued to pursue T. E. Lawrence in the years after he had withdrawn from public life, were undergoing rapid transformation into mass-circulation dailies whose fierce competition for readers had produced a growth in human-interest stories and sensationalism. The dependence of the Lawrence of Arabia image upon the complex modern media of mass communication necessarily means that Lawrence himself could not possibly be 'in control' of it.[11]

As Richard Dyer has shown, any 'star image' is a complex construction produced by a variety of agencies, from the entertainment industry operating according to an increasingly rationalized division of labour, to reviews and commentators, to fans themselves. The outcome – a fabricated image of a real person – systematically blurs the distinction between itself as image, a product of representation, and the 'private' or authentic self of the person thought to be 'behind' it. The public image of the star feeds off real-life events as off the more clearly fabricated fictions, indiscriminately, and itself becomes 'real' insofar as the public identity of the real person is transformed by it. Any attempt by the star to distance him- or herself from this public image, to deny aspects of it or even to claim privacy, is likewise absorbed into it, locking the star into publicity.[12] A further repercussion of Dyer's argument may be that, in the blurring and 'leaking' between public and private, star image and real person, the real person may lose the ability to distinguish one from the other. Public recognition may lead to identification with the image, so that publicity becomes desirable and stimulating, and the star image an attractive and empowering way of imagining the self. The lack of personal control over these recognitions, however, makes this kind of investment fraught with psychic danger.

After Thomas's show, the Lawrence image was recognized by an invisible mass public for whom he was a figure of fantasy; so that, for example, T. E. Lawrence received hundreds of love letters from women he had never met, addressed to the hero of a film.[13] The already complex self-imagining that had generated the energy sustaining his activities throughout the Arab Revolt was rendered even more complex by the necessity of negotiating this mass-public recognition. To say this is not to fall back upon a clear-cut – and ultimately untenable – distinction between a 'real man' and a 'star image', between clearly demarcated 'facts' and 'fictions', or between 'private awareness' and 'public reputation'. The contradictions experienced by Lawrence – his ambivalence at being a soldier hero – concerned his own imaginative investments in different versions of himself (some of which were magnified

194

as a public spectacle for audiences around the world) and his own desire for particular kinds of recognition.

Dyer suggests that the extraordinary situation of the star magnifies onto a larger public stage what is actually a very ordinary, though disturbing, aspect of everyday life in modern Western cultures: namely, the difficulty of composing a coherent individual identity, given the proliferation of images and versions of the self (and of alternative, possible selves).[14] Seeking 'exemplary lives' for the modern world, we watch the public spectacle of stars negotiating this difficulty and probe into their private lives to find out whether, and how, those images can be fitted together into some kind of coherence; or alternatively, whether and how it is possible to live with their multiplicity and fragmentation. So it is that even the most intimate of exchanges between T. E. Lawrence and his confidants, the stories he told friends in domestic privacy or wrote in personal letters, are now available alongside Harry Chase's original photographs of Lawrence of Arabia, for our scrutiny and judgement.

In a diary entry recording a private conversation with Lawrence made by his friend Richard Meinertzhagen at the time of the Paris Peace Conference, for example, we can read that:

> He told me that ever since childhood he had wanted to be a hero, that he was always rushing into limelight and hiding in utter darkness but the limelight had always won He hates himself and is having a great struggle with his conscience. Shall he run away and hide, confess his sins and become hopelessly discredited – or carry the myth on into the limelight in the hopes of not being exposed He blames Hogarth, Lowell Thomas, Storrs and many others . . . for making him a little War Hero.[15]

What emerges here, and in many other accounts of Lawrence in the diaries, memoirs and letters upon which his biographers have feasted, is a representation of a man not at all 'in control', but driven by a deep-rooted psychological conflict centring on the discrepancy between public identity and its recognition, and a sense of other hidden and unrecognized private selves. The hero, the myth, the limelight, all become simultaneously desirable and feared under a drive that has operated 'since childhood', but must now negotiate an intensified public scrutiny in which Lawrence's very conflict about the legend becomes incorporated into it and ensures its continuing vitality and interest.

The fascination exerted by such insights into the 'private moments' of Lawrence, where he appears 'really' to be a tortured soul, lies in its diametrical contrast to the heroic public image. Where Thomas's Lawrence is the figure of an omnipotently powerful masculinity, the 'real' Lawrence revealed in these private (and therefore presumed authentic) moments is out of control, damaged, a man whose very identity as a man has been thrown

into crisis: the subject of a narrative far more complex and contradictory than any adventure story.

Disturbing adventure: *Seven Pillars of Wisdom*

Lawrence himself was the first of many to attempt that other story. The outcome was *Seven Pillars of Wisdom*, his own self-consciously epic narrative about the Revolt, which he wrote between 1919 and 1922.[16] The contrast with Thomas's heroic adventure could not be greater, and indeed the book establishes a dialogue with the legend, in a kind of settling of accounts. It can be read as Lawrence's attempt to compose a public identity that he could live with more comfortably, and to elicit recognition of himself as a man more complex than Thomas's adventure hero.

Seven Pillars is a vast labyrinth of a book, criss-crossed by Lawrence's journeys to and fro across the desert, back and forth to Cairo, away on raids. Narrative action is interspersed with lengthy passages of reflection upon his spiritual and moral, as well as physical, vicissitudes; upon his Arab companions, their culture and his relationships with them; upon the landscape in all its stark and empty grandeur; and upon the diplomatic, political and military complexities of the Revolt. Adventure themes arise only to be displaced by some further shift in mood and tone. Most importantly, both the moral certainties of Thomas's adventure quest and his hero's triumphal overcoming of obstacles are dissolved into an altogether equivocal and unsettling narrative in which Lawrence 'painfully works to construct the Arab Revolt, yet . . . shows himself falling apart in the process'.[17] This subjective fragmentation – the very antithesis of that complete masculine coherence imagined by Thomas – is shown to result from the profoundly disturbing, and indeed ultimately destructive, quality of Lawrence's lived experiences in Arabia; fraught, as it must necessarily have been, with massive contradictions and dangers, which Thomas's omnipotent fantasy flattened out, ignored or whisked away with a wave of his magic wand.

Several distinct although interconnected sources of disturbance can be identified in *Seven Pillars*. There are disturbances stemming from the contradictory nature of Lawrence's political role as British agent and his guilty awareness of British duplicity in dealing with the Arab leaders, by withholding from them knowledge of the secret Sykes–Picot agreement by which – contrary to promises made by Lawrence to Hussein and Feisal – agreement on the carving-up of the post-war Middle East was reached between Britain and France. Lawrence's guilty sense of having betrayed the Arab cause is made all the more devastating by his own recognition of the right to self-determination of the Arab people.

> The Arab Revolt had begun on false pretences. . . . I could see that if we won the war the promises to the Arabs were dead paper. Had I

been an honourable adviser I would have sent my men home, and not let them risk their lives for such stuff. Yet the Arab inspiration was our main tool in winning the Eastern war. So I assured them that England kept her word in letter and spirit. In this comfort they performed their fine things: but of course, instead of being proud of what we did together, I was continually and bitterly ashamed. . . . In revenge I vowed to make the Arab Revolt the engine of its own success, as well as handmaid to our Egyptian campaign: and vowed to lead it so madly in the final victory that expedience should counsel to the Powers a fair settlement of the Arabs' moral claims. . . . Clearly, I had no shadow of leave to engage the Arabs, unknowing, in a gamble of life and death. Inevitably and justly we should reap bitterness, a sorry fruit of heroic endeavour.[18]

Split loyalties of this kind, and the contradictory pull that they exert, are rendered invisible in Thomas's portrait of the omnipotent blond Bedouin.

This conflict exacerbates Lawrence's already difficult encounter with the otherness of Arab culture: 'The Bedo were an odd people. For an Englishman, sojourning with them was unsatisfactory unless he had patience wide and deep as the sea.' Far from the smooth induction portrayed by Thomas, *Seven Pillars* dwells upon the physical hardships of Bedouin life, especially acute at the first encounter, for one not brought up to it.

The long ride that day had tired my unaccustomed muscles, and the heat of the plain had been painful. My skin was blistered by it, and my eyes ached with the glare of light striking up at a sharp angle from the silver sand, and from the shining pebbles. The last two years I had spent in Cairo, at a desk all day or thinking hard in a little overcrowded office In consequence the novelty of this change was severe, since time had not been given me gradually to accustom myself to the pestilent beating of the Arabian sun, and the long monotony of camel pacing.

Elsewhere, Lawrence writes of 'the beastliness of living among the Arabs' and at one point describes how 'a homesickness overcame me, stressing vividly my outcast life among these Arabs . . . I was dead tired, longing as seldom before for the moody skies of England.'[19]

Lawrence's account charts the energy required to maintain the mental and physical endurance that underlies the achievements performed so effortlessly in Thomas's romance and their human costs. *Seven Pillars* catalogues an endless sequence of physical pain and suffering: 'dysentery and delirium, thirst and starvation, boils and bruises, stings and bites, broken bones and bullet wounds, torture and degradation'.[20] Where Thomas attributes to Lawrence a playful enjoyment in killing, in *Seven Pillars* the excitement of 'train-blowing' is countered by his concern to prevent unnecessary loss of

life. When required to personally execute an Arab murderer to prevent an inter-tribal blood-feud:

> Then up rose the horror which would make civilized man shun justice like a plague if he had not the needy to serve him as a hangman for wages Afterwards the wakeful night dragged over me, till, hours before dawn, I had the men up and made them load, in my longing to be set free of Wadi Kitan. They had to lift me into the saddle.[21]

The responsibilities of command weigh heavily upon him with regard to loss of life. After a fierce engagement with the Turks, who 'astonished' Lawrence by their attack on the Wadi Hesa and the village of Tafileh, he agonizes that, 'by my decision to fight, I had killed twenty or thirty of our . . . men. . . . This evening there was no glory left, but the terror of the broken flesh, which had been our own men, carried past us to their homes.' The adventure ethos and his own 'heroism' is mocked in Lawrence's parody of a regulation military report on this engagement, which he considered a 'verbal triumph, for the destruction of this thousand poor Turks would not affect the issue of the war'.[22]

A different form of subversion occurs when he tells of failure. Where adventure involves a controlled risk of failure – operating as a *frisson* not a threat – here we find an account of Lawrence's failure to accomplish one of the most important missions given him by Allenby: the destruction of the railway bridge at the Yarmuk Gorge, which would 'isolate the Turkish army in Palestine . . . from its base in Damascus, and destroy its power of escaping' when Allenby advanced into Palestine in November 1917. An accidentally dropped rifle alerts the Turkish troops, frightened Arabs dump the explosives into the ravine and the guerrilla force hastily withdraws. The raiders ride home, 'our minds . . . sick with failure', into a 'grey dawn' accompanied by a 'grey drizzle of rain . . . so soft and helpless that it seemed to mock our broken-footed plodding'.[23]

Where Thomas's adventure hero enjoys effortless omnipotence, in Lawrence's own account the heroic persona crucial to his prestige among the Arabs has to be struggled for in the face of these disturbances and is sustained only through a continual assertion of self-control and will-power. This forms the cohesive principle upon which Lawrence's masculine identity is constructed. In one sense, then, the difficulties encountered by Lawrence function as the necessary condition of his self-fashioning, comparable to the obstacles in an adventure quest. The most devastating source of disturbance in *Seven Pillars*, however, is sexuality, which precisely undermines the cohesive principle itself.

Entirely absent from Thomas's romance, as from the nineteenth-century exemplary-life tradition, sexuality is here present from the first page, in Lawrence's description of the masculine brotherhood of the Arab army, where 'our youths began indifferently to slake one another's few needs in

their own clean bodies'.[24] It assumes greatest importance in the famous 'Deraa incident', in which Lawrence narrates his capture on a spying mission whilst disguised as an Arab in the Turkish-controlled town of Deraa, leading to his sexual violation and brutal whipping by Turkish soldiers. The episode is pivotal in the book as a figure for risk gone wrong, envisaging the encounter with otherness in wartime conditions as being not only deeply threatening, but ultimately crippling to both physical and psychic coherence. Riding south after his escape, Lawrence feels

> curiously faint; my muscles seemed at once pappy and inflamed, and all effort frightened me in anticipation. . . . Now I found myself dividing into parts . . . and my parts debated that their struggle might be worthy, but the end foolishness and a rebirth of trouble.

The lasting impact of the incident is his conviction that 'the citadel of my integrity had been irrevocably lost' and himself irreparably ruined.[25]

Jeffrey Meyers has usefully located the Deraa incident in the context of a series of symbolic oppositions running throughout *Seven Pillars*, in which masculinity, endurance and the will are correlated with cleanliness and spiritual purity. This gives rise, on one hand, to Lawrence's idealization of Arab homosexual love, developed in his account of the pure affection of the two young Arabs, Farraj and Daud; while on the other, it produces a misogynistic association of femininity with weakness, corruption and filth, and with the carnality of the body, in a projective disavowal necessary to secure Lawrence's identification with the masculine. By violating his body and pushing it beyond its capacity to endure, the torture and rape at Deraa breaks Lawrence's will, and so throws into crisis the system of values upon which the coherence of his masculinity depends. Furthermore, in the brief description of how, after the flogging stopped, 'a delicious warmth, probably sexual, was swelling through me', Lawrence is forced to confront his own masochistic sexuality, a symptom of 'moral weakness' which operates like 'traitors from within'. Deraa literally 'shattered' him, leaving him exposed to self-persecution and destructive self-punishment from chivalric ideals of purity to which he no longer feels able to aspire.[26]

Since the publication of *Seven Pillars*, a debate has raged about whether or not the Deraa rape actually occurred. Edward Said, for example, has argued that it was a 'necessary fantasy' of Lawrence's in which he expiated personal and political guilt in a wished-for scenario of sexual punishment.[27] But in either case – whether as a response to a real traumatic event or as an entirely imagined scenario – the pivotal position of Deraa within Lawrence's narrative establishes its central significance for the public identity composed and seeking recognition there. An analysis of this significance is suggested by Jessica Benjamin's argument about the pervasiveness of sado-masochistic phantasies of erotic domination in modern Western cultures.[28] She explains sado-masochism in terms of a general splitting of the self – along the

199

polarities of controller and controlled, violator and violated, assertive and yielding – brought about by partially successful efforts towards individuation. In this, the 'masculine' impulse towards differentiation (whereby the boundaries of the self are asserted, establishing its separateness and autonomy from others) is split off from the 'feminine' impulse towards recognition by a significant other (prototypically the mother, in relation to whom the self experiences its own connectedness and dependence on others); either of which may become the dominant element in the psyche. Since differentiation and recognition are interdependent (with the self paradoxically needing to be recognized in its autonomy, and needing to be autonomous in order to recognize the other as different), the denial of either will tend to inhibit the capacity to give and receive recognition and feel connected to an other experienced as independent from the self.

Benjamin suggests that modern masculinities tend to be formed in a denial of the impulse to recognition, establishing gender difference through 'the repudiation of the mother': a 'false differentiation' secured by overly 'rigid and tenacious' boundaries, at the price of a psychically deadening isolation. 'If the sense of boundary is established by physical, bodily separation, then sexual and physical violence (if not in reality, then in fantasy) are experienced as ways of breaking the boundary' and escaping from its 'numbing encasement'. Benjamin sees the masochist as one who is unable to relinquish control voluntarily 'and must or wishes to be forced to do so'. Masochism is 'a desire for subordination to another person, rather than for the experience of pain as such. . . . a search for recognition of the self by another who alone is powerful enough to bestow this recognition'.[29] According to this argument, Lawrence's identification with the position of the violated in his account of the Deraa incident can be read as an impulse towards recognition which requires a breaching of the boundaries established by the masculine self. In the extremity of his self-control, Lawrence's own body, rather than that of another, becomes an object and instrument of his will. The breaking of his will occurs when Lawrence has temporarily abandoned the position of power he occupies as a British officer among Arabs and, in disguise, is subjected to the desire of the Turkish colonizer for a 'white', colonized Circassian Arab. The power relations between British, Turks and Arabs underpin a colonial fantasy in which the positions of violator and violated are now reversed. Once 'broken', however, Lawrence's renewed identification with the position of the master proves impossible.[30]

Where the adventure hero is an ideally unified being with ceaseless energy, the compounding, after Deraa, of the various disturbances narrated in *Seven Pillars* produces an overwhelming sense of Lawrence's personal and political exhaustion. Faced by a further setback promising 'the complete ruining of my plans and hopes', he returns to Allenby's headquarters confessing that 'I had made a mess of things', and asking to be relieved of his responsibilities.

I complained that since landing in Arabia I had had options and requests, never an order: that I was tired to death of free-will, and of many things beside free-will. For a year and a half I had been in motion, riding a thousand miles each month upon camels: with added nervous hours in crazy aeroplanes, or rushing across country in powerful cars. In my last five actions I had been hit, and my body so dreaded further pain that now I had to force myself under fire. Generally I had been hungry: lately always cold: and frost and dirt had poisoned my hurts into a festering mass of sores.

However, these worries would have taken their due petty place, in despite of my body, and of my soiled body in particular, but for the rankling fraudulence which had to be my mind's habit: that pretence to lead the national uprising of another race, the daily posturing in alien dress, preaching in alien speech: with behind it a sense that the 'promises' on which the Arabs worked were worth what their armed strength would be when the moment of fulfilment came. . . . Chargeable against my conceit were the causeless, ineffectual deaths of Hesa. My will had gone and I feared to be alone, lest the winds of circumstance, or power, or lust, blow my empty soul away.[31]

His request being turned down, Lawrence returns to the field to take part in a swirl of renewed activity on Allenby's eastern flank, which leads seven months later to the fall of Damascus.

In this final stage of the narrative, however, moral value and meaning inexorably drain away. This is epitomized by Lawrence's account of the Arab army's discovery of a Turkish massacre of Arab men, women and children at the village of Tafas: 'I said, "The best of you brings me the most Turkish dead", and we turned after the fading enemy, on our way shooting down those who had fallen out by the roadside, and came imploring our pity.' In the attack on the column,

> By my orders we took no prisoners, for the only time in our war. . . .
> In a madness born of the horror of Tafas we killed and killed, even blowing in the heads of the fallen and of the animals; as though their death and running blood could slake our agony.

The Arab army then find 'one of us' left to die with 'bayonets hammered through his shoulder and other leg into the ground, pinning him out like a collected insect'.

> When we said, 'Hassan, who did it?' he drooped his eyes towards the prisoners, huddling together so hopelessly broken. They said nothing in the moments before we opened fire. At last their heap ceased moving; and Hassan was dead; and we mounted again and rode home slowly . . . in the gloom, which felt so chill now that the sun had gone down.[32]

In claiming responsibility for this massacre of Turkish prisoners and making no attempt to conceal or justify its immorality, Lawrence's account of Tafas, more than any other single episode in *Seven Pillars*, undermines both the idealized heroic image of Lawrence of Arabia and the moral nature of his quest. This chill landscape of depressive weariness and loss is the very antithesis of Thomas's romance world, figuring instead a nightmarish dystopia.

Subtitled 'A Triumph', *Seven Pillars*'s ending is decidedly equivocal and can be read as an ironic commentary upon Thomas's legend. Despite the cheering crowds and dancing dervishes, Lawrence's arrival in Damascus is far from heroic: 'the won game of grab left a bad taste in my mouth, spoiling my entry'.[33] Lawrence's loyalties remain ambivalent to the end: one minute hopeful that 'we [*sic*] should be safe, with the Arabs in so strong a place that their hand might hold', the next celebrating the arrival of Allenby, 'fit representative of the Power which had thrown a girdle of humour and strong dealing round the world'. The end comes when Lawrence relinquishes to Allenby the burden of responsibility for public order and essential services in the city, which dominates the final pages.

> In ten minutes all the maddening difficulties had slipped away. Mistily I realized that the harsh days of my solitary battling had passed. The lone hand had won against the world's odds, and I might let my limbs relax in this dreamlike confidence and decision which were Allenby.

Even this, with its lapse into heroic posturing, is contradictory: requesting 'leave to go away. . . . In the end he agreed; and then at once I knew how much I was sorry'.[34]

Composing the self: modernism, public recognition and ambivalence

Under the impact of the various disturbances that undermine the adventure story in *Seven Pillars*, the imagined coherence of Thomas's idealized hero disintegrates into a multiplicity of competing identifications. 'In his self-portrait, Lawrence appears contradictory and unpredictable, a man . . . able to assume many roles precisely because of the multitude of personalities he harboured within. . . . Viewed objectively as a character in *Seven Pillars*, Lawrence *is* his contradictions.'[35] Where Thomas's adventure offers an imaginary flight from modernity into a romance world, the exploration of paradox, ambiguity and contradiction in *Seven Pillars* suggests that it can usefully be located within modernism, as a text charting a response to the uncertainties of modern existence.[36]

Marshall Berman has characterized the modern world as a 'dynamic new landscape' of constantly changing human environments and proliferating moral uncertainties, 'capable of everything except solidity and stability', a

world of 'agitation and turbulence, psychic dizziness and drunkenness, expansion of experiential possibilities and destruction of moral boundaries and personal bonds, self-enlargeenth and self-derangement, phantoms in the street and in the soul'.[37] This description of modernity perfectly captures the atmosphere established in *Seven Pillars* from the very first page:

> Some of the evil of my tale may have been inherent in our circum-stances. For years we lived anyhow with one another in the naked desert, under the indifferent heaven. By day the hot sun fermented us; and we were dizzied by the beating wind. At night we were stained by dew, and shamed into pettiness by the innumerable silences of stars. We were a self-centred army without parade or gesture, devoted to freedom, the second of man's creeds, a purpose so ravenous that it devoured all our strength, a hope so transcendent that our earlier ambitions faded in its glare.
>
> As time went by our need to fight for the ideal increased to an unquestioning possession, riding with spur and rein over our doubts . . . we had surrendered, not body alone, but soul to the overmastering greed of victory. By our own act we were drained of morality, of volition, of responsibility, like dead leaves in the wind.
>
> We lived always in the stretch or sag of nerves, either on the crest or in the trough of waves of feeling. . . . Gusts of cruelty, perversions, lusts ran lightly over the surface without troubling us; for the moral laws that seemed to hedge about these silly accidents must be yet fainter words. We had learned that there were pangs too sharp, griefs too deep, ecstasies too high for our finite selves to register.[38]

Lawrence's staging of the self needs to be seen in juxtaposition to other modernist narratives that attempt to fashion meaningful perspectives and articulate new sensibilities from within the maelstrom. In a world without God, human beings must imagine themselves anew, and in doing so, dis-cover within the psyche the sources of creativity and destructiveness once mapped in terms of providential design. Subordination of the will to God is replaced with the liberating assertion of human will to fill the void. The power to create new worlds, to bring into being human dreams, is matched by its inverse: the power to bring about a nightmare. 'The possibilities are at once glorious and ominous. Our instincts can now run about in all sorts of directions; we ourselves are a kind of chaos.'[39] The coherence and moral integrity of individual human subjectivity imagined in both realist and romantic narratives of the nineteenth century fragments into a variety of modernist subjectivities, imagined as 'a psychic battlefield, or an insoluble puzzle, or the occasion for a flow of perceptions and sensations'.[40]

In this general 'crisis of individuality', the effort towards new forms of subjectivity produces comparable manifestations across the boundaries of national cultures. The move from Lawrence's original fascination with the

ancient civilizations of the Middle East to *Seven Pillars*, for example, bears comparison with the shift in Yeats's poetry from romantic dreaming of the heroic cultures of 'old Ireland', through the endeavour to transform the modern world in their image, to ironic wisdom in the discovery of their dark and hollow antithesis. Similarly, the world of *Seven Pillars* has some striking affinities with German Expressionism: its source in feelings of self-contempt, guilt and unworthiness; its subordination of form to articulate an intense emotional and visionary experience; its powerful release of erotic and violent instincts; its tormented and apocalyptic language; its refusal of resolution and harmony, in the face of intense longing for regeneration and an end to suffering.[41]

The main difference between *Seven Pillars* and these more familiar modernist forms is that its imagining of the divided self is shaped, just as surely as Thomas's romantic hero, in the encounter with the otherness of Arabia and the Arabs. Lawrence's fractured sensibility is located, not within the paradigmatic modern landscape of the metropolitan city, but instead within the once-romantic 'natural' landscape of the desert.[42] This is now transformed through Lawrence's modern mode of inhabiting it, in those ceaseless journeys by camel, aeroplane and car, into a setting fit for a Western quest, now governed by the 'will to power'. 'Self-overcoming and extreme freedom' are its promised rewards, to be accomplished in Nietzschean mode through denial of the body, the search for wisdom through excess, the assumption of a right to take exceptional actions, often extended to powers over life and death. The Western imaginary of the Arabian desert correlates with this landscape of the soul; the harshness of its climate and terrain providing conditions conducive to such a test, the Bedouin being its measure. 'It was precisely with a Nietzschean will that Lawrence created his world, a new Arab empire.'[43] Conversely, it is the disturbing encounter with Arab otherness – precisely Lawrence's '*efforts* to live in the dress of Arabs' – that 'quitted me of my English self, let me look at the West and its conventions with new eyes' and 'destroyed it all for me' (my emphasis).[44] *Seven Pillars* narrates both the assertive movement of modernist masculinity into the colonial periphery, and its unravelling and breakdown there.

When one considers *Seven Pillars* as the search for a form of self-imagining, however, it is important to hold the distinction between the Lawrence engaged in the Arab Revolt in 1916–18 and the Lawrence composing a narrative perspective back in the city in 1919–22. In his post-war writing, Lawrence worked at his memories of the war and sought to compose them into a narrative that he could live with, in which the problematic and contradictory impulses to self-idealization and self-denigration might be transformed into a more integrated sense of self. Stephen Tabachnick has stressed the importance of humour and irony in Lawrence's efforts to establish a 'balance' between elements of the contradictory self-portrait. Humour is used to debunk and question conventional assumptions,

to introduce an element of ironic relief into painful events and to distance himself through self-mockery 'in any situation in which he threatens to become too proud of himself. . . . Time and again in *Seven Pillars*, his humour restores a sense of proportion when he begins to portray himself as a hero.'[45] However, this ironically humorous voice can itself be seen as composing yet another of Lawrence's many 'selves', rather than expressing a new-found authentic coherence.

For if the stake in Lawrence's search for a voice was the construction of an alternative public version of himself to set against Thomas's, as a solution to this lived dilemma of public recognition, the writing of *Seven Pillars* only went half-way. In one sense, the narrative operates as a confessional: a form of public self-revelation of problematic dark truths hidden behind the legend, designed to help assuage the guilt and allay the resulting self-punishment. As such, though, the writing itself becomes caught up with the shame attached to the Deraa incident in particular, producing an intense ambivalence: 'He came perilously close to a nervous breakdown as . . . he could never seem to reveal exactly what had happened but could not conceal it either.'[46] The writing in a sense repeats the loss of integrity that it seems designed to counter, under the impact of that prevailing division between public and private life which was so central to contemporary masculinity: 'The sort of man I have always mixed with doesn't so give himself away.'[47] Lawrence rewrote the narrative twice in its entirety (once, apparently, after losing the manuscript), and it was extensively revised before publication. Its publishing history also tells a story of ambivalence: eight copies printed for friends in 1922, and a lavishly produced limited edition in 1926, made it 'the decade's most talked about and least available book'. A heavily abridged version, *Revolt in the Desert*, appeared in 1927, but the first fully public edition was withheld until after Lawrence's death in 1935.[48] The writing and publishing of *Seven Pillars* registers the conflict within a masculinity seeking public recognition of its own disturbance and contradiction, but in crisis over the public form in which to appear; its strategies for coherence shattered, and torn between the desire and the impossibility of telling the truth about the self.

Read within the wider context of Lawrence's legend and life, *Seven Pillars* exposes a peculiarly modern paradox: that the most appreciative forms of public recognition – in Lawrence's case, public honours offered by the monarch on behalf of the national state, popular fame in the public media as the doer of great deeds, the respect of many leading public figures in various fields – may not meet the pressing need of the self to be recognized in some other form. Where the recognition desired of the other is not forthcoming, but takes some alternative form, with which the self is not able to identify, the recognition on offer may give rise instead to the experience of misrecognition, and contribute to degrees of unease that it simultaneously renders invisible.

Lawrence's own self-identifications were always more multifarious than 'Lawrence of Arabia'. His 'multiplicity', an investing of the self in many different forms, can be suggested in terms of a variety of different practices in which he engaged at different times in his life: archaeologist, classical scholar, traveller, writer, military strategist, ordinary ranker in the army, diplomat, flagellant, music-lover, speedboat engineer, motorbike enthusiast. His social worlds spanned the imperial metropolis and the Arabian desert, the public sociability of the RAF camp and the secluded privacy of his retreat at Clouds Hill. In each of these he sought recognition of an identity from its particular public: from the London literary intelligentsia to Bedouin sheiks, and from the political leaders of Western Europe to British aircraft mechanics.[49] His self-identification as an adventure hero, which provided an energizing myth within one of these worlds, proved impossible to sustain even there; within his other social worlds, the public identity of Lawrence of Arabia brought the burden of misrecognition. Lawrence's circumstances and the range of his public worlds were unique, yet this experience is only an exaggerated and amplified version of the common dilemma of social recognition in modern conditions.

It has been argued by Elie Kedourie that Lawrence's public career as an intelligence agent, soldier and diplomat is 'the only reason for any interest in him'; that his private life attracted attention 'entirely because of his public activities'; and that the various intrusions into his privacy conducted by biographers and investigative journalists over the years have tended to detract from clear evaluation of those activites. Kedourie holds Lawrence himself responsible for this, as 'the first to tincture public affairs with his own private passions':

> [Lawrence] promoted a pernicious confusion between public and private, he looked to politics for a spiritual satisfaction which it cannot possibly provide, and he invested it with an impossibly transcendent significance. In doing so, he pandered to some of the most dangerous elements to be found in the modern Western mentality.

Seven Pillars is a 'corrupt work' inducing in readers inappropriate emotions by means of 'falsehoods'.[50]

Against this, I would argue that 'public affairs' and 'private passions' are not so readily distinguished, since the investment of the latter in the former is precisely what gives *any* politics its subjective purchase and power to mobilize. The value of *Seven Pillars* lies in its exploration of Lawrence's own energizing myth. It sheds light on the investments enabled by adventure and on their cost as forms of psychic splitting; and it bears witness to the phantasies of creation and destruction that underpin human endeavour, for which adventure in war has been one of our culture's most powerful metaphors. In the Havelock legend, depressive phantasies aroused by the hero's death are reinvested by further projective idealization in forms of

public reparation. In Lawrence's case, where public recognition is itself a source of anxiety and no such reparation is to hand, a critique of adventure becomes possible. While Thomas's romance and its Buchanesque fictional counterpart worked to re-energize phantasies of the omnipotent and idealized adventure hero in modern conditions, *Seven Pillars* went public on the psychic scenarios concealed within the adventure landscape, contributing to an alternative trajectory in which these forms of military imagining would be contested and ensuring that paradox and contradiction would become the essence of the Lawrence legend. It is a Faustian text for the modern age, telling of masculine transgression of the ways of 'ordinary men' and its psychic retribution. Rather than pandering to the most dangerous elements of modernity, it contributes to their better understanding.

Seven Pillars can be more pertinently criticized, not for introducing 'private' material where it does not belong, but for its silences about Lawrence's relationship to 'domesticity'. In mirroring the quest structure established by Thomas, *Seven Pillars* reproduces the structural absence of women, and especially Western women, from the world of the legend; thus reproducing, too, the damaging, indeed mysoginistic split in adventurous masculinities inherited from the nineteenth century. Whether we locate this gendered splitting within the individual psyche of Lawrence, or – as I prefer – within the structure of a public form of 'masculine' imagining, it performs a defensive function in relation to contradictions that are prevented from surfacing as such. In Lawrence's case, the notion of adventure as being, quite literally, a 'flight from domesticity' with all its complicated entanglements, is an attractive one. His earliest travels across France and the Middle East as a young man have been linked to emotional conflicts with an authoritarian mother.[51] His own relationships with women remained mostly complicated and difficult throughout his life; and avoidance of this unease shapes his writing, where it is reproduced in public form. If the writing of *Seven Pillars* represented one kind of effort at subjective composure, Lawrence's continuing search for peace assumed other forms in his life thereafter. There is another story to be told here, about his efforts to establish a domestic sanctuary; not in a conventional family household, but in the spartan sociability of his cottage at Clouds Hill, and in the all-male company he sought out in army and airforce barracks, far from the public gaze.[52]

8

PUBLIC PATHOLOGIES

T. E. Lawrence, psychological biography and the cultural politics of imperial decline

Public media, private life

If Havelock was the product of the mid-Victorian expansion of the culture industries, Lawrence of Arabia is unimaginable without twentieth-century developments in the media of mass communications. Where Havelock can be seen as a prototype of the media 'star', in the Lawrence created by Thomas's show we see this phenomenon in one of its earliest fully modern forms. The modernity of the Lawrence heroic image is guaranteed by its association with the most advanced media and supersedes more established images simply by being new and up-to-the-minute. It is first and foremost a visual image, released from the authoritative confines and longevity of print into the spontaneous immediacy of filmic presence. Tantalizingly, it both offers and withholds the essence of its enigmatic subject. This provokes a less deferential mode of engagement by its public: Lawrence of Arabia was not a hero to be set upon a pedestal, but one to be devoured by curiosity or love. Above all, whereas Marshman's Havelock was a carefully cultivated public image with the controversial and contradictory elements of both his public and his private lives edited out, Lawrence of Arabia was the product of twentieth-century mass media which actively seek out the controversial aspects of the private man and expose his 'secret lives' to the public gaze of ever-widening audiences. In this, *Seven Pillars* proved to be an active stimulant.

The equivocal relationship between public image and private man evident in the genesis of Thomas's legend was reproduced in subsequent reports about Lawrence in the popular press. With current affairs downgraded in favour of the human-interest story and mass-appeal entertainment in the circulation wars of the 1920s and 1930s, intrusion into private lives, along with the fabrication of stories and the publishing of unfounded speculation, became commonplace features of popular journalism. The *Daily Express*, for example – the paper that in 1922 'discovered' Lawrence to be serving in the RAF as an anonymous ranker – saw its circulation rise from under half a million in 1910 to nearly two and a half million in 1939. In January 1929,

208

intense press coverage of his alleged (and totally fabricated) spying activities on the Afghanistan border forced Lawrence to leave service with the RAF in India. Audiences of millions in the several thousand cinemas existing throughout Britain were able to see the man himself in newsreel films of his disembarkation on returning home.[1]

These attempts to breathe new life into the Lawrence of Arabia legend in order to make sensational news headlines fuelled continuing public interest in the 'mysterious' Lawrence while he lived, and ensured that revelations about his private life and character would receive maximum publicity after his death. Since the 1920s, the press has eagerly distributed the findings of Lawrence's many biographers to a wider public and continues to do so into the 1990s.[2] It has also commissioned its own investigative journalism, most notoriously in the case of the interviews with John Bruce, a services colleague of Lawrence, published in 1968 by the *Sunday Times*. Bruce revealed that he had administered to Lawrence periodic beatings with birch rods, at Lawrence's request, over the twelve-year period before his death.[3] Since the 1960s, even wider public audiences have been introduced to these proliferating narratives in a number of television documentaries, while the classic David Lean and Robert Bolt feature film, *Lawrence of Arabia*, brought their version of the story to cinema and television audiences worldwide.[4]

Lawrence himself was strongly image-conscious about the myth-making power of the modern popular media: initially being ambivalently fascinated and repelled by the representations of himself that they produced, he later came to dread the unwelcome attention of news reporters. Far from debunking the Lawrence legend, however, *Seven Pillars* contributed a further layer to it, enhancing the very contradictoriness that has made Lawrence such a fascinating figure for over seven decades, and stimulating ever more biographical investigations. This has caused the Lawrence heroic image itself to take a rather different trajectory from that of the guerrilla-soldier adventure tradition bequeathed by Thomas and Buchan. Taken up and further developed through the nexus of biographical probing and mass-media publicity, the modernist anti-hero lurking beneath the surface of the idealized adventurer has itself been incorporated into the Lawrence heroic image. Enigmatic, plural, contradictory, this image continues to resist efforts to resolve any single coherent account of Lawrence's life and personality.[5]

Lawrence's own narrative derives its psychic intensity from its yoking together of extreme opposites. Indeed, it constitutes a locus of virtually all the unconscious phantasies of power and desire through which, according to psychoanalytic thinking, sexual identity is constructed. The story incorporates the ambivalent desires to give and take life, to create and destroy, kill and save, rescue and punish. It deals with hope and betrayal, victory and defeat, prohibition and transgression, reward and punishment. Lawrence fluctuates between an omnipotent, messianic (or Satanic?) sense of personal power, and humiliating, denigrating experiences of absolute powerlessness;

between narcissistic self-love and self-hatred; strength and vulnerability; being the leader and the led; actively doing, yet passively done to; in control and yet controlled; concealing, yet revealing; giving in and holding out; triumphant victor, yet abject failure; courageous yet fearful; pure, yet guilty; aggressor, yet victim. The 'multiplicity' of the Lawrence character in *Seven Pillars* derives from the fluidity with which he oscillates between the subjective positions implied in these contraries, and thence in his relationship to others in the narrative, and indeed to the reader, who finds it impossible to fix Lawrence in any one position.

Faced with this fluid *mélange*, the most common response of biographers since Thomas has been to individualize these fantasies as attributes of Lawrence himself, in psychological investigations of his personality and sexuality. We have already seen this tendency at work in Meyers and Stewart, but it was established by the earliest post-Thomas biographer, Robert Graves (1927). In his influential account, the complex masculine psychology of a 'divided Lawrence' – 'a bare, even fanatical self that could blow up trains and hold to an ideal, and the over-civilized European self' – is rooted in Lawrence's failure to come to terms with sexual difference and the existence of women.[6]

The emergence of this kind of psychological biography, so taken for granted in the later twentieth century, represents the single most decisive shift in biographical writing away from the Victorian exemplary-life tradition, with its emphasis on the flowering of moral character with maturity. It was determined by that more general extension and consolidation of psychology as 'a science of the individual', which Nikolas Rose locates in the period 1875–1925.

> The psychology of the individual had as its object, not the general laws of functioning of the human psyche, but the specific mental capacities and attributes of human individuals. It particularly concerned itself with the variation of these capacities and attributes among individuals and the causes and consequences of such variations.

Psychological knowledge of an individual in his or her difference from others was conceived of in terms of a quantifiable division between the normal and the pathological, generating categories against which identifiable 'dysfunctions' in the realms of thought, belief, intellect, emotion and conduct could be mapped. In the years up to and after the Second World War, it was instituted in a 'complex' of practices within 'schools, clinics, the judicial and penal processes, the factories and the army', as a new technology of social regulation.[7] Its usefulness for biographers inhered in the possibilities it offered for the interpretation of a subject's personality and conduct by means of the identification of pathologies and the reconstruction of their causes within the developmental framework of a life, as in Meyers' analysis of Lawrence's 'sexual pathology', discussed in the previous chapter.[8]

The effect of this tendency to contain and manage the disturbances evoked by *Seven Pillars* through reference back to Lawrence's personal psychology has been to over-individualize the production of the legend, thus robbing it of any wider cultural resonance and meaning. As in Thomas's original narrative, to focus all the limelight onto Lawrence himself is to displace attention away from the biographer's own interest in him. The extent to which these complex and troubling phantasies are activated in the processes of reading, interpreting and investigating the Lawrence life and legend, for biographers, critics and readers themselves, is then concealed. Yet insofar as we are interested at all in Lawrence, we too are implicated in them. The locus of phantasies apparent in *Seven Pillars* constitutes a series of imaginary scenarios into which readers project their own phantasies. This is arguably all the more potent for the very lack of fixity in the Lawrence image, since the reader is thereby denied the security of that kind of stable, fixed identification enabled by Thomas's adventure story. This latter, more consistent identification with a protagonist has been described by Cora Kaplan as operating at a more conscious level of fantasy, whereas in the former case, identification corresponds more closely to the fluid character of unconscious primal phantasies. In these, 'scenarios . . . take precedence over any fixed identification of the subject with any one character in the scene, and indeed such identification may shift in the course of the fantasy scenario'. Kaplan cites, in support of this argument, Freud's analysis of the scenario 'A child is being beaten', where he notes that 'both the sex of the child and the figure of the beater oscillate'. Identification may also oscillate between the beater and the beaten, taking up first one position, then the other, and perhaps even both at once, in an identification with the process itself rather than either of its positions.[9]

This is illuminative of critical reaction and interpretation regarding the Deraa incident in *Seven Pillars*. For it suggests that, far from being neutral, objective and 'normal' witnesses of a bizarre scenario of physical brutality, torture, rape and humiliation, our intellectual assessments are marked by our own imaginative (and unconscious) investments in the scene – and by denial and other forms of defence against them. In Anthony Nutting's interpretation of what happened at Deraa, for example, he imagines Lawrence learning that he was a 'rabid masochist, whose happy endurance of pain disclosed a perversion of the flesh rather than a triumph of the spirit. Thus exposed to himself and mocked by his tormentors he broke down and submitted to their pleasure.' Tabachnick, in evaluating this assertion, remarks that it is 'an extreme and unsupported, though possible, reading of Lawrence's own confession in the Deraa chapter'. Nutting's reading, however, articulates a phantasy activated by Lawrence's far more equivocal description of the scenario, expressing a desire to exercise power over an other, to teach a lesson, to humiliate, to expose the most shameful secrets of the other's nature, to be in the position of mastery. It registers – and invites –

an identification with Lawrence's attackers, by inviting us to dwell upon the spectacle of Lawrence, the '*rabid* masochist' – an object of hate – exposed and displayed for our pleasure and mockery in the reading. Lawrence's own account can also support the converse identification with the exposed and violated one, in a phantasy of oneself being mastered, shamed, humiliated. Both positions in the dialectic of power are present in the scenario. Critical analysis of sado-masochistic phantasy, like that of Jessica Benjamin discussed in the previous chapter, can provide insight into the psychic significance of Deraa for Lawrence himself; but it can equally profitably be turned upon the structures of phantasy animating *Seven Pillars* as a public narrative and the readings made of it; to illuminate, for example, Nutting's homophobic fixing of his own 'normality' in terms of the re-assertion of masculine boundaries.[10]

The Deraa incident and several other episodes in Lawrence's life especially invite the imaginative investments of readers and critics, since they remain, after all the scholarly investigation, 'genuine mysteries' about which no conclusive proof has been found.[11] The lack of decisive, factual information opens the door to speculative interpretation which may deny that the event happened at all, or spin further imaginings around the existing versions. While Edward Said has argued that the Deraa incident was a 'necessary fantasy' of Lawrence's, Desmond Stewart questions the form of the episode but considers it to be a disguised representation of another scenario of torture and rape enacted upon Lawrence by an Arab sheikh whom he loved. Stewart goes to some lengths to establish the plausibility of this second episode, about which no historical record whatsoever exists, and which is based entirely on conjecture and imaginative interpretation.[12]

Often, such biographical speculations publicize or develop stories that are themselves the product of unexplored imaginative investments in Lawrence. Stewart's biography, for example, recycles the popular rumour that Lawrence had been murdered: a rumour that H. Montgomery Hyde would later state could be unequivocally 'dismissed as fantasy'.[13] Tabachnick suggests that 'many people seem to want Lawrence to have died in as interesting and mysterious a manner as he had lived during the Arab Revolt, and they would seize upon any detail to make an interesting death possible'.[14] Another example is the oft-cited entry from Richard Meinertzhagen's diary recounting his first meeting with Lawrence. Whilst working at night in his tent at Gaza, in December 1917,

> in walked an Arab boy dressed in spotless white, white headdress with gold circlet; for the moment I thought the boy was somebody's pleasure-boy but it soon dawned on me that it must be Lawrence whom I knew to be in the camp. I just stared at the very beautiful apparition which I suppose was what was intended. He then said in a

soft voice, 'I am Lawrence, Dalmeny sent me over to see you'. I said, 'Boy or girl?' He smiled and blushed, saying 'Boy'.[15]

What is going on here? What is the significance of Meinertzhagen's question? What happened next? In two separate citations of the passage, by Stewart and James Morris, the absence of any comment about the nature of the man's relationship with Lawrence leaves the reader with nothing but an arresting image of Lawrence's homoerotic seductiveness and his use of Arab dress to play with gender identifications. This represents an explicit sexualizing of Thomas's 'blond Bedouin' theme; but what does the scenario owe to Lawrence's, what to Meinertzhagen's, and what to Stewart's and Morris's imaginings? Similarly, what are we to make of Jeffrey Meyers's statement that 'Lawrence's gift was his extraordinary power to influence and command everyone he ever met, and no-one has been able to analyse or explain this mysterious power'?[16] Here, sexual seductiveness is replaced by the mystique of personal authority, exercised now not simply over Arab rebels, but 'everyone he ever met' – and even beyond that, over people he never met, including Meyers and countless other readers, who have been seduced and fascinated by the 'mysterious power' of Lawrence's complex and multi-faceted star image as presented in the public narratives of his life.

Lawrence has become a locus of the phantasies of others. This is the case as much for those who knew 'the real T. E. Lawrence' personally and wrote about (their versions of) him as for those who 'know' him discursively, through the reading and interpretation of texts. (The two categories of person are not necessarily mutually exclusive.) Readers, critics and biographers have no secure ground outside this charged field of attractions and repulsions. This is not to say that critical assessment need or should be abandoned. It is rather to emphasize how the foundations upon which critical assessment is built represent in themselves a stance within and towards phantasy, a stance writ large in the public media.

Biography, phantasy and post-imperial masculinity

The character of these various imaginative investments in Lawrence has changed with the historical shifts in cultural imaginaries since 1918. We have seen how Thomas's version of Lawrence was produced in the circumstances of the Great War and its aftermath. A rather different kind of idealizing investment in Lawrence's mysterious authority was the product of fascist political imaginings rife in Britain during the 1930s. 'The dangerous desire . . . for an overwhelmingly powerful leader', a 'political saviour', was shared by Basil Liddell Hart, whose 1934 biography of Lawrence immediately ran to many printings.

I am told that the young men are talking, the young poets writing, of him [Lawrence] in a Messianic strain – as the man who could, if he

would, be a light to lead stumbling humanity out of its troubles –
he seems to come nearer than any man to fitness for such power – in a
state that I would care to live in He is the Spirit of Freedom come
incarnate to a world in fetters.[17]

In most of the biographies produced in the 1950s and 1960s, beginning with
Richard Aldington's (1955) and including Nutting's, idealization is replaced
by its psychic opposite, denigration.

In these post-war biographies, the new interest in Lawrence's 'perverse'
psychosexual make-up is utilized in a full-scale debunking of the hero figure,
in which sado-masochism and his alleged homosexuality are linked with
charges of self-glorification and dishonesty. Aldington interprets the key to
Lawrence's personality as 'an abnormal vanity' and its 'identical opposite –
abnormal self-depreciation'; finding the sources of these traits in his early
life, especially his difficult relationship with a strict and domineering
mother, his discovery of the family's guilty secret that his parents were not
married and his own consequent illegitimacy. 'According to Aldington,
Lawrence serves largely as an example of how a neurotic misfit can perform
an arch imposture on his period by devoting all his talents to self-
glorification rather than actual achievement.'[18] Subsequently, writers
attracted or sympathetic to Lawrence have had to take seriously this psycho-
logical critique of the hero and re-interpret it. The psychiatrist, John Mack,
for example, argues that:

> His illegitimacy caused him problems of self-esteem; he created an
> idealized mediaeval self and suffered greatly when he failed to measure
> up to impossible standards. In *Seven Pillars*, he tried to create such an
> ideal self-image but could not sustain it and relapsed into frequent self-
> depreciation, sometimes exaggerating his deeds when his awareness of
> failure was greatest.[19]

The 'impossible standards' and 'ideal self-image' in question, however, are
not wholly peculiar to the individual Lawrence, but are culturally available
forms of masculinity. Lawrence's perceived failure to 'measure up to' and
'sustain' these ideals can be read as a personal failure to assume a desired
masculine identity, of the kind that Thomas imagined him as embodying.
But these shifting assessments of Lawrence's masculinity are also the prod-
uct of changes in the very standards and ideals themselves.

This is apparent even in 1919, in the popular acclaim that greeted
Thomas's 'blond Bedouin' image at its first appearance in the London show.
The sexualizing of the chivalric hero by Lawrence's female admirers –
rendered even more explicit in E. M. Hull's bestseller, *The Sheik* (1921) and
in Valentino's screen version[20] – was one result of the more liberated sexual
climate after the war, which also produced the flapper, Mae West and Marie
Stopes's *Married Love*. After 1918, shifts in women's relation to the public

sphere, evident in political and economic as well as social life, altered (without seriously threatening) their centrality to the domestic imaginary. 'A very real antagonism to the traditional role of Victorian women' in the post-war years necessarily unsettled not only the stable femininity of the angel in the house, but also its chivalric masculine counterpart.[21] At a time of some potential fluidity across traditional gender boundaries, the youth and effeminacy of Thomas's hero readily align him with that cultural formation identified by Martin Green as the *Sonnenkinder* (or 'Children of the Sun'). Emerging after 1918, this 'established a new identity for "England", a new meaning to "being English", based on a strong contrast with the pre-war world'. *Sonnenkinder* characteristics, including sexual transgressiveness and 'dandyism', were part of a revolt against the modes of 'mature seriousness' of the pre-war generation. Green argues that this breakdown of cross-generational identification 'marked a profound change from pre-war England and intensified the extent to which its imaginative life was no longer organized around strong images of responsibility and maturity'.[22]

A more significant impact upon the imagining of powerful British masculinities was brought about by the decline of British imperial power and its far-reaching transformation of the national imaginary. Hastened by the Second World War, this provides the context for the debunking Lawrence biographies of the 1950s. Heralded by the Boer War and well underway by 1918, imperial decline had gained momentum throughout the 1920s and 1930s, spurred in particular by the Irish War of Independence, the rise of Indian nationalism and new relationships with the 'White Dominions'. This 'story of decline' had been arrested temporarily by the establishment of that new empire in the Middle East to which Lawrence – with his conception of 'our first brown dominion' – had contributed.[23] But even there, the discovery of oil in Iraq in 1920 coincided with a full-scale, popular rebellion 'which cost Britain more than she had spent on all her wartime operations in the middle east to put down, and more than 400 soldiers' lives besides'.[24] Although Britain emerged from the 1939–45 war with its empire intact, the dismantling of the Indian Raj in 1947, coupled with its weakened position in a world order now polarized between the American and Soviet superpowers, fundamentally undermined imperial authority. A plethora of national liberation movements began to contest it with increasing confidence and, where they were resisted, with armed force. Riots in the Gold Coast produced a Black government under a British governor in 1950 and the independent state of Ghana by 1957. The Sudan and Malaya also won independence in the 1950s, the latter after a major colonial war (1948–58), a spectacle that was repeated in Kenya (1952–6) and Cyprus (1954–9), to the discomfiture of sections of the British public.[25]

Above all, it was the Suez crisis of 1956 that brought home the realities of Britain's new position. Gamal Abdel Nasser's revolutionary nationalist movement had seized power in Egypt in 1952, and within a few years had

forced Britain to give up its military bases on Egyptian territory, sending anti-imperialist shock-waves through the Arab world and 'effectively ending British suzerainty in the Middle East'. When in 1956 Nasser seized control of the Suez Canal and nationalized the company that ran it, Britain joined with France and Israel to restore control by military invasion, only to withdraw the invasion force under the combined threats of Soviet missiles on London, the US refusal to support the pound, and implacably hostile world opinion.[26] If the Suez débâcle exacerbated a prevalent sense of 'waste, unfairness and helplessness' among pro-imperialists at the demise of imperial power, it also exposed the hollowness of imperialist claims to moral purpose.

> The ethos of Empire, as of war, was acceptable to the British when it was backed by convictions of honour – by the belief, false or mis-guided, that the British were acting rightly, for the good of themselves and the world. Fair play! In most of their wars the British had been so convinced. . . . Now, in Port Said, 1956, there was only pretence – a sham virility, a dubious cause, a nation divided.[27]

Besides generating intense conflict within the British imperial imaginary, Suez is linked in many accounts of the 1950s with a more pervasive cultural crisis of British values and identity. Robert Hewison has described how the work of the younger generation of artists and writers was characterized by 'a criticism of the cultural values that had been passed on to post-war society'; by 'the hostility of the new writers of the 1950s to both aesthetic and social attitudes of the 1930s'; by (as Doris Lessing put it) 'a confusion of standards and the uncertainty of values'. The decline of Empire contributed to this crisis, even among what Alan Sinfield calls 'the dissident middle class intelligentsia [who] were constituted in opposition to the empire-building middle class'.[28]

One of its effects was the calling-in-question of traditional masculine authority and identity. In an often quoted speech from John Osborne's *Look Back in Anger*, Jimmy Porter articulates a particularly masculine malaise:

> I suppose people of our generation aren't able to die for good causes any longer. We had all that done for us, in the Thirties and Forties, when we were still kids. [*In his familiar, semi-serious mood*] There aren't any good, brave causes left. If the big bang does come, and we all get killed, it won't be in aid of the old-fashioned grand design. It'll just be for the Brave New-nothing-very-much-thank-you. About as point-less and inglorious as stepping in front of a bus.[29]

The 'people' referred to here, of course, are men, while the causes should be read as including the imperial mission, as well as the more directly relevant Spanish Civil War and the Second World War (itself complexly bound up with Empire). The crisis of the new generation of men is being registered

here in terms of a widespread decathecting of heroic adventure as a public narrative inviting identification and active participation. The 1950s also saw the end of compulsory conscription – an event that marked a breakdown in the transmission of masculine ideals and standards, even as forms to identify the self against – and the emergence of a range of rebellious masculine styles such as the teddy boy and the beatnik. The 'generation gap', which became such a marked feature of the later 1950s and 1960s, would be lived out in cross-generational misrecognitions between traditionally dominant and newly oppositional forms of masculinity, the stake being the maintainance of a masculine authority that was once rooted in imperial imaginings. 'One cannot imagine Jimmy Porter', wrote Kenneth Tynan in a review of Osborne's play, 'listening with a straight face to speeches about our inalienable right to flog Cypriot schoolboys'.[30]

Lawrence became one of the figures through which the impact of the loss of Empire upon British masculinity could be registered. The debunking, Aldington-type biographies are symptomatic of a more generalized reckoning with the values, standards and ideals of a pre-1939 imperialism which now appeared to have been less secure and powerful than it had once imagined itself to be. Nutting, whose book on Lawrence appeared in 1961, had been a minister at the Foreign Office until his resignation over Suez. Aldington's own re-assessment of Lawrence's heroic reputation struck at the heart of idealized Englishness. Sir Ronald Storrs, with whom Lawrence had first arrived in Arabia in 1916, and who had gone on to become Governor of Cyprus, denounced Aldington in a BBC broadcast for maligning a hero who was 'a touchstone and a standard of reality', and demanded: 'To what purpose has this been done? . . . What can be the gratification in attempting to destroy a famous name – an inspiration to youth all over the free world?'[31]

Here as ever, the Lawrence heroic image proved contradictory. While Storrs was claiming him as an establishment figure, Lawrence himself had always been uncomfortably resistant to any such alignment. In pointing out that 'he differed entirely from the pukka sahib or Blimp-type' in 'not [sharing] their Wog and Gippo attitudes to Arabs', Aldington might have been aligning Lawrence's own ambivalent relationship to traditional authority with the questionings of the new, post-war generation. Instead, he accuses him of 'favouring Arab rather than British interests', a claim that might be compared to the contemporary Cold War association of homosexuality with 'evil' and treachery to the state. For the Arab historian, Suleiman Mousa, on the other hand, Lawrence is 'a cold-blooded imperialist agent who cared nothing for the Arabs and sought only to advance British interests'. In either case, Thomas's fantasy of the powerful British hero leading the subject races to freedom is now regarded with deep suspicion, its imagined integration of interests and identities fragmenting along a realigned and differently charged axis of power.[32]

Storrs was right to question the 'gratification' to be had by those who 'destroy' a public reputation. For any interpretation or claim to knowledge of Lawrence necessarily involves an attempt to fix one's own position, through the relation established to him, towards and within these cultural imaginaries. This is as much the case with Richard Aldington, whose negative treatment of his subject is marked by what Tabachnick has called 'an extraordinary obsessiveness', as with Lowell Thomas, whose idealization is more obviously the product of a wish-fulfilling investment.[33] Indeed, this extreme splitting that is evident in writing about Lawrence, and the projection onto him of diametrically opposed extremes of good and bad qualities – from Thomas's omnipotent and virtuous 'blond Bedouin' to Nutting's 'almost demonic suicidal sado-masochist who uses the Arabs to fulfil his own lust for revenge'[34] – is itself the most compelling evidence of the determining presence of phantasy. The wish to make Lawrence either one thing or the other, to solve the enigma and resolve the contradictions, is at root bound up with a wish to fix one's own identity in relation to forms of imagined masculinity and British colonial power.

If we can read in the history of the Lawrence legend this other history, of imaginative investment in an ideal form of imperial masculinity and its increasing disturbance and breakdown as it enters a post-colonial world, critical understanding requires that we refuse to inhabit either side of these split opposites, but investigate the relation between them. This is the project of the David Lean/Robert Bolt feature film, *Lawrence of Arabia*.

Lean and Bolt's Faustian epic

Since its release in 1962, *Lawrence of Arabia* has been the most popular vehicle for the Lawrence legend.[35] Tabachnick describes it as a 'film biography' offering 'a fairly legitimate and powerful interpretation of Lawrence's own writings', but one marred by the screenplay's 'distortion' of the facts, and suffering from 'the usual cinematic tendency to collapse, select and even invent incidents and characters'.[36] For this reason, the Estate of T. E. Lawrence, copyright holders of *Seven Pillars of Wisdom*, refused permission for the film-makers to use this title. The most useful way to approach the film, however, is not as a corrupt version of someone else's story, but as a unique version in its own right. It incorporates elements drawn from the popular adventure story and modernist psycho-biography, establishing a creative tension between these two alternative trajectories of the Lawrence story. *Seven Pillars* is clearly a primary source, but the film includes material absent from it, as well as offering a filmic interpretation of some of its key episodes. It is informed by a detailed awareness both of Thomas and of subsequent, more critical biographies: Sir Anthony Nutting served as principal adviser to the producer, Sam Spiegel.[37]

Unsurprisingly, it proved to be 'an unusually controversial picture',

provoking a bitter row about its politics and characterization, with Lady Allenby objecting to its alleged slander of her husband, and accusations that screenwriter Robert Bolt's CND sympathies had influenced his portrait of Lawrence.[38] At its first press screening, one critic acclaimed it as British cinema's first 'queer epic', and rhapsodized over its treatment of Lawrence's young admirers, Farraj and Daud, and the relationship with his Arab friend and rival, Sharif Ali.[39] If, as Spiegel declared, 'we did not set out to solve the legend of Lawrence of Arabia, we tried to perpetuate it',[40] the film proved remarkably successful.

Yet it does more than this. Robert Bolt explained his view of the Lawrence enigma in these terms:

> Here was a man, physically insignificant, born a bastard, conscious of special powers. An awkward man, deliberately so. He finds acceptance not among his own but among an alien people, in borrowed robes, and not as one man among others, but as a god-sent Leader. He is alone. He can do what he wants. Is that a privilege or an intolerable burden?[41]

The film's dramatic energy derives from its use of this question as a springboard for an explicit investigation of the Lawrence legend and its contemporary relevance. Lowell Thomas's myth-making and his propagandist intentions are scrutinized through the fictional character Bentley, a reporter for the *Chicago Courier*, who visits Feisal's HQ announcing that 'I'm looking for a hero' and seeking to report 'the more adventurous aspects' of the Arab Revolt so as to persuade America into the war. Later he interviews and photographs Lawrence and accompanies the Arab forces in the field. At the end of the film, Lawrence's photograph appears on the front page of the American newspaper, and Feisal is able to remark, as he opens diplomatic negotiations with the British and French, that the world has been inspired by Lawrence and the spectacle of the Arab success in capturing Damascus. The film's time-scale therefore collapses together two distinct historical moments – the capture of Damascus and the reporting of Lawrence's involvement in the Revolt – to preserve the unity of its dramatic form.

Like Thomas and *Seven Pillars*, its focus is Lawrence's involvement in the Arab Revolt, from the Cairo Map Department to the moment when he leaves Damascus. Despite its often flat and rather obvious stereotyping – most evident in its treatment of the Arabs according to the conventions of popular cinematic storytelling,[42] but also in its contrasts between Arabs and British – the film succeeds in subjecting the process of myth-making to ironic scrutiny (for Feisal's remark is loaded with irony and cynicism) whilst simultaneously retaining something of the wonder and excitement of the Thomas legend. Imaginative investment and critical distance are held together in a powerful, dramatic tension. The subjective dimensions of this dichotomy are explored by the juxtaposition of the adventure hero with its

dark inverse, located as a psychic conflict within Lawrence himself. Established prior to the arrival of the journalist, this conflict is shown to be enhanced but not created by the public myth-making.

In the first part of the film, Lawrence undergoes a Thomas-like transformation in the course of two epic journeys that take him from Cairo to Feisal and on to the capture of Akaba. Initially established as a clumsy, gangling clown, dismissed as worthless by his CO in Cairo, Lawrence celebrates his leave to visit the 'fiery furnace' of Arabia ('it'll be fun!') with a demonstration of a trick in which he tests his endurance of pain by grasping a burning match. In a marvellous fade and mix that transforms a close-up of the flame into a shot of the sunrise over the desert, the film takes Lawrence (and the viewer) into an epic landscape in which he makes himself anew. Here, endurance is not a party trick but a necessity of life, and in accepting and adapting to this, Lawrence discovers a new dignity and courage. At his first encounter with Arab customs on the journey to Feisal, Lawrence articulates his sense of being different, not from the Bedouin (whose food he eats, with humorous difficulty, and whose ways with water and camels he is quick to emulate), but from other Englishmen: the 'fat people', whose way of life prevents them experiencing the wonder of stars in the desert night.

Unlike Thomas's Arabia, Lean's strange and unknown landscape is dangerous. The heat kills. On the journey to Akaba, Lawrence and the Bedouin have to cross overnight a waterless expanse of desert, known as 'the sun's anvil', before sunrise the following day, or perish. The rhythm and arduousness of the long camel-rides are emphasized: the creaking of harnesses in the silence; the painful need to walk the camels over rocky ground; the dangers of 'drifting' into a dazed stupor through the monotony. Lawrence's increasing capacity to endure the desert's hardships and dangers marks his growth in stature. This is dramatized in Bolt's screenplay by the foregrounding of a short episode in *Seven Pillars*, where Lawrence returns alone to find a man lost during the night after dismounting to relieve himself and falling asleep.[43] Lean's direction builds suspense upon the imminent rising of the sun. The dialogue plays free with T. E.'s own account by having him first defy orders to leave the man, Gasim, to his fate, and then reappear to joyful celebration by the Bedouin for having saved his life. Bolt renders this episode a major recognition scene by introducing for the first time the familiar iconography: the Arab leader Sharif Ali rewards Lawrence's courage by burning his shabby British Army clothes and dressing him in white Sharifian robes, as an Arab.[44]

If Lawrence's development in stature is established, as in Thomas, through the story of his 'becoming an Arab', the film deploys religious imagery to establish Lawrence's growing phantasies of omnipotence in explicit contrast to the devotion and faith of his Muslim allies. There are suggestions of divine powers at work in the film world, when the wind sets the tentpoles creaking after Feisal's sad remark to Lawrence that 'we need a

miracle, and no man can provide it'. But Bolt's script plays on the ambiguities about whether this is or is not a providentially ordered world, in making Lawrence claim that *he* will 'work your miracles'. His plan to attack Akaba takes shape after a night alone in the desert, and the association with Moses is strengthened by the iconography of his abstraction under a thorn tree. The implication that Lawrence imagines *himself* as a prophet – a man imbued with divine powers – is held in contradiction with his secular refusal to acknowledge a god and his insistence that success is dependent on human will. Providential and secular conceptions of history as a narrative written by God or by human agency are brought into dialogue in the argument between Lawrence and Sharif Ali over the disappearance of Gasim, which Ali interprets as God's will. In refuting this, Lawrence's triumphal return and garbing in Sharifian robes is weighted with ambiguous religious significance, as the Bedouin salute 'He-for-whom-nothing-is-written' and bestow a quasi-divine status on Lawrence as the saviour (or giver) of life.[45]

Lawrence himself interprets his refusal to accept the limits on human will set by divine law as evidence of his superiority to the Bedouin. But this confidence in will-power also includes a rejection of Bedouin humility and prayer for God's help in the dangerous environment of the desert. When Ali objects to Lawrence's intention to cross Sinai *en route* for Cairo, protesting the difficulty, Lawrence retorts: 'Why not? Moses did it'. The omnipotent, wish-fulfilling hero is shown to be one of Lawrence's own identifications, as he himself comes to believe in the reality of his own fantastic power. But religious imagery is further utilized to show Lawrence's assertion of unlimited human will to be a deeply transgressive act that puts the self at risk. His imaginative investment in heroism undergoes a sudden and dramatic reversal into its opposite – a man taken over by fear and self-hatred – under the impact of psychic disturbances like those explored in *Seven Pillars*. These transform Lawrence into a contemporary Faust figure,[46] and darker elements increasingly obtrude into the narrative.

The turning-point is Lawrence's first identification of himself as a destroyer of life, when called upon to perform the ritual execution of a murderer, required by Arab law to avoid a blood feud. Watching the death-throes in horror, Lawrence is confronted with the implication that omnipotent power over life also involves omnipotent destructive power: an irony intensified by the film's further dramatic licence with *Seven Pillars* in conflating the murderer with Gasim, the man whose life Lawrence had saved. The hero has met his demon; and in the gruelling journey across Sinai accompanied by the two young admirers in his care, Farraj and Daud, the demon returns to haunt him. The first sign that this third journey will take Lawrence to hell comes when he mistakes a desert whirlwind in exhaustion-induced delusion: 'Look! A pillar of fire!' The two boys demur: 'No, Lord, dust!' Lawrence's failure to save Daud from a gruesome death by quicksand is a trauma that plunges him into a haunted abstractedness, parodying his

rapt state of inspiration earlier. Destructive phantasies of omnipotent responsibility here produce a depressive scenario of horror and guilt, in which Lawrence punishes himself by refusing to ride, and instead walks grim-faced and dirty beside Farraj on the sole remaining camel.[47]

Lawrence's ensuing crisis of identity is played out for the first time on his reappearance in Cairo, which completes a three-stage circular journey and brings to a close the first part of the film. If, in Thomas, this return is a moment of recognition for Lawrence as a hero, in *Lawrence of Arabia* it is the occasion of competing and incompatible (mis)recognitions that pull Lawrence apart. Religious transgression of desert law is replaced here by racial transgression of colonial apartheid. Marching up the imposing marble steps into Army HQ with the Arab boy, both clothed in grimy Arab robes, Lawrence is first misrecognized as 'a dirty little Arab' by the guards, who seek to prohibit them from entering this citadel of power; and then encounters the hostile silence of the officers' mess where he takes Faraj for refreshment. The hostility of this reception undercuts any possibility that the other British officers will appreciate his news that 'we've taken Akaba': 'our side' and 'the wogs' being incompatible terms within the discourse of this racist dominant culture.

Dramatic tension in this pivotal scene is strongly reinforced by the iconography of the blond Bedouin. A network of contrasts and equivalences in dress runs throughout the film and organizes in visual terms the shifts in Lawrence's identifications with or against the positions of Arabs and British. On this occasion, the blond Bedouin is not the focus of idealizing attention but of aggressive hostility, and his robes are not shining white but travel-stained and dirty. This is a complex image. Visually, Lawrence is at this moment identified with the Arabs and against the tight-buttoned, spit-and-polish military smartness of the British messroom. Visibly out of place, his return to the mess echoes the earlier scene featuring the awkward clown in scruffy, ill-fitting khaki, and measures the new dignity and moral courage acquired since then. So, too, is the viewer positioned with Lawrence in this challenge to British racism. At the same time, the dirtying of Lawrence's white robes in the Sinai desert marks his psychic descent from god-like inspiration (distinguishing him from 'ordinary' Arabs) to demonic denigration and self-punishment – the icon sullied. These visual connotations of a morally 'fallen' Lawrence complicate identification with him and function as a figure of the confused and divided self who appears before Allenby. The motif is repeated twice more, at the Deraa incident and the Tafas massacre, contributing, in the second part of the film, to the situating of Lawrence as a man torn by psychic conflict and oscillating rapidly between two dichotomous identifications that constitute a deeply and irrevocably split masculinity.

The pattern for the narrative working-out of this conflict is established by Lawrence's first meeting with Allenby. Unlike the benevolent and authori-

tative father-figure of Thomas and *Seven Pillars*, Allenby is imagined here as a manipulative flatterer who plays upon Lawrence's messianic phantasies in order to ensure his return to Arabia and continuing usefulness.[48] Allenby privately considers Lawrence to be a 'poor devil' who is 'riding the whirlwind'. Operating on individual initiative without orders, he is beyond the rule of law which guarantees psychic safety (in a second transgression of the law of the father, which parallels that of Islamic religious teaching). Allenby's positive recognition of Lawrence rekindles a manic excitement ('I'll have Arabia in chaos'), helps him to (temporarily) overcome his trauma, and offers an authoritative (if also temporary) resolution to Lawrence's conflicting identifications in fostering the belief that Arab interests and British interests are at one. Lawrence's own mania is shown to be decisively underpinned and made 'realizable' by the imperial authority of British High Command. The resolution offered by Allenby initiates a sequence of events in which Lawrence repeats the conflictual scenarios in an increasingly destructive spiral. His oscillations between the depressive and the triumphal, the ordinary and the extraordinary, are connected to the unifying or splitting of his identifications with the British and the Arabs.

Restored to his idealized self, clad again all in white and basking in the adulation of the Arabs as well as the popularity of the British, Lawrence is next seen leading an adventurous attack on a Turkish train (without himself taking part in the killing), and later parades on its roof to be photographed by Bentley the journalist. This renewed sense of omnipotent invulnerability ('They can only kill me with a golden bullet') gives way to depressive deflation after he has again had to kill, only to swing back again in response to criticism from Ali: 'Do you think that I'm just anyone?' His capture whilst spying in Deraa is shown to stem directly from Lawrence's courting of dangers in the face of Ali's repeated warnings to stop flaunting himself in the town ('see how they look at you'), protected only by an omnipotent sense of magical invulnerability ('I'm invisible').

In the film's treatment of Lawrence's sexual violation at Deraa, the Turkish commander ironically fails to recognize him as Lawrence, the British officer with a price on his head, but is attracted by his blue eyes and fair skin. In a reversal of colonial phantasy that follows *Seven Pillars*, Lawrence's abandonment of the position of power that is Britishness results in his misrecognition as a Circassian subject of the Ottoman Empire.[49] Exchanging colonial omnipotence for the vulnerability of the colonized, Lawrence is forced by this physical violation to confront his split between will and body, and his own ordinariness. Accepting that 'you have a body like other men', Lawrence's lost belief in being extraordinary is equated here with the further forced recognition of his own racial identity:

LAWRENCE: Look Ali, look. [*Pinching his skin*] That's me. What colour is it? That's me. And there's nothing I can do about it.

ALI: A man can do whatever he wants. You said.

LAWRENCE: He can. But he can't want what he wants. This is the stuff [*pinching his skin again*] which decides what he wants. You lead them. They're your people. And let me go back to mine.

Thrown into the mud by the Turkish officers, this more extreme 'dirtying' than Sinai drives Lawrence back to Allenby: 'I'm going . . . I've come to the end of myself . . . I'm not the Arab Revolt, Ali, I'm not even an Arab.' Phantasies of omnipotence founder on the incommensurability of race, racial forms of recognition and desire for the racial other.

The inescapability of colonial relations, and the necessity of finding *some* place to occupy within them, makes this return to ordinariness yet another unrealizable fantasy. To become British again is to take up a particular position within the system of recognitions that reinforces colonial power relations. At his next appearance back in Cairo, Lawrence has resumed his Army uniform and become again the awkward clown trying desperately to belong, amid talk of 'squash-courts' and 'wogs'. By contrast, Allenby's unscrupulous desire to have Lawrence back in the field at the head of an Arab army, and his ability to bring this about by the deployment of British imperial resources, makes the only alternative fantasy seem the more realizable. For the last time, Lawrence attempts to square the circle by returning to Arabia: 'I'm going to give them Damascus'.

This time, the intensity of his contradictory needs to identify with the Arabs and yet retain a position of power and psychic safety, in the aftermath of Deraa, leaves him no defence when he is confronted by yet another spectacle of death. The Tafas massacre is the decisive episode in *Lawrence of Arabia* because it is here that Lawrence's messianic dream of nobly leading a people to freedom is finally destroyed.[50] Instead of internalizing his horror at death in an experience of psychic conflict and self-punishment, on this occasion Lawrence identifies fully with the exhilaration of violent release as he takes up the Arab call for 'No prisoners' and leads their charge on the Turkish column. The result is an orgy of killing and destruction, the film's most powerful invocation of the horrors of war, both as a literal statement and as a metaphor for the horror of a psyche overcome by phantasies of its own omnipotent destructiveness. In a direct parallel with Deraa, Lawrence is discovered after the attack in a state of shocked withdrawal by Ali (who has again tried to prevent it). This time his robes are stained bright red. When Bentley arrives to witness the massacre, he discovers, like Conrad's Marlow, a hidden 'heart of darkness' made visible for the first time. Like Kurtz, Lawrence has assumed the most feared shape of his imagined other. When

Ali confronts Lawrence with his own earlier definition of the Arabs as 'cruel and barbarous', the two rivals appear to have changed places. Lawrence, he tells Bentley, is a 'rotten man'. 'Why don't you take his photo now?'

The Tafas massacre marks the end of the quest in *Lawrence of Arabia*, even though the narrative follows *Seven Pillars* in taking the Arabs into Damascus and explores Lawrence's attempts to place control of the city under the authority of the Arab Council. These efforts fail due to the Arabs' lack of 'modern' experience and know-how. Allenby waits patiently until chaos breaks out, and then steps in to restore order. Unlike *Seven Pillars* – where the depressive image of Lawrence leaving Damascus in exhausted sadness, a man 'so stained in estimation that afterward nothing in the world would make him feel clean', is to some extent held in check by the image of a benevolent Allenby assuming control and setting Lawrence free from his burden – in *Lawrence of Arabia* there is no such countervailing image.[51] Allenby is presented in a wholly cynical light as the chief representative of a *realpolitik* that is shown to have defeated Lawrence, destroying him and his dream. Lawrence is driven away from Damascus in a car past Arabs on camel-back who no longer recognize him, to whom he can no longer speak, with whom he will never again ride. 'Well Sir, going home?', asks the driver (the film's final words); but 'home' no longer exists for Lawrence. The film ends fascinated with failure, evoking an intense yearning for what is being left behind.

A lament for imperial adventure

The powerful elegiac quality of this ending can be explained in terms of the film's contradictory positioning of the viewer in relation to the romance of Lawrence's adventure. The film certainly subjects this narrative to critique, in terms of the messianic excess of Lawrence's motivating fantasy. It also highlights the paradox in Lawrence's own investments in the Arabs, between fascination with the otherness of the 'traditional' and authentic Arab way of life, and frustration at their lack of modern qualities and understanding. His third epic camel ride across the Sinai desert to Cairo, for example, is in one sense made necessary and in another enabled by the destruction of the telephone by Arab looters. The film suggests that Lawrence needs the Arabs to remain 'traditional' in order to sustain his own investments in them and to guarantee his own epic opportunities, even though the outcome of his political ambitions – 'Arabia for the Arabs now' – depends on Arab ability to create a free and independent modern state. Modernization is precisely what the Arab leaders themselves are shown to desire; and in Bolt's screenplay, Feisal explicitly identifies the projective investment of the Englishman in his country when he accuses Lawrence of being 'a Gordon of Khartoum', exposing the acquisitive romanticism of Western Orientalist fantasies and their risk to the romantic imaginer.[52] These scenes introduce moments of

possible self-consciousness for Western audiences about their own invest-ments in this filmic Arabia.

On the other hand, the viewer is also invited in the earlier sequences to make powerful, unconscious imaginative investments in Lawrence, in 'Arabia' and in the film as such. The chief vehicle for this is the cinemato-graphy of the desert. This is breathtakingly beautiful. Shot on 70-mm. film that provides added depth of focus and sharpness of detail for the wider screen of cinemascope, it captures the vastness of space, the richness of colour, the subtlety and clarity of light that gives way to a mesmeric shimmering of heat haze.[53] From the first sunrise shot, the camera dwells lovingly and at length on these visual properties of a landscape wherein human beings are reduced to the tiniest of dots moving beneath the massive grandeur of towering rock formations and the perfect curves of the big dunes. Time seems to stand still as landscape shots are held beyond their conventional length: most memorably on the first appearance of Sharif Ali, who emerges on camel-back from a dark pinprick on the horizon to fill the centre of the frame in the course of a single static shot lasting three and a half minutes. This cinematography constructs 'the Arabian desert' of the film (actually shot in Jordan and Morocco) as a visual feast, a veritable landscape of the imagination. This visual dimension, supported by Jarré's score, intensifies the emotional pitch of the film to epic heights, implicitly endorsing Lawrence's sense of growth into new and superior modes of being. These are the primary means by which the film organizes the viewer's investment in the Lawrence legend and they are never fully displaced or undermined by the narrative's subsequent dramatization of conflict, nor by its ironic scrutiny of the very myth-making process that makes such investments possible in the first place (and with which the film is, in its early stages, complicit). They remain residual but active, and determine the intense sadness and sense of loss with which the film ends.

This loss was registered in 1962, at a precise moment of reckoning with the emerging features of a post-colonial world. A film like *Lawrence of Arabia* could not be newly made today, and its re-issue in 1988 was a profoundly nostalgic moment, for a world in which it was still possible to feel sad about the failure of the imperial mission. The re-issue was a great success, with 1980s film reviewers generally waxing lyrical about its aesthetic qualities: in particular, the 'visual perfection' of the cinematography, the 'perfectly phrased and witty' screenplay and Peter O'Toole's 6-foot Lawrence, 'one of the indelible film images of the post-war period'.[54] Yet their political evaluations reproduced the ambiguities (and ignorances) that have been evident throughout the story of the Lawrence legend. One review, noting that '*Lawrence* has sometimes been condemned as a piece of jingoism', reflected that 'it is hard to imagine many Western films treating an Islamic War of Independence [which the Arab Revolt decidedly was not] with quite such sympathy today, and the British characters are on the whole treated far more sardonically than the Arabs'. An American critic, on the

other hand, suggested that '*Lawrence* offers the kick of empire – it is a profoundly conservative movie that will doubtless be upvalued in the current cultural climate'.[55] These contradictions, and the uncertainties that underpin them, are well summed up by a review in *The Guardian*: '*Lawrence of Arabia* was always one of the cinema's greatest adventure films. Now, with these scenes and bits of scenes restored, it emerges as one of the greatest and most disillusioned studies of British colonialism ever made.'[56] Since the adventure tradition has worked precisely to energize British colonialism, this assessment is a contradiction in terms: the film's adventure narrative is qualified and then undermined by the colonial disillusionment, which is in turn limited in impact by the adventure. As a definition of the narrative's ambivalence, however, it is perfect.

For *Lawrence of Arabia* is ultimately a lament for the lost romance of Empire, overturned by a wholly modern power-politics represented by both Feisal and Allenby, who are shown to have cynically manipulated Lawrence for their own ends throughout. Lawrence, it appears, was never 'in control', and his failure was always inevitable. But the film narrative endorses Lawrence in this moment of failure through the exhilaration with which it tells of his attempt to make a new world. What is most memorable about *Lawrence of Arabia* is the epic uplift and expansiveness in its treatment of Lawrence's first journeys in the desert and his heroic mastery of this environment. The film suggests that the forces that destroy Lawrence as a romantic adventure hero destroy, too, the very possibility of such a hero as an energizing myth. In its ending, it laments the loss of Empire as a possible location where adventure romance could continue to be imagined. It laments the loss of the romantic periphery itself, with its 'traditional' way of life, under the pressure to modernize and to contest imperial power not with swords and camels, but with artillery, aeroplanes and engineers. And it laments the relinquishing of the imperial adventure hero as a particular form of masculine transcendence and imagined release from the pressures of difference, psychic conflict and contradiction.

*

If the Lawrence of Arabia legend began as a popular adventure story, the simplicity of that narrative form was complicated in subsequent retellings by modernist fragmentation, and a dark antithesis to its idealized hero was exposed and explained by psychological interpretation. Yet the legend retains a popular resonance today. In its exploration of the tension between popular adventure and high modernist seriousness, the Lean/Bolt epic incorporated elements of both into its own distinctive narrative form, and gave renewed life to the unresolved and enigmatic star image of Lawrence, which remained straddled across this cultural divide. In challenging the heroic image, modernist seriousness has in effect complicated that image without destroying it, thus rendering it more interesting and prolonging its life by a

proliferation of new aspects. In this, the legend is like a palimpsest in which the original script has not been fully erased, but remains visible beneath each new rewriting. The original adventure hero of the epic camel-rides, astonishing audacity and exotic otherness continues to exercise an energizing attraction that injects excitement into the complex and dark dealings of the later versions. In the field of tension between these two poles, the Lawrence image continues to resonate.

As a popular adventure hero, this twentieth-century legend embodies a number of important differences from his Victorian predecessors. In the shift from the religious to the secular and psychological categories within which the character of the hero has been articulated; in the contradictions introduced into the British imperial imaginary by the impact of anti-colonial liberation movements and by the undermining of traditional imperialist forms of authority and moral certainty in a modern, post-colonial world; and in the new, more dynamic modes of inter-relation between the 'public' and 'private' lives of the hero brought about by developments in the modern media of mass communication, whereby the private, far from being rendered publicly invisible, is itself magnified into a public spectacle: in all these respects, Lawrence of Arabia is modern in the way that Havelock is not.

The intersection of these various dimensions of change produced a radically new emphasis on the individual self of the hero. Whereas nineteenth-century adventure was governed by the fixed reference point of duty, an absolute value with an objective guarantee outside the hero's own subjectivity, in the twentieth century, adventure becomes invested with the quality of freedom, and the capacity to generate excitement and find fulfilment lodges within the hero alone. Various different fantasies of freedom are activated by the Lawrence legend: the winning of freedom on behalf of an oppressed other; the freedom from the dehumanizing structures of modern life; the freedom to do as you like; freedom from the body or indeed from the ordinary, everyday self; freedom from the domestic world and from femininity. What all these share in common is their dependence on Lawrence's self-willed masculine agency to give them existence. Lawrence is imagined to have 'made himself' in a sense that was quite unthinkable with regard to Havelock, Roberts or Gordon. The twentieth-century hero's dark antithesis provides a reminder of the dangers inherent in such freedom, nowhere more apparent than in the Bruce revelations of Lawrence's desire for flagellation: the very image of a man imprisoned by his own obsessions.

Since the (almost) final withdrawal from Empire initiated by the Labour governments of the 1960s, the Lawrence story has become to some extent detached from wider colonial resonances, as adventure itself has vacated colonial imaginaries fast becoming archaic and residual. The old narratives continued to circulate in those school textbooks, and new film treatments of Gordon and the last stand at Rorke's Drift continued to be possible in the 1960s.[57] Under the influence of popular television and film produced in

the United States, however, adventure excitement had already begun to move elsewhere in the 1950s – to the safely mythical frontier of the American Wild West and to the adventure landscapes of the Second World War. These were the settings in which post-war generations, including my own, were most likely to encounter their soldier heroes; and I shall return to them in Part IV of this book. While much Second World War adventure was indeed located within colonial imaginative geography, its specific psychic charge was displaced into the universal struggle for Good against Evil in the war against Nazism and Fascism. With the desert and the jungle recoded as imaginative equivalents to the fiord, the Alpine castle or the German-occupied countryside of France or Italy – all settings for commando or spying operations whose mode was directly inspired by Lawrence, among others – colonial adventure found itself subsumed into this larger field of heroic, national memory, which continued to resonate at the heart of the post-imperial British national imaginary well into the 1980s.[58]

In this guise, Lawrentian colonial adventure has continued to be popular. For example, in 1983 – several years before the Lawrence anniversary revival – John Harris's popular thriller, *Harkaway's Sixth Column*, reworked a number of Lawrence motifs in an adventure set in British Somaliland after its invasion by Axis forces in the summer of 1940.

> Cut off behind enemy lines – their radio dead, their chances of escape few – they decide to . . . fight a daring rearguard action. Led by the mysterious Corporal Harkaway, and aided by local warring tribes, they create an extraordinary fighting unit whose skill and ferocity will play havoc with the enemy.[59]

Like Thomas's Lawrence, its hero is a subaltern whose leadership qualities emerge once he is freed from regular army control, generating a recognition narrative that revels in extravagant romantic escapades. Like Thomas, Harris locates his tale in the historical realities of a precise time and place, supported by maps, and assurances to the reader that, 'odd as many of the events in the story might seem, many of them actually happened'.[60] Like that of the blond Bedouin, Harkaway's irregular campaign is redolent with triumph rather than horror, and delights in projective denigration of the barbaric Somalis (echoes of the 'Mad Mullah' here) and 'the I-ties' alike.[61] Unlike Thomas's, this 1980s version plays with heterosexual, masculine fantasies (an alternative scenario proposed by Harkaway's colleagues imagines their living in luxury with 'a few birds' for the duration) and features a love interest for the hero. It also imaginatively aligns Harkaway's column with Churchill's support for anti-communist Special Operations.[62]

The Lawrence heroic image itself has also retained a contemporary imperialist charge. Since the Lean/Bolt film was made, Western audiences have watched on their television screens the working-out of the mischief sown by British and French imperialists in the Middle East by their settlement after

1918. The Six Day War and Israeli annexation of the Occupied Territories, the emergence of the Palestinian Liberation Organization, the invasion of Lebanon and the shattering of Beirut, the Palestinian Intifada, the Iraqi invasion of Kuwait, the war to force Iraqi withdrawal and the brutal Baathist reprisals against Shi-ite and Kurdish rebellions: all these events ultimately stem from the imperialist carve-up of the southern Ottoman Empire and consequent efforts to retain Western hegemony in the region. The reappearance of Lawrence as a political reference-point, at public meetings and in television histories during the Gulf War of 1991, suggests that his story retains its centrality within the British imaginary of Arabia and the Middle East.[63] To this day, it remains among the most likely sources of popular knowledge about the region and its people, thus helping to reproduce Anglocentric assumptions and perspectives, and to transmit into the present the imagined relations of power from a bygone colonial era that are inscribed in them.

As Edward Said has shown, Western neo-colonialist control of its Middle Eastern client states generates versions of the Arab world every bit as self-serving as in the heyday of colonialism.[64] Forms of identification and recognition are also at stake in current conflicts, and at heightened moments of tension and anxiety the traditional defensive repertoire derived from colonial imaginaries remains available for reactivation. This continuing potential of the Lawrence story, to organize British imaginings of who 'we' are and how we are related to others, is an exemplary lesson that it is not simply the historical form of adventure that matters, but the active psychic investments made in it which bring it alive and to which it gives a cultural form. If, by contrast to the turmoil of the contemporary Middle East, the Lawrence story as told in the Lean/Bolt film bears the hallmark of nostalgia for simpler, more innocent days, it is important to insist that the British imperial adventure in the Middle East was, from its inception, a far from innocent story. Nor, as Lawrence himself knew only too well, was the masculine adventure hero at its centre entirely free of guilt.

Part IV

Soldier heroes and the imagining of boyhood masculinity

The patient, who was a naval officer, dreamt of a pyramid. At the bottom of this pyramid there was a crowd of rough sailors, bearing a heavy gold book on their heads. On this book stood a naval officer of the same rank as himself, and on his shoulders an admiral. The admiral, he said, seemed in his own way, to exercise as great a pressure from above and to be as awe-inspiring as the crowd of sailors who formed the base of the pyramid and pressed up from below. Having told this dream, he said: 'This is myself, this is my world. The gold book represents a golden mean, a road on which I try to keep. I am squashed between the pressure of my instincts and what I want to do, and the prohibitions coming to me from my conscience.' Later associations enabled him to identify the admiral with his father. But this admiral, his father, was very changed from the real father as he remembered him. The fact that this admiral was just as strong and frightening as the sailors, representing the patient's instincts, made it clear that the severity of the super-ego was due here to the projection of his own aggressive instincts into his father. We can see here the interrelationship between phantasy and external reality, the reality of the father's personality being altered by projection. His main defence mechanism, repression, is represented in phantasy by the combined pressure of the admiral super-ego, and the naval-officer ego, trying to keep the instincts under. His personality-structure is also clearly represented by the three layers, the instincts pushing upwards, the super-ego pressing down from above, and his feeling of his ego being squashed and restricted between the two. In this dream we can also clearly see the operation of projection and introjection: he projects his aggression into his father, and the introjection of his father forms his super-ego. All this . . . was presented by the patient himself in his dream. And when he said, 'This is me – this is my world', he made it clear that he was describing phantasies that he had about himself and his internal world.

Hanna Segal, *Introduction to the Work of Melanie Klein* (1973)[1]

Another type of modern throws himself into parodies of the past: he 'needs history because it is the storage-closet where all the costumes are kept. He notices that none really fit him' – not primitive, not classical, not mediaeval, not Oriental – 'so he keeps trying on more and more', unable to accept the fact that a modern man 'can never really look well-dressed', because no social role in modern times can ever be a perfect fit.

Friedrich Nietzsche, summarized in Marshall Berman,
All That Is Solid Melts Into Air: the Experience of Modernity (1983)[2]

9

PLAYING AT SOLDIERS
Boyhood phantasies and
the pleasure-culture of war

Introduction: boyhood play and the pleasure-culture of war

The legends of Havelock and Lawrence exemplify the imagining of the
soldier as public hero under modern cultural conditions. Projective invest-
ments organized by historically specific cultural imaginaries assume public
form in adventure narratives produced and circulated by the media of mass
communication. Psychic and social determinants intersect in the composing
and contesting of the soldier hero as an idealized figure of identification for
vast public audiences. By examination of these processes, it is possible
to analyse the historical imagining of particular forms of masculinity, to
account for their popularity and to trace their persistence and transform-
ation within changing social circumstances. But the precise mode of identifi-
cation with the adventure hero – its take-up and use by boys and men as a
lived form enabling particular kinds of subjective composure and relations to
others – cannot be ascertained by studying these public forms alone. A
different kind of analysis is necessary to account for what these forms 'feel
like' from the inside, as 'private' imaginings, to those who invest in and
inhabit them.

Other conditions deriving from the sphere of cultural consumption and
use bear upon these processes: conditions which have their own history, and
make possible different kinds of investment in the 'same' heroic figure.
Although the Havelock legend remained in public circulation until the
1960s, its 'use-value' at that time necessarily differed from that of the 1860s
or 1900s, due to historical shifts in cultural imaginaries and the modes of
social recognition enabled by them. Seen from the perspective of consump-
tion, cultural products that might appear to be generally available at any
historical moment turn out to have a highly uneven distribution. Variable
mediations determine the very possibility and means of encountering the
Havelock narrative in the course of an ordinary life in particular circum-
stances, as well as the significances it acquires and the recognitions it enables
within this context. Identification is never simply a matter of projective
investment in a public form, but involves a moment of introjection, when

the adventure hero as cultural form is drawn into the internal world of phantasy to operate there as an imago: a figure in the subjective drama where psychic integration and gender identity are struggled for against anxiety and the effects of psychic defence. As we have seen in the case of T. E. Lawrence, whose own investments in the idealized chivalric hero appear to have operated as a psychic defence against sexual difference, the adventure hero is never the only available identification: it does not exist in an imaginative vacuum, but in complicated and conflictual relations with the other components of any lived masculinity. These specific psychic determinations upon introjective identification are crucial to understanding the ways in which collective identities – masculine, ethnic, national – acquire their subjective purchase by becoming parts of the self.

In this final part of the book, I turn away from the public forms of the adventure hero as such, to focus more directly on questions of their introjection, consumption and use. To supply these further conditions is to specify the full circuit of exchanges – between psychic and social domains, and between the spheres of production and of consumption – that bring into being historical forms of imagining and determine their effects. Returning to the perspectives outlined in Part I concerning the articulation of inner and outer worlds, in Part IV I aim to render these arguments more concrete by examining one social instance in the context of its specific determining conditions, developing it as a case study, like those of Havelock and Lawrence, to illuminate the more general processes.[1]

There are a number of possible focuses for such a study. One would be the role of adventure as an energizing myth in the experience of 'going for a soldier'. The imaginative investments of a Lawrence, or a Havelock (who took his own inspiration from military histories of the Roman Empire), are matched by the many invisible lives of men who have looked to soldiering for adventure.[2] In terms of phantasy, the omnipotent invulnerability and denigration of the enemy enabled by triumphalist adventure doubtless provides a degree of psychic defence and composure in the face of the tensions and terrors of combat; while the charge of excitement generated by such phantasy is in a sense legitimated in certain circumstances of combat where the capacity for psychic release and discharge through aggression is encouraged.[3]

Rather than pursue this line of enquiry, however, my focus will be on a radically different paradigm: those imaginings of soldier heroes and their adventures found within boyhood cultures. In the fascination that stories about fighting men beyond the frontier hold for boys far removed from those particular dangers, we find a clear example of the metaphorical use of narrative forms to organize imagined subjectivities. This interests me precisely because of its distance, both physical, temporal and imaginative, from the site of real wars: a distance that, as Cawelti has argued, constitutes a condition of the pleasure to be found in these adventure fantasies and

distinguishes them from energizing myth in Green's sense. The heroic imaginings of British boys have been made possible by the historical circumstance that – with the exception of air and sea raids in the two world wars, and the periodic guerrilla campaigns waged by Irish Republicans – Britain's wars have always been fought in other people's countries.[4]

Boyhood interest in adventure cannot be divorced from the wider history of public imaginings which I have traced in Parts II and III, or considered independently of the wider conflicts that have raged within and about the repertoire of, in particular, the military and national imaginaries. Various adult investments in, and critiques of, children's culture are evident throughout this history. Adventure has been a key form in boyhood culture since the first targeting of children as a distinct market-sector from the 1870s, when it was coded as a gendered form contributing to that general splitting in cultural imaginaries explored in Chapter 5.[5] In the huge commercial expansion of the 1880s and 1890s, a mass market emerged not only in adventure literature but also in toys and the paraphernalia of war play. In 1893 Britains Ltd became the first company to mass-produce toy soldiers using hollow casting in lead alloy. They were modelled on British Army regiments and 'soon began to branch out following contemporary events: the South Australian Lancers at Queen Victoria's Jubilee, the 21st Lancers "Heroes of Omdurman", the Boer War'.[6] By 1905, Britains was producing over one hundred different figures and casting five million of them each year, and toy soldiers had replaced the train set as 'the most popular masculine nursery game'.[7] As this reference to the nursery suggests, the market at this time would have been dominated by the middle and upper classes, especially for the more elaborate props such as dressing-up costumes or wooden forts (which feature in many accounts of late-Victorian and Edwardian childhoods, like those of Winston Churchill and of Lawrence's friend, Richard Meinertzhagen).[8] (See Figure 7)

The imperialist imaginings that accompanied play are suggested by H. G. Wells, who describes in his book on *Floor Games* (1911) one called 'The Game of Wonderful Islands': 'We land and alter things and build and arrange and hoist paper flags on pins, and subjugate populations, and confer all the blessings of civilization upon these lands.'[9] Boys' play, in the era of popular imperialism, was one of the wide range of cultural practices that provided an entry into the colonial imaginaries. As such, commercially produced children's culture participated in that wider cultural project which overtly set out to inculcate in boys the desirable subjectivities of imperialist patriotism and moral manhood. In contemporary pacifist and anti-imperialist critiques, disapproval of adventure stemmed from a recognition of its energizing potential and from a belief that the interest and excitement that it generated was helping to foster the militaristic spirit without which wars fought for national or imperialist motives would not receive popular support. In early 1914, for example, the National Peace Council was arguing

that 'there are grave objections to presenting our boys with regiments of fighting men, batteries of guns and squadrons of Dreadnoughts'. As an alternative, it organized an exhibition of so-called 'peace toys' – 'not minia-ture soldiers but miniature civilians, not guns but ploughs and the tools of industry'.[10] The peace movement's biggest impact was in the 1920s and early 1930s, when hostility to the pleasure-culture of war contributed to its challenge to the dominant national rhetoric of heroic adventure and spawned alternative representations of war. This tradition was revived in the anti-nuclear movement of the early 1980s and fed into opposition to the South Atlantic adventure in 1982.[11]

Since 1918, commercial children's culture has been instrumental in bring-ing about the shifts in adventure and its cultural imaginaries discussed in previous chapters. A steady proliferation in forms has been driven by an expansion in the industrial production of toys, games and narratives for children, under the impetus of a profit motive now detached from moral purpose and emphasizing instead those new values of entertainment and pleasure, evident in the Lawrence legend, which I have referred to as the masculine pleasure-culture of war. The growth of the toy industry into big business, with fierce competition over international export markets, has its origins in the trade war between Britain and Germany prior to 1914, but it really became organized in the interwar period through the development of toy production in the United States. The appearance of an indigenous American toy industry was itself stimulated by the blocking in 1914 of German exports, which had absorbed a quarter of German toy production. By 1939 it had become established as a significant economic sector with its own trade fairs, and was producing 95 per cent of a now massive American domestic toy-market. As with other culture industries, this provided the basis for a take-off into the world export markets, and in the twenty years after 1945, the American toy industry quadrupled its production, began to measure its retail figures in billions of dollars each year and enjoyed high profit margins.[12]

The increasing influence of American popular culture in Britain, made possible by economic market-penetration, amounted in effect to an export-ing of American cultural imaginaries. Most influential of all were the genre products of the Hollywood film industry, among which the western became established as one of the most popular from the 1930s. By the mid-1950s, B-movies for the cinema were being replaced by series for television (*Gun-smoke*, *Cheyenne*, *Wagon Train*, *Wells Fargo*, *Maverick*, *Wyatt Earp*, *Laramie*, *Boots and Saddles*) and these were among the most popular American programmes imported into Britain by the new commercial tele-vision companies whose franchise to broadcast began in 1955, to be followed shortly after, in competition, by the BBC. A vast new broadcasting public was exposed to the forms of a Wild West imaginary that was steadily displacing British imperial imaginings from their centrality in the national

culture: the television audience in Britain grew at the rate of over one million new licence-holders per year between 1953 and 1959, and by 1959 an estimated 60 per cent of British adults (not to mention children) were tuning in every evening for an average five hours in winter, three and a half in summer.[13]

Just as the popularity, in 1893, of toys on British Empire themes is clearly related to the tradition of imperial adventure, so too did film and television narratives located in the American Wild West stimulate interest in western toy soldiers. By 1940, Britains had supplemented their British Army lines with an 'Armies of the World' series, in which American models, including 'Types of the Wild West', were hugely predominant. The transformation continued in the export-led revival of British toy production from the early 1950s, when the Wild West, together with the recent World War, furnished the central repertoires for manufacturers of toy soldiers and other war toys, who were keen to exploit the new injection-moulding techniques in plastic. Cheap, easily automated plastic moulding was of a higher quality and hence enabled a greater variety of figures that were light-weight, durable and of self-coloured material. Within ten years plastic had completely replaced the traditional lead-casting technique, and with it, the old Empire soldiers disappeared too. Between 1950 and 1965, the years of a general expansion in cultural consumption that saw the greatest development of commercially produced children's culture since the 1880s and 1890s, the British toy industry experienced a boom period in which imperial themes were almost totally abandoned in favour of the new imaginaries. These held in turn until the 1980s, when the microchip revolution heralded a further significant transformation in the forms of children's culture towards 'star wars' and similar themes. In current trends, national imaginaries themselves are beginning to give way under pressure from international marketing.[14]

The forms of twentieth-century war-pleasure culture for boys have been designed, mass-produced and marketed as commodities generating exchange value: they are the outcome of specific choices and decisions calculated to maximize profit. However, production decisions of this kind are not determined solely on economic criteria, since specifically cultural factors obtrude. The culture industries draw upon (and help replenish) the reservoirs of established popular elements from existing cultural imaginaries; or they gamble on the imaginative resonance of a newly introduced repertoire. It is at this intersection of economic and cultural factors that the choice to market cowboys and Indians (rather than, say, Elizabethan seadogs or figures from the English Civil War) can be located. Whilst dispensing with the explicit pedagogic aims of popular imperialism, commercial cultural products targeted at children remain one of the primary means whereby children are inducted into their culture's imaginaries, and continue to effect a subjective positioning of each new generation in relation to their historical shifts.

In this argument about boyhood war fantasies, I take issue with the

essentialist assumptions of common sense that underpin much of the (sparse) historical literature on children's toys.[15] In Leslie Daiken's *Children's Toys Throughout the Ages*, for example, we are told that: 'If the doll is the universal plaything for a girl, so is the toy soldier the natural toy for boys.'[16] Here, boys' desires for war toys, and investments in war fantasies, are seen to arise spontaneously from within, at the promptings of 'human nature', in the form of innately aggressive masculine instincts. 'The expression of the herd instinct among boys of a certain age invariably takes the form of war games', which are 'merely a variation of the animal hunt'.[17] Successive forms of war toy – from the wooden sword to the rifle to the model tank or fighter-plane – simply imitate the increasing sophistication of actual combat. Similarly, Antonia Fraser, in her *History of Toys*, argues that:

> In a martial era boys will inevitably turn to soldiers, and in a period when the Roman eagle travelled so far . . . symbols of martial prowess naturally became toys coveted by children. . . . It is inevitable that an age which has known wars should produce soldiers and war toys. . . . This is obviously the natural development of an age when a child's admired father is dressed up as G.I. Joe. As long as men go to war and armies exist children will want to play with soldiers.[18]

In between the Romans and G.I. Joe, Fraser accounts for the existence of war toys in medieval times, the American War of Independence, nineteenth-century Europe and the First World War in the same vein, concluding from this argument that 'therefore one can scarcely blame the manufacturers for trying to fill the need'.[19]

Toy-industry spokespersons have often had recourse to similar arguments about 'human nature', which they link to evocations of consumer sovereignty. A typical example comes from Frank Martin, then marketing development and services director of leading toy-maker, Hasbro-Bradley, who argued in 1985 that: 'Young consumers are pretty smart. They will not respond to something that is not value for money – or if they do, they will do it only once.'[20] In similar vein, John Sanders, editorial director of IPC juvenile magazines during the 1970s, responded to criticism of their war comic, *Valiant*, with this argument:

> It's an irrefutable fact that the second world war is today the most popular feature on boys' comics. . . . If I could do anything to change this trend within the commercial structures by which I have to abide, I would. In fact I do that as far as possible, but if your readers are constantly clamouring for something, what else can you do?[21]

In 1964, in an era prior to the current hard-sell marketing of children's culture, a more thoughtful argument about the relationship between toys and fantasies was advanced by the then director of brand-leader Lone Star Products, who criticized the too-perfect verisimilitude of toy guns with this

argument: 'The gun mechanism and its appearance should be simple. . . . An essential which applies to any toy, not just Western guns, [is] that it should stimulate rather than stultify its owner's imagination, providing the one tenth original idea round which the child can develop his [*sic*] private fantasy.'[22]

A child's 'private fantasy', however, is shaped far more deeply than this by the associations surrounding different forms of toy – guns or vacuum cleaners – and by the immediate discursive context supplied for them by toy-industry marketing strategies and advertising campaigns. Public imaginings in this wider sense 'inform' private fantasies and determine the imaginative resonance of particular forms of toy. It is hard to imagine today's children playing out 'The Game of Wonderful Islands', while the appearance in the British list of the top ten best-selling toys for 1982, of Action Man 'particularly in an SAS outfit', needs to be placed in the context of the SAS attack on the Iranian Embassy in Prince's Gate: seen live on television in May 1980, this stimulated a wave of popular fictions that helped establish the SAS's cult status in the 1980s. The appearance in that year's 'toys top ten' of three different kinds of war toys, and the notable increase in baby-doll sales, suggest that the fantasies privately woven in play around these artefacts are likely to have been influenced by gendered representations in the media responding to those most public occasions: the Falklands War and the birth of the Princess of Wales's first baby.[23]

However, this shaping process should not be construed as an entirely passive socialization of children by powerful cultural institutions. Boys' desire for adventure and other forms of war culture cannot be attributed solely to exploitation by toymakers, and to this extent the commercial lobby is correct to emphasize the importance of the active imaginative investments made by children in play fantasies. Their appropriation of public forms of adventure depends upon an active choice and involves an element of active cultural production by boys themselves, in what can still usefully be called their own 'private' imaginings.[24] This process is subject to a far wider range of determining conditions, both psychic and social, than is usually acknowledged; and these require further investigation if we are to understand the private adventure fantasies that boys compose for themselves in the course of model building, or play with soldiers, or while climbing into the seat of a Spitfire at an RAF Open Day.

Gaining access to the 'private' moment of cultural consumption, particularly its psychic aspects, poses difficult problems of research methodology. One strategy, developed by oral historians and other ethnographers and extended into the study of audiences in literary and media studies, is to use interviews and methods of participant observation to reconstruct the symbolic significances of particular cultural forms for the individual or group under scrutiny, within an interpretative framework established by the researcher.[25] If 'read' appropriately, ethnographical accounts of play might be

used as source-material for insights into the boyhood imagining of masculine identities. The problem that resurfaces in these approaches, as in the biographical narratives of Havelock and Lawrence, is that of the researcher's own investments in the material. The study of other people's imaginings is not only a question of the legitimate criteria of cultural criticism, or the positions from which other people's pleasures are to be spoken about and approved or disapproved, but involves a more fundamental implication of the researcher her- or himself within that same field of phantasized attractions and repulsions. Research, too, involves complicated issues of identification and recognition, and is not itself outside the circuit of psychic exchanges, of projection and introjection.[26]

My own interest as a researcher into boyhood imaginings of heroic adventure cannot be divorced (and indeed, in a sense, arises) from my involvement in the pleasure-culture of war as a boy growing up in England in the late 1950s and the 1960s. Its forms, for me, were always closely bound up with efforts towards masculine composure, being among the most powerful means by which I imagined and secured an identity for myself as a boy. My investment in war toys, war play and adventure fantasy was strong and enduring. It began when I was aged 2 and lasted into my early teens. I dressed up and imagined myself as a cowboy, a cavalier, a US cavalryman and a Second World War British commando. I played war games at school and in the country lanes near our house, in imaginings shared with other boys. I made and painted models of fighter- and bomber-planes, and hung them from my bedroom ceiling. I played alone for hours with toy soldiers. Details of uniform, kit and weaponry became important, and I delved into these in books about actual armies and military campaigns, repainting my soldiers in their 'proper' colours. I consumed a vast range of war adventure stories, in comics, books, television series and old movies. The pleasures, excitements and absorptions of war play and fantasy in all its forms were certainly among the most intense of my boyhood. Then, in my early teens, I left war culture behind, fiercely rejecting it in a wholehearted embrace of pacifism. This personal subtext means that my research is necessarily caught up in conflicting identifications shaped by approval and disapproval of the soldier as hero.

My solution to the problem of method has been to turn these difficulties to useful account, by adopting an autobiographical approach to adventure fantasy in boy culture.[27] By exploring the character and vicissitudes of my own imaginative investments in war stories, contextualized in the particular circumstances of my early life, I aim to shed light on the general process of identification with soldier heroes and on its effects in terms of imagined masculinities and their articulation to British national identity.

Phantasy, play and memory

In remembering childhood, I have found it possible to produce a detailed description both of past events, kinds of play, the forms of toys and games, and also of the imaginative investments I once made in them, of their pleasures and significance. These investments from the past, however, reappear in a quite different context in the present. Memory is never simply a 'record' of the past made 'at the time', but is a constant process of reworking, driven by the needs of the present. Any account of our own childhood experience based on memory is necessarily an adult evaluation of that experience and a reflection upon our own cultural formation. By this, I mean the processes that shape us subjectively into a 'boy' or a 'girl', and later into a particular kind of man or woman, who belongs to and identifies with particular social groups and who has acquired as a result their characteristic tastes, beliefs, sensibilities and values. Remembering childhood involves an effort to compose 'a past that we can live by',[28] and the investments of the adult in her or his own childhood are intrinsic to a sense of adult identity. While the remembering adult is, in a sense, once again inside the child's way of inhabiting the world, this discrepancy between past investment and current social context simultaneously renders it open to fresh examination and interpretation. This active working at memory can establish a peculiar kind of double consciousness, both 'inside' and 'outside' childhood. What the investment once felt like and meant is recovered in order to be held at a critical distance, questioned and evaluated within the interpretative frameworks of the adult present.[29]

Kleinian psychoanalytic theory offers an especially useful framework for this evaluation, since Melanie Klein was a pioneer of the 'play technique' that made possible the psychoanalysis of children. Her argument was that:

> Play for the child is not 'just play'. It is also work. It is not only a way of exploring and mastering the external world but also, through expressing and working through phantasies, a means of exploring and mastering anxieties. In his [sic] play the child dramatizes his phantasies, and in so doing elaborates and works through his conflicts.[30]

Klein believed that the rich symbolic fantasies expressed in 'free play' help children to manage their anxieties and come to terms with the demands made upon them in social life. Through the narratives of play, psychic conflict, generated by anxieties experienced in the child's real relationships with others, can be displaced into symbolic form and worked through to a symbolic resolution which represents the fulfilment of an unconscious wish. This affords intense pleasure while protecting the child from the anxiety that would accompany the fulfilment of that wish in real life. In her work with one little boy, Klein interpreted his damaging a toy figure as representing attacks on his brother, driven by jealousy. He replied:

that he would not do this to his real brother, he would only do it to his toy brother. My interpretation of course made it clear to him that it was really his brother whom he wished to attack; but the instance shows that only by symbolic means was he able to express his destructive tendencies in the analysis.[31]

According to Klein, the boy was unable to express aggression towards his real brother because of a frightening phantasy about the effects of his aggression on the imagos that compose his internal world.

A child's parents, together with siblings and other family members and friends from immediate everyday life, may be imagined (and experienced) by children through the extreme, opposite imagos that result from defensive splitting. Klein argues, however, that it is safer to openly hate and unreservedly idealize 'real people somewhat removed from oneself' (such as a distant relative or a teacher) than those closest, most loved, most depended upon. The 'closer' people from everyday life are most likely to be experienced ambivalently, since they are intimately bound up with the subjective struggle to relate coherently to real people, recognized as complex contradictory others, rather than as the repositories of split-off and projected aspects of the self.[32]

In dramatization of these phantasies in play, a wide range of relationships with the various imagos can be acted out, through the transference of aggressive and destructive impulses onto toys that stand as symbolic substitutes (and thus entail no consequences) for people in social life. Klein's case histories supply examples of many different forms of toy and other play materials being used by children for the expression of psychic conflict and the narrative handling of anxiety. In private play fantasy, cars can be banged together and dolls punished, as well as toy soldiers killed. Each can equally well provide a symbolic setting for the acting out of aggressive wishes in narratives that place the imaginer, boy or girl, in an omnipotently powerful and controlling position in relation to 'helpless' toy objects. By the same token, war play as well as apparently 'nurturing' forms such as 'doctors and nurses' or 'looking after baby', may be used in (equally omnipotent) reparative phantasies whereby relationships with loved ones are made 'all right again' after conflict.

The pleasure experienced in successful play stems partly from the fulfilment of unconscious wishes in this displaced form and partly from the relief obtained through the separating-out and symbolic management of the child's own conflicting impulses and identities. In a process that Klein terms 'the distribution of imagos', the difficult effort towards their integration can be temporarily abandoned, and the fragmented imagos into which the child's various identifications disintegrate can be projected into ('distributed around') the symbolic figures of toys.[33] As these are brought into relation with each other during the course of play, the implications of different kinds

of object relations with imagos can be explored and worked-through at a safely symbolic distance from real other people. In the process, the toys themselves become charged with powerful emotional resonances.

Kleinian theory offers a useful corrective to those approaches that see playing at war as in some sense uniquely 'about' physical aggression and fighting. However, as I argued in Chapter 2, the Kleinian approach tends to neglect any consideration of cultural forms, or of the impact of specific toys and play narratives upon the internal phantasy world.[34] In Klein's description of her 'play technique', the toys she provided for the use of her young patients were 'neutral', so as not to suggest by their form themes that might interfere with the expression of unconscious phantasy. She particularly insisted 'that the human figures, varying only in colour and size, should not indicate any particular occupation'. Analytic interest is directed, not at the toys themselves, but at the unconscious phantasies underlying the child's projective investments in them.[35] In the establishment of my own critical framework, the questions posed to memory by Kleinian perspectives on war fantasies have been supplemented by further questions concerning the introjection of those forms, and their placing in terms of contemporary cultural imaginaries.

Kleinian theory is also helpful for the light it casts upon the working of unconscious transference within the relation of past to present. Reflection upon and evaluation of one's past is not necessarily under conscious control. Memory can be 'triggered' involuntarily – during play with young children, for example, as described by Michelle Cohen:

> I first sat with the [two 6-year-old] boys and their deployment of toy soldiers, knights and a rudimentary cardboard castle. They were involved in a 'battle'. I picked up a knight and felt that I 'didn't know what to do with it'. This was not a new realization. At home while D. [her son] plays soldiers with the man I live with, I've often expressed my lack of interest in those toys and games. I then went over to the little [4-year-old] girl, who was sitting with tiny dolls, a doll's house and furniture. I picked up a doll and, when I started playing, was astonished by the sudden awareness that I KNEW what to say, I KNEW the fantasies, the words, the gestures. A surge of emotion overwhelmed me, I felt that I was *in touch* with my own childhood self. And I realized that D.'s 'boy' games . . . had been leaving me totally 'blank', while when playing with the little girl, my whole experience resonated with the gestures and words of the game. [*Original emphases*][36]

Here, feeling 'in touch with my own childhood self' is the occasion of a transference in the psychoanalytic sense: the repetition of an emotional relation that originates in the past but remains active in the internal world of unconscious phantasy, to reappear in later scenarios resembling the

original.[37] The transference is triggered here for Cohen by handling and using toys that reactivate her own childhood investments in similar objects. The 'resonance' of the fantasies, words and gestures of 'girls' games' marks the transferential repetition of an imaginative investment that once yielded meaning and pleasure, and now does so again; in striking contrast to the 'blankness' accompanying her encounter with 'boys' games', which remain obstinately uncathected. Cohen's adult experience thus repeats a gendered distribution of interest/uninterest in forms of play, that originates in infancy.

In my own case, I have found the experience of remembering and writing about my war play and adventure to be intensely ambivalent. Identifying with the boy within me, I have been surprised at the extent to which I can still recover the thrill it once evoked. The recapturing of past investments in play has brought to light many positive feelings, so that remembering itself has been extremely pleasurable in these cases. Often, this has been in direct contradiction to the wish to attain a critical distance, from whence I might question its role in my imagining of masculinity. Indeed, the effort needed to sustain any sort of critical perspective in the face of this positive transference has been a salutary reminder that, like others writing about adventure, I am not and cannot be a comfortably detached observer. We are all implicated, in our 'blankness' and our critical dismissal as much as our interest and excitement, in cultural forms that remain powerfully active as organizers of imagined identities in contemporary culture.

Having become aware of the determining presence of unconscious transference, I have endeavoured to turn it to critical account by using its repetitions as a research tool. Guided by psychoanalytic method, critical evaluation of my memories began to centre on the effort to step outside the transference and become self-conscious about its process, as a way of exploring the idealizing investments repeated in it. This involved rereading the writing I had first produced 'from memory', to make conscious its moments of intense identification with boyhood forms, its moments of critical detachment, and its gaps and silences, uncovering the contradictions concealed within its account as a transferential guide to boyhood dilemmas.[38]

Playing at soldiers

War toys feature among my very earliest fragmentary memories of infancy as objects of anxiety and desire. I was fascinated by, and coveted, the collection of lead cowboys and Indians owned by my elder brother, and I recall my bitter disappointment on hearing that the coalman (complete with a large sack of coal) had stepped on them, wreaking destruction. Disappointment was followed by a moment of sickening horror as it dawned on me that I was responsible for leaving them lying around on the path. One

wet Saturday morning, at the age of 3 or 4, I acquired the first of my own collection on a family shopping trip to Doncaster market. This was a larger figure mounted on a base, some 3 inches high, made of moulded plastic brightly painted in the blue and yellow uniform of the US cavalry. Back at home, I excitedly unwrapped my first toy soldier from its brown paper-bag on the carpet in our sitting room, beside the television broadcasting Saturday afternoon sport. I was a television baby, one of the first generation in Britain to be born *en masse* into houses already equipped with 'the box', and my earliest memories also include westerns like *The Lone Ranger* and *Boots and Saddles* – my first war stories.

My entry into the pleasure-culture of war occurred at the height of the post-war boom in toy production and television culture, during which British imperialist imaginings were phased out as a significant childhood archive. My recollections of imperial adventure themes are restricted to a game called 'Zulus' that I played for a time at school, probably stimulated by the 1964 film, *Zulu*;[39] and a 'white hunter' dressing-up outfit with plastic topi that I once received as a Christmas present. So far removed was this colonial figure from my imaginative repertoire that the reference to 'white' was lost on me, and the outfit had to be re-imagined as a soldier to be usable in play. Since I was born in the year of Suez, and was already playing at war when David Lean and Robert Bolt's *Lawrence of Arabia* was released, my heroes were neither Lawrence nor Havelock, nor any other imperial figure, but cowboys, US cavalrymen and British soldiers from the Second World War.[40]

Of the seventy or more toy figures that followed this first cavalry officer into my possession over the next few years, most had been designed from Wild West or Second World War motifs (my only other 'genre' featured medieval knights-in-armour). All represented fighting men fashioned in a variety of poses and known collectively as my 'soldiers'. I had large groups of US cavalry – the Federal Government troops who fought the Indian Wars and the American Civil War – and of Wild West cowboys and Indians, together with a handful of grey-uniformed Civil War Confederates. My Second World War troops were mainly British, with smaller groups of Germans, Americans, Italians, Japanese and Australians. My play with all these soldiers centred on the stories that I made up about their adventures. These were acted out by handling the figures, moving them around the room or garden, knocking them against one another. Each play-session generated its own narrative, which I spoke aloud in a constant running commentary (with sound-effects). The motor for a story was usually a conflict between two or more groups (the Indians versus the cavalry, say, or Wild West figures against Second World War ones), which I would develop into quite long narratives with recurrent themes and motifs, usually leading up to a battle.

As with any other commodity, the design and marketing of the toy figures

had taken account of their use-value and prefigured their role in the fantasy-narratives of play. Each of my soldiers was represented in mid-action, frozen in time, with swords raised and guns pointing. One cavalryman was leaning forward, bent at the knees, half-turning back as if leading a charge and encouraging his men, weapons at the ready. A colour sergeant was striding forward with his flag outstretched before him, making to draw a revolver. Frozen moments in an implied narrative, they generated enigmas and suspense: why is this figure drawing his gun? who is that one shooting at? who is he anyway? what happens next? The very form of the figures invited the composition of a story around them.

Within these play fantasies, I imagined every one of my soldiers as a distinct character. Through repetition, these acquired a continuity and stability over time – 'a life of their own' – and eventually they developed into more elaborate figures through the stories in which they were involved and the imagined relationships into which they entered. In essence, though, they were characterized as heroes and villains. The central focus of my stories was always a hero-figure, like the one I called 'the Corporal' – a wounded Confederate with one arm in a sling, who epitomized personal courage and resilience in the face of overwhelming odds and certain defeat; or like 'the Sergeant', brave, unarmed, exposed to danger with nothing to protect him but his own bare hands. A story would bring the heroes into conflict with cruel and vindictive enemy hate-figures, like the Japanese officer and the Indian witch-doctor: my equivalents of Nana Sahib or the 'fiendish Turk'. Other figures, less charged, functioned as allies, special friends or the rank-and-file in the armies of the heroes or their enemies. These imaginings can be readily understood in terms of psychic splitting and the 'distribution' of conflicting imagos around the whole set of soldiers, with the heroes becoming the recipients of 'positive' and 'desirable' ideal qualities projected into them as an extension of valued aspects of the self, and the hated villains becoming the repositories of 'negative', frightening or devalued qualities, projected in order to deny and disown them.

These projective investments were the vehicle of my initiation into the cultural imaginaries from which the design features of my soldiers were drawn. As a young child, learning to recognize the representational form of a toy (national uniforms, the signs of military rank), and to decode its significance, was a process of cultural discovery. Play involved me in an answering of questions, a gradual placing of my soldiers in imaginative terms: who were they? where did they belong? what qualities did they possess? who were their enemies? Far from being a neutral process, the making of these basic recognitions depended upon projective splitting and brought into being a world of difference based on conventional moral values (goodies and baddies, cowboys and Indians, the British and the Germans). Curiosity about my soldiers, prompted initially by design features and the packaging of products in the shops, thus led me to acquire some basic

conventions and forms of popular knowledge, and drew me outwards from them into the branching networks of the national and military imaginaries of Britain and the United States in the 1950s and 1960s. These in turn furnished information that was interesting to me precisely to the extent that it enabled me to project further significance into my soldiers.

The most readily available sources of such information were the many public forms of war story. My developing ability to decipher the codes of storytelling was closely bound up with early experiences of narrative pleasure as a reader and viewer of war stories. Besides the television westerns and chivalric adventure series – *Ivanhoe, The Adventures of Robin Hood, Richard the Lionheart* – that were prevalent in the late 1950s, I watched countless Second World War films, and from my seventh year began to read *The Victor*. This was a new war comic launched in the early 1960s by D. C. Thomson & Co., publisher of boys' adventure papers since the 1920s, which continued to land on our front-doormat every Saturday morning until I was 10 or 11 years old. Mastery of its comic-strip conventions opened the door to exciting adventure worlds of 'male camaraderie, rivalry and contest', from which women were completely absent. The most striking aspect of this black-and-white picture comic was its full-colour cover story about an act of military heroism – usually leading to a military decoration like the Victoria Cross – performed by a real historical soldier whose exploits were located very precisely in historical time and geographical space: mostly in the Second World War, or otherwise in the Great War, Korea or a colonial setting like Malaya. In their comic-strip form, these stories were indistinguishable from those featuring apparently fictional heroes: a blurring of fictional and historical adventure, the origins of which lie in the late-nineteenth century.[41]

Adventure stories provided me with a conception of historical events and of my own imaginative relation to them. I first encountered the term 'Nazi' in *The Victor*, and the presence of adventure motifs gave me a way into the sequence of national commemorative events to mark the twenty-fifth anniversary of wartime episodes like the Battle of Britain: for my generation of children, who grew up in the immediate post-war period, what was referred to simply as 'the war' remained perhaps the central motif in the national imaginary.[42] As an older boy, adventure fantasies stimulated more detailed historical enquiries: when I was about 10, I researched the uniforms of the American Civil War so as to repaint my soldiers in authentic colours, and traced the course of its campaigns on the map.

Adventure stories also furnished me with ideas that I could incorporate into my own play fantasies: narrative scenarios such as revenge or the setting-to-right of some injustice; incidents like the ambush or hiding from enemy reconnaissance; even ways to organize and develop my own narratives, from simple, sequential chronicles into more complicated imaginings with sub-plots and conventions for moving between simultaneous episodes

('meanwhile . . .', or 'while they were . . .'), and for bringing a story to a close. Characters, too, could be transferred from public narratives into play. The visual imagery of combat in a comic like *The Victor*, being strikingly similar to the representational form of my toy soldiers, facilitated their identification with the qualities of comic-heroes and their enemies (the evil Japanese officer, the brave American wielding a sten-gun). I called two of my cowboys 'Jess Harper' and 'Slim Sherman', after the heroes of *Laramie*; and the character of one of my favourite soldiers, 'the Corporal', derived from the wider imaginative resonance of the defeated Confederate Army. Contributing in this way to the imagining of the characters and adventures of my soldiers, cultural forms produced for mass-public audiences came to inform my 'own' fantasies, by literally 'giving form' to my investments in play.

If, through these projective identifications, adventure provided me with a means of entry into the imaginaries of my culture – a means to render my social world interesting and exciting in available cultural terms – it simultaneously came to constitute, through introjection, a psychic landscape within my inner world. This process can be illustrated by analysis of one particular story from *The Victor Book For Boys 1967*.[43] D. C. Thomson & Co. would have had this hardback, comic-strip annual in the shops in good time for Christmas 1966. I was then 10½ years old, and nearing the end of my readership. Its lead story, 'Attack on Marzuk', one of three on Second World War themes, is situated historically by an introductory caption: 'In the summer of 1940, during the Second World War, British forces, operating behind enemy lines, attacked the Italian held fort and airfield at Marzuk, in the Western Desert.' It provides a good example of that shift identified in Chapter 8, whereby the motifs of a Lawrence-like guerrilla escapade in a colonial setting become incorporated within the differently accented national imaginary of the anti-fascist war.[44]

This quest involves a difficult journey across the hostile terrain of the Sahara desert, '1000 miles from Cairo and slap in the middle of enemy territory', to destroy a valuable but threatening object: an important enemy base, 'strongly garrisoned' and 'heavily protected with machine guns and heavier weapons'. Its protagonist is one Sergeant Miller, whose acceptance of a challenge propels the narrative forward: the success of the attack depends upon his seizing an opportunity to display heroism. Miller's courage, self-confidence and initiative emerge most clearly in his voluntary acceptance of responsibilities beyond the line of duty as a mere Sergeant. His initial orders are simply to rendezvous in the desert with a senior officer, Major Morrison, but on reaching the rendezvous point, he discovers that Morrison's unit has been bombed. Despite an order from the dying Morrison to return to Cairo, Miller makes his own judgement of the situation and decides to go ahead with the attack: 'It's a *daring* plan and can still be done! *I'm not giving up* now' (my emphases). The obstacles encoun-

tered along the way function, not to generate suspense, but as a foil for the qualities of physical strength, resourcefulness and decisiveness displayed by Miller. Above all, the narrative revels in his 'smartness'. This enables him, among other things, to thwart a sabotage attempt on his convoy by Egyptians, to lose the Italian reconnaisance planes monitoring their movements, and, confronted with the impregnable base, to launch a surprise attack which is their only hope of success (see Figure 8).

My enjoyment of the story would have depended upon my making a projective identification with Sergeant Miller. To recognize his heroic qualities would be to project those qualities into this imaginary figure and see them cohere in an idealized unity, secured through these specific kinds of narrative acts – as being not just brave and clever, but the beater of Egyptians and the outsmarter of Italians. Through introjection, 'Sergeant Miller' could then be taken into the internal world as a positive imago, with whom I could identify in imagining myself. The valued qualities projected into the story could thus be reabsorbed, but in a new form: they were now imbued with the further connotations attached to them by the narrative, and held together in a single, unified figure. To recognize these combined qualities in Miller was to make him the repository of a possible masculine self.

The imagining of this idealized and desirable masculinity, however, depended upon an opposite, linked projection of split-off and disowned 'negative' qualities. Identifying myself with Miller was to identify myself against the enemy who, in this narrative, as in the Lawrence of Arabia legend, are imagined as contemptible idiots. When Miller's force approach the fort during their surprise attack, for example, the guards mistake them for fellow-Italians, and he is able to run them down with his jeep and drive straight in through the gates. The narrative makes fools of the enemy in order to exult in Miller's triumph. During the attack inside the base, the Italians offer no effective resistance and are only shown being shot or running away. The 'strong', 'heavily protected' base, now rendered ridiculous and contemptible, becomes fit for destruction.

Its accomplishment is effortless and instantaneous: 'In the space of a *few minutes*, Marzuk had been turned into a smoking shambles' (my emphasis). This quality of omnipotent wish-fulfilment, familiar from both the Havelock and the Lawrence stories, permeates the entire narrative. It is encouraged, of course, by the brevity of the comic strip as a form which has only a limited amount of space at its disposal – in this case, 82 frames – for the narration of an episode that, in real life would span vast geographical space and take many days to complete. At issue here, though – as in Marshman's narration of Havelock's life – is the construction of narrative time within the story, involving a necessarily unequal distribution of interest between its different components. The narrative dwells lovingly on the moment of destruction, devoting 11 frames to 'the space of a few minutes'. This is a significant slowing down of narrative time in relation to the time-

scale of the story as a whole: by contrast, the 1,000-mile journey across the desert (potentially comparable to Lawrence's epic camel-rides, imagined in detail in the David Lean/Robert Bolt film) occupies only 4 frames and the return journey only 2. The effect of this is to minimize the difficulties encountered in the desert, thereby establishing the destruction of the base – narrated in images of combat centring on Miller – as the imaginative centre of the narrative.

The ideal qualities and coherence offered by my identification with the hero were secured in a phantasy of omnipotent triumphalism resting upon this construction of narrative time. My investment in this kind of story enabled the imagining of my superiority over other masculinities, which are defined by my own disavowed qualities. I imagined myself against that which I wished not to be: stupid, cowardly, incompetent, ridiculous, laughable and powerless. The projective disavowal of those qualities as belonging to *national* others – the Egyptian and Italian enemies – secured my introjective identification with the position of superiority and power associated with Britishness. Thus, in the imagined victory over the enemy, the triumph of British military manhood over the axis powers in the Second World War became fused with the triumph of my own wished-for masculine self over what I wished not to be. As the last mortar-bomb blows up the central tower and flag-pole at Marzuk, a British soldier points the moral and political significance of the attack, in a comment that condenses the phantastical and social implications of the narrative in its splitting-off and destruction of the 'bad object': 'that'll teach 'em to stay home where they belong!'

The successful attack, however, is not the end of the narrative. On their triumphant return to Cairo, Miller and his team are welcomed as 'blooming heroes'. A bristling-moustachioed, peak-capped officer shakes Miller by the hand: 'By Jove, Sergeant, you did a magnificent job. We quite thought you'd turn back after what happened to Major Morrison's force.' Miller's victory is sealed, in another echo of Lawrence, through his recognition as a hero by this higher-ranking masculine authority figure. He also wins the admiration and recognition of his men. Like Lowell Thomas's Lawrence, Sergeant Miller is hardly a paragon of military smartness and at the beginning of the story he is denigrated by his men as a 'scruffy object'. Midway through the attack on Marzuk, one of them remarks: 'I'm beginning to change my mind about him. He's smart in the way that really counts.' By the end of the quest, those who originally doubted his abilities now declare: 'After this there ain't a man in the unit who wouldn't follow Sergeant Miller anywhere.' Through introjection, praise of Miller could be transformed into the desired recognition and praise of my own abilities. Triumphalist phantasies like 'Attack on Marzuk' enabled me to imagine the fulfilment of a wish: if the enemy could be destroyed, then I would no longer be troubled by fears, uncertainties and doubts, and the self I wish to be would become real through the admiration and recognition of significant others.

My private play fantasies were not wholly determined by these public forms of adventure. While based on the figure's representational form, my imagining of a character always involved some further elaboration and modification. For example, the gradations I introduced between different ranks of officer – an especially significant element in my fantasies – were rarely marked on the toy itself, but were supplied by my own imaginative investments in the military hierarchy. I made distinctions between fighting officers and their superiors, who directed their actions from afar: the former being those of my soldiers possessed of the most interesting postures, defined according to the use to which I could put them in play. I rarely kept them upright or imagined them as only firing guns and hitting their enemies at a distance, but frequently tended to hold one combatant in each hand so as to bring them into close physical proximity, in imagined sword-fights and other kinds of hand-to-hand combat. Sometimes I would modify the form of a figure to render it usable in this way. The one I called 'the Sergeant', for example, was transformed into one of my favourite soldiers after I had chewed off his plastic flag. His right arm now stretched satisfyingly into a firmly clenched fist, and he became a deadly puncher, a hero of close combat who would lead small, commando-like raising parties, which needed to creep up stealthily behind their heavily armed foes. The effects of wear-and-tear and accidents around the home could also be worked into a character: the worn state of my oldest soldiers came to signify the battle-stained appearance of veteran campaigners, as against the fresh colours of newly purchased 'recruits', and some sported 'wounds' produced by the Hoover.

Unlike the pleasures of reading and viewing, which are contingent upon attention to a narrative process structured by another, play narratives can be more responsive to the promptings of impulse. In play, I made the soldiers into what I wanted them to be, which did not always correlate with what they were supposed to be. This imaginative fashioning was determined by other conditions besides the current forms of cultural imaginaries, for these intersected with impulses and phantasies arising from, and concerned with, the relationships and conflicts of my everyday life at home.

War play and domestic life

Most of the play of infants takes place in the context of domestic life within the household that is the core of their social world. At once the place of safety and a source of the most deep-rooted conflicts and disturbances, everyday life in the domestic space generates the psychic agenda to which, according to Klein, play is a response. Among the items on this agenda, we must include the ambivalence that is often felt about domesticity itself.

The very existence of this complex and ambivalent, privatized space within the home, along with its physical organization and the kinds of imaginative investments made in it, is the result of profound historical

changes. The domestic life of my own family was a product of those wider post-war aspirations that brought the enjoyment of domestic comfort and leisure increasingly within the ambit of working people. The vision of a new kind of domestic life in a new kind of home was a central component of the promised better deal which had emerged from the 'war to win the war' and had inspired post-war reconstruction.[45] Like the domestic imaginary of the nineteenth-century, middle-class families described by Davidoff and Hall, the attainment of a comfortable and secure domestic environment had been the prime goal for my parents in the years immediately after their marriage in 1946.[46] They had suffered in the immediate post-war housing shortage and had been forced to live apart until moving, in 1950, into a new semi-detached house in a Doncaster suburb. When my elder brother was born, my mother was still living in her parents' two-up, two-down back-to-back in town, with a younger sister and a father on night-work. Despite the considerable financial struggle it involved, the move to the suburbs represented freedom from the claustrophobia of an extended family in a traditional, cramped, working-class house where children's best place to play was out in the street. By comparison the new three-bedroomed house offered a spacious environment for a small nuclear family, with the added bonus of a decent-sized garden in which my father installed a sand pit. I was born into, and spent the first six years of my life in, this house, which provided the domestic context for my earliest play. This wider history created, quite literally, the space for me to enjoy the long, solitary play fantasies that I spun around my soldiers.

An adventure might begin in the sandpit and sprawl onto the lawn and into the flowerbeds, or take over whole rooms, spreading across carpets and armchairs and along the tiled hearth of the fireplace. These features constituted a changing landscape, the setting not only for battles but for the siege and invasion of the wooden fort built by my father, for long migrations across hazardous terrain, for surprise attacks in the mountains, for kidnappings, chases and heroic last stands, for escapes, pursuits, capture, rescue and revenge. My play was self-absorbed, private, yet coincident with the activities of others sharing the same space: primarily, this meant my mother, a housewife and my full-time carer, who was my constant companion until I went to school in my fourth year. In our daily routines, my play was interwoven with her domestic work about the house and the interruptions of other kinds of domestic pleasure and chore, as well as forays to the shops or visits to friends and family. The return of my father and brother from school in the evening introduced an alternative rhythm which carried over into weekends and school holidays. While stitched into the texture of this life, play could involve me in utter abstraction from it – a memory confirmed by my parents. Coexisting alongside their own domestic labour, conversation or television-watching, it provided me with a way of inhabiting that shared space and making it my own. In play with soldiers, I was composing myself:

using 'composure' here in that double sense I explained earlier, both of 'invention' and of 'making myself comfortable', making myself 'at home'.[47]

Yet these adventure fantasies were predicated on leaving behind domestic security and crossing over an imaginative frontier into a world of quests, conflicts and danger. As in Cawelti's formula stories, the discrepancy between an apparently secure base and a more intense and exciting alternative world is striking.[48] In war play, domestic space was transformed into an adventure world that existed at a substantial imaginative distance from domesticity – a distance upon which my excitement and interest in adventure, and the possibility of my imagining and introjecting the desirable qualities of soldier heroes, both depended. In transforming the sitting-room and garden into a different place – the Sahara Desert, the western plains of America, the icy fiords of Norway – these fantasies made domesticity, the primary condition of my own social life, disappear entirely. In this place, there was no father, no elder brother, and certainly no mother: there were only soldier heroes, with their comrades and their enemies.

Similar conditions pertained in many of the war stories I watched on television; if not in the structure of the narratives themselves, then in my readings of them. My exclusive investment of interest in the adventure aspects of westerns occurred at the expense of the romantic themes – the 'love interest' – that frequently secured their appeal to mixed audiences. In one typical cavalry western, *Bugles in the Afternoon* (1952), for example, the motivating conflict between the hero (played by Ray Milland) and a re-encountered rival from the past is fuelled by their new rivalry for the love of a woman.[49] The narrative interest for me concerned the hero's volunteering for the US Seventh Cavalry to fight the Sioux Indians, as a means to redeem himself from a charge of cowardice; and his persecution by the rival, who is now a superior officer in the regiment. This story-line, however, is intrinsically bound up with their romantic rivalry, driven by the hero's desire to return from the hard life of the frontier to domestic security and marriage. As a boy, my loudly expressed impatience with these 'slushy' and 'boring' love scenes generated much humour in the family. This lack of interest can be interpreted psychoanalytically as positive 'uninterest': a form of denial that rendered invisible the hero's desire for the love and recognition of a woman by 'reading it out' of the narrative. A distinctively gendered reading of the narrative as an unalloyed adventure, this secured for me an amused recognition of my typically boyish responses from the family. But the refusal signifies the difficulty I experienced in engaging with the contradictory desires articulated by such narratives: to secure the masculine self through the recognition of manly combat on the frontier and to secure sexual and emotional recognition from a woman.

If any explicit treatment of family relations was ruled out in my adventure fantasies, these preoccupying themes reappeared in play in another guise. The comfortable surfaces of domesticity were replaced in war-play by

fiercely conflictual phantasy scenarios. These constituted a symbolic world into which the conflicts of everyday life were displaced and where wishful resolutions to them could be enacted. The doorway to this world was projective identification, of the kind I made in Sergeant Miller, with those soldiers which I idealized as heroes. My closest identifications were with figures I imagined as subalterns, especially NCOs like those I knew as 'the Sergeant' and 'the Corporal'.

My play narratives centring on these characters were often preoccupied with power, subordination and the search for recognition from authority figures. One recurring theme was that of the Sergeant's persecution by one of his commanding officers. These would be imagined as cruel authority figures, every bit as threatening as the ostensible enemy, who were out to destroy him by ordering him on impossibly perilous assignments which promised little chance of survival. In a variant on this theme, I imagined one of my newly acquired figures as a raw, inexperienced superior officer: in fighting through to victory, the Sergeant would be demonstrating to the new officer both his own greater experience, wisdom and courage and the officer's own foolishness, both of which the latter would finally be forced to admit. (Another variant involved a benign CO to whom the Sergeant was devoted, and who would trust him with the most vital but dangerous missions.) The outcome of the Sergeant's success was his recognition as a hero.

The NCO is an imaginative figure well suited to express recognition phantasies. As an underling with responsibilities within a hierarchy, his successful completion of a quest results in the proving and reward of masculine qualities that are valued according to an authoritative standard. This is a variant on the 'younger man with father-figure' adventure motif identified by Green and exemplified in Thomas's version of Lawrence. Indeed, the NCO crops up again and again in public adventure narratives: all three of the Second World War heroes in the 1967 *Victor Book For Boys* are sergeants, for example, while the hero of *Harkaway's Sixth Column* is a corporal.[50] Psychoanalytic theory would suggest that this figure has a particular resonance for boys who know their own masculinity to be subordinate to the authority of adult men, and who are torn by conflicting Oedipal desires: to challenge and supplant the father and to acknowledge and identify with his authority while securing his approval.

Where this proving of the masculine self depends upon negotiating the persecution scenarios of the kind that featured in my play narratives, the phantasy is structured rather differently. Here, too, it is striking how closely my imaginings correspond to similar scenarios found in many public adventure narratives. In *Bugles in the Afternoon*, for example, the hero's rival is his superior officer, who deliberately orders him into the most dangerous situations and fails to rescue him when under attack from Indians. Indeed, at the moment of greatest danger, when an assault by Indians fresh from

victory over General Custer at the Little Bighorn threatens to overwhelm the hero and his comrades, the hostility of this officer breaks out in an attempt to murder him. Ironically, the hero is only saved at the last minute when his rival is shot by an Indian. The narrative leaves no doubt which poses the greater threat. Klein locates threatening imagos of this kind in the super-ego, described as the repository of introjections derived from the punitive aspects of the mother, which may be experienced, in the paranoid-schizoid position of earliest infancy, as a terrifying threat to the existence of the self. The extremity of the threat produces a corresponding need for idealized imagos capable of resisting it so as to ensure the survival of the internal world. Defensive idealization in this case is guarding against fears originating in a much deeper, pre-Oedipal psychic landscape that over-determines the classical Oedipal conflict.[51]

In my efforts to explore the precise character of the fears and defences symbolized in these play scenarios, I found myself struggling to move beyond the 'manifest form' of the toys and narratives to their underlying imagos, derived as they are from introjections of various aspects of my parents, both 'positive' and 'negative', supportive and threatening. It gradually became clear to me that the descriptive detail generated in my early attempts to write about play effectively repeated my childhood investment in its forms, by displacing interest away from more disturbing and emotionally charged issues onto the pleasurable terrain of adventure. To make progress, I made use of the classic psychoanalytical method of association to retrace the links in the chain of displacement, and to render visible that which is made to disappear whilst one is inhabiting a particular form of identity.

One of my strongest associations with the pleasure of playing at soldiers can be described as a denial that this activity has anything to do with aggression. As a boy I had a fear of physical violence. The only serious fight I recall participating in as a child occurred when I was 6 years old and found myself threatened by an older boy who bullied me and then attacked me on my way home from school. My fear was not about being physically hurt, but was a terror about being destroyed. Although I defended myself against his first attack, and proved strong enough to get the upper hand, I found the whole experience so threatening that I got up and walked away without hurting him. He resumed his attack on my now retreating figure, and beat me up. Almost as shocking as the fight itself was a second attack: my mother's reaction when I arrived home in tears. Doubtless anxious on my behalf, she was cross that I had not stuck up for myself more effectively.

A Kleinian reading of this episode would suggest that my primary fear was not of being hurt, but of hurting. In the underlying phantasy, to hurt is to destroy; and were I to destroy the threatening other, then I myself would be destroyed. The fear is a persecutory anxiety about the existence in the internal world of a threatening, destructive force that can turn on and attack

the self. I was afraid of my own destructiveness, and felt a lack of any means to defend myself against it. This psychic condition is explained by Klein, often in problematically normative terms, as a failure in infancy to introject sufficiently 'positive' imagos derived from the mother.[52] In my childhood memories of my mother, she is an alternately loving and frightening figure of great unpredictability. As on the occasion of the fight, I was often bewildered by what I experienced as her withdrawal of support and by her tendency to put me into her 'bad books' without explanation or apparent hope of redress. I did not feel I could rely on her, and I made this doubt a part of myself. But I was also afraid of her, and of aspects of myself that became bound up with the threatening imago. By contrast, most of my strongest memories of childhood affection and support feature my father. I invested 'positive' aspects of myself in him; hence his recognition of me was of primary importance, since it provided my best chance to combat my fear. Through my play adventures with soldiers, I was replaying over and over again my desired recognition by a strong and supportive authority figure, and my victory over the frightening persecutor which this enabled.

In effect, my identification with heroes who were always victorious enabled a working-through of persecution anxieties by imagining the defeat of the Kleinian 'bad object'. And since, in the course of a narrative, my heroes freed themselves from persecution and became powerful, the way was opened for explicit enjoyment of this power in triumphalist phantasies. My pleasure in these play narratives, however, depended upon a projective disavowal of cruelty and vindictiveness as motives for aggression: these were attributed solely to the tyrannous and threatening enemy. Like British narratives of the Indian Rebellion, I liked to imagine that my heroes, such as the Sergeant, never engaged in wanton violence against other characters, but always acted out of self-defence or with justice on their side. Through this mode of manic defence, in which destruction of the imagined enemy is accompanied by its devaluation into an object meriting attack, I was able, like Thomas's Lawrence, to identify with and enjoy my own destructive impulses without suffering their consequences in terms of fear and guilt.[53]

But there was a price to pay for this mode of composure. As a defence against fear, weakness and vulnerability, my identification with triumphant heroes necessarily involved the splitting-off and projective disavowal of these qualities. Since the victorious hero, in order to be triumphant, needs an appropriate enemy to triumph over, my play fantasies required certain figures to be dispensable pawns (like the anonymous bit-parts who get killed off in a war movie). These were commonly figures whose representational form precluded my imagining them as 'good fighters'. Their presence introduced a potential unease into my narratives, since they signified the place of weakness and vulnerability and threatened to evoke feelings otherwise kept out of play. One particular soldier evokes an acute and uncomfortable memory. He was a Second World War American infantryman who marched

with packs on his back and chest, clasping their straps close by his shoulders. He carried no weapons and his arms were moulded and, as it were, pinned to his body. In the terms in which I imagined my characters, he was completely defenceless, and I remember experiencing on occasions a sadistic intensity of feeling, released by play fantasies of what would be done (what I would do) to him. (His belly was exposed; it would be riddled with bullets from a sten-gun, pierced with a stab wound. He would be punched mercilessly in the face.) I imagined this character as a paratrooper, and the connection with flying marks another association. I named him 'Jock', after a character in a war film – a member of a bomber crew that never came back from a mission over Germany – seen on television one Sunday afternoon when I was about 8 years old. The pathos that this film-character aroused in me was trans-ferred onto my soldier, and this was the only moment when loss and mourning (for the most part a well controlled, almost ritualized aspect of my play narratives) threatened to break out of its own accord. Behind this useless, dispensable and devalued figure, there lurked an intensity of feelings with a quality otherwise absent from my play with soldiers, which in its linking of sadism with loss and mourning, suggests the sudden appearance of ambivalence and depressive anxiety.[54]

Like the heroes and villains of comics and films, my soldiers were forms of imagined masculinity produced by the splitting and distribution of imagos. As the focus of introjective identifications, they made possible different masculine selves. In psychic terms, the attraction of heroic idealizations lay in their relative invulnerability to persecutory and depressive anxieties, and in the consequent security to be found in identifying with them. In order to sustain the idealized hero, however, splitting also produces denigrated forms which carry far-reaching psychic repercussions. In the character of Jock, the *doppelgänger* of my heroic self, qualities of vulnerability, weakness and pain were rendered negative and undesirable in a quite specific cultural form. Through unconscious identification with this character – whose masculinity I struggled hard to disavow, not always with success – the defenceless, defeated and worthless side of my own split self continued to haunt the battlefield even after victory had apparently been won.

Neither the anxieties nor these psychic defences against them were unique to myself as an individual. The war pleasure-culture of my boyhood drew its resources from historically determined cultural imaginaries that organized collective investments in particular aspects of the social world and rendered it interesting and knowable in specific terms. In imagining myself in terms of adventure, I was also assuming a recognizable position within that world, and entering into wider imaginative relations to real as well as phantasized others. While forms from other cultural imaginaries might perform a similar function of psychic defence, these different forms in which anxieties are contained and managed are important because they organize different imaginative orientations within social life. If one important dimension of

this process is the gradual building-up of highly charged national identifications, another relates to masculinity and domestic life. Playing with baby-dolls, as with soldiers, may involve violent phantasies about the destruction of negative imagos as well as phantasies about the nurturance and care of positive imagos. But the narratives in which these scenarios are acted out, and their psychic conflicts worked through to resolution, draw upon different cultural imaginaries and thus enable the introjection of different forms of imago. In the imaginative geography of the public forms of adventure that I encountered and introjected as a boy, domestic space – and the overt family drama involving mothers and fathers, children and babies, enacted therein – was held apart and decathected. Rendered invisible or uninteresting for boys, imaginative investments in domesticity came to be coded as feminine. In the dysjunction between the domestic setting and the forms of my war play, even as a very little boy I was registering and internalizing the gendered separation of spheres, and the ensuing ambivalence of the masculine relation to domesticity.[55]

Even though, in infancy and early childhood, both boys and girls occupy the same position within domestic space and the same kind of relation to the public world beyond the front door, they are beginning to imagine their relation to these spaces in terms of cultural imaginaries that are themselves already 'gendered'. The differences between these forms of imagining become progressively more significant as boys grow older, enter the public world and have to negotiate the separation of spheres in their own movements back and forth across the border. Adventure now offers forms for the imagining of masculinity in the new conditions of this wider social world.

10

SELF-IMAGINING
Boyhood masculinity, social recognition and the adventure hero

Imagining myself in the social world

As a very small boy, I became notorious in the family as an inveterate wearer of hats. I had a number of different kinds, but my favourites were black felt cowboy hats that could be tied under the chin with cord, of which I had several over the years, worn until they were quite battered and unserviceable. I am wearing cowboy hats in a number of photographs from the family album, all taken between 1958 and 1961 in the house and garden in Doncaster, or on seaside holidays on the north-east coast near Scarborough (see Figures 9–12). The earliest were taken when I was about 2 years old. I am wearing dungarees, clutching a glove-puppet and wearing that first cowboy hat. How did I get it? Was I given it? Did I find it lying around somewhere? Did I see it in a shop? None of the family remembers, but it is clear that the wearing of hats in general, and cowboy hats in particular, rapidly became a sign of my individuality – a way of identifying myself, of saying: 'This is me, Graham; I am someone who wears hats'. I can recall with precision the feeling of satisfaction and composure that accompanied the purchase of a new hat. With this feeling, another is mingled: that of being affirmed and basking as the centre of attention within the family. My family enjoyed my wearing of hats, appreciated me as a hat-wearer. I remember my father at the seaside, chuckling and marvelling at it.

This attitude of approval is also evident in the photographs. I am wearing a cowboy hat and looking very pleased with myself in an affectionate family portrait with my parents taken in 1959. Further photographs catch me wearing them (undoubtedly with parental approval) in public places like the beach or a fairground, as well as in the privacy of our back garden. In some, the hat is supplemented by other basic features of 'the cowboy'. In one, dated 1959 (when I was 3), I am standing on a quay holding a shiny toy six-gun. In another, I am sitting on a white-painted wooden horse called Snowy, made by my father, wearing a black 'Lone Ranger' face mask. Dependent as my public appearance was upon parental approval, it is inconceivable that, without it, my hat-wearing would have been recorded for posterity at all.

The achievement of such approval was an important part of the cowboy hat's meaning for me as a little boy.

The other part of its meaning, invisible to the camera, derived from the use made of hats and other dressing-up materials in play fantasies in which I acted out adventures featuring myself as hero. Whether I was riding Snowy or being shot by my friend, Janet, the hats and guns were accessories to this central imaginative process. They were not indispensable: I remember galloping round the new garden, after our move to Hemel Hempstead, on a broomstick horse with a tablecloth thrown over my shoulders as a cloak, a feather stuck in my hat for a plume and a stick for a sword, as a cavalier serving under Prince Rupert in the English Civil War. The representational form of play-clothes and toys, though, made these identifications more 'realistic', and so over the years I acquired a sizeable collection of hats, dressing-up clothes and toy weapons.[1]

My basic cowboy gear was fleshed out by further items: a 'Lee Enfield' rifle, a sheriff's badge, holster and bullets, a bow and arrows and, one Christmas, a whole US cavalry uniform of matching blue-cotton blouse and trousers with yellow stripes and a yellow neckerchief, which I wore with a toy sword and scabbard. After we moved to Hemel Hempstead, Wild West outfits were gradually superseded by Second World War ones. My favourite hat now became a plastic, American-style 'steel helmet' complete with camouflage netting. Accessories included a plastic tommy-gun, a hand grenade and a combat knife on a belt. These various items, of course, were all commodities produced for a mass market and designed for their compatibility with the currently popular genres of adventure.

Like my play-fantasies with toy soldiers, the imaginative identifications that I made in dressing up drew upon the available cultural repertoire of stories and heroes like the Lone Ranger. In dressing-up narratives, however, projective identification and third-person narration were replaced by introjective identification and first-person narration.[2] Wearing a cowboy hat, a cavalry outfit or a soldier's helmet, I was imagining myself to be the cowboys, cavalrymen and soldiers of the comics and television, and I acted out adventures of which I was the protagonist as well as the creator. Through introjective identification, whereby words, images and stories already charged with my own projective investments were now incorporated into my own sense of self, I was quite literally composing 'myself'. Whereas in solitary and introverted play with soldiers my imagined narratives were significant only in reference to my own internal world, in dressing up and acting a part I was representing this imagined self to others and assuming the shape in which I wanted to appear in the world. My imaginings were taking on a more fully social form.

This social imagining of the self was not something neatly contained within a special activity called 'play', but continually affected all aspects of everyday life. Being an adventure hero empowered me to go out into the

public world beyond the garden gate. I remember, as a 5-year-old on the front of my father's bike, turning to wave encouragement to my troops marching behind, and becoming a great and magnanimous military commander at the head of his column. As a compliant world of troops and horses took shape around me, I embodied in my own person the fulfilment of a wish: to be bigger, stronger, more powerful and effective in the world. The narrative expressed a phantasized domination over imagos which I projected onto the landscape and figures around me, controlling them, ordering them around and subordinating them to my own desire and will. My father, who sat out of sight behind me, pedalling the bike that actually carried us forward, also featured in this narrative as the commander's driver. His presence, of course, rendered safe my being 'in public', thus underpinning the possibility of such a fantasy. However, on this occasion my father refused to play the part allotted to him, and instead asserted his real authority: seeing my wave, he scolded me for making traffic signals, and the great and magnanimous military commander deflated in tears.

This bruising deflation of my imagined self occurred through an encounter with the rules of a sociocultural order that governed public behaviour, but that I knew little about (in this case, the Highway Code as mediated by my father's authority). It would be wrong, though, to read in this the simple predominance of 'reality' over 'fantasy', or the re-imposition of my 'real' identity as a small boy onto my imagined identity as a soldier hero. All identities must be imagined, and the great and magnanimous soldier was merely one among several other current identities, formed under the impact of a splitting that also produced the foolish, irresponsible and powerless little boy whom I felt myself to be after scolding. Bossed around and made to feel small by my big, powerful father, I now imagined *him* to be controlling *me*, ordering me around and subordinating me to his desire and will. Both narratives were imaginative responses to my real social relations. While the latter might appear to correspond more accurately to the actual power relations pertaining between my father and myself, it was nonetheless a phantasy governed by defensive splitting, that retained in reversal those same two roles and produced an experience of my father as a punitive figure in the black-and-white terms of my own preoccupations with authority. Where imagining myself was governed by splitting, then, I moved in and out of various incompatible and even dichotomous identities, each of which required the projection of 'other' qualities in order to sustain itself.

Whereas in solitary play with toys, identities are imagined through projection directed at omnipotently controlled, purely symbolic objects, these social imaginings position real others, inviting approval and affirmation and running the risk of refusal and negation. At stake here is the winning and withholding of social recognition: 'who I can imagine myself to be' becomes inseparable from 'who they will recognize me as'. My father's scolding was, in effect if not intention (he was not a party to this particular

fantasy), to withdraw recognition of me as a great and magnanimous soldier, such that I could no longer sustain this identity in public. The deflation of fantasies through encounters with other people constitutes the means to discover which imaginings can be recognized and so sustained in particular public worlds and which will elicit the experience of misrecognition. The difference between these two outcomes is itself dependent on the social imaginings of the other: on, that is, the reciprocity or discrepancy between the form in which I identified myself and the form in which I was imagined by my father.

Neither self-imagining nor recognition is an arbitrary product of individual whim or tolerance. Both are governed by norms and taboos, definitions of what is possible or 'appropriate' for people occupying different positions within social relations, as these are furnished by cultural imaginaries. Just as I drew from available cultural imaginaries in imagining myself, so other people did in investing imaginative significance in me as a son, a brother, a boy. The composition of sustainable public identities involved a negotiation between my own wishes and other people's recognitions of me: who they wanted me to be, and who they would allow me to be. This process is deeply bound up with power – to elicit recognition or to refuse it, to impose or to contest it. It is therefore shaped by the relations of power that constitute the social divisions and conflicts of the wider hegemonic order. Children, while peculiarly dependent upon affirmative recognition, are relatively powerless to determine its conditions or forms.[3]

Some of the most powerful adult investments that impinge on the identities children can imagine for themselves are to do with gender. Since gender identity is so important in our culture, a child's need for affirmative recognition from others gives rise to a pressure to make him or herself clearly recognizable as 'a boy' or 'a girl'. This makes attractive those cultural forms that identify the self most clearly according to current definitions of appropriateness. The effects of this process have been described in a story told by Michelle Cohen about her son:

> When D was about 3 he decided one morning to wear a woman's smock . . . [that] he loved to 'dress up' in. He put it on, but when his father realized D wanted to wear it to walk (with me) to the CCC [Children's Community Centre], he became furious and yelled that D was not to go out with a dress on. He refused to explain why he was so violently opposed to this. I was very upset but told D that he could wear the dress if he wanted, comforted him, and we left. When we arrived at the CCC a male visitor greeted us and said to me 'Is she your child? What's her name?' (D also had, at this time, long blonde curly hair which both I and his father loved). I retorted that my child was a boy called D but D turned to me, gripped me intensely and whispered 'take off the dress, take off the dress'. No amount of comforting

could persuade him to change his mind. He has never worn a dress since.[4]

This story testifies to the anxieties that surround the imaginative acquisition and maintainance of an 'appropriate' gender identity. Whatever identity D imagined for himself whilst wearing that dress – whatever self it enabled him to be – he cannot sustain it against the public threat to his gender identity that it brings about. His transgression of the codes that mark him as a boy prompt anger and then misrecognition, both crucially coming from men, including his father. His mother's affirmative recognition, tolerance and encouragement cannot offset D's desire to identify himself as a boy and to be recognized as such by men in particular. Crucially, this leads to a withdrawal of D's investment from a form in which he had previously secured recognition from his mother. It establishes conflict between competing recognitions.

My parents may have refused my imaginings on 'inappropriate' occasions like the bike-ride to school but, in contrast to D, I met no essential rejection of my imagined self as a cowboy-soldier. Not only did it meet with the approval of both my parents, it also furnished the clothes I felt comfortable in, and so affected the ways I liked to appear in the wider public world. As a 6-year-old, my blue cavalry blouse did service as a 'real' shirt, while a new check shirt, to which I had taken an instant dislike such that I refused to wear it, became a favourite after my mother had suggested its likeness to the check shirts worn by cowboys. Her recognition enabled me to 'see' myself in that shirt; and so powerful was this identification that some of the clothes I wear today, in my thirties, continue to echo this childhood style. This experience is the polar opposite of D's experience with the dress. The cowboy-soldier repertoire furnished a range of significant styles that were then considered 'appropriate' for a boy. It provided the forms that enabled me to imagine myself *as* 'a boy' because these invited, through long convention and use, recognition as a boy from others; both from my parents and from the wider culture. To use or 'inhabit' those forms made it possible to elicit such recognition and to avoid the distress of scenes like D's encounter at the Children's Centre.

Anxieties about gender identity, and the desire to locate myself clearly and firmly in a world of sexual difference, would seem to have driven me towards precisely the most conventional forms and styles. The cowboy, the soldier, the adventurer, were not only 'masculine' forms but had come to be signs of masculinity as such. As popular, recognizable boyhood forms, they were already widely available in 1950s culture and were there lying in wait for me. In imagining myself in their terms, I entered into them, tried them on for size and cut myself to fit them. But at what price? When, in a panic, D takes off his dress for the last time, he takes off a part of himself with it, securing a 'masculine' identity by separating himself, through psychic

splitting, from a 'femininity' that is associated with the rejected forms. The process of splitting is made manifest through this cutting of the self to fit these recognizable cultural forms.

But this is not the end of the story. In the first place, while every boy has to learn to cut himself to fit, some 'manage' this more thoroughly than others; and all inhabit those styles and use those forms in different ways, making (within limits) their own versions of masculinity. Second, imagining an identity is not a fixed, once-and-for-all achievement, but is subject to continual reworking and transformation. The fixities of a clear and unambiguous gender identity are something desired as much as achieved; a wished-for end to the confusion and distress produced by a world divided by gender. In the ordinary course of growing up, children encounter new social situations and new publics, which bring about new anxieties and pressures on identity, as well as new sources of affirmative recognition and pleasure. Among these, school looms largest.

Boy culture

Recognition, of course, is not the monopoly of adults. Children play with other children: siblings, relatives, the children of neighbours and parents' friends all provide possible playmates, and opportunities for more equal and reciprocal recognitions than are possible between children and adults. My earliest playmate was a girl, Janet, a year older than me, whose garden backed onto ours. Photographs confirm that we used to dress up and play cowboys and Indians together (see Figure 12). While this confounds any simple identification of these as exclusively or necessarily boys' forms, our play did nevertheless have to negotiate sexual difference. I registered Janet's difference from me in terms of the frilly white braid around her cowboy hat. This made it, to my mind, not a 'real' cowboy hat, just as she was not a 'real' cowboy but a 'cowgirl', an Annie Oakley skilled with the six-gun.[5] Partly due to the distance I had to travel to my first school, I had no other regular playmate during my Doncaster years. But after our move to Hemel Hempstead in 1962, I became one of some thirty children attending a brand-new school that opened at the bottom of our road. As the school rapidly expanded, along with the housing estate that it served, a steady stream of new children joined my class. After a couple of years, this settled down into a cohesive and stable group that remained together for my four years in junior school, between the ages of 7 and 11. In this rich, new public world, all my most significant friendships were with other boys.[6]

Despite the school's egalitarian ethos and the friendships that flourished between boys and girls within the classroom, playtimes saw the formation of sharply gendered groups with distinctive forms of shared play. Chief amongst our boys' games were 'British Bulldog' (the tag game), playground football – and playing at war. All these games involved a large group which

divided itself into two sides. When playing at war, each side would attack and defend agreed 'bases' using a variety of tactics – charging, creeping up, outmanœuvring, holding strong defensive positions, counter-attacking and retreating – the aim being to capture the base and 'kill' all the enemy. Physically, the play was not unlike games of tag, the major difference residing in our narrative imaginings, amongst which Second World War themes were especially popular.

Since we were not allowed to bring toys to school or to use sticks, our weapons in all these narratives were completely imaginary, being represented for others by particular hand and arm positions; mostly those appropriate to each weapon, 'as if' we were holding a tommy gun at the hip or a sword in the hand. How these imaginary weapons were to be used, and the distances at which they would be effective, was governed by elaborate conventions, called 'taking your shots'. When 'using guns', for example, the convention was to catch the eye of your enemy whilst simultaneously 'firing' by making the appropriate sign at whomever you were shooting. 'Taking your shots' meant acknowledging when you were the target of a successful hit and falling down dead (with a cry reminiscent of the 'a-a-a-rghs' and 'u-u-u-rghs' much loved by the war comic-strip writer). You were then out of the game for the duration of that particular attack. If there was any ambiguity, you could claim to be 'only wounded' and continue the game partly immobilized. Anyone 'not taking their shots' would be pursued by a clamour to that effect. Disputes were resolved verbally between the two boys involved, and in serious cases the game would halt and others be brought in to pass a group judgement. 'Taking your shots' not only regulated the public interaction, but also set limits to private fantasy. Within these bounds, however, a great deal of give-and-take sharing occurred, whereby friends would reciprocally allot and be allotted places in each others' fantasies, regularly stepping out of self-absorption in the role in order to provide a commentary on 'what is happening now', so as to enable the other to respond appropriately.

At school, play became a social relation. To be successful, playing together necessarily involved the sharing of narratives and self-imaginings. These assumed a social form, governed by conventions and rules, through active negotiation with others who were also investing their own imagined selves in a narrative that was at one and the same time determined by numerous internal worlds and had a public existence. Since my own imaginings had to respond to the doings of others, the fantasies of shared play involved a significant giving-up of omnipotent control. In recompense, to allow an other to enter into and share in some of my most significant fantasies, and to be allowed to enter into and share in his, promoted a very powerful kind of social recognition: one that depended on trust, mutual enjoyment and the reciprocity and equality of the exchange. Through shared play and the negotiations that sustained it, we could give each other a kind of

recognition that was available nowhere else. Our play identities as soldier heroes, recognized and affirmed by others, became 'real' in the sense that our play relationships and play itself were central components of our real, developing friendships. Just as we could move fluidly between absorption of the self in play and the explanation and negotiation needed to secure its shared character, so the medium of our friendship could shift fluidly between being a soldier hero and being the boy who explained, negotiated and helped resolve disputes.

As this kind of reciprocity developed, and my group of boy friends began to provide an alternative basis of affirmative recognition, playground war games became increasingly important in my life. The pleasures of war play were a significant factor in attracting me away from the security of the domestic sphere into a more fully committed participation in the public world of the school: as a 7-year-old, it was their lure that prompted me to ask my mother if I could begin to stay for school dinners. My independence from the family household, and perhaps especially from my mother, was strengthened to the extent that I could belong, with mutual recognition, among other boys with similar needs, in a group that bonded together around common interests and practices. The shared forms of this distinctive 'boy culture' were those of a collectivity defined by age and gender, in and through which we affirmed our 'masculinity'.[7] As its influence spread beyond the school gates, the connotations of distance and independence from domesticity became increasingly attached to its forms. From the age of 7 or 8 years old, as we were trusted farther afield without parental supervision, we began calling for each other not only to stay in and play in our various houses and gardens, but also to 'go out to play'. Boy culture gradually came to occupy the wider public spaces of the neighbourhood: the streets, alleys and garage-areas of the estate, the apple-orchard behind the shops, the green and, given our semi-rural location, the nearby country lanes, farmers' fields and woods.

These became an adventure world, invested with excitement by frontier narratives of exploration, survival and combat like the Crusoe story. Indeed, in a sense these narratives functioned here as an energizing myth, no longer inspiring men to go out to the imperial frontiers, but now inspiring boys to invest their own neighbourhood with all the characteristics of a wilderness. We made secret camps in trees and in thickets of ferns that rose above our heads, followed paths and tracks to see where they would lead, and played war games with extended scope for hiding, ambushing and tracking. The imagining of adventure offered the means for us to move away from the safety of home and garden into an engagement with a real public world that was as new and unknown to me as Crusoe's island was to him. Learning to inhabit that world as a significant and exciting place was not entirely an imaginary act, but involved the acquisition of actual skills and knowledges: orienteering, exploring, building.[8] Entering into it also enabled an actual

freedom, from parental control and the tasks of the domestic home, to do what I wanted, with my friends. This is a distinguishing mark of boyhood that contrasts with the more restricted mobility of little girls, a result of the greater responsibility that they are often given for the care of younger children and other domestic labour.[9]

My remembering of boy culture during the four-year period of my time at junior school is vivid with excitement and pleasure. I see it as the period when my overall self-confidence blossomed and when, especially as a 9- and 10-year-old, I enjoyed being popular with other children in the class.[10] Two 'best friends', Michael and Patrick, stand out from a number of other close friendships as being especially long-lasting and significant. Alongside our sharing of adventure fantasies, what I remember most clearly is an easy physical warmth and closeness, often expressed in wrestling; indeed, my feelings for Patrick had all the passionate intensity of a love not fully recognized as such. I retain a nostalgic yearning for this lost boyhood intimacy, and this period of my life has assumed in memory the ideal quality of a golden age when all was happiness and contentment. At one point during it, however, my father was treated in hospital for a serious illness and was off work for some months. I was badly affected by this, and among the unspoken anxieties of family life at the time, I became an insomniac in need of sleeping pills and a night-light. The discrepancy between these anxieties and my idealized memories of boy culture in this period, from which they are utterly dissociated, suggests that my self-imagining as an adventure hero, and my recognition as such by other boys, was the cultural form of a psychic splitting in manic defence against them.

In Kleinian terms, defensive idealizations of this kind are not necessarily a bad thing and, in the protection they provide against the unravelling effects of anxiety, may have important psychic benefits. These benefits may be augmented in imaginings that are shared with others. In contrast to the omnipotent control exercised in wish-fulfilling play with toys, the reciprocal recognitions that occur in shared play fantasies offer possibilities for the introjection of qualities derived from real other people rather than from one's own projected wishes. According to Klein, these are the kinds of introjection upon which any effective integration of the internal world depends: they make possible the 'modification of imagos' into more complex and less dichotomous figures, and thus enable a greater capacity for subjective coherence.[11] While the adventure fantasies of boy culture can be understood in terms of psychic splitting and the operation of manic defence against anxiety, the social recognition involved in their sharing may help to promote an increased cohesion and security of the inner world that in turn facilitates the facing and working-through of difficulties encountered in social life.

Yet my identification with this particular cultural form of idealization was not without its costs. Whilst I was an adventure hero, other aspects of my

social world literally disappeared. Participation in boy culture took me out into the 'adventure worlds' of school and neighbourhood which were predicated increasingly upon their separation, both physical and psychic, from the world of domestic life. The composure of self-imagining as a hero, the pleasures of war play and the recognitions of boyhood friendship all came to depend upon this distance. But of course I did not thereby cease to live in that domestic world: at home I continued to be involved in intense and tangled relationships with my mother, father and brother, and to participate in the extended family circle. Locating myself in these social relations required an altogether more complicated kind of self-imagining, one capable of negotiating the full range of adult recognitions and misrecognitions. Similarly, the exclusion of girls from boy culture did not mean that we boys ceased to relate to them within the public space of the classroom. Friendship with girls made other kinds of demands upon our self-imagining, and the presence of teachers insisted on other kinds of recognition, in forms that were 'policed' by the educational and egalitarian ethos of the school. Even within boy culture, the adventure hero coexisted with those other selves who played football or marvelled at the natural world. Seen within the context of my experience as a whole, the adventure hero appears as one split form among many other selves, between which 'I' would fluctuate. These were at once the inhabitants of a complex and divided social world and of the fractured inner world correlated to it.

To understand my boyhood self-imagining as a soldier hero, then, it is necessary to enquire into its relation to these other selves. In the Kleinian model, the various split parts of the self coexist within a more extensive subjectivity for which further integration is a psychic option both feared and desired: feared, because splitting offers distinct benefits, that render forms like the idealized adventurer so attractive to inhabit and so difficult to relinquish; desired, because greater psychic coherence holds out the promise of a fuller and more effective participation in social life. The social and psychic costs of preserving defensive splits become visible at moments of schism between different selves, when temporarily their connectedness cannot be denied, so that their incompatibility is experienced as a contradiction: one self is exposed to consequences brought about by the actions (or imaginings) of another. To explore these moments of schism as they break open the apparently seamless coherence of my boyhood adventure heroes is to step outside the pleasurable memories of past investments into more difficult and troubling memories of discord and distress. These are precisely the experiences against which the adventure hero offered a defence, but which inevitably occurred, despite him.

One painful memory of my boyhood concerns the collision between two worlds, and two selves, when I was 10 years old. It features my best friend Patrick, who lived nearly a mile away from our house and the school at the bottom of our road. One Friday I had made an arrangement with him to

play down the lanes after school. He wanted to go home and change into his soldier's gear, and would then walk all the way back to my house to call for me *en route* to the lanes. When I arrived home, however, my parents insisted that I went shopping with them in town, forbade me to go out and overrode all my protests about Patrick. I felt dismayed and humiliated at my inability to honour our arrangement. Through no fault of my own, I was going to let Patrick down and betray our friendship. He would come all this way for nothing, and (in the days before we acquired a telephone) I could do nothing to prevent it. When Patrick arrived, eagerly expectant and togged out in his soldier's kit, helmet and gun, and I had to give him the news, I burst into tears.

The intensity of my memory repeats the intensity of the original experience: a moment of irresolvable contradiction when the splitting between alternative selves was exposed as such, and my powerlessness in relation to my parents was seen to override the self I wished to be. I felt my parents to be unfair, but more importantly, to be denying my autonomy by refusing to recognize the importance – and the forms – of my friendship with Patrick. This sense of my powerlessness in the face of parental authority was heightened by its explicit negation of the powerful, even omnipotent, soldier hero whom I would become on leaving behind the controlled space of the home in Patrick's company. Feeling the distress arising from this contradiction only made it worse, since my would-be bravado in the face of danger and adversity was replaced by the actual tears of a small boy resigned to defeat. Worst of all, these tears were shed, not in front of my parents alone, nor in front of Patrick in his ordinary clothes, but at the sight of a Patrick who had already become a soldier hero. Dressed up, he was the very image of what I wished to be but had now been denied; and instead of exchanging the empowering recognitions of shared adventure, I stood before him as the very image of what we both hoped to escape.

Both the desirability of splitting and its costs as a defensive strategy are captured in this image of two boys facing each other through an open doorway. One remains inside experiencing distress and wishing to escape over the threshold, but is powerless to 'go out'; while the other, already over that threshold, is powerless to help. For adventure, as we knew it, could only handle such conflicts by offering escape from them. The imaginary coherence of the kind of adventure hero whose forms we inherited depends upon its clearly occupying the 'public' side of the public–private division. The price of this coherence is the splitting-off of the adventure hero from the imaginary selves who inhabit the 'private' side of the division. When I was called away from the exciting world of adventure down the lanes to go shopping at Tesco, the mundane and boring tasks of the domestic household were reaffirmed *as* mundane and boring by comparison; and the reciprocity of boy friendship appeared so much more preferable to the complicated

relationships of the family, saturated as they were with controlling power and resistance to it.

In another memory of boyhood discomposure, my discomfort also derived from the temporary impossibility of shared adventure, this time with a girl. Within the structured context of school activities, friendships between girls and boys flourished: one of my own favourites was a girl named Anne, with whom I shared a double-desk during my second year in the juniors. Outside that context, so many of our pleasures, pursuits and imaginings were gender-exclusive that it was hard to find common ground. Gender separatism in playground and neighbourhood was such that Anne and I never called for each other at home, and my efforts to remember anything about girls' culture or any shared forms of play have drawn the blankness born of difference. Certainly I and the boys in my group did not extend the recognitions of shared adventure to girls. On the unusual occasions when girls and boys did meet outside school – at birthday parties and suchlike – the atmosphere was charged with a peculiar kind of excitement and permeated by a very different kind of imagining: romance. Contrary to the assumptions of some cultural critics, masculinities are also imagined in 'feminine romance'.[12] The chief vehicle of my own introduction to these narratives of heterosexual love and desire – in a form that was easily split-off at a safe distance from the adventure world – was pop music: the radio charts, but especially my older brother's Beatles' albums that I listened to over and over again on his tape-recorder. Here, at least, was a possible common ground.

Romance hung uneasily in the air on one extraordinary occasion when, as an 8-year-old, I was chosen together with Anne to accompany the headmaster on behalf of the class on a shopping trip to buy a leaving-present for our class teacher. This unusual contact with her augmented the excitement of the occasion, but when we eventually found ourselves left alone together in the Headmaster's van, we were suddenly shy of each other and sat tongue-tied and vacuous. How much easier it would have been, with a boy, to share the excitement of the trip as an imagined adventure! By comparison, the self I could imagine through romance was so much more tentative and uncertain of itself. I felt the adventure hero to be the most powerful of my self-imaginings because it enabled the avoidance of such difficulties in a world where these other relationships did not (or should not) exist. The dangers inherent in the collision between boyhood adventure and romance were to be demonstrated a year or so later when, one day in the school playground, Anne became the first girl I ever kissed romantically, and the other boys ridiculed me mercilessly as a 'softie' (one who was 'soft' on girls). Construed in terms of romance, this could be seen as an expression of friendship with positive connotations. In terms of the 'harder' codes of an exclusive boy culture, however, it was an act of weakness that invited projective disavowal of the adventure hero's denigrated other. Here, the masculinity of the

idealized adventure hero appears to have been, not one choice among many possible selves, but a form that was installed as the norm, to be policed by group recognitions and by the withdrawal of affirmation.

The common factor in my distressing memories about Anne and Patrick is the collision between two very different imagined selves, and the exposure of limitations and inadequacies in the adventure hero as a mode of defensive self-imagining. These contradictions can be closely related to splitting in cultural imaginaries and the different positions occupied by boys and girls in relation to the public sphere. Far from enabling me to locate myself effectively within these social divisions, and to handle the many kinds of recognition generated by them, adventure tended to render these complexities invisible. These difficulties became magnified once I left the juniors for secondary school, and entered adolescence.

Hornblower meets the skinheads: the abandoning of adventure

In contrast to my memories of primary school as a nostalgic golden age of happiness and contentment, I remember my first three years at secondary school (1967–9) as a time when I was lonely and unhappy and lost a good deal of confidence. Allocated to different schools in various parts of town, my group of primary-school friends was split up. None accompanied me to the grammar school some twenty minutes' walk away, where I followed my older brother, and under the demands of a new way of life, losing touch with them seemed inevitable. In my new school-public I encountered new kinds of recognition, not all of it affirmative, and experienced new anxieties. I sought to make friends among boys who mostly lived on an estate neighbouring the school – an estate that I found distinctly 'rough' in comparison with our 'respectable' area – or who were bussed in from the 'posh' parts of nearby Abbot's Langley. In this new school I had to confront and live out the ambiguities and contradictions of my family's class position, experienced in terms of my encounter with different forms of adolescent masculinity.

My father was a primary-school teacher whose promotion to a Deputy Headship had enabled our 'escape' from Doncaster and the claustrophobia of a traditional working-class family network. My mother, after working for several years in low-skilled jobs on the local industrial estate, became a school dinner-lady and eventually trained as a teacher herself. Our own tentative social mobility, as we gradually settled into the life-style of an aspiring, lower-middle-class professional family, was paralleled and to some extent obscured by the more general expansion of horizons and opportunities characteristic of many working people's lives in the 1960s.[13] Our New Town housing estate and primary school, with its uprooted mixture of skilled and unskilled, working-class and middle-class families, was typical of these transformations in class and culture. My experience there left me utterly unprepared for the degree of physical intimidation and fighting, as

271

well as the overt and, to my sheltered sensibility, rather brutal, masculine sexuality, that were part and parcel of my new school's culture. From basking in the centre of positive recognition and approval at primary school, I now found myself increasingly marginalized within a new public of tough, sporty skinhead lads who defined successful masculinity in terms that I felt myself unable to meet. Afraid of some, while admiring and wishing to emulate others, I gained little affirmation from any of them.

In response, I sought solace in the comfort of adventure, but found even this to have changed. While continuing to play with my soldiers into my twelfth year, I became increasingly conscious of their 'childishness'. Having lost the friends with whom I once shared adventure play fantasies, I was now confronted by adolescent, subcultural expectations of real masculine prowess and by the impossibility of recognition as an adventure hero without the performance of actual rather than imagined deeds. In these circumstances, my adventure fantasies became solitary once again. The forms that gave me pleasure, however, were ones that related to these new dilemmas.

I have a vivid memory of a particularly satisfying game that I played by myself as a 12-year-old, during the summer holiday following my first year at secondary school, while camping in the Lake District with my family. With a carefully chosen stick I would absorb myself for long periods in swathing down dense banks of nettles, some as tall as myself. The stick was a sword, the nettles were the massed enemy hordes, whose unpleasant sting justified their destruction. They would outnumber in quantity, but not outmatch in quality, the gallant and deft swordsman who would cut a path through them back to the family tent and evening meal, defying sting-wounds which, if received, were never more than a scratch. This swordsman was Captain Hornblower RN, the naval hero of C. S. Forester's famous sequence of novels set in the Napoleonic Wars, in which I immersed myself for the first time on that very holiday (and would reread several times over the next few years).[14]

In Hornblower, I found a hero relevant to the new conflicts and anxieties that I faced at secondary school. Anxieties about not fitting in and my lack of affirmative recognition were augmented by a feeling that I was somehow responsible for this, that I must be at fault. I came to experience conflicts stemming from my relationships with other boys as a conflict in myself, between the rather pathetic and inadequate boy I now felt myself to be and the powerful, well-liked boy I wanted to be and saw in others. The form of my misrecognition by the skinhead lads coincided with and reinforced denigrated imagos with which I now began to identify myself, establishing a vicious circle of lowering self-esteem. I could counter these anxieties, however, in wish-fulfilling fantasies in which I became omnipotently powerful and triumphed over all enemies and obstacles. Playing the part of

Hornblower in solitary play, and swathing down compliant nettles in a most satisfying manner, I became the hero I wished to be.

The Hornblower novels appealed to me as a 12-year-old because of the greater realism of their characterization in comparison to many other adventure stories. The simple splitting that produces hero and enemy in narratives like 'Attack on Marzuk' or *Bugles in the Afternoon* is tempered into a more complicated and troubled hero who spoke more directly to my own anxieties. The novels that I read first – coincidentally the earliest in the sequence to be written – tell of Hornblower as an up-and-coming junior captain in the Royal Navy. Like my own long-established play fantasies and many other public adventure narratives, they deal explicitly with the desire-for-recognition theme and invest martial rank with intense significance. Hornblower's worth is not yet recognized and he sets out to prove himself through military adventure. As a captain commanding his own ship, he is sent on individual missions to distant waters, where his initiative is given full scope but where the opportunity for success always carries a high risk of failure. In order to succeed, besides defeating the French and Spanish enemy, he must also negotiate the navy's hierarchy of authority and prestige. He becomes engaged in a constant struggle to win the respect, obedience and loyalty of his officers and crew, and – in a familiar evocation of persecutory anxiety – he finds his risks magnified by orders from above that are seemingly arbitrary, often ill-judged and always punishingly demanding.[15] Performing the impossible against all the odds of course enables Hornblower to become a hero. But even when successful, his achievements are not given the recognition they deserve by the Admiralty. In *A Ship of the Line*, for example, the story begins with Hornblower lamenting his ill-fortune at being granted no prize money for his victory over a much larger Spanish warship, narrated in the previous novel, *A Happy Return*.[16] Social recognition of the hero is withheld – to fuel further adventures.

Another factor that helps to explain my attraction to Hornblower is the way his struggle for respect and recognition is given explicit class connotations throughout the novel-sequence. In subsequent volumes, Forester fleshes out his hero's past as a boy-midshipman and service-orphan – echoes of the orphan phantasy so prevalent in girls' comics, here – from a poor family with no influential connections. Upwardly mobile and of middling rank, Hornblower's original class location always renders him vulnerable in a highly stratified society even as he rises through it by promotion. As a captain he lives in constant fear of being ruined, and at the start of *A Ship of the Line* his 'poverty-stricken condition' gives rise to anxieties regarding status and prestige. What other captains take for granted – the trappings of status, the outward signs of power – Hornblower cannot afford and has to fight for. Since he moves in circles above his station, almost every social encounter with his colleagues and superiors involves some degree of shame, unease and social doubt, which fuel his self-criticism and his need to prove

himself. Material security, his naval reputation and an established position in society are all dependent on his success as a fighting captain. At the same time, in dealings with his own subordinates he has to win the respect of tough ordinary-seamen whose expectations and standards of behaviour are equally alien to him.[17]

The question of masculine identity lies at the centre of Hornblower's struggle for recognition. Here again his attraction, for me, lay in the unconventional characteristics that disadvantage him for the achievement of ideal heroism. Just as I failed to achieve the required masculine standard in terms of physical prowess, Hornblower is apparently a non-starter as a soldier hero. As a midshipman he is gauche and gangling, while as a captain he remains physically weedy, with spindly legs and poor arm-strength – and invariably he gets sea-sick at the start of every voyage. Like my own adolescent self-identification in terms of brain rather than brawn, Hornblower's natural bent is as an intellectual: he has a calculating, analytical mind and an extensive knowledge of seamanship and naval strategy, which he applies in careful planning of any sortie or attack. All his adventures involve moments of carefully realized calculation and risk-taking, as he devises daring solutions to the tasks and dangers before him. Nevertheless, Hornblower does make himself into a fighting man. Not content to be the distant tactician, and refusing to order his men to do anything he has not proved himself capable of doing, he insists on himself leading the missions and expeditions he has designed; and this in the teeth of his own palpable fears and sense of physical inadequacy. A fighting hero by effort of will, who demonstrates courage and integrity as qualities to be struggled for, Hornblower made it possible for me to imagine their achievement. Combining in himself qualities that I struggled to hold together – intellectual and physical achievement; fear and courage – he offered me the possibility of integrating what might otherwise be split between different imagos (one an impossibly idealized hero and the other a contemptible rival or enemy), and so of modifying the more extreme features of my own self-denigration.

Hornblower, too, is a figure torn by warring parts of the self and constantly strives for that elusive masculine integrity himself. His own self-esteem remains low, and he is engaged in a constant struggle to live up to his own impossibly high ideals and to cope with his own savage self-criticism. This inner conflict only ceases when he is involved in the problem-solving associated with running a ship, following an order or fighting a battle. The start of novels often finds him itching to get into his ship and set sail. Once at sea, he achieves a mode of 'being himself' that is constantly thwarted on land. Action and adventure, then, provide the means by which inner conflict and self-doubt can be imagined as overcome, enabling Hornblower to attain his ideal self and win public recognition. The heroic fantasies that accompanied my sword-fights with nettles did the same for me. When I imagined myself as Hornblower, not fitting-in had its own recompense.

Like Sergeant Miller from the *Victor* story, Hornblower succeeds in winning the admiration and affection of the men he commands; and as the novel-sequence progresses, even the naval hierarchy is gradually brought to bestow recognition and honour upon him. At the culmination of this public recognition, Hornblower becomes a Lord and an Admiral.[18] To this extent, he remains a conventional, wish-fulfilling adventure hero. Even as a Lord, however, he never inhabits positions of status and prestige comfortably, and never quite belongs either in aristocratic circles or among the seamen he commands. Like myself at that time, he is an essentially lonely figure. In Hornblower the self-made man, self-contained and self-reliant, able to negotiate successfully the cultures he never really belongs in, but never escaping a background that marks him out as different, I found an ideal hero relevant to my own experiences.

With hindsight, however, the ideal appears more problematic. The earlier novels reproduce the damaging split between the worlds of adventure and domesticity by closely associating Hornblower's escape to sea with escape from the demands of his wife, Maria.[19] She is described as a plain and dumpy woman who simultaneously nags and adores him. Her presence in the narrative makes Hornblower into a stereotypical hen-pecked husband. He observes the forms of marriage with dutiful resignation, but guiltily wishes to leave Maria far behind. This conventional 'escape from domesticity' motif gave me little help in coming to terms with my own contradictory relation to domestic life. However, it is complemented by the introduction into the Hornblower adventures of a love interest. To his great surprise, Hornblower exercises a great charm and attraction for women, who fall in love with him easily, despite his own uncertainties and lack of initiative. In the very first book, Hornblower finds himself in a hopeless mutual passion with the glamorous, high-born Lady Barbara. In a later novel, the contradictions in Hornblower's class position are resolved on this rather effortless romantic terrain when Forester conveniently kills off Maria and their children with the smallpox. The narrative displaces Hornblower's grief and guilt into excitement at the possibility, and eventual achievement, of marriage with Lady Barbara. The female characters in the Hornblower novels are split in this way into an idealized romantic aspect and a denigrated, ultimately dispensable domestic aspect.[20] This corresponds closely to the dominant forms of recognition for girls and women within the culture of adolescent boyhood at my school: forms that were becoming increasingly problematic for me as I began to turn to friendship with girls as an alternative source of pleasure and affirmation.

It also seems significant in retrospect that, unlike my earlier identification as the Lone Ranger, Hornblower is a British hero. For it is by virtue of intensely personal fantasies and meanings of the kind that I have explored in these last two chapters that British military masculinity becomes a figure of excitement and pleasure for boys and men. Hornblower is sustained

throughout his career by an ideology of service to King and Country, which gives meaning to his life, and to which he submits his personal destiny. In many respects, he is a deeply conservative figure, and it would not be difficult to produce a reading of the novels that demonstrated their affinity with a number of themes central to the discourse of conservative British nationalism. Duty, freedom, the individual and self-help all feature prominently. They are linked to an uncritically 'patriotic' popular memory of the Napoleonic Wars as a struggle for national survival against continental tyranny. This found a powerful contemporary echo in the British response to the Soviet invasion of Czechoslovakia in summer 1968, when I was first reading the novels. Horatio Hornblower himself bears some striking resemblances to Nelson, that pillar of the conservative nationalist military pantheon.[21] In projective identification of myself with Hornblower, I was opening myself to the introjection of these conservative values and this version of Britishness.

That the national military masculinity represented by Hornblower failed to attain a lasting purchase into my teens was not due to any inherently radical political leanings on my part, but because my identification with the soldier hero failed to provide the composure and affirmative recognition that I now needed in the public worlds of school and beyond. Abandoning my deeply attractive but solitary adventurer, I looked elsewhere in search of new heroes. I discovered alternative possibilities in the counter-culture that began to develop a foothold in my school in the late 1960s and early 1970s. I was drawn to this by the attraction of possible new friendships with boys who were esteemed within the school, but who subscribed to a very different set of values and inhabited a different style of masculinity from the skinhead lads. There was scope in this for new ways of relating to people, new kinds of self-expression and new narratives that explored rather than sought to escape from the complexities of the self. I began to write poetry and play the guitar, to practise yoga and enjoy the world of psychedelia, to read Tolkien and Herman Hesse, to grow my hair long and wear flared trousers and brightly coloured T-shirts.[22]

Although the Women's Liberation Movement would subsequently criticize the supposed 'sexual revolution' stimulated by the counter-culture for reproducing established gender relations, in my experience it offered forms of masculinity that were less polarized in opposition to femininity than those I had known. The more emotional and vulnerable masculinity of the post-Beatles John Lennon, and the overtly 'feminine' style of musical heroes like Marc Bolan and David Bowie, offered new ideals to aspire towards in the early 1970s. Consequently, friendship with girls that went beyond romance became imaginable and increasingly important to me. Indeed, in psychic terms, my involvement with the counter-culture facilitated an identification with 'feminine' aspects of myself. In its espousal of liberation, self-fulfilment and 'playpower', and in its critique of the structures and

values of 'straight society', the counter-culture and its successors in the 1970s made possible a rebellious assertion of independence which called in question masculinity along with everything else.[23] This rebellion was directed against my parents and the school authorities, but also against their internalized imagos from whom I had sought recognition in adventure fantasies.

The counter-culture was furthermore inimical to the adventures of soldier heroes in its critique of militarism and wholehearted support of pacifism.[24] Two fixed memories from this period mark my transition from *The Guns of Navarone* in 1969 to *The Politics of Ecstasy* in 1971.[25] The first is a feeling of intense revulsion at a scene in a war film (the last I watched for many years). An American soldier, fighting the Japanese in the Burmese jungle during the Second World War, rests in the sun by a roadside, takes off his boots, enjoys a beautiful butterfly – and has his throat cut from behind by the enemy. The second is of my mother, furious, shouting at me to remove the white poppy I wore on my school blazer during Remembrance Week, and refusing to listen, in her rage at my disrespect for the nation's dead, to my explanation that I wished there to be no more war. The depth of my new-found revulsion in the first memory, and my sense of unfair misrecognition in the second, suggests a shift in the significance that war held for me, that was deeply bound up with attempts to compose a new sense of self. By belonging to the counter-culture, I could become someone different, both independent from my parents and better able to cope with the pressures of adolescent masculinity at school. Social recognition within the counter-culture depended upon inhabiting various shared beliefs and practices, and if these proved incompatible with my enjoyment of the masculine pleasure-culture of war, then the latter would have to be relinquished. Drawn into the forms of this new cultural imaginary, I abandoned my investments in adventure.

The return of the soldier

But is it ever possible to 'abandon' an identity that has become so deeply rooted in the psyche? The wish to rid oneself of an identification now felt to be an encumbrance is the concomitant of the process described earlier as 'cutting oneself to fit'. In order to inhabit one form, other parts of the self are trimmed away and consigned to the waste-bin. Rubbishing, denigration, disavowal: these are the psychic accompaniments of splitting and defensive projection, turned now against the once-idealized form as the idealizing investment is transferred on to its replacement. The hippy and the pacifist, just as well as the soldier hero, may become the forms assumed by the self as it 'searches for the secrets' of a painless and coherent identity.[26] However, those aspects of contradictory subjectivity that are denigrated and dis-avowed in this process do not thereby cease to exist. Their psychic reality

remains, even if unacknowledged, to perpetuate psychic conflict along new alignments, with implications for the possibility of social relationship.

In effect, while attempting to renounce the adventure hero, I maintained its existence as a split imago but simply reversed its value from positive to negative. There was more than a hint of a retreat from unresolved Oedipal dilemmas in this: my identification with the feminine also involved a new intimacy between myself and my mother, while the abandoning of my identification with adventure heroes would seem to have involved a projection of this now-denigrated imago into my father, whom I began to experience as the antithesis of my new self. Just as there had always been aspects of my life about which the adventure hero had nothing to say, relationships with which it could cope only by shutting them out, so the sustenance of my new oppositional identity now involved a rejection, not only of a part of myself, but also of a popular form of imagined masculinity and those boys and men identified with it. Among the problems this would generate for my future relationships with other men, the first and greatest difficulty that it delivered me into was an overt and damaging conflict with my father. It was he who bore the brunt of my rebellion, and in reacting to this, only exacerbated a conflict that came close to blows on one occasion in my later teens, when he contested my right to wear long, shoulder-length hair.

These conflicts, both psychic and social, ensured that the counter-cultural identity of my teenage years could only be – like any other identity – a provisional and semi-resolved response to the contradictions of subjectivity. I sustained it, nevertheless, through to my second year at university in 1975-6, after which the need to find some means of integration became pressing. When I was introduced at university to Marxist cultural studies, alternative ways of understanding my history and that of my family, within the broader context of socialist and feminist politics, became available. These helped me to begin building bridges between my father and myself: to begin to effect reparation of the damage done through defensive splitting to us both. Our arguments about whether or not *The Dirty Dozen* was just harmless escapism played an early part in this process. My encounter with psychoanalysis and psychotherapy has been one of the directions it has taken subsequently; writing this book, and rethinking my own relation to adventure and its significance in my past, has been another.

In the course of this investigation I have been surprised by the potential of my long-renounced identification with the soldier-hero imago to revert to its original positive value. In Chapter 9 I touched on the pleasures of remembering boyhood adventure, and the obstacles that this transference placed in the way of my endeavours to attain a critical distance on masculinity.[27] One manifestation of this ambivalence has been my difficulty in achieving a flexible writing voice when exploring these memories, a voice that could enter into the unconscious investments that have transferred on to my descriptions of boyhood forms, without getting caught up in them. My

first drafts invariably tended to reproduce boyhood excitements in over-elaborate and uncritical detail, while many of the gaps and silences that marked the parameters of those original investments were repeated in the writing. My first discussion of women characters in adventure stories, for example, took the form of a paragraph tacked on at the end, as an after-thought to the serious business of analysing the hero. The crucial domestic context of play and its connection to family dynamics and my relationship to parents has proved especially difficult to recover.

I have come to see these transferential investments at work in my writing as the site of an active contradiction. My analysis of the adventure hero and masculinity has developed in fruitful dialogue with feminism. Feminist ideas and politics have profoundly influenced my understanding of gender relations and my own sense of myself as a man. They have contributed to my growing awareness of how my 'socialization' as a boy and a man has involved benefits, privileges and opportunities less readily available (at the very least) to girls and women, but also how it has subjected me to a variety of negative pressures, that have stultified and limited me, caused me unhap-piness and contributed to failures of understanding and communication. To tease open this process and explore its contradictory results can be a positive and challenging experience that opens out masculinities to constructive change; this being one of the motivating desires behind my investigation of adventure. In remembering my own boyhood, however, I found myself defining my approach to the soldier hero and adventure *against* feminist approaches, many of which have tended to be overtly critical, even hostile, to these forms of narrative and subjectivity. This was particularly the case in my writing about boy culture, which I sought to rescue from charges of misogynistic 'male bonding' and of fostering masculine aggression.[28] There was more to this than rational academic or political disagreement. In effect, my writing functioned here as a defensive reaction against criticism of war play that seemed to threaten the value I had invested in those memories. It became charged with a sense of my misrecognition as a man by women, and with a corresponding wish to overcome this by composing a positive account of boyhood masculinity that would elicit more favourable recog-nition instead.

Soldier heroes are not only kept alive by the reproduction of public narratives that tell their stories, as in the unbroken reprinting of *Seven Pillars of Wisdom*, or the twentieth-century history books featuring Indian Mutiny generals. Introjections of the idealized heroes and heroines of children's culture persist as imagos in the internal worlds of adults, where they retain the potential to become active once again. While each new generation of boys will encounter only the very latest heroes or those handed down to them from the past, others live on in the psyches of their fathers and grandfathers. These latter are altogether more ambivalent phenomena, which give rise to some unexpected conflicts.

One notable instance is that of the Kenyan novelist and playwright, Ngũgĩ wa Thiong'o, who has written about the 'drama of contradictions' that he had unwittingly played out as a 16-year-old reader of the Biggles books in mid-1950s Kenya.[29] While Ngũgĩ at his colonial high school was thrilling to the adventures of Captain W. E. Johns' fictional RAF hero, his brother was fighting for Kenyan independence with the Mau Mau guerrillas in a war that was eventually won for the Empire by RAF bombers.

> Biggles . . . would have been pitted against my own brother who amidst all the fighting in the forest found time to send messages to me to cling to education no matter what happened to him. In the forests they, who were so imbued with Kenya nationalist patriotism, had celebrated my being accepted into the same Alliance High School where I was to meet Biggles, an imaginary character so imbued with a sense of British patriotism. . . . The flag which we saluted every day accompanied by God Save the Queen, may she long reign over us, was central to the Biggles enterprise.

Thirty-six years later, the contradiction can be named and understood as such: 'The Royal Air Force? That should have alerted me, should have made Biggles my enemy.' Yet Ngũgĩ also testifies to the power of these stories to cut across the more obvious political identifications by evoking a more direct and exciting fantasy:

> The Biggles series were full of actions, intrigues, thrills, twists, surprises and a very simple morality of right against wrong, angels against devils, with the good always triumphant. It was adventure all the way, on land and in the sky. . . . The books did not invite meditation; just the involvement in the actions of the hero and his band of faithfuls. They were boy's books really. I could never think of Biggles as an adult. He remained an adolescent, a Boy Scout . . . a boy daring to try, never giving up, stretching the boundaries of what was credible, but still inviting his boy readers to join in the adventure.

Ngũgĩ's memories evoke the pleasures of Biggles in terms of a utopian, adolescent longing for an uncomplicated, unthreatening world of boundless possibility where the harsh realities and ferocious conflicts of colonialism need not intrude and where everyone is still a boy.

Although Ngũgĩ does not say whether the memory of these past investments in the cultural forms of the colonizer poses any problems for him today, his essay implies that the reality of this contradiction became evident to him as he left boyhood to fully enter the adult world, where he learned to recognize who his enemies really were. But what of cases where the contradictions cannot be named as such – where the conflicting identifications are not worked through to some fuller understanding? What of those of us formed on the other side of the colonial divide, and whose national imaginary

has become so profoundly nostalgic for the days when 'Britain was . . . the nation that had built an Empire and ruled a quarter of the world'?[30]

Something of the utopian excitement, the manic triumphalism of a boyhood adventure magically transferred to the real world, characterized the national-popular mobilization that sustained the Falklands-Malvinas War. Without seeking to reduce the complex determinations of that conflict to a simple matter of identity-politics, I want to suggest that this mobilization depended upon narratives whose psychic charge tapped the childhood bases of subjectivity in generations brought up on either the national heroics of the Second World War or the imperial epic before it. It is no accident that the Falkands War, like so many others, was fought in the name of the past, in defence of an idealized value – 'our way of life' – that was imagined to be under threat. The extraordinary conditions of wartime encouraged the transference, on a collective scale, of anxieties and fears of destruction and loss that might otherwise have had no occasion to manifest. The idealizations recalled in defence against them were familiar, recognizable forms from the national imaginary: brave and righteous soldier heroes who fought the good fight against their moral inferiors, under a leader who, although disturbingly a woman, was closely identified with Churchill, the great masculine protector. At this psychic level, the Falklands-Malvinas War was conditional upon the condensation of national and colonial imaginaries that occurred during and after the Second World War, and would have been unimaginable without it. However much we might wish that the national past would cease to haunt us, soldier heroes like these will keep on returning, until such time as we can face the conflicts and contradictions of our position in the contemporary world more realistically.

AFTERWORD
Soldier heroes and the cultural politics of reparation

> It is only by understanding the real contradictions of the world, and tolerating them in an emotional sense, that it is possible to consider how to bring about change.
>
> Stephen Frosch, *The Politics of Psychoanalysis* (1987)[1]

I have argued in this book that the modern tradition of British adventure has furnished idealized, wish-fulfilling forms of masculinity to counter anxieties generated in a social world that is deeply divided along the fracture-lines of ethnicity and nation, gender and class. The soldier heroes composed in adventure narratives, being ideally powerful and free from contradictions, function psychically and socially as positive imagos to set against the fragmenting and undermining effects of anxiety. They offer the psychic reassurance of triumph over the sources of threat, promising the defeat of enemies and the recovery of that which is valued and feared lost. Having accomplished their quest, they win recognition and bask in the affirmation of their public, for whom they become idealized vessels preserving all that is valued and worthwhile. Identification with these heroes meets the wish to fix one's own place within the social world, to feel oneself to be coherent and powerful rather than fragmented and contradictory. It offers the assurance of a clearly recognizable gender identity and, through this, the security of belonging to a gendered national collectivity that imagines itself to be superior in strength and virtue to others.

As defensive strategies of containment, the split forms of modern British adventure are an historically specific response to social contradictions and psychic anxieties that developed in the course of the nineteenth century. In the reconfiguration of cultural imaginaries that emerged from mid-century, two particular relations proved to be of decisive significance in the history of adventure, a significance that has lasted into the late twentieth century. The first was the new centrality of Empire to the imagining of British national identity. The triumphalist narratives of nineteenth-century soldier heroes like Havelock were underpinned by the deployment of modern imperial power to subjugate and dominate colonial territories and colonized peoples.

But they were also, crucially, the products of phantasies in which the values of 'Britishness' were felt to be under threat of loss and destruction. The heroic national masculinity required to counter this threat came to be secured through the gendered splitting in cultural imaginaries along the public–private divide. In this second decisive relation, the qualities and achievements of the adventure hero became separated from, and defined against, the concerns and values of the domestic sphere: the locus of femininity and everyday intimacies, of parenthood and relationship between the genders. The modern soldier heroes produced within this configuration were made widely available as national-popular figures under a further material condition: the development of the public media of communications into a nationwide network addressing an inclusive and increasingly unified national public.

In tracing the subsequent transformations of these Victorian imaginaries through the latter parts of this book, I have sought to demonstrate that, notwithstanding the many shifts in the significance of soldier heroes and their enemies, these fundamental conditions of existence have remained in place to determine late-twentieth-century forms of adventure. The popular resonance of the Falklands War story – the original starting-point for this investigation – can be understood in terms of its evident continuities with the post-Victorian tradition of adventure. These are manifest in the war's origins in a dispute over colonized territory; in its long, preliminary adventure (the journey stage of the quest), as the all-male Task Force sailed far from home and family into a recognizably bleak and forbidding adventure landscape where the decisive conflict would take place; in its commando-like excitements and eventual victory over the denigrated 'Argie' enemy; and in its construction as a national spectacle by a patriotic British media operating under archaic restrictions reminiscent of the era before television.

Through soldiers' stories of this kind, a national past lives on. It does so both in the sedimented forms and facilitated pathways of the national imaginary, where powerful historic connections with military and imperial imaginings continue to be reproduced, and in the psychic lives of succeeding generations, including those of the post-imperial era, who have introjected these forms as aspects of their own internal worlds. The purchase of public forms of adventure narrative, and of the identities composed within their terms, have their roots in these psychic introjections. They remain attractive for the solutions that they offer, as phantasies, to psychic conflicts. Those boys and men who wish and are able to identify with them may feel themselves to be in possession of the secrets of masculinity and freed from anxieties about being 'unmanly'. British national-popular mobilizations, from the Indian Rebellion to the Falklands-Malvinas War, have tapped these latent sources of triumphalist psychic energy and enabled its collective expression. This has been reinforced by the hostile and coercive misrecognition of those who reject this expression, as in the white feather sent to

'unpatriotic cowards' refusing military service, or the headline in the jingoist press labelling political opposition to war, and even critical commentary upon its conduct, as 'traitorous'.[2] Together, these strategies have furnished leaders of the nation at war with a formidable arsenal of cultural fire-power that opponents have laboured to rival.

In the 1980s and 1990s, however, we have seen the beginning of a shift in adventure away from national forms of identification towards more 'global' conflicts between 'the West' and its enemies, often some supranational entity or 'terrorist' organization. This process is evident in the cult status achieved by the SAS following their storming of the Iranian Embassy – the British base of the new 'terrorist state' – in Prince's Gate in 1980; in recent forms of war toy and their comic and video spin-offs, such as the 'Action Force' series, produced by multinational conglomerates for a world market; and in the pattern of actual Western military intervention, seen in the establishment of NATO Rapid Deployment Forces and, more significantly, in the 'Allied' war effort during the 1991 Gulf War against Iraq.[3]

In the narratives of this latter conflict, in which elements of the old tradition of adventure coexisted alongside emergent elements suggestive of a new configuration of imaginaries, the outlines of adventure in the future could be discerned. The demonizing of Iraqi leader, Saddam Hussein, as an irrational and dangerous hate-figure – an imaginative compound of Hitler and half-forgotten anti-colonial rebels like Nana Sahib or the Mad Mullah – derived from a paranoid splitting that legitimated Western military intervention. This familiar displacement of complex geopolitical and cultural determinants – in this case, the historical context of the Iraqi invasion of Kuwait – onto the synecdoche of a single figure of evil concealed, as ever, the reality that a war against 'him' would actually be directed at a whole people. Cruise missiles might be addressed 'To Saddam', in supposedly playful echo of Second World War movies, but they were always going to land on hotels and houses rather than on the Iraqi leader. The many thousands of Iraqis killed in these raids were subsequently rendered non-people in news narratives that spoke incessantly about 'kicking ass', 'smart bombs' and the 'killing of tanks'. The human consequences of unleashing such a war were wrapped in mists of fantasy, in which the political complexities of the situation were lost and British national-public imaginings – about the strength of the Iraqi forces, the likely duration of the war, its possible outcome – oscillated wildly between extremes of optimism and gloom. Echoes of the Indian Rebellion, of Lawrence in Arabia, of other Empire narratives, began to resonate once again. The BBC even cancelled its screening of the film *Khartoum* (1966), starring Charlton Heston as General Gordon and Laurence Olivier 'as the murderous Mahdi', scheduled for 12 August 1990. A spokesman said, 'With the safety of British people in the Gulf possibly at risk, we felt it might have been insensitive'.[4]

Yet this renewed cathexis of imperial imaginings offered a specifically

British angle on a multinational war effort whose imaginative centre lay elsewhere. Just as British forces, notably the pilots of the Tornado bombers attacking Baghdad, were operating within a much more extensive command structure dominated by the USA, so too were British national imaginings caught up within a larger collective identification whose most striking features were an American Commander-in-Chief, high-tech American weaponry and female American soldiers; the latter, of course, posing a transgressive challenge to the entire tradition of modern British adventure and undermining the quintessential masculinity of the soldier hero. The very language of the Gulf War was that of American newspeak. Its primary images were captured by camera-crews from the American CNN station, beamed into our homes by satellite, together with the narrative commentaries of CNN presenters, in accordance with American news-values. In Baghdad on the night of the first Cruise-missile attack, as a world-public watched the city sky light up with tracers and explosion-flashes whilst an excited reporter crowed about the 'firework display', war became live, armchair entertainment as never before.

One paradox of this new, instantaneous and omnipresent media eye that focused the public gaze of the world upon the cities and deserts of Iraq lay in what ultimately it could not help but see: namely, the effects of Western high-explosives upon Iraqi men, women and children. The psychic material split off and disavowed in triumphalist adventure resurfaced in images of slaughter along the 'road to Baghdad'. Television cameras now surveyed from on high the endless lines of burned-out vehicles caught without cover in full retreat from the front-line. Probing inside them, they discovered human bodies carbonized into horrible shrunken statues. If these images could, after all, be rationalized as those of an army at war, those beamed into our sitting-rooms from the streets of Baghdad, showing desperate, grieving, angry men and women, could not. Perhaps the most powerful of all the 'depressive' images to emerge from the Gulf War showed us some of the consequences of a Cruise missile penetrating an air-raid shelter full of sleeping families. Domestic narratives – centred on the sufferings of children, mothers and fathers, husbands and wives, young lovers – remain the forms in which our culture is best able to imagine the pain, fear and loss of others. Yet these narratives reproduce the disjunction between the locus of suffering and that of triumphalist excitement – the split between adventure and the domestic; and in so doing they remain unable to trace the causes of such suffering back into the public world that is its source.

From a Kleinian perspective, ours is a damaged culture, impaled on the twin horns of 1990s media-speak and the triumphalist legacy of our own national imaginary. The imagining of adventure and its heroes has been the historical occasion of unacknowledged traumas as well as utopian excitements, because these idealizations are founded upon manic triumphalism and its denial of psychic realities. Identification with British adventure can

never be achieved without serious cost whilst its valued and desired qualities are imaginatively secured through the splitting and projective disavowal of other aspects of experience. Suffering, fear, loss: these elements of depressive anxiety are not only disavowed with regard to others ('their' pain, after all, is not 'our' concern, and we need feel no guilt on their behalf), but our capacity to recognize our own pain is also denied, or itself recast in heroic light.

The damage caused by manic triumphalist phantasies is wreaked within masculinities through their exacerbation of splitting along the public–private divide. In their denial of the existence of conflicting and incompatible identifications, they may give rise to a peculiarly masculine form of splitting, involving the cutting-off of emotions, an inability to relate to a range of feelings expressed by others, and a consequent difficulty in achieving or sustaining intimate relationships. Where these phantasies are projected into and acted out in the social world, they may prompt the psychotic violence of a Michael Ryan or, more routinely but no less damagingly, the domestic violence that is inflicted on a shocking scale by British men upon British women.[5] Manic denial also operates at the level of the cultural forms that make up the national imaginary, as well as within the internal world of the individual psyche. When Prime Minister Thatcher celebrated victory in the Falklands as proof that 'Britain has not changed and that this nation still has those sterling qualities which shine through our history', her speech was not a nostalgic evocation of a lost golden age, as some commentators have suggested, but a triumphalist denial of British national decline.[6] Such reassertions of British greatness and even superiority – insisted upon in the face of the long-term deterioration of Britain's economy and national institutions, of the remorseless crumbling of its social infrastructure, of the mounting stresses and sufferings of its people – have been a striking feature of national imaginings in the 1980s and 1990s.

Any oppositional politics sensitive to the subjective dimensions of masculinity and of British national identity might benefit from the insight of Kleinian perspectives into defensive splitting and the difficulties and contradictions that this introduces into the processes of identification, composure and recognition. Moreover, as I suggested in Chapter 2, Kleinian thinking pushes beyond the mere diagnosis of damage to pose the possibility of its reparation.[7] This depends upon a readiness to acknowledge the intrinsic and dynamic inter-relation of the subject and its objects, the self and its others. Whereas idealization and projective disavowal fix and guard a social identity within a sharply polarized boundary between those who are 'like me' and those whose likeness is denied in the name of some irreducible difference, the Kleinian theory of the depressive position identifies a psychic potential for the movement of these split and defensive modes of composure towards more integrated, open and tolerant modes.

The realization of this potential is founded upon the emotional tolerance of once-disavowed experiences of pain and loss, and upon recognition of the

gendered self as a multiple and contradictory compound of 'masculine' and 'feminine' introjections. Unlike subjective change brought about by abandoning an unwanted identification, with its risk of reversed splitting (discussed at the end of Chapter 10), reparative integration involves a 'working through' of contradictions in which splitting may be undone and bridges built between the conflicting imagos of the internal world. As these cease to be so starkly dichotomous (good or bad, weak or strong, manly or unmanly), the integration of imagos makes it possible to see the contradictions of the social world in social terms – to see, according to Klein, 'realistically' – rather than in terms of split projections of the self. New connections with others become imaginable, and social identities may now emerge that are psychically capable of peaceful coexistence, inter-relatedness and dialogue across the boundaries of differentiation. Naming the damage done in the name of adventure, to ourselves as well as others, becomes a precondition of working through to the composure of a more integrated narrative form, founded upon the acknowledgement rather than the denial of psychic realities.

If my primary concern in this book has been the use of Kleinian concepts to gain insight into the split and idealized forms of the British adventure hero, the further potential of the Kleinian contribution to a progressive cultural politics lies in this distinction between split and integrated psychic positions and the different kinds of imagined relation to others that are possible in each. This potential cannot be realized at the psychic level alone. Klein herself argued that the reparative process depends upon a relinquishing of psychic control to allow the encounter with a real other to occur. While most concerned to theorize the specifically psychic conditions of its possibility, she also pointed to its dependence upon social conditions.

In this sense, as Michael Rustin has argued, a correlation can be made between the Kleinian language of psychic reparation and integration and progressive political languages based on principles of mutuality, democracy and cultural pluralism.[8] And yet, the ease with which this social dimension is allowed to slide out of focus in Klein's writing – as in her account of colonialism in terms of reparative phantasy, discussed in Chapter 2 – should warn us that the psychic process of reparation is not inherently progressive in social terms. Reparative psychic energies may be mobilized within many different political forms, on behalf of more or less exclusive modes of collective identity. While the reparative work evident in the commemoration of Sir Henry Havelock encompassed a wish to make amends in India too, this wish did not give rise to a programme of decolonization, but on the contrary, helped to fuel a tightening of the imperial grip under Crown rather than Company rule. British colonial policy after 1858 marks the limits beyond which further reparation became unimaginable. In a different context, the failure of Australian multiculturalism of the 1970s and 1980s to encompass the Aboriginal peoples may stand as a further example of this

kind of partial reparation; as Prime Minister Paul Keating acknowledged in his statement of December 1992, accepting responsibility for the historic actions of white settlers in Australia: 'We took the traditional lands and smashed the traditional way of life. We committed the murders. It was our ignorance and prejudice and failure to imagine these things done to us.'[9] Partial reparation of this kind is the norm rather than the exception in a social world torn by antagonism and conflict.

These fracture-lines of ethnicity, gender, class and nation are not products of the imagination but of socio-economic structures and institutionalized relations of power that constitute the real terrain of social life and shape all human possibilities. The anxieties and desires of psychic life also have an existence upon this social terrain and are constituted in terms of its divisions. Wishes arising among the oppressed and dispossessed for social power may unravel reparation just as surely as fears arising among the powerful of losing that which they already enjoy. The potential for greater psychic integration is both bounded by these social divisions and enabled by their overcoming.

In this sense, the dimensions of subjectivity explored in this book are a necessary but not a sufficient condition of any effective progressive politics, since this must be based upon practices capable of transforming real social relations as well as the ways in which these are imagined and lived. I continue to find persuasive Marx's argument that a more complete development of human potential depends on constructing the new social arrangements that are its condition.[10] It is my view that socialism remains the most inclusive and thoroughgoing of all progressive projects, in its identification of the economic and political world-system of advanced capitalism as the determining context of all modern social divisions. The transformation of this system is itself a necessary condition for the emergence of the more expansive modes of reparation that are conceivable in Kleinian terms. From this wider political context are derived the terms of reference and the evaluative criteria for a specifically cultural politics. While my focus in this book has been on forms of subjectivity, I have therefore sought to avoid exaggerating their importance in the manner of much fashionable 'postmodernist' cultural analysis.[11] My emphasis has been on the material conditions of imagining within social relations of cultural production and consumption that are themselves aspects of broader historical processes.

At the same time, in developing the concepts of psychic composure, social recognition, narrative imagining and the cultural imaginary, I have wanted to establish a deliberate distance from some key terms of analysis in post-1968 Marxist cultural studies.[12] Ultimately, I believe a rapprochement will be desirable, in which the mode of tracing subjective forms, their historical origins and their current implications proposed in this book will re-engage with the insights of Marxist political economy into the material conditions of cultures and identities. Kleinian psychoanalysis is no substitute for this

other kind of analysis, but in its conception of the dialectical inter-relation between psychic and social that I have sought to articulate, it holds out the prospect of a novel and fruitful dialogue.

While social conflicts and contradictions cannot be overcome by imagination alone, but must be transformed by human activity in the social world, the capacity to recognize those contradictions as such, to understand their dynamics and to tolerate their sometimes devastating effects on the internal psychic world, is dependent on imaginary forms. So, too, is the possibility of 'something new' emerging; for 'what distinguishes the worst architect from the best of bees is this, that the architect raises his structure in imagination before he erects it in reality'.[13] For Klein, this possibility depends upon split imagos being held together in one vision, while integration in this sense is also the psychic precondition of 'realistic' understanding, for it enables the effects of phantasy to be identified as such, so that the apparently separate facets of the social world may be seen to be connected as aspects of a whole social process. Cultural imaginaries are the source not only of those hegemonic cultural forms that give shape to idealized imagos and seek to define 'who we are supposed to be', but also of those more integrated and complex forms that facilitate the recognition of conflicts both psychic and social, their emotional toleration and their possible reparation. Kleinian theory can help to develop criteria for evaluating the cultural conditions and forms of reparative imagining that would be most conducive to progressive politics. It can help to identify where defensive structures are at work, what they are holding apart and which strategies might open up idealized and defensive identities to productive contradiction and multiplicity. In this, it can contribute to the recreation of oppositional cultures.

Is there a place for the soldier hero of adventure in a progressive cultural politics for the year 2000, or is this an irredeemably conservative mode of narrative? This question is not simply about narrative forms of imagining, but also concerns their publics and the ways in which new or familiar forms are used in processes of composure and recognition. Insofar as adventure remains a popular narrative form, working within its terms may be the only way to reach popular audiences which will in any case continue to enjoy its pleasures. There is certainly scope for imagining new kinds of hero, and these might well challenge or complicate the ethnocentric and imperialist assumptions that have long structured the adventure form. Michael Mann's exhilarating film, *The Last of the Mohicans* (1992) – a radical reworking of the novel by James Fenimore Cooper (1826) – is one recent demonstration of this potential.[14] Set in the British North American colonies during the French and Indian War of 1757, the narrative excitement generated in the film by a concatenation of classic adventure motifs works to secure identification with an imaginary position founded upon the tenets of eighteenth-century revolutionary republicanism. The claims of natural justice and the Rights of Man – and woman – are asserted by the film's American

backwoods hero, Hawkeye, and his lover, Cora, elder daughter of the British General Munro, against the tyranny of British colonial and patriarchal authority represented by her father. This film stands as an indicator of how adventure can be detached from the sexist and imperialist imaginings with which it has so long been associated, and articulated instead to progressive principles which also enjoy popular resonance.

Yet it also provides a clear illustration of the limitations of such a strategy. It is no coincidence that Hawkeye, despite his blood-brotherhood with the Mohican Indians, is still a white man (and an American to boot). The ex-White Dominions could doubtless furnish many other anti-imperialist heroes with whom popular audiences might readily identify. But a Native American, a Black or a female soldier hero remain unlikely protagonists in the world of popular cinema. *The Last of the Mohicans* retains instead an uncritical splitting of the native American peoples into helpers and enemies of the white hero's quest, with the composed integrity and comradeship of the Mohicans, Chingachgook and Uncas, offsetting the traditional 'Red Indian' savagery of the Huron 'bad object', Magua. Most disappointingly of all, despite introducing an element of sexual yearning in Hawkeye's passion for Cora and hinting at his attraction to a settled homestead life, the film remains conservative in its failure to develop and explore these themes. Hawkeye simply does not need Cora deeply enough to become an interestingly contradictory hero rather than a triumphalist adventurer in an unfamiliar cause. *The Last of the Mohicans* misses a promising opportunity to subvert the conservative idealizations of adventure by intruding into the narrative structure conflicting elements from the domestic imaginary, its political unconscious. As well as complicating the effortless public masculinity of the adventure hero by pressing him into other kinds of situation and relationship, a hero reimagined in this way would undermine the ingrained connections facilitated for over one hundred years between masculinity, military adventure and the nation.

It may be that the quest structure buckles under this kind of pressure so that a different kind of protagonist emerges and the narrative ceases to be 'an adventure' in any recognizable sense. An alternative strategy, that offers more scope to move outside the traditional imaginative frontiers of adventure, then becomes possible. By bringing adventure into relation with other kinds of story, a new hybrid form composed of many voices and nodes of identification might be created. One recent example is Susan Sontag's fictional reworking, in her novel, *The Volcano Lover* (1992), of one of the most famous of all British soldiers' stories, that of Lord Nelson.[15] The focal point of this narrative is not Nelson himself but his mistress, Emma Hamilton, and her elderly husband, 'the Cavaliere', British Ambassador in Naples during the French Revolutionary Wars, whom Nelson first met during the Mediterranean campaign of 1793. Using the licence of fiction to explore areas that remain murky in the Nelson hagiography, Sontag is able to

displace the imaginative centre of the story of 'the hero' – as Nelson is referred to, aloofly, throughout – away from the well-worked grooves of his adventures on to more equivocal terrain: Nelson's intense and complicated *ménage-à-trois* with the Cavaliere and Emma, and his brutal reprisals against the Neapolitan republicans responsible for the pro-French revolution of 1798–9. The re-imagining of 'the hero' from these unusual perspectives is taken a stage further in the final part of the novel, where the entire previous narrative is subjected to further re-evaluation by the voices of five women protagonists speaking from widely divergent and conflicting points of view: the Cavaliere's first wife, Emma's plebeian mother, Emma herself, and two of the executed republicans. The story of the hero, decentred and divested of projective idealization, is thereby brought into dialogue with the narratives of those excluded or marginalized by adventure, so that his actions – and identity – may be re-evaluated according to alternative standards. Hybrid storytelling of this kind is closely related to the theorization of identity as a compound, never found as a pure essence, but always constructed through cultural exchanges, translations and borrowings across diverse cultural traditions and imaginaries.[16]

Both *The Last of the Mohicans* and *The Volcano Lover* demonstrate in their different ways the continuing fascination of old soldiers' stories retold in new ways. Tracing historical shifts in the narration of modern British adventure heroes, from their first appearance in the mid-nineteenth century through to the present, has been central to the method of investigation developed in this book. While neither of these two recent narratives is concerned with the modern era of imperialism – both focus instead on the post-Enlightenment and Romantic world that preceded it – each suggests a narrative strategy that could inform a contemporary retelling of soldiers' stories from the zenith and decline of the British Empire. While both have their merits, hybrid modes of narrative seem particularly well suited to the challenge of remembering the Empire in ways that might enable an imaginative relocation of the present in relation to the past. If the heroes of British imperial adventure could be brought into dialogue with the colonized peoples whom they once triumphed over, and if the dichotomous narratives of adventure and domestic life could be brought into creative tension and enabled to speak and argue with each other, then it might become possible to acknowledge the historical damage that has accompanied heroic idealization and to readjust our conceptions of others accordingly. Seeking neither to reinvest the old forms of triumphalist adventure nor to turn away from them in aversion, these new hybrid narratives should endeavour to steer a course between fixation and amnesia towards new ways of remembering, in which guilt and remorse, understanding and an impulse towards amelioration, might come to replace unalloyed celebration at what has been done in our name.

Hybridity is the imaginative terrain occupied most famously by Salman

Rushdie's *The Satanic Verses* (1988), in which old stories from conflicting traditions of Islamic religion and history-writing are articulated, controversially, to a new fiction of emigration and cultural flux within the tradition of the modernist novel. It is a terrain where different kinds of storytelling – the biography and the history, the fiction and the sacred text – may meet, argue and learn from each other.[17] As the furore over *The Satanic Verses* has made cruelly evident, the attempt to bring into being new forms of imagining that cross established cultural frontiers, in a world where many long-established fracture-lines between religious, ethnic and national idealities are being reopened, is a process fraught with risk. It may also be that unexpected reparations become possible, on the unlikely terrain of old battlefields.

NOTES

The place of publication is London unless otherwise noted.

Introduction

1 The common interchangeability of 'English' and 'British' as designations of identity poses problems for any cultural historian sensitive to the full range of national identities within 'the United Kingdom of Great Britain and (Northern) Ireland', who yet wishes to explore the shared 'Britishness' that has resulted from belonging to 'the imperial race'. The epithets of 'Englishman' and 'Englishwoman' came to refer not only to English people in the strict sense, but also to the Scottish, Welsh and Irish who also enjoyed the privileges of 'being British' in the colonies, and to settlers and their descendants in the white Dominions. In this book, I use the term 'British' when referring to this more expansive national identity underpinned by the British State – in its heyday an imperial identity; and 'English' where my focus is specifically on the culture of England and where I wish to eschew unfounded generalizations about the impact of Empire upon the cultures of Scotland, Wales and Ireland.

2 'Hegemony' and 'hegemonic' are terms derived from the writings of Antonio Gramsci, and now widely used within cultural studies to refer to the ideological processes whereby consent to a dominant cultural order is secured and contested. See S. Hall, 'Cultural Studies and the Centre: Some Problematics', in Centre for Contemporary Cultural Studies, *Culture, Media, Language*, Hutchinson, 1980, pp. 35–6; T. Bennett, G. Martin, C. Mercer and J. Woollacott (eds), *Culture, Ideology and Social Process*, Batsford/Open University Press, 1981, Section Four, pp. 185–218.

3 For an account of the military war, see P. Bishop and J. Witherow, *The Winter War: The Falklands*, Quartet, 1982. For analyses of Falklands War narratives and other representations, see R. Johnson, 'Cultural Studies and English Studies: Approaches to Nationalism, Narrative and Identity', *Hard Times*, 31, 1987 (Berlin); J. Aulich (ed.), *Framing the Falklands: Nationhood, Culture and Identity*, Open University Press, Milton Keynes, 1992; J. Carr, *Another Story: Women and the Falklands War*, Hamish Hamilton, 1984; R. Harris, *Gotcha! The Media, the Government and the Falklands Crisis*, Faber & Faber, 1983; K. Bruder, '*The Sun's* Coverage of the Falklands-Malvinas War', MA dissertation, Centre for Contemporary Cultural Studies, University of Birmingham, 1982 (unpublished); P. Holland, '"In These Times When Men Walk Tall": The Popular Press and the Falklands Crisis', *Cencrastus*, 17, Summer 1984.

4 On the internal politics of the war, see Harris, *Gotcha!*; A. Barnett, *Iron*

293

Britannia: Why Parliament Waged Its Falklands War, Alison & Busby, 1982; A. Arblaster, 'The Falklands: Thatcher's War, Labour's Guilt', Socialist Society Pamphlet No. 1, June 1982; S. Hall and M. Jacques (eds), *The Politics of Thatcherism*, Lawrence & Wishart, 1983, Part 3, 'The Falklands Factor', pp. 257–88.

5 See B. Schwarz, 'The Language of Constitutionalism: Baldwinite Conservatism', in *Formations of Nation and People*, Routledge & Kegan Paul, 1984; B. Schwarz, 'Conservatism, Nationalism and Imperialism', in J. Donald and S. Hall (eds), *Politics and Ideology: A Reader*, Open University Press, Milton Keynes, 1986, pp. 154–86. For the bases of these competing conceptions of the nation, see J. G. Kellar, *The Politics of Nationalism and Ethnicity*, Macmillan, 1991, pp. 20–33; J. Breuilly, *Nationalism and the State*, Manchester University Press, Manchester, 1982, pp. 334–51.

6 Popular Memory Group, 'Popular Memory: Theory, Politics, Method', in Centre for Contemporary Cultural Studies, *Making Histories: Studies in History-writing and Politics*, Hutchinson, 1982; G. Dawson and B. West, 'Our Finest Hour? The Popular Memory of World War Two and the Struggle Over National Identity', in G. Hurd (ed.), *National Fictions: World War Two on Film and Television*, BFI Publishing, 1984. Little of the later material was published, but see Johnson, 'Cultural Studies'; M. Clare and R. Johnson, 'Nationalism, Narrative and Identity', unpublished paper presented to the Conference of the Association of Cultural Studies, 22 March 1986.

7 See, for example, 'Fight for the Falklands', the cover story of the boys' comic, *Battle*, IPC Magazines, 6 Nov. 1982.

8 See the extract from Antonio Gramsci's *Prison Notebooks* in Bennett et al., *Culture, Ideology and Social Process*, p. 201; Popular Memory Group, 'Popular Memory', pp. 234–40.

9 See, for example, M. Green, *Dreams of Adventure, Deeds of Empire*, Routledge & Kegan Paul, 1980, pp. 24–5: 'The great historical adventurers of empire . . . and their stories powerfully excited and stimulated the West's imagination of itself and its opponents. . . . Indeed, the narratives of the historians have been more important than those of fiction in shaping the image of the heroes of empire.' Green's study nevertheless concentrates on fiction. More recent interest has focused on explorers' and travellers' narratives: see S. Mills, *Discourses of Difference: An Analysis of Women's Travel Writing and Colonialism*, Routledge, 1991; T. Youngs, '"My Footsteps on These Pages": The Inscription of Self and "Race" in H. M. Stanley's *How I Found Livingstone*', *Prose Studies*, 13/2, Sept. 1990.

Part I

1 W. M. Thackeray, *Vanity Fair*, Penguin, Harmondsworth, 1968, p. 356.

2 S. Freud, 'Creative Writers and Day-dreaming', in *Standard Edition of the Complete Psychological Works of Sigmund Freud*, vol. IX, Hogarth Press/Institute of Psycho-Analysis, 1959, pp. 149–50.

3 S. Sassoon, *Siegfried's Journey, 1916–20*, Faber & Faber, 1945, p. 79.

1 Soldier heroes and the narrative imagining of masculinities

1 L. London and N. Yuval-Davis, 'Women as National Reproducers: The Nationality Act (1981)', *Formations of Nation and People*, Routledge & Kegan Paul, 1984.

2 *Parliamentary Debates: House of Commons Official Report: Standing*

Committee F, the British Nationality Bill, Third Sitting (17 Feb. 1981), columns 105–19.

3 ibid., columns 115–16.

4 ibid., column 110.

5 ibid., columns 113–14.

6 For Social Darwinism, racism and the New Right, see M. Barker, *The New Racism: Conservatives and the Ideology of the Tribe*, Junction Books, c.1981. For Powell's conception of the nation, see also T. Nairn, *The Break-Up of Britain*, Verso, 1981, pp. 256–90.

7 *Parliamentary Debates*, Fourth Sitting (19 Feb. 1981), columns 127–9.

8 See D. Sheridan, 'Ambivalent Memories: Women and the 1939–45 War in Britain', *Oral History* 18/1, Spring 1990, p. 38; D. Parkin, 'Women in the Armed Services, 1940–5', in R. Samuel (ed.), *Patriotism: The Making and Unmaking of British National Identity*, vol. II: *Minorities and Outsiders*, Routledge, 1989. See also J. B. Elshtain, *Women and War*, Harvester, Brighton, 1987; S. Saywell, *Women in War: First Hand Accounts from World War Two to El Salvador*, Viking-Penguin, Markham, Ontario, 1985.

9 For rich examples of this vein of history writing, see the work of Conservative historian, Sir Arthur Bryant, especially *English Saga*, Collins, Eyre & Spottiswoode, 1940; *History of Britain and the British People*, vol. I: *Set in a Silver Sea*, Panther, 1985; vol. II: *Freedom's Own Island*, Grafton, 1987. On the past and British national identity, see P. Wright, *On Living in an Old Country: The National Past in Contemporary Britain*, Verso, 1985; R. Samuel (ed.), *Patriotism: The Making and Unmaking of British National Identity*, vol. I: *History and Politics*, Routledge, 1989.

10 G. Dawson and B. West, 'Our Finest Hour? The Popular Memory of World War Two and the Struggle Over National Identity', in G. Hurd (ed.), *National Fictions: World War Two on Film and Television*, BFI Publishing, 1984; A. O'Shea, 'Trusting the People: How does Thatcherism Work?', in *Formations of Nation and People*, Routledge & Kegan Paul, 1984; S. Hall and M. Jacques (eds), *The Politics of Thatcherism*, Lawrence & Wishart, 1983.

11 'Thatcher Warning on Soviet Strength', *The Times*, 20 Jan. 1976, p. 1 (g/h), p. 2 (a). See also Julian Amery's speech at Maltby, South Yorkshire, reported in *The Times*, 19 Jan. 1976, p. 3 (a/b/c). (Letters in parenthesis refer to the column.)

12 *Parliamentary Debates (Hansard)*, Fifth Series, vol. 1,000, House of Commons Official Report (Nuclear Deterrent), 3 March 1981, column 158.

13 Margaret Thatcher, Speech to a Conservative Rally at Cheltenham Racecourse, 3 July 1982, in A. Barnett, *Iron Britannia: Why Parliament Waged Its Falklands War*, Alison & Busby, 1982, pp. 149–53.

14 M. Roper and J. Tosh, 'Introduction: Historians and the Politics of Masculinity', in M. Roper and J. Tosh (eds), *Manful Assertions: Masculinities in Britain since 1800*, Routledge, 1991, p. 1.

15 ibid., pp. 8–11.

16 For debates on masculinity within feminism, see L. Segal, *Is the Future Female?: Troubled Thoughts on Contemporary Feminism*, Virago, 1987; L. Segal, *Slow Motion: Changing Masculinities, Changing Men*, Virago, 1990. On radical feminism, see also M. Barrett, *Women's Oppression Today: Problems in Marxist Feminist Analysis*, Verso, 1980, pp. 42–8.

17 C. Mansueto, 'Take the Toys from the Boys', in D. Thompson (ed.), *Over Our Dead Bodies: Women Against the Bomb*, Virago, 1983.

18 ibid., pp. 118–19.

19 ibid.

20 See B. Harford and S. Hopkins (eds), *Greenham Common: Women at the Wire*, Women's Press, 1984; Segal, *Is the Future Female?*, pp. 163–8.

21 V. Woolf, 'Three Guineas', in *A Room of One's Own; Three Guineas*, ed. M. Shiach, Oxford University Press, Oxford, 1992, p. 313.

22 For a powerful statement of this position, see S. Brownmiller, *Against Our Will: Men, Women and Rape*, Penguin, Harmondsworth, 1976.

23 For the debate about masculinity and violence, see T. Eardley, 'Violence and Sexuality', in A. Metcalf and M. Humphries (eds), *The Sexuality of Men*, Pluto, 1985; Segal, *Slow Motion*, pp. 233–71; Segal, *Is the Future Female?*, pp. 85–116, 162–203.

24 J. Batsleer, T. Davies, R. O'Rourke and C. Weedon, *Rewriting English: Cultural Politics of Gender and Class*, Methuen, 1985, pp. 70–85.

25 J. G. Cawelti, *Adventure, Mystery and Romance: Formula Stories as Art and Popular Culture*, University of Chicago Press, Chicago, 1976, pp. 47–8. See Chapter 3 for further discussion of Cawelti's conception of adventure.

26 These different positions can also be related to the terms of the 'culturalism versus structuralism' debates of the late 1970s and 1980s. See R. Johnson, 'Three Problematics: Elements of a Theory of Working-Class Culture', in Centre for Contemporary Cultural Studies, *Working-Class Culture: Studies in History and Theory*, Hutchinson, 1979, pp. 212–37; S. Hall, 'Cultural Studies: Two Paradigms', in T. Bennett, G. Martin, C. Mercer and J. Woollacott (eds), *Culture, Ideology and Social Process*, Batsford/Open University Press, 1981, pp. 19–37.

27 See, for example, V. Walkerdine, *Schoolgirl Fictions*, Verso, 1990; C. Kaplan, *Sea Changes: Essays on Culture and Feminism*, Verso, 1986; C. Steedman, *Landscape for a Good Woman*, Virago, 1986. For feminist debate on the uses of psychoanalysis in writing social history, see Chapter 2, pp. 27–9 below, and notes 1, 5 and 9.

28 Kaplan, 'Pandora's Box: Subjectivity, Class and Sexuality in Socialist-Feminist Criticism', in *Sea Changes*, p. 162.

29 C. Steedman, 'True Romances', in Samuel, *History and Politics*, pp. 30–1.

30 Steedman, *Landscape*, p. 16.

31 V. Walkerdine, 'Some Day My Prince Will Come: Young Girls and the Preparation for Adolescent Sexuality', in *Schoolgirl Fictions*.

32 ibid., p. 92.

33 ibid., pp. 90–6.

34 C. Steedman, *The Radical Soldier's Tale: John Pearman, 1819–1908*, Routledge, 1988. Among the more interesting recent investigations of masculinities are Segal, *Slow Motion*; Tosh and Roper, *Manful Assertions*; D. Jackson, *Unmasking Masculinity: A Critical Autobiography*, Unwin Hyman, 1990; J. Rutherford, *Men's Silences: Predicaments in Masculinity*, Routledge, 1992.

35 Steedman, *Soldier's Tale*, pp. 37–9.

36 ibid., p. 7.

37 ibid., p. 37.

38 On narrative and cognition, see W. J. T. Mitchell (ed.), *On Narrative*, University of Chicago Press, Chicago, 1981. The account I develop below is based on discussions in the Popular Memory Group at the Centre for Contemporary Cultural Studies.

39 Carolyn Steedman makes suggestive use of theories of hegemony in relation to narrative, in *Landscape*, pp. 21–2. See also R. Williams, *Marxism and Literature*, Oxford University Press, Oxford, 1977, pp. 108–14, 128–35.

40 R. Johnson, 'What Is Cultural Studies Anyway?', *Anglistica*, 26/1–2, 1983 (Istituto Universitano Orientale, University of Naples), pp. 26–39. A shorter version

of this article appears as 'The Story So Far and Other Transformations', in D. Punter (ed.), *Introduction to Contemporary Cultural Studies*, Longman, 1986.

41 ibid. I am grateful to Richard Johnson for sharing with me his developing thoughts about these concepts. On masculinity and the public sphere, see J. Hearn, *Men in the Public Eye: The Construction and Deconstruction of Public Men and Public Patriarchies*, Routledge, 1992.

42 ibid.

43 ibid., p.37.

2 Masculinity, phantasy and history

1 On feminism and psychoanalysis, see R. Coward, 'Sexual Politics and Psychoanalysis: Some Notes on their Relation', in R. Brunt and C. Rowan (eds), *Feminism, Culture and Politics*, Lawrence & Wishart, 1982; J. Mitchell, *Women: The Longest Revolution*, Virago, 1984, pp. 219–313; J. Mitchell and J. Rose (eds), 'Introductions I and II', *Feminine Sexuality: Jacques Lacan and the École Freudienne*, Macmillan, 1982; J. Rose, 'Femininity and its Discontents', in *Sexuality in the Field of Vision*, Verso, 1986. On the turn to psychoanalysis in men's sexual politics, see J. Rutherford, *Men's Silences: Predicaments in Masculinity*, Routledge, 1992, pp. 27–62, 80–6.

2 See C. Steedman, *Landscape for a Good Woman*, Virago, 1986, especially pp. 83–97, 125–39; M. Barrett, *Women's Oppression Today: Problems in Marxist Feminist Analysis*, Verso, 1980, pp. 58–60.

3 S. Frosch, *The Politics of Psychoanalysis: An Introduction to Freudian and Post-Freudian Theory*, Macmillan, 1987, pp. 26–7. This book gives an excellent account of differences between the various schools of psychoanalysis and their implications for social theory: for Freud's conception of fantasy, see pp. 19–39; and R. Wollheim, *Freud*, Fontana, 1971, pp. 42–64.

4 See T. G. Ashplant, 'Psychoanalysis in Historical Writing', *History Workshop*, 26, Autumn 1988, pp. 102–19.

5 On the possibilities for a 'dialogue' between the disciplines of psychoanalysis and history, see Ashplant, 'Psychoanalysis'; T. G. Ashplant, 'Fantasy, Narrative, Event: Psychoanalysis and History', *History Workshop*, 23, Spring 1987, pp. 165–73; S. Alexander, 'Feminist History and Psychoanalysis', in *History Workshop*, 32, Autumn 1991, pp. 128–33. For interdisciplinary engagements with psychoanalysis, see V. Burgin, J. Donald and C. Kaplan (eds), *Formations of Fantasy*, Methuen, 1986; Rose, *Sexuality*; and J. Donald (ed.), *Psychoanalysis and Cultural Theory: Thresholds*, Macmillan, 1991. See also note 28 to Chapter 1.

6 Rose, *Sexuality*, pp. 90–1. For introductions to Lacanian theory, see Frosch, *Politics of Psychoanalysis*, pp. 129–38, 192–207; Mitchell and Rose, *Feminine Sexuality*. For Lacanian approaches to gender and popular narrative forms, see A. Easthope, *What A Man's Gotta Do: The Masculine Myth in Popular Culture*, Paladin, 1986; and V. Walkerdine, 'Some Day My Prince Will Come: Young Girls and the Preparation for Adolescent Sexuality', in *Schoolgirl Fictions*, Verso, 1990.

7 S. Alexander, 'Women, Class and Sexual Differences in the 1830s and 1840s: Some Reflections on the Writing of a Feminist History', in T. Lovell (ed.), *British Feminist Thought: A Reader*, Blackwell, Oxford, 1990, p. 35.

8 See, for example, E. Wilson, 'Psychoanalysis: Psychic Law and Order?', in Lovell, *British Feminist Thought*, pp. 222–5; Barrett, *Women's Oppression Today*; Frosch, *Politics of Psychoanalysis*, pp. 195–202; L. Segal, *Slow Motion: Changing Masculinities, Changing Men*, Virago, 1990, pp. 83–94.

9 Frosch, *Politics of Psychonanalysis*, pp. 119–20. See pp. 112–29, 165–7 for his

introduction to Klein. For a clear overview of Kleinian thought, see H. Segal, *Introduction to the Work of Melanie Klein*, Hogarth Press, 1973. For a helpful critique, see J. R. Greenberg and S. A. Mitchell, *Object Relations in Psychoanalytic Theory*, Harvard University Press, Cambridge, Mass., 1983, pp. 119–50. For discussion of the relative merits of Kleinian and Lacanian approaches to cultural studies, see M. Rustin, 'Kleinian Psychoanalysis and the Theory of Culture', and G. Seymour, 'A Reply to Michael Rustin: Kleinian Psychoanalysis and the Theory of Culture', both in F. Barker, P. Hulme, M. Iversen and D. Loxley (eds), *The Politics of Theory*, University of Essex, Colchester, 1982, pp. 57–78. For an example of Kleinian cultural readings, see M. Rustin and M. Rustin, *Narratives of Love and Loss: Studies in Modern Children's Fiction*, Verso, 1987. For the emerging debate on Klein, gender and feminism, see *Women: A Cultural Review*, Summer 1990, 1/2, special issue, 'Positioning Klein'. Klein's essays are collected in two volumes: *Love, Guilt and Reparation and Other Works 1921–1945*, Virago, 1988; and *Envy and Gratitude and Other Works 1946–1963*, Virago, 1988. For a selection, framed by a useful introduction by the editor, see *The Selected Melanie Klein*, ed. J. Mitchell, Penguin, Harmondsworth, 1986.

10 N. Chodorow, *The Reproduction of Mothering*, University of California Press, Berkeley, 1978. See Frosch, *Politics of Psychoanalysis*, pp. 179–92.

11 On object-relations theories, see Frosch, *Politics of Psychoanalysis*, pp. 94–111; Greenberg and Mitchell, *Object Relations*; M. Rustin, 'Post-Kleinian Psychoanalysis', in *New Left Review*, 173, January–February 1989.

12 For a lucid summary of these problems, in an otherwise favourable analysis of Klein's 'transitional' position between the two models, see Greenberg and Mitchell, *Object Relations*, pp. 147–50.

13 'Hanna Segal Interviewed by Jacqueline Rose', *Women: A Cultural Review*, Summer 1990, 1/2, pp. 206–9.

14 ibid., p. 207.

15 ibid., pp. 209–13. On 'biological' essentialism in Klein, see Mitchell, 'Introduction I', in Mitchell and Rose, *Feminine Sexuality*, pp. 22–3; and J. Mitchell, 'Psychoanalysis: Child Development and Femininity', in Mitchell, *Women*, pp. 309–11.

16 See Frosch, *Politics of Psychoanalysis*, pp. 119–20, 128–9, to which my own use of Kleinian thought is especially indebted.

17 S. Isaacs, 'The Nature and Function of Phantasy', in J. Riviere (ed.), *Developments in Psycho-Analysis*, Hogarth Press/Institute of Psycho-Analysis, 1952, p. 81.

18 Frosch, *Politics of Psychoanalysis*, p. 117. See also Segal, *Introduction*, pp. 11–23. For a critique of the assumptions underpinning the Kleinian concept, and an alternative psychoanalytic account of fantasy, see J. Laplanche and J.-B. Pontalis, 'Fantasy and the Origins of Sexuality', in Burgin *et al.*, *Formations of Fantasy*, pp. 5–34. In this book, I have followed the Kleinian usage to draw attention to the presence of unconscious processes and retained the common spelling in more general reference to imaginative forms.

19 Segal, *Introduction*, p. 14.

20 Frosch, *Politics of Psychoanalysis*, p. 117; Segal, *Introduction*, p. 15.

21 *Selected Klein*, ed. Mitchell, p. 20; M. Klein, 'Our Adult World and Its Roots in Infancy', in *Our Adult World and Other Essays*, Heinemann, 1963, pp. 5–8; P. Heimann, 'Certain Functions of Introjection and Projection in Early Infancy', in Riviere, *Developments*, pp. 139–62, especially pp. 142–3.

22 Heimann, 'Certain Functions', p. 160. On 'imagos', see Isaacs, 'Nature and Function', pp. 104–5; M. Klein, 'On Identification', in *Adult World*, pp. 56–7.

23 Segal, *Introduction*, pp. 20–1; Klein, 'Adult World', p. 8.

24 *Selected Klein*, ed. Mitchell, p. 20; Klein, 'Adult World', p. 8; Klein, 'On Identification', pp. 59–60.

25 Klein, 'Adult World', pp. 8–11; *Selected Klein*, ed. Mitchell, pp. 57–8; Segal, *Introduction*, pp. 43–4.

26 M. Klein, 'Personification in the Play of Children', in *Contributions to Psycho-Analysis 1921–45*, Hogarth Press/Institute of Psycho-Analysis, 1948, p. 220.

27 Klein, 'On Identification', pp. 57–60. See also Heimann, 'Certain Functions', p. 160; Frosch, *Politics of Psychoanalysis*, pp. 121–2.

28 Greenberg and Mitchell, *Object Relations*, pp. 143, 134. This latter sense helps avoid the tendency, noted earlier, for Kleinian theory to construct a normative developmental route from infancy to adulthood.

29 Klein, 'Adult World'. Klein's theoretical arguments are often embedded in her case studies about children's play: see 'The Psychological Principles of Infant Analysis' and 'The Psycho-Analytic Play Technique: Its History and Significance', both in *Selected Klein*, ed. Mitchell; and Klein, 'Personification', especially pp. 221–5. Whereas in this chapter I am concerned to extract a general Kleinian account of phantasy, I consider the specifics of children's play fantasies in Chapters 9 and 10, below.

30 See, for example, the Kleinian discussion of the infantile roots of adult learning patterns and problems, in I. Salzberger-Wittenberg, G. Henry and E. Osborne, *The Emotional Experience of Learning and Teaching*, Routledge & Kegan Paul, 1983.

31 On the 'paranoid-schizoid position', see Frosch, *Politics of Psychoanalysis*, pp. 123–5; Segal, *Introduction*, pp. 24–38, 54–66.

32 Klein, 'On Identification', pp. 56–7; Isaacs, *Nature and Function*, pp. 83–6.

33 Heimann, 'Certain Functions', pp. 142–57; Klein, 'Personification', especially pp. 219–25.

34 Klein, 'Personification', footnote on p. 219; M. Klein, 'Love, Guilt and Reparation', in M. Klein and J. Riviere, *Love, Hate and Reparation*, Hogarth Press/Institute of Psycho-Analysis, 1937, p. 114. Battlefield metaphors occur in many of Klein's case studies of children's play: see, for example, Klein, 'Psycho-Analytic Play Technique', p. 41.

35 On the depressive position, see Frosch, *Politics of Psychoanalysis*, pp. 120–7; Segal, *Introduction*, pp. 67–81.

36 Segal, *Introduction*, p. 84: see pp. 82–91 on manic defences.

37 ibid., p. 75. On reparation, see pp. 92–102; and Frosch, *Politics of Psychoanalysis*, pp. 127–8.

38 On symbolic displacement, see Klein, 'Psycho-Analytic Play Technique', pp. 51–2; Klein, 'Psychological Principles', p. 67; 'Love, Guilt and Reparation', pp. 96–8. Klein's account of symbolic violence in play offers a persuasive retort to the radical feminist critique of 'male violence' discussed in Chapter 1, pp. 16–17.

39 Greenberg and Mitchell, *Object Relations*, p. 134. Cf. the argument about psychic recognition in J. Benjamin, 'Master and Slave: The Fantasy of Erotic Domination', in A. Snitow, C. Stansell and S. Thompson (eds), *Desire: The Politics of Sexuality*, Virago, 1984, discussed in Chapter 7, pp. 199–200.

40 Greenberg and Mitchell, *Object Relations*, p. 134. See pp. 131–6 and 148–50 on the different explanations in Klein's writings about the modification of imagos through social interaction, which they relate to different stages in the development of her theoretical views. One implication of her theorization of the depressive position – that an individual self's awareness of its own sociality is a necessary condition of its differentiation and individuation – forms the basis of claims for the progressive character of Kleinian thinking: see M. Rustin, 'A

Socialist Consideration of Kleinian Psychoanalysis', in *New Left Review*, 131, 1982, pp. 71–96.

41 Frosch, *Politics of Psychoanalysis*, p. 234; Greenberg and Mitchell, *Object Relations*, pp. 145–8. The latter argue that 'the richness and detail of the parents' personalities is missing' in Klein, who 'does not allow for the impact of the parents' character defects or particular strengths'. This underdevelopment is explained as a function of Klein's 'transitional' straddling of both the Freudian 'drive/structure model' of the psyche and the object-relations model.

42 See 'Hanna Segal Interviewed by Jacqueline Rose', pp. 201–6, on the interconnections between public politics and psychic life.

43 See Frosch, *Politics of Psychoanalysis*, pp. 231–4, on the goals of Kleinian psychotherapy.

44 I have drawn, in this discussion of the Kleinian approach to gender identity, upon M. Waddell, 'Gender Identity: Fifty Years on from Freud', *Women: A Cultural Review*, Summer 1990, 1/2, pp. 149–59. For the Kleinian reformulation of the Oedipus Complex, see Segal, *Introduction*, pp. 103–16.

45 Waddell, 'Gender Identity', pp. 150–4, 156.

46 ibid., pp. 152, 157.

47 Klein, 'Love, Guilt and Reparation', pp. 102–5.

48 ibid., p. 105.

49 ibid., p. 103.

50 ibid., p. 97.

51 R. Williams, *Culture*, Fontana, 1981, pp. 89–95, 130–47; J. Wolff, *The Social Production of Art*, Macmillan, 1981, pp. 26–40.

52 On Kleinian therapeutic practice, see H. Segal, *Klein*, Harvester, Brighton, 1979, p. 44; Klein, 'Psychological Principles', pp. 62–3.

53 E. W. Said, *Orientalism*, Routledge & Kegan Paul, 1978. On discourse, see also R. Young, *White Mythologies: Writing History and the West*, Routledge, 1990; D. Macdonell, *Theories of Discourse: An Introduction*, Blackwell, Oxford, 1986. My conception of cultural imaginaries is influenced by B. Anderson, *Imagined Communities: Reflections on the Origins and Spread of Nationalism*, Verso, 1983, especially pp. 15–18. My emphasis on their historical plurality differs from the more abstract conception of *the* Imaginary as a mode of psychic existence in Lacanian psychoanalysis, and its take-up in Althusser's formulation of 'ideology in general' as an 'imaginary relation to real social relations' (in L. Althusser, 'Ideology and the State', *Lenin and Philosophy*, New Left Books, 1977, pp. 152–9).

54 Said, *Orientalism*, pp. 2–3, 54–5. See also pp. 201–5, 210–11.

55 ibid., p. 8.

56 ibid., pp. 72, 215.

57 ibid., pp. 56, 87. On danger and composure, see also pp. 56–60, 93–5, 167.

58 ibid., pp. 36–40, 206–7.

59 ibid., pp. 115, 154, 172.

60 ibid., pp. 119, 154–5. For a comparable argument on the distinction between different forms of colonial fantasy using Lacanian categories, see A. R. JanMohammed, 'The Economy of Manichean Allegory: The Function of Racial Difference in Colonialist Literature', in H. L. Gates (ed.), *'Race', Writing and Difference*, University of Chicago Press, Chicago, 1990. For theoretical critiques of *Orientalism*, see Young, *White Mythologies*, pp. 126–9, 137–45; and H. K. Bhabha, 'The Other Question: Difference, Discrimination and the Discourse of Colonialism', in F. Barker, P. Hulme, M. Iversen and D. Loxley (eds), *Literature, Politics and Theory: Papers from the Essex Conference, 1976–84*, Methuen, 1986.

61 On the 'facilitated paths' which invest the psychic apparatus with 'a form of memory' in early Freudian theory, see Wollheim, *Freud*, pp. 47–8.

62 For an argument about the complexity of Britishness in relation to a range of external others, see S. Hall, 'The Local and the Global: Globalization and Ethnicity', in A. D. King (ed.), *Culture, Globalization and the World System*, Macmillan, 1991.

63 I explore the introjection of the soldier hero as imago in Chapters 9 and 10.

64 See R. Williams's emphasis on the 'whole social process', in *Marxism and Literature*, Oxford University Press, Oxford, 1977, pp. 11–44.

3 The adventure quest and its cultural imaginaries

1 I follow here the methodology developed in R. Williams, *Keywords*, Fontana, 1988; relying on *The Shorter Oxford English Dictionary*, ed. C. T. Onions, 3rd edition, Clarendon Press, Oxford, 1959.

2 J. G. Cawelti, *Adventure, Mystery and Romance: Formula Stories as Art and Popular Culture*, University of Chicago Press, Chicago, 1976, p. 16. See pp. 5–41.

3 A. MacLean, *The Guns of Navarone*, Fontana, 1959.

4 N. Frye, *The Anatomy of Criticism*, Princeton University Press, Princeton, NJ, 1957, pp. 186–97. Frye's profound influence upon thinking about adventure is evident in Cawelti, *Adventure*, and the books by Paul Fussell and Martin Green, noted below (nos 10, 17).

5 See, for example, 'Tragic Fictional Modes', Frye, *Anatomy*, pp. 35–43.

6 ibid., pp. 33, 136–7, 151–8.

7 ibid., pp. 33–4, 131–40, 238. For the imagery of these symbolic worlds, see pp. 141–50. For C. Steedman's discussion of working-class soldiers' stories, see above, Chapter 1.

8 See, for example, the contrast between MacLean, *The Guns of Navarone*, and the 'realist' fiction of the Second World War, such as Zeno, *The Cauldron*, Pan, 1966.

9 For Klein's concepts of the depressive position and manic defence, see above, Chapter 2, pp. 38–40.

10 P. Fussell, *The Great War and Modern Memory*, Oxford University Press, Oxford, 1975.

11 ibid., pp. 21–2.

12 For examples of the former, see J. Buchan, *Greenmantle*, Hodder & Stoughton, 1916; and *Mr Standfast*, Penguin, Harmondsworth, 1956 (first published 1919); and of the latter, see Edmund Blunden, *Undertones of War*, Richard Cobden-Sanderson, 1928.

13 Frye, *Anatomy*, pp. 131–40. See also Cawelti, *Adventure*, pp. 47–8. For a more detailed critique of their archetypal theories, see my doctoral thesis, 'Soldier Heroes and Adventure Narratives: Case Studies in English Masculine Identities from the Victorian Empire to Post-Imperial Britain', University of Birmingham, 1991, pp. 22–33. See, too, the dialectical rereading of Frye's generic criticism in F. Jameson, *The Political Unconscious: Narrative as a Socially Symbolic Act*, Methuen, 1981, pp. 68–74, 103–50; and the critique of Frye and structuralist narrative analysis more generally in T. Eagleton, *Literary Theory: An Introduction*, Blackwell, Oxford, 1983, pp. 91–6.

14 Jameson, *Political Unconscious*, pp. 98–100, 140–1.

15 'To walk alone in London seemed of itself an adventure.' Charlotte Brontë, *Villette*, Pan, 1973, p. 42. See the *OED* for the etymology and these examples.

16 The question of women's relation to 'masculine' forms of adventure is beyond the scope of this book, but see J. Wheelwright, *Amazons and Military Maids: Women*

Who Dressed as Men in Pursuit of Life, Liberty and Happiness, Pandora, 1989. For an argument that, after the First World War, 'many of the sites of adventure were taken over by women's and girls' fiction', see A. Light, *Forever England: Femininity, Literature and Conservatism Between the Wars*, Routledge, 1991, pp. 173 and 256. On the question of cross-gender identification by women with male characters, see T. Modleski, *The Women Who Knew Too Much: Hitchcock and Feminist Theory*, Methuen, New York, 1988, pp. 1–15.

17 M. Green, *Dreams of Adventure, Deeds of Empire*, Routledge & Kegan Paul, 1980, p. 37. This book is the most substantial account to date of the historical relationship between the genre of 'masculine adventure' and colonialism. See also his more recent trilogy on adventure, *The Robinson Crusoe Story*, 1990; *Seven Types of Adventure Tale: An Etiology of a Major Genre*, 1991; and *The Adventurous Male: Chapters in the History of the White Male Mind*, 1993; all Pennsylvania State University Press, University Park, Pa.

18 Green, *Dreams of Adventure*, pp. 23–4, 50; Daniel Defoe, *Robinson Crusoe*, Oxford University Press, Oxford, 1972. Green suggests that, in British literary adventure, explicitly military themes are displaced by the 'mercantile imagination', although 'there are often adventures which turn the merchant into a temporary soldier', (ibid., p. 26). For an extended presentation and critique of Green's argument, see Dawson, 'Soldier Heroes and Adventure Narratives', pp. 40–54.

19 Green, *Dreams of Adventure*, p. 3.

20 P. Brantlinger, *Rule of Darkness: British Literature and Imperialism 1830–1914*, Cornell University Press, Ithaca, NY, and London, 1988, p. 13.

21 Sir Walter Scott, 'Prefatory' to *The Surgeon's Daughter*, quoted in Green, *Dreams of Adventure*, pp. 113–14.

22 For analyses of these contemporary imaginings of India, see Brantlinger, *Rule of Darkness*, pp. 73–107; F. Mannsaker, 'Early Attitudes to Empire', in B. Moore-Gilbert (ed.), *Literature and Imperialism*, English Department of Roehampton Institute of Higher Education, Roehampton, 1983; G. D. Bearce, *British Attitudes towards India 1784–1858*, Oxford University Press, Oxford, 1961, pp. 102–20; C. A. Bayly, *The Raj: India and the British 1600–1947*, National Portrait Gallery, 1990, pp. 26–230. For working-class soldiers' stories of India, see C. Steedman, *The Radical Soldier's Tale: John Pearman, 1819–1908*, Routledge, 1988, pp. 34–52. For the reformist challenge to traditional imaginings, see note 25, below.

23 Scott, quoted in Green, *Dreams of Adventure*, pp. 113–14.

24 E. H. Trelawney, quoted ibid.; Scott, quoted ibid.; ibid., pp. 57–65, 115–8, on British 'moral seriousness' and India.

25 ibid., p. 115. For analyses of evangelical and reformist imaginings of India, see F. G. Hutchins, *The Illusion of Permanence: British Imperialism in India*, Princeton University Press, Princeton, NJ, 1967, pp. 3–19, 53–78; A. T. Embree, *Charles Grant and British Rule in India*, George Allen & Unwin, 1962, especially pp. 141–57; Bearce, *British Attitudes*, pp. 65–101, 121–79.

26 Green, *Dreams of Adventure*, pp. 31–5; G. A. Henty, *With Clive in India: or, the Beginnings of an Empire*, Blackie & Son, 1884.

27 Green, *Dreams of Adventure*, pp. 97–108.

28 For Nelson, see R. Southey, *Life of Nelson* (two vols), John Murray, 1813. This had gone to thirteen editions (including two abridgements) by 1853, and another thirty-nine by 1914. The British Library catalogue lists several pages of biographies, poems, ballads, sermons and other texts on Nelson's life. For the Byronic hero, see M. Praz, *The Romantic Agony*, Oxford University Press, Oxford, 1970, pp. 60–76. For the Jacobin radical, see E. P. Thompson, *The Making of the*

English Working Class, Penguin, Harmondsworth, 1968, pp. 84–203. For the methodist working man, see ibid., pp. 385–440; W. J. Warner, *The Wesleyan Movement in the Industrial Revolution*, Russell & Russell, New York, 1967, pp. 165–206. For Cowper, see L. Davidoff and C. Hall, *Family Fortunes: Men and Women of the English Middle Class 1780–1850*, Hutchinson, 1987, pp. 91–2, 112, 149, 162–7.

29 Green, *Dreams of Adventure*, p. 23.

30 ibid., pp. 54–64.

31 J. Batsleer, T. Davies, R. O'Rourke and C. Weedon, *Rewriting English: Cultural Politics of Gender and Class*, Methuen, 1985, pp. 78–9.

32 Maclean, *The Guns of Navarone*; *Who Dares Wins*, Euan Lloyd Productions, 1983; *The Heroes*, a three-part TVS/Network 10 co-production, 1989.

33 J. Tosh, 'Masculinity, Empire Sentiment and the Flight From Domesticity', unpublished paper presented at 'Gender and Colonialism: An Interdisciplinary Conference', University College, Galway, 21–24 May 1992; H. Rider Haggard, *King Solomon's Mines*, Penguin, Harmondsworth, 1958, p. 12.

34 See, for example, the 'Bower of Bliss' episode in Book Two of E. Spenser, 'The Faerie Queene', in *Edmund Spenser's Poetry*, ed. H. MacLean, W. W. Norton, New York, 1977, pp. 148–97. For an exploration of masculinity and colonialism in Spenserian romance, see S. Greenblatt, *Renaissance Self-Fashioning From More to Shakespeare*, University of Chicago Press, Chicago, 1980, pp. 157–92, especially pp. 169–79.

35 Batsleer *et al.*, *Rewriting English*, pp. 71–80.

36 R. Malcolmson, *Popular Recreations in English Society 1700–1850*, Cambridge University Press, Cambridge, 1973, p. 163. For the middle-class 'reform of manners' and its impact upon traditional masculinities, see also ibid., pp. 168–9; Davidoff and Hall, *Family Fortunes*, pp. 109–13, 397–401; S. Andrews, *Methodism and Society*, Longman, 1970, pp. 68–75.

37 Davidoff and Hall, *Family Fortunes*, p. 112. See pp. 149–92 for their analysis of the early-nineteenth-century domestic imaginary.

38 ibid., pp. 90, 178. See generally pp. 81–95.

39 ibid., pp. 361–2, 357; Isaac Watts, the 'Puritan poet', quoted in Green, *Dreams of Adventure*, p. 64.

40 Davidoff and Hall, *Family Fortunes*, pp. 108–18.

41 ibid., p. 28.

42 On colonial settlement as 'a plot of England overseas', see J. Morris, *Heaven's Command: An Imperial Progress*, Penguin, Harmondsworth, 1979, pp. 271–2.

43 Davidoff and Hall, *Family Fortunes*, p. 82. See also pp. 103–6.

44 ibid., pp. 401, 108.

45 James Luckock (1815), quoted ibid., pp. 16–18. On the contradictions of masculinity, see ibid., pp. 91–2, 110–13. For men's relation to the private sphere, see also M. Roper and J. Tosh (eds), *Manful Assertions: Masculinities in Britain since 1800*, Routledge, 1991, pp. 12–13 and *passim*.

46 William Hutton (1841), quoted ibid., p. 330. See pp. 329–35 on fatherhood.

47 Sir Walter Scott, *Waverley: or, 'Tis Sixty Years Since*, Macmillan, 1905.

48 Green, *Dreams of Adventure*, pp. 104–8, 366–9; Sir W. Scott, 'General Preface to the First Edition of *Waverley*', p. xxi. Green, *Dreams of Adventure*, p. 101, and see pp. 100–8 for his discussion of *Waverley*.

49 Lord Byron, quoted in 'Editor's Introduction to *Waverley*', p. xcv; Green, *Dreams of Adventure*, p. 104; P. Womack, *Improvement and Romance: Constructing the Myth of the Highlands*, Macmillan, 1989; H. Trevor-Roper, 'The Invention of Tradition: The Highland Tradition of Scotland', in E.

Hobsbawm and T. Ranger (eds), *The Invention of Tradition*, Cambridge University Press, Cambridge, 1983. Ethnographic authenticity in *Waverley* is heightened by the 'Author's Notes' and glossary of Scottish words.

50 'Editor's Introduction to *Waverley*', pp. lxxxv–lxxxviii.
51 J. Lauber, *Sir Walter Scott*, Twayne, 1966, pp. 49–50; J. G. Lockhart, *Memoirs of the Life of Sir Walter Scott*, vol. II, New York, 1901, pp. 534–5; Green, *Dreams of Adventure*, pp. 108–12; Scott, 'General Preface', pp. xxv–xxvi.
52 D. Rosman, *Evangelicals and Culture*, Croom Helm, 1984, pp. 185–9. See also Davidoff and Hall, *Family Fortunes*, pp. 27–8, 111, 159–60.
53 Scott, *Waverley*, pp. 20–6, 34.
54 ibid., pp. 34, 40.
55 ibid., p. 136.
56 ibid., pp. 143–50.
57 ibid., pp. 146, 171. For the significance of the Highlands landscape, see Womack, *Improvement and Romance*, pp. 61–86.
58 Scott, *Waverley*, pp. 204–5, 214, 253–5.
59 ibid., pp. 374, 385–6. Cf. Waverley's 'becoming a Highlander' with Lawrence of Arabia's 'Becoming an Arab', Chapter 6, below.
60 ibid., p. 472. On Rose, see pp. 124–5; the title of this chapter is 'Waverley becomes domesticated at Tully-Veolan'. See also pp. 468–74, where the comparison between Rose and Flora is developed at length.
61 ibid., pp. 399–400.
62 ibid., pp. 415–19.
63 ibid., pp. 433, 451.
64 On Talbot, ibid., pp. 467–8. On the developing conflict, ibid., pp. 467–508.
65 ibid., pp. 555–6.
66 ibid., pp. 565–7.
67 ibid., pp. 590–607.
68 ibid., pp. 618–46.
69 ibid., pp. 230–42; 295–332.
70 ibid., pp. 505–7.
71 If Waverley occupies the position of the ego, then the King is a super-ego figure. On the super-ego and its powers of punishment and forgiveness, see *The Selected Melanie Klein*, ed. J. Mitchell, Penguin, Harmondsworth, 1986, pp. 57–8; and Chapter 2, pp. 33–4 and 43–4 above.
72 On the increasing 'separation of spheres', see Davidoff and Hall, *Family Fortunes*, p. 181.
73 On camp followers, see John Pearman's Memoir in Steedman, *The Radical Soldier's Tale*, pp. 75–6; and her comment on the 'curiously domestic tone' of his account of the soldiers' daily lives, p. 48. For an account of a battle in India, 1843, in which 'so completely was our force taken by surprise, that the ladies rode into the field on elephants', see J. C. Marshman, *Memoirs of Major-General Sir Henry Havelock, KCB*, Longmans, Green & Co., 1909, p. 140. For the general point, see J. Weeks, *Sex, Politics and Society: The Regulation of Sexuality Since 1800*, Longman, 1981, pp. 24–33, 72–6; B. Waites, 'Popular Culture in Late Nineteenth and Early Twentieth Century Lancashire', in Open University (U203), *The Historical Development of Popular Culture 1*, Milton Keynes, 1981, pp. 91–6; H. Cunningham, *Leisure and the Industrial Revolution*, Croom Helm, 1980, pp. 76–109; S. Smiles, *Self-Help*, extract in B. Dennis and D. Skilton (eds), *Reform and Intellectual Debate in Victorian England*, Croom Helm, 1987, pp. 52–7.
74 On domesticity, femininity and national identity, see Davidoff and Hall, *Family Fortunes*, pp. 114–15, 151, 370–5; J. Mackay and P. Thane, 'The Englishwoman', in R. Colls and P. Dodds (eds), *Englishness: Politics and Culture 1880–1920*,

Croom Helm, 1986; A. Davin, 'Imperialism and Motherhood', in R. Samuel (ed.), *Patriotism: The Making and Unmaking of British National Identity*, vol. I, Routledge, 1989. For the rendering publicly invisible of female labour and domestic life, see Davidoff and Hall, *Family Fortunes*, pp. 28–33 and *passim*.

75 Jameson, *Political Unconscious*, pp. 48–9.

76 ibid., pp. 47–8, 52–3. See his analyses of class fantasies in the texts of Balzac and Gissing, pp. 151–205. Jameson makes no reference to gender, even though his close reading of the generic contradictions in Conrad's *Lord Jim* (pp. 206–80), for example, would benefit from a discussion of the gendered split in the romance genre, and from analysis as a masculine as well as a bourgeois fantasy.

77 ibid., pp. 48–9, 81–2, 152–3.

Part II

My naming of Indian people and places throughout Part II follows the nineteenth-century English versions found in my sources: thus Cawnpore rather than Kānpur. Where alternative spellings occur in the sources – Nena for Nana Sahib, for example – I have retained them. References to frequently cited books and newspapers use the following abbreviations: MHH for J. C. Marshman, *Memoirs of Major-General Sir Henry Havelock, KCB*, Longmans, Green & Co., 1909; LW for *Lloyd's Weekly Newspaper*; RN for *Reynolds' Newspaper*; TT for *The Times*. All newspaper citations give an abbreviated date followed by a page number and column designation: thus, TT 29.9.57, p. 8 (f) refers to *The Times*, 29 Sept. 1857, p. 8, sixth column.

1 Lord Palmerston, quoted in J. P. Grant, *The Christian Soldier: Memories of Major-General Havelock KCB*, J. A. Berger, 1858, p. 87.

2 R. Kipling, 'The Incarnation of Krishna Mulvaney', in *Life's Handicap: Being Stories of Mine Own People*, Penguin, Harmondsworth, 1987, p. 31.

3 J. A. James, quoted in L. Davidoff and C. Hall, *Family Fortunes: Men and Women of the English Middle Class, 1780–1850*, Hutchinson, 1987, p. 115.

4 The imagining of a hero

1 Unspecified newspaper, quoted in J. C. Pollock, *The Way to Glory: The Life of Havelock of Lucknow*, John Murray, 1957, p.1.

2 O. Anderson, 'The Growth of Christian Militarism in Mid-Victorian Britain', *English Historical Review*, 84/338, Jan. 1971, p. 49; TT 29.9.57, p. 8 (f). Havelock also became an international hero, famous in the USA, Germany, Italy and Australia: see J. C. Marshman, *Memoirs of Major-General Sir Henry Havelock, KCB*, Longmans, Green & Co., 1909, pp. 456–7 (hereafter referred to as MHH); and references in Chapter 5, notes 24 and 93, below.

3 Pollock, *Way to Glory*, pp. 256–7.

4 J. Morris, *Heaven's Command: An Imperial Progress*, Penguin, Harmondsworth, 1979, p. 228. For introductions to the Indian Rebellion, see ibid., pp. 218–48; S. Wolpert, *A New History of India*, Oxford University Press, Oxford, 1982, pp. 226–38; C. Hibbert, *The Great Mutiny, India 1857*, Penguin, Harmondsworth, 1978. For the historiography of the Rebellion, see S. B. Chaudhuri, *English Historical Writings on the Indian Mutiny 1857–1859*, The World Press Private Ltd, Calcutta, 1979.

5 For nineteenth-century conflicts over national identity, see H. Cunningham, 'The Language of Patriotism', *History Workshop*, 12, Autumn 1981.

6 F. G. Hutchins, *The Illusion of Permanence: British Imperialism in India*, Princeton University Press, Princeton, NJ, 1967, pp. 83–6; E. M. Spiers, *The Army*

and Society 1815–1914, Longman, 1980, p. 133. On pre-1870s imperialism, see P. Brantlinger, *The Rule of Darkness: British Literature and Imperialism 1830–1914*, Cornell University Press, Ithaca, NY, and London, 1988, pp. 19–32.

7 Hutchins, *Illusion of Permanence*, pp. 83–6.

8 See Morris, *Heaven's Command*, pp. 86–112, 175–91; Wolpert, *New History*, pp. 201–28. By these wars, British rule in India was virtually doubled, and the British had 'all but consolidated their grip over the entire subcontinent' (Wolpert, p. 224). On 'national-popular', see D. Forgacs, 'National-Popular: Genealogy of a Concept', *Formations of Nation and People*, Routledge & Kegan Paul, 1984; R. Simon, *Gramsci's Political Thought: An Introduction*, Lawrence & Wishart, 1991.

9 Anderson, 'Growth', p. 46.

10 ibid., pp. 49–52.

11 See A. Lee, *The Origins of the Popular Press in England 1855–1914*, Croom Helm, 1976, pp. 54–63. By 1850, F. Knight Hunt could claim that newspapers were 'a positive necessity of modern civilized existence': quoted in Asa Briggs, *The Age of Improvement*, Longmans, Green & Co., 1959, p. 427.

12 See J. M. MacKenzie, *Propaganda and Empire: The Manipulation of British Public Opinion 1880–1960*, Manchester University Press, Manchester, 1984, pp. 16–38.

13 On Wolseley, Roberts and Kitchener, see J. Morris, *Pax Britannica: The Climax of an Empire*, Penguin, Harmondsworth, 1979, pp. 236–40.

14 On the narrative construction of 'the news', see J. Hartley, *Understanding News*, Methuen, 1982.

15 On the expansion and character of the English press in the 1850s, see G. A. Cranfield, *The Press and Society from Caxton to Northcliffe*, Longman, 1978, pp. 204–21; Lee, *Origins*, pp. 29–37, 59–76, 131–46, 274–5; A. Lee, 'The Structure, Ownership and Control of the Press 1855–1914', in G. Boyce, J. Curran and P. Wingate (eds), *Newspaper History from the Seventeenth Century to the Present Day*, Constable, 1978, pp. 118–24; V. S. Berridge, 'Popular Sunday Papers and Mid-Victorian Society', ibid. See also V. S. Berridge, 'Popular Journalism and Working-Class Attitudes, 1854–6: A Study of *Reynolds' Newspaper*, *Lloyd's Weekly Newspaper* and the *Weekly Times*', Ph.D. thesis, University of London, 1976 (unpublished).

16 See *The History of 'The Times'*, vol. 2, The Times, 1939, pp. 68–86; Morris, *Heaven's Command*, pp. 200–7; Cranfield, *Press and Society*, pp. 163–4, 171.

17 Cranfield, *Press and Society*, p. 171; *History of 'The Times'*, pp. 82–3.

18 Cranfield, *Press and Society*, p. 165.

19 *History of 'The Times'*, pp. 87–9; Lee, *Origins* pp. 59–61, 75. On foreign news in the popular Sunday press, see Berridge, 'Popular Sunday Papers', p. 258; for empire news, Berridge, 'Popular Journalism', pp. 297–305.

20 See, for example, RN 6.9.57, p. 8 (d); 10.1.58, pp. 8 (d), 9 (a). See also LW 6.9.57, p. 1 (d), and *The North and South Shields Gazette*, 3.9.57, p. 2 (e) for a report attributed to the 'Homeward Mail from India and China' of 31 August; LW 10.1.58, p. 7 (a) for a reproduction of *The Times*'s review of the Indian news; and the reproduction of *The Times*'s story from 21.9.57, p. 7 (f), in *The North and South Shields Gazette*, 24.9.57, p. 2(b).

21 Wolpert, *New History*, pp. 228–31.

22 *History of 'The Times'*, p. 86. See pp. 309–10 on the *The Times*'s Indian correspondents and the Rebellion.

23 On Russell and the emergence of the war correspondent, see P. Knightley, *The First Casualty: The War Correspondent as Hero, Propagandist and Myth-Maker from the Crimea to Vietnam*, Quartet, 1978, pp. 3–17.

24 Following Hutchins, *Illusion of Permanence*, p. 101, I use this term to refer to the British community in India, in preference to their own self-identification during the years of British rule as 'Anglo-Indian', a term now used to designate people of mixed British and Indian parentage.

25 Wolpert, *New History*, p. 230.

26 In the following analysis of news stories, I have focused on three newspapers – *The Times* and the popular Sundays, *Lloyd's Weekly* and *Reynolds' Newspaper* – which I take to be representative of the three main political positions on the Rebellion, identifiable across the English press as a whole. This includes the provincial middle-class press: those newspapers that I sampled – *The North and South Shields Gazette*, *The Stockton and Hartlepool Mercury*, *The Manchester Guardian* and *The Northern Daily Express* – did not articulate a substantially different position from the main paradigms found in the papers that form the basis of my study. I have noted interesting differences and similarities.

27 LW 6.9.57, p. 6 (b). See also LW 27.9.57, p. 6 (b/c). On the importance of Empire to this prestige, see Chaudhuri, *English Historical Writings*, pp. 282–3.

28 TT 17.9.57, p. 9 (c).

29 J. Bryne, 'British Opinion and the Indian Revolt', in P. C. Joshi (ed.), *Rebellion 1857: A Symposium*, People's Publishing House, New Delhi, 1957, pp. 295–6. See Hibbert, *Great Mutiny*, pp. 212–13 on rumours in the letters written by soldiers in India; and on rumours generally, see also Brantlinger, *Rule of Darkness*, pp. 209–10. See LW 13.9.57, p. 2 (a) for one example, an eyewitness account from Calcutta.

30 Spiers, *Army and Society*, pp. 126–7. For the recycling of atrocity rumours in histories and fictions, see Brantlinger, *Rule of Darkness*, pp. 199–224; Chaudhuri, *English Historical Writings*, *passim*, including pp. 47–8, 69–71. During Russell's investigation in 1858, he found evidence of massacres but not of more gruesome atrocities (*History of 'The Times'*, p. 318).

31 TT 25.9.57, p. 7 (d).

32 RN 6.9.57, p. 8 (d); TT 31.8.57, p. 7 (c).

33 TT 31.8.57, p. 7 (c).

34 TT 16.9.57, p. 6.

35 J. P. Grant, *The Christian Soldier: Memories of Major-General Havelock KCB*, J. A. Berger, 1858, pp. 26–7.

36 Brantlinger, *Rule of Darkness*, pp. 210–12.

37 See my account of the paranoid-schizoid position in Chapter 2, pp. 36–8 above.

38 TT 31.8.57, p. 7 (c); TT 17.9.57, p. 9 (c).

39 Grant, *Christian Soldier*, pp. 26–7.

40 Bryne, 'British Opinion', pp. 293–4. See also Hibbert, *Great Mutiny*, pp. 415–16.

41 Bryne, 'British opinion', p. 299.

42 Hibbert, *Great Mutiny*, pp. 224–8. See also pp. 164–70.

43 LW 6.9.57, p. 6 (b).

44 Most usefully, Brantlinger, *Rule of Darkness*, pp. 203–4.

45 C. Christ, 'Victorian Masculinity and the Angel in the House', in M. Vicinus (ed.), *A Widening Sphere: Changing Roles of Victorian Women*, Methuen, 1980, p. 146. Coventry Patmore's popular poetic work, 'The Angel in the House', appearing between 1854–63, was directly contemporary with the Rebellion.

46 P. T. Cominos, 'Innocent Femina Sensualis in Unconscious Conflict', ibid., pp. 166–7.

47 Christ, 'Victorian Masculinity', p. 149.

48 TT 31.8.57, p. 7 (b); Spiers, *Army and Society*, p. 127.

49 LW 13.9.57, p. 2 (i).

50 *Who and What is Havelock?*, a pamphlet, G. Asingdon, 1857; Brantlinger, *Rule of Darkness*, pp. 217, 295; Hibbert, *Great Mutiny*, pp. 194–5; *The Stockton and Hartlepool Mercury*, 19.9.57, p. 5 (a). See also C. A. Bayly (ed.), *The Raj: India and the British 1600–1947*, National Portrait Gallery, 1990, p. 241, for the striking juxtaposition of an illustration from Charles Ball's *History of the Indian Mutiny* (1858), 'Miss Wheeler Defending Herself against the Sepoys at Cawnpore', with Sir Joseph Noel Paton's controversial painting of passive female martyrdom, 'In Memoriam' (1858). Many narratives of British-Indian women in the Rebellion suggest their vigorous self-defence and display of 'manly' courage and endurance, which contradicts and disturbs the dominant constructions of femininity. See Chaudhuri, *English Historical Writings*, pp. 135–54. Lord Palmerston himself was moved to praise their heroism in his Guildhall speech, 9 November 1857: 'In the ordinary course of life the functions of woman are to cheer the days of adversity, to soothe the hours of suffering, and to give additional brilliancy to the sunshine of prosperity; but our country-women in India have had occasion to show qualities of a higher and nobler kind. . . . Henceforth, the bravest soldier may think it no disparagement to be told that his courage and his power of endurance are equal to those of an Englishwoman': J. Ridley, *Lord Palmerston*, Constable/Book Club Associates, 1970, p. 477.

51 Cf. Brantlinger's analysis, *Rule of Darkness*, pp. 209–12.

52 Christ, 'Victorian Masculinity', pp. 147–52.

53 Spiers, *Army and Society*, 125–7; Bryne, 'British Opinion', pp. 295–8.

54 Chaudhuri, *English Historical Writings*, pp. 249–50, 257–8; *History of 'The Times'*, pp. 310–15.

55 Hibbert, *Great Mutiny*, pp. 122–5, 200–2, 213–14.

56 ibid., p. 131. See p. 125 on 'blowing away from guns'.

57 Hutchins, *Illusion of Permanence*, p. 85.

58 All published between 17 July and 23 October 1857, and quoted in Bryne, 'British Opinion', pp. 297–8; except LW, 20.9.57, p. 6 (b). Even *Reynolds' Newspaper* (6.9.57, also quoted in Bryne) concurred with this.

59 Bryne, ibid., pp. 295–6; 301–2. On Tupper, see also Chaudhuri, *English Historical Writings*, p. 259; Brantlinger, *Rule of Darkness*, p. 205. Lord Shaftesbury himself spoke on the theme of revenge at public meetings in support of the Indian Relief Fund; see TT 31.10.57, p. 5; 2.11.57, p. 6; and see TT 28.9.57, p.8 (d/e) on calls for revenge at another Relief Fund meeting. For the Fund, see below.

60 G. Moorhouse, *India Britannica*, Harvill Press, 1983, p. 117. For Dickens, see Brantlinger, *Rule of Darkness*, pp. 206–7.

61 MHH, p. 264; Hibbert, *Great Mutiny*, p. 203.

62 Spiers, *Army and Society*, p. 132; Palmerston, quoted in Grant, *Christian Soldier*, p. 87.

63 On the Crimean news-reports, see Spiers, *Army and Society*, pp. 97–120; T. Royle, *War Report: The War Correspondent's View of Battle from the Crimea to the Falklands*, Grafton, 1989, pp. 19–32. See Spiers, pp. 132–5, for details of the Indian campaign. Russell did go to India, but not until 1858: *History of 'The Times'*, pp. 316–19.

64 TT 31.8.57, pp. 5 (e/f), 7 (c).

65 TT 31.8.57, pp. 5 (e/f), 7 (c).

66 TT 17.9.57, p. 9 (a). See also Hibbert, *Great Mutiny*, pp. 209–12. For the 'too late' motif, see also Revd W. Owen, *The Good Soldier: A Memoir of Major-General Sir Henry Havelock*, Simpkin, Marshall & Co. 1858, p. 224; and Chapter 5, pp. 117–19 and 123 below.

67 *Who and What is Havelock?*, pp. 7–8. For the stories about Wheeler's daughter, see note 50 above. For Victorian melodrama, see note 111 below.

68 Brantlinger, *Rule of Darkness*, pp. 202–4. On Nana Sahib as the 'fiend-in-chief' of the Rebellion, see LW 20.9.57, pp. 6–7; and *The Northern Daily Express*, 17.9.57, p. 2 (a/b). In December 1857 Nana Sahib's place in English demonology was secured by the unveiling of his wax effigy at Madame Tussaud's in London, while an English MP mounted an exhibition of his clothes in Leicester Square. LW 27.12.57, p. 6 (b).

69 Unattributed quote in MHH, p. 447. Cf. variations on this theme in TT 17.9.57, p. 9 (a); and *Who and What is Havelock?*, p. 7.

70 LW 4.10.57, p. 1 (a).

71 TT 29.9.57, p. 8 (f); TT 31.8.57, p. 7 (c).

72 Reproduced in TT 17.9.57, p. 9 (a).

73 TT 21.9.57, p. 7 (a). Cf. Mrs Thatcher's victory speech at Cheltenham Racecourse after the Falklands War, quoted in Chapter 1.

74 Reproduced in TT 17.9.57, p. 8 (a).

75 RN 30.8.57, pp. 16 (a), 8 (d); 6.9.57, p. 8 (d); 20.9.57, p. 8 (d). LW 6.9.57, p.1 (d); 27.9.57, p. 6 (b); 4.10.57, p. 1 (b). TT 21.9.57, p. 7 (a). Descriptions such as 'swarming like hornets' would become a stock-in-trade of boys' war stories.

76 LW 4.10.57, p. 1 (a/b).

77 *Illustrated London News*, no. 881, vol. 31, 3.10.57. TT 29.9.57, p. 6 (a). LW 18.10.57, p. 6 (c); 25.10.57 p. 6 (c).

78 TT 11.11.57 (second edition), pp. 6 (c) and 9 (a). See also 13.11.57, p. 6 (c).

79 TT 13.11.57, p. 6 (c).

80 TT 11.11.57, p. 6 (c).

81 LW 22.11.57, p. 6 (b).

82 TT 8.12.57, p. 7 (f); 12.12.57, p.11 (f). The whole city was not retaken until March 1858, and only then after fierce resistance. The Rebellion was not finally crushed until November 1859.

83 MHH, p. 449.

84 Both quoted in MHH, p. 452. For heroic military painting, see J. W. M. Hichberger, *Images of the Army: The Military in British Art, 1815–1914*, Manchester University Press, Manchester, 1988. See Charles Wood's play, '*H*': *Being Monologues at Front of Burning Cities*, Methuen, 1970, pp. 166–81, for a dramatic critique of this effort to render Havelock's death as a conventional deathbed tableau.

85 Grant, *Christian Soldier*, p. 99. For an analysis of the treatment of masculinity and death in Tennyson's poetry, see Christ, 'Victorian Masculinity'.

86 MHH, p. 441.

87 *Daily Telegraph*, quoted in MHH, p. 452; *Blackwood's Magazine*, quoted ibid., pp. 441–2. See also LW 10.1.58, p. 6 (b).

88 'The Havelock Polka Militaire' and 'Havelock's March' – 'a musical inspiration worthy of the great deeds of the illustrious warrior' – were advertised, each with a 'splendid' portrait, in TT 13.11.57, p. 4 (c).

89 R. Dyer, *Stars*, BFI, 1979, pp. 22–4. See also R. Dyer, *Heavenly Bodies: Film Stars and Society*, Macmillan, 1987, pp. 1–18.

90 Dyer, *Stars*, pp. 6–22; Dyer, *Heavenly Bodies*, pp. 2–6.

91 LW 6.9.57, p. 6 (d); 13.9.57, p. 6 (d); LW 20.9.57, p. 7 (d). For more details about the Indian Relief Fund Committees, see G. Dawson, 'Soldier Heroes and Adventure Narratives: Case Studies in English Masculine Identities from the Victorian Empire to Post-Imperial Britain', Ph.D. thesis, University of Birmingham, 1991, pp. 160–4, 179–81.

92 See Briggs, *Age of Improvement*, pp. 350–1, 420–5 on Palmerston, pp. 377–85

on the politics of the Crimean War, and pp. 430–3 on the growth of popular philanthropy.

93 MHH, p. 448. See, for example, the Relief Fund meeting at Wenlock, which paid special tribute to Havelock and his troops, TT 8.10.57, p.10 (e).

94 Dyer, Stars, p. 30.

95 For a more detailed discussion of mid-Victorian class conflict, national identity and the Havelock image, see Dawson, 'Soldier Heroes and Adventure Narratives', pp. 160–6, 179–97. See also R. Gray, 'Bourgeois Hegemony in Mid-Victorian Britain', in T. Bennett, G. Martin, C. Mercer and J. Woollacott (eds), *Culture, Ideology and Social Process*, Batsford/Open University Press, 1981; Cunningham, 'The Language of Patriotism', pp. 18–21.

96 TT 14.11.57, p. 6 (b); TT 24.11.57, p. 7 (a); TT 18.11.57, p. 6 (b). The Mutiny heroes were all acclaimed as 'Englishmen', even where, like Neill, the man was a Scot, or, like Nicholson, Anglo-Irish. See my Introduction, note 1.

97 *Illustrated London News*, 12.9.57, no. 878, vol. 31, p. 264; TT 16.9.57, p. 5 (f).

98 TT 3.10.57, p. 10 (e). For an anecdote about Havelock's martial gallantry, which confuses his early career with that of his brother William, a Peninsular War hero, see TT 13.10.57, p. 10 (a).

99 TT 26.10.57, p. 9 (b); TT 30.10.57, p.10 (e). Cf. MHH, pp. 41, 46 on these anecdotes.

100 Quoted without attribution in MHH, p. 448. See also TT 17.9.57, p. 9 (a).

101 Hichberger, *Images of the Army*, p. 39. See also Anderson, 'Growth', pp. 49–52. On the cult of chivalry, see Hichberger, pp. 5–6; R. Chapman, *The Sense of the Past in Victorian Literature*, Croom Helm, 1986, pp. 49–51; M. Girouard, *The Return to Camelot: Chivalry and the English Gentleman*, Yale University Press, New Haven, Conn., 1981, especially pp. 219–30 on 'Empire Knights'. See also my discussion of T. E. Lawrence and chivalry in Chapters 6 and 7, pp. 175–6, 188, 192 and 199 below.

102 LW 22.11.57, p. 6 (b/c); RN 20.9.57, p. 8 (d); RN 13.12.57, p. 1 (b). For the relation of the popular Sunday press to popular and working-class politics, see Berridge, 'Popular Journalism' and 'Popular Sunday Papers'; Bryne, 'British Opinion', pp. 300–11; Dawson, 'Soldier Heroes and Adventure Narratives', pp. 164–6.

103 LW 29.11.57. For the link with Reform, see LW, 22.11.57 p. 6 (c); 13.12.57, p. 1 (b/c).

104 RN 5.7.57, quoted in Bryne, 'British Opinion', p. 201; RN 6.9.57, pp. 1 (a), 8 (c/d); RN 30.8.57, p. 8 (d); RN 6.9.57, p. 8 (d).

105 LW 6.9.57, p. 6 (b/c); LW 20.9.57, p. 6 (b/c). See also *The North and South Shields Gazette*, 30.7.57, p. 4 (d).

106 LW 13.9.57, pp. 2 (a) and 6 (b). The theme is developed in LW 20.9.57, p.6 (d). Cf. the second attack on Havelock, 4.10.57, p. 1 (a/b), and p. 6 (c).

107 LW 13.9.57, p. 6 (b). For its critique of governmental apathy, see also LW 6.9.57, p. 6 (c); LW 27.9.57, p. 6 (b). Criticism in this vein was also directed against the official Day of National Humiliation and Prayer imposed by the Government as a compulsory holiday in October. See LW 11.10.57, p. 6 (b/c/e); *Manchester Guardian* 30.9.57, p. 745 (a); Bryne, 'British Opinion', p. 306. On the popular Volunteer Movement, see H. Cunningham, *The Volunteer Force: A Social and Political History 1859–1908*, Croom Helm, 1985.

108 It can be dated by a report in TT, 20.11.57, p. 6 (b), on the French accusations.

109 L. Shepard, *The History of Street Literature*, David & Charles, Newton Abbot, 1973. On burlesque 'double consciousness', see R. Weimann, *Shakespeare and the Popular Tradition in the Theatre*, Johns Hopkins University Press, Baltimore, Md, 1978.

110 Many of these adventure motifs also occur in, for example, G. Barnett Smith's *Life of Sir Charles Napier*, including his 'charmed life' and the many horses shot under him (*Heroes of the Nineteenth Century*, Pearson, 1899, pp. 137–9).

111 For Victorian popular melodrama, see M. Booth, *English Melodrama*, Jenkins, 1965; A. Humphreys, 'Popular Narratives and Political Discourse in *Reynolds' Weekly Newspaper*', in L. Brake, A. Jones and L. Madden (eds), *Investigating Victorian Journalism*, Macmillan, 1990.

112 TT 17.9.57, p. 9 (c); TT 18.9.57, p.6 (e); *Who and What is Havelock?*, p. 8. On the 'instrument of vengeance' theme, see also *The Manchester Guardian*, 9.9.57, p. 704 (c/d). For the phantasy of saving lives by conquest and killing, see Chapter 2, p. 45 above.

113 See *The Manchester Guardian*, 16.9.57, p. 721 (a). This can be seen most clearly in the 'London Sepoys' murder story which *Lloyd's Weekly* featured on its front page, 18.10.57, p. 1 (a): 'In our midst are savages as cruel and as dastardly as the revolted Sepoys. Near our mechanics' institutes; within an ear-shot of people's concerts; in the great centre of human activity, and where the pulse of giant newspaper engines never ceases – comes forth a tale of unutterable horror!'. In its evocation of the savage at the heart of the modern metropolis, this story pre-empts themes usually associated with the later nineteenth century in, for example, Conrad's *Heart of Darkness*.

114 I take issue here both with Spiers, *Army and Society*, p. 127, who sees a relatively undifferentiated 'whole nation' unified in support of imperial retribution against a small opposition; and Bryne, 'British Opinion', p. 311, who identifies 'the working class' with this oppositional voice.

115 MHH, p. 448; LW 4.10.57, p. 1 (a); TT 18.11.57, p. 6 (a); LW 13.12.57, p. 1 (a/b); TT 24.11.57, p. 7 (a); LW 29.11.57, p.1 (a/b). For further details, see Dawson, 'Soldier Heroes and Adventure Narratives', pp. 184–5.

116 *Daily Telegraph*, quoted in MHH, p. 452; Owen, *Good Soldier*, pp. 224–5. See also MHH, pp. 450–7; TT 8.1.58, p. 6 (a).

117 MHH, p. 449; Pollock, *Way to Glory*, pp. 1, 9, 254.

118 B. Anderson, *Imagined Communities. Reflections on the Origins and Spread of Nationalism*, Verso, 1983, pp. 30–1, 37–40.

119 Lee, *Origins*, p. 73.

120 MHH, pp. 449–50; TT 22.1.58, p. 7 (f); TT 25.1.58, p. 10 (a); TT 11.2.58, p. 9 (b).

5 Commemorating the exemplary life

1 Revd W. Owen, *The Good Soldier: A Memoir of Major-General Sir Henry Havelock*, Simpkin, Marshall & Co., 1858, pp. 224–5; MHH, p. 449 (for abbreviations see prefatory note to Part II).

2 *Quarterly Review*, quoted in MHH, p. 455. See Chapter 2, pp. 38–43 above, for my acount of the Kleinian 'depressive position'.

3 Revd A. Reed, *A Good Soldier: A Sermon Preached on the Death of Major-General Sir Henry Havelock Bart. KCB*, Ward & Co., 1858, p. 4.

4 MHH, p. 449; *The Examiner*, quoted in MHH, p. 452.

5 *Quarterly Review*, quoted in MHH, p. 455.

6 See Chapter 4, p. 97 above, for the 'too late' motif. Cf. its reappearance in responses to General Gordon's death at Khartoum over twenty-five years later: see Lt. Gen. Sir W. Butler, *Charles George Gordon*, Macmillan, 1920 (1st pub. 1889); and the popular song, 'Too Late! The Death of General Gordon', in L. Shepard, *The History of Street Literature*, David & Charles, Newton Abbot, 1973.

7 See Chapter 2, pp. 40–3 above.

8 O. Anderson, 'The Growth of Christian Militarism in Mid-Victorian Britain', *English Historical Review*, 84/338, Jan. 1971, p. 50; Owen, *Good Soldier*, pp. 228–30. See also TT 25.1.58, p.10 (a); MHH p. 449.

9 J. C. Pollock, *Way to Glory: The Life of Havelock of Lucknow*, John Murray, 1957, p. 1. See the 'Sketch' of Havelock by J. C. Marshman, *Baptist Magazine*, March 1858; C. Ricks (ed.), *The Poems of Tennyson*, Longman, 1969, pp. 1105–6; M. Dowdin Evans, *Ode on the Death of General Sir Henry Havelock, KCB*, Simpkin, Marshall & Co., 1858; MHH, pp. 453–4. For the pulpit sermons, see note 15 below.

10 MHH, p. 449.

11 Reed, *A Good Soldier*, p .11.

12 See N. Frye, *The Anatomy of Criticism*, Princeton University Press, Princeton, NJ, 1957, p. 187.

13 *Blackwoods Magazine* and *The Daily Telegraph*, both quoted in MHH pp. 453–4; TT 8.1.58, p. 6 (b).

14 TT 8.1.58, p. 6 (b).

15 My analysis here uses the following sermons: Revd W. H. Aylen, *The Soldier and the Saint; or Two Heroes in One. A Christian Lecture in Memory of the Late General Havelock*, Judd & Glass, 1858; L. J. Bernays, *Havelock, The Good Soldier. A Sermon Preached in the Parish Church of Great Stanmore, Sunday 17th January 1858*, Sampson Low, 1858; E. P. Hood, *Havelock the Broad Stone of Honour; A Just Tribute of the Tongue and Pen*, John Snow, 1858; Reed, *A Good Soldier*; F. S. Williams, *General Havelock and Christian Soldiership*, Periodical Publications, 1858; O. Winslow, *Honouring God and Its Reward: A Lesson from the Life of the Late General Sir Henry Havelock KCB*, Shaw, 1858.

16 Reed, *A Good Soldier*, p. 3; Winslow, *Honouring God*, p. 1.

17 Bernays, *Havelock*, pp. 1–4; Reed, *A Good Soldier*, pp. 4–6.

18 Bernays, *Havelock*, pp. 4, 9, 13–15, 17, 19; Reed, *A Good Soldier*, p. 6; Aylen, *The Soldier and the Saint*, pp. 8, 10.

19 Reed, *A Good Soldier*, p. 9; Aylen, *The Soldier and the Saint*, p. 12.

20 Reed, *A Good Soldier*, pp. 5, 11–12.

21 For church-going and evangelical activity in the 1850s, see J. Walvin, *Leisure and Society 1830–1950*, Longman, 1978, pp. 48–50; A. D. Gilbert, *Religion and Society in Industrial England. Church, Chapel and Social Change, 1740–1914*, Longman, 1976, pp. 23–48, 99–110, 134–49; I. Bradley, *The Call to Seriousness: The Evangelical Impact on the Victorians*, Jonathan Cape, 1976, pp. 34–56.

22 Bradley, *Call to Seriousness*, pp. 41–3. See also L. James, *Fiction for the Working Man 1830–50*, Penguin, Harmondsworth, 1974, pp. 135–44.

23 James, *Fiction*, pp. 143–4.

24 Owen, *Good Soldier* (235 pp.), Preface; J. P. Grant, *The Christian Soldier: Memories of Major-General Havelock KCB*, J. A. Berger, 1858 (104 pp.); W. Brock, *A Biographical Sketch of Sir Henry Havelock*, James Nisbet, 1858 (304 pp.); MHH, first published 1860 (457 pp.). Two further biographies appeared in the USA (J. Tyler Headley, *The Life of General Henry Havelock*, New York, 1859) and Germany (J. F. Muerdter, *Major-General Sir Henry Havelock*, Stuttgart, 1859). Muerdter's, however, was compiled from Brock, Grant and Marshman (MHH); and Pollock, *Way to Glory*, claims that Headley's was 'mostly pirated from Brock' (p. 3). The *British Workman* was an illustrated monthly paper to promote 'the Health, Wealth, and Happiness of the Industrial Classes', price ½*d.* monthly. Grant's book also includes advertisements for

Band of Hope Review and *Children's Friend*, as well as for Bibles and prayer-books.

25 Pollock, *Way to Glory*, p. 3.
26 A. Summers, 'Militarism in Britain before the Great War', *History Workshop*, 2, 1976.
27 Pollock, *Way to Glory*, p. 3.
28 ibid.; Marshman's Preface to the 1867 edition of MHH.
29 For the Serampore missionaries, see E. D. Potts, *British Baptist Missionaries in India 1793–1837: The History of Serampore and its Missions*, Cambridge University Press, Cambridge, 1967. For Joshua and John Clark Marshman, see *Dictionary of National Biography*, pp. 1140–1. For arguments about the role of the missions in fomenting the Rebellion, see A. T. Embree, *Charles Grant and British Rule in India*, George Allen & Unwin, 1962, pp. 237–51.
30 MHH, pp. 14, 32; Pollock, *Way to Glory*, pp. 16–17.
31 MHH, Preface to 1867 edition.
32 Cf. Liz Stanley's argument on the biographer's role, in 'Biography as Microscope or Kaleidoscope? The Case of "Power" in Hannah Cullwick's Relationship with Arthur Munby', *Women's Studies International Forum*, 10/1, 1987, pp. 19–31.
33 R. Dyer, *Heavenly Bodies: Film Stars and Society*, Macmillan, 1987, pp. 10–12.
34 For Allahabad, see MHH, pp. 275–84. For Harry's VC, see MHH, pp. 312, 359–64.
35 ibid., pp. 286–351 for the first stage; pp. 351–95 in Cawnpore; pp. 395–423 for the second stage.
36 ibid., pp. 302, 311, 326–7, 287, 351–2, 355, 438. The 'delusion' that it was necessary for British troops to wear pith helmets in the tropical sun was exposed by T. E. Lawrence, who, going without one, 'was said to be the first British serviceman to do so' (J. Morris, *Farewell the Trumpets: An Imperial Retreat*, Penguin, Harmondsworth, 1979, footnote to p. 466).
37 MHH, pp. 298–301, 329.
38 ibid., pp. 324, 326, 334, 341–2.
39 ibid., pp. 294, 311–19, 333, 350.
40 ibid., pp. 343–6, 445.
41 ibid., pp. 358, 370. See also pp. 368–85, 392–5.
42 ibid., pp. 405–6, 412, 418–21.
43 ibid., pp. 411–13. See pp. 408–11 for the attack on the bridge.
44 ibid., pp. 421, 423–39.
45 ibid., pp. 413, 306. For the language used to describe battles, see J. Keegan, *The Face of Battle*, Penguin, Harmondsworth, 1978.
46 MHH, pp. 439–41.
47 ibid., pp. 27, 126–7, 190.
48 ibid., pp. 8–10.
49 ibid., p. 12.
50 For the structuralist mode of narrative analysis used here, see J. Donald and C. Mercer, 'Reading and Realism', in Open University (U203), *Form and Meaning One*, Open University Press, Milton Keynes, 1981. I return to the typical ellipses of time in adventure narratives below, in Chapters 6 and 9.
51 MHH, p. 16.
52 ibid., pp. 21–2.
53 ibid., pp. 26–7, 57, 136. See p. 148 for Havelock's excitement at battle.
54 ibid., pp. 140, 157.
55 ibid., p. 135.
56 ibid., pp. 442, 153–4.

57 ibid., p. 179. See also pp. 173–8, 442–3.
58 ibid., p. 27.
59 ibid., pp. 32, 42–3, 49, 135–8, 185.
60 ibid., p. 220.
61 ibid., pp. 22–3.
62 ibid., p. 191.
63 ibid., p. 32.
64 See, for example, Havelock's letters on pp. 162–7.
65 ibid., p. 35. See also the story of his wedding day, pp. 32–3.
66 ibid., pp. 37, 43–4.
67 ibid., pp. 134–7. See also pp. 50, 62–5. Military historians have pointed to the return home as one of the most difficult moments for servicemen to cope with. See, for example, Alistair Thomson's discussion of the return of the Australian troops after 1918, in *Anzac Memories: Living with the Legend*, Oxford University Press, Melbourne, 1994.
68 MHH, pp. 35–7.
69 ibid., pp. 44, 48.
70 E. M. Spiers, *The Army and Society 1815–1914*, Longman, 1980, pp. 14–15. On the position of the middle-class officer in the army, see pp. 1–34 *passim*, especially pp. 19–20: 'There was certainly no class of a comparable social status, with the possible exceptions of the naval officer and the country clergyman, who had to work for so little.'
71 MHH, p. 49. See also pp. 42–3, 46.
72 ibid., pp. 162–7.
73 ibid.
74 ibid., pp. 191–3.
75 ibid., pp. 191–212.
76 ibid., p. 207.
77 ibid., pp. 204–5, 210; L. Davidoff and C. Hall, *Family Fortunes: Men and Women of the English Middle Class 1780–1850*, Hutchinson, 1987, pp. 91, 225–8.
78 MHH, p. 210.
79 ibid., pp. 210–12.
80 See, for example, ibid., pp. 45, 50 (concerning his promotion); p. 99 (concerning battles); pp. 44, 48, 166 (concerning family tragedies). For Havelock's own belief in God's protection and mercy towards him, see p. 197. The most poignant section of the book, concerning the final years of Havelock's life in India (pp. 212–29), accentuates the sense of his renunciation of earthly attachments for God.
81 I. Rivers, 'Strangers and Pilgrims: Sources and Patterns of Methodist Narrative', in J. C. Milson, M. M. B. Jones and J. R. Watson (eds), *Augustan Worlds: Essays in Honour of A. R. Humphreys*, Leicester University Press, Leicester, 1978, pp. 196–8.
82 MHH, pp. 229, 276.
83 ibid., p. 449.
84 Pollock, *Way to Glory*, p. 3. He claims Marshman was 'equally guarded about public matters' such as the Outram supersession, and quotes the view of Havelock's son, Harry, that 'the reserve he has shown in dealing with the more delicate parts of the narrative was a mistaken one. . . . Mr Marshman shrank from raising the storm of argument, it might be of obloquy, which would follow.'
85 ibid., pp. 9, 11.
86 ibid., p. 17. See also pp. 27–33.

87 ibid., pp. 36–8. 'With this background of domestic happiness, Havelock . . . was working far harder than most' and Hannah was jealous of his time.

88 ibid., pp. 37, 99–100, 104.

89 ibid., p. 50.

90 ibid., pp. 121–4.

91 This is a striking illustration of the argument in Davidoff and Hall, *Family Fortunes*, that the power of Victorian public men was underpinned by a network of invisible and privatized domestic relationships. Hannah herself paid testimony to the strength of the Victorian assumption that public affairs and public men were more important and interesting than domestic affairs in the women's sphere by destroying all her own letters to Havelock after his death, whilst preserving his to her.

92 A. Forbes, *Havelock*, Macmillan, 1890. See pp. 1, 14–17.

93 Revd J. S. Banks, *Three Indian Heroes: the Missionary, the Statesman, the Soldier*, Wesleyan Conference Office, 1871; H. F. Wakefield, *Some of the Words, Deeds and Success of Havelock in the Cause of Temperance in India*, 1861; T. Smith, *The Life of Havelock: Lectures Delivered before the Young Men's Christian Association*, Sydney, 1860; *General Havelock; or The Christian Soldier*, translated from the fourth Italian edition by Lt. Col. B. D. W. Ramsay, London, 1871.

94 J. M. MacKenzie, *Propaganda and Empire: The Manipulation of British Public Opinion 1880–1960*, Manchester University Press, Manchester, 1984. See also W. H. Fraser, *The Coming of the Mass Market 1850–1914*, Macmillan, 1981.

95 Morris, *Farewell the Trumpets*, p. 28. For the 'small wars', see Major D. H. Cole and Major E. C. Priestley, *An Outline of British Military History 1660–1937*, Sifton Praed & Co., 1937, pp. 219–64; B. Porter, *The Lion's Share: A Short History of British Imperialism 1859–1970*, Longman, 1975, pp. 74–195.

96 J. O. Springhall, '"Up Guards and At Them!": British Imperialism and Popular Art 1880–1914', in J. M. MacKenzie (ed.), *Imperialism and Popular Culture*, Manchester University Press, Manchester, 1986. For the press and late-Victorian imperialism, see J. Curran and J. Seaton, *Power Without Responsibility: The Press and Broadcasting in Britain*, Methuen, 1985, pp. 49–51. See A. Lee, *The Origins of the Popular Press in England 1855–1914*, Croom Helm, 1976, for the 'new journalism' (pp. 117–30) and its relation to imperialism (pp. 161–2). For the war correspondents and their reports from the Empire, see T. Royle, *War Report: The War Correspondent's View of Battle from the Crimea to the Falklands*, Grafton, 1989, pp. 40–77; and P. Knightley, *The First Casualty: The War Correspondent as Hero, Propagandist and Myth-Maker from the Crimea to Vietnam*, Quartet, 1978, pp. 42–5, 52–5. For examples of press narratives from the 1880s, reprinted in pamphlet and book form, see *Lives and Adventures of Great Soldiers in the British Army*, The General Publishing Company, 1885.

97 For brief sketches of the former three men, see J. Morris, *Pax Britannica: The Climax of an Empire*, Penguin, Harmondsworth, 1979, pp. 236–40. For the stories of Wolseley's Red River and Ashanti expeditions, and of Gordon at Khartoum, see J. Morris, *Heaven's Command: An Imperial Progress*, Penguin, Harmondsworth, 1979, pp. 337–57, 392–404, 490–513.

98 MacKenzie, *Propaganda*, pp. 21–8.

99 ibid., pp. 219–26. See also J. Bristow, *Empire Boys: Adventures in a Man's World*, Harper Collins Academic, 1991; J. Richards (ed.), *Imperialism and Juvenile Literature*, Manchester University Press, Manchester, 1989; K. Reynolds, *Girls Only? Gender and Popular Children's Fiction in Britain, 1880–1910*, Harvester Wheatsheaf, Hemel Hempstead, 1990; M. Green, *Dreams of*

Adventure, Deeds of Empire, Routledge & Kegan Paul, 1980, pp. 214–34; J. Rowbotham, *Good Girls Make Good Wives: Guidance For Girls in Victorian Fiction*, Blackwell, Oxford, 1989, pp. 180–220.

100 MacKenzie, *Propaganda*, pp. 213–15.

101 E. C. Looker, *Sir Henry Havelock, Colin Campbell (Lord Clyde)*, Cassell & Co., 1885; F. M. Holmes, *Four Heroes of India: Clive, Warren Hastings, Havelock, Lawrence*, Partridge & Co., 1892; G. B. Smith, *Heroes of the Nineteenth Century*, vol. III, Pearson, 1901; L. Taylor, *The Story of Sir Henry Havelock, The Hero of Lucknow*, Nelson, 1894; Forbes, *Havelock*.

102 MacKenzie, *Propaganda*, pp. 173–97. For history-writing and empire, see also S. Marks, 'History, the Nation and Empire', *History Workshop*, 29, Spring 1990.

103 MacKenzie, *Propaganda*, pp. 202–3.

104 ibid., p. 206.

105 ibid., pp. 228–51. See also Summers, 'Militarism'; M. Blanch, 'Imperialism, Nationalism and Organized Youth', in Centre for Contemporary Cultural Studies, *Working Class Culture: Essays in History and Theory*, Hutchinson, 1979; J. R. Gillis, *Youth and History: Tradition and Change in European Age Relations, 1770–Present*, Academic Press, New York, 1981, pp. 95–147; C. Dyhouse, *Growing Up A Girl in Late Victorian and Edwardian England*, Routledge & Kegan Paul, 1981; J. Springhall, 'Building Character in the British Boy: the Attempt to Extend Christian Manliness to Working-class Adolescents, 1880–1914', in J. A. Mangan and J. Walvin (eds), *Manliness and Morality: Middle Class Masculinity in Britain and America 1800–1940*, Manchester University Press, Manchester, 1987. For a comparison with the USA during the same period, see J. L. Dubbert, *A Man's Place: Masculinity in Transition*, Prentice Hall, Englewood Cliffs, NJ, 1979, pp. 80–121.

106 A. Davin, 'Imperialism and Motherhood', *History Workshop*, 5, Spring 1978, pp. 16–26. See also J. Mackay and P. Thane, 'The Englishwoman', in R. Colls and P. Dodds (eds), *Englishness: Politics and Culture 1880–1920*, Croom Helm, 1986.

107 Major-General Sir Frederick Maurice, KCB, quoted in Davin, 'Imperialism', p. 15, and *passim*. Maurice's argument to the Committee on Physical Degeneration was that the army should become the medium of national regeneration. See also Summers, 'Militarism', pp. 110–12; A. R. Skelley, *The Victorian Army At Home*, Croom Helm, 1977, pp. 59–60, 246–7 and *passim*.

108 Blanch, 'Imperialism', p. 118.

109 Summers, 'Militarism', pp. 118–19; Morris, *Heaven's Command*, p. 328.

110 A. E. Hake, *The Story of Chinese Gordon*, Remington & Co., 1884; E. Hope, *Life of General Gordon*, Walter Scott, 1885, p. 362.

111 V. Brooke-Hunt, *Lord Roberts: A Biography*, Nisbet & Co., 1901, pp. 342, 317. For moral lessons, see pp. 141, 46–7. The single reference to Roberts as a Christian soldier (p. 337) is tokenism. Morris describes Roberts as 'the most beloved of imperial generals', *Pax Britannica*, p. 31. See also ibid., pp. 237–8; Summers, 'Militarism', pp. 118–19.

112 Brooke-Hunt, *Lord Roberts*, pp. 345, vii.

113 Hope, *General Gordon*, p. 362.

114 Banks, *Three Indian Heroes*, Preface; Holmes, *Four Heroes*, Preface, p. 6; Taylor, *Sir Henry Havelock*, pp. 13–14, 20.

115 Taylor, *Sir Henry Havelock*, pp. 3–10, 60. Similarly, Archibald Forbes was closely associated with the 'new journalism', which also aspired to a livelier style of reporting.

116 In Forbes 63 per cent of the narrative, and in Smith 79 per cent, is devoted to the Rebellion, compared to Marshman's 42 per cent.

117 For example, Banks, *Three Indian Heroes*, p. 108; Taylor, *Sir Henry Havelock*, pp. 12, 15–16, 58, 72; Forbes, *Havelock*, pp. 8–9; Holmes, *Four Heroes*, pp. 96–9, 132, 138, 144–5; Smith, *Heroes*, pp. 103, 107–10, 169.

118 Forbes, *Havelock*, p. 12; Holmes, *Four Heroes*, p. 98. Taylor gives one sentence, without comment, about Havelock's marriage in the context of a discussion about his baptism, *Sir Henry Havelock*, p. 17. Smith is also more interested in Havelock's baptism, *Heroes*, p. 109. Banks, the single exception, discusses Havelock's poverty and fears for his family, *Three Indian Heroes*, pp. 109–10.

119 Banks, *Three Indian Heroes*, p. 119; Holmes, *Four Heroes*, 119; Forbes, *Havelock*, pp. 75–9.

120 Smith, *Heroes*, pp. 115–17.

121 Canon J. H. Skine, quoted in Summers, 'Militarism', pp. 120–1.

122 See, for example, the account of the Boy Scout movement's development out of Baden-Powell's experiences in the Boer War, in E. E. Reynolds, *B-P: The Story of His Life*, Oxford University Press, Oxford, 1943, pp. 39–68. See especially the first-hand account of the mobilization of the Scouts in August 1914, which included military duties, on pp. 76–7: 'But quite the most exciting adventure was the capture of three men who had been flashing messages from a small house on the cliffs. . . . The military were over two hours in reaching us – two hours which to us were full of exciting possibilities.' On the Scouts, see also J. Bristow, *Empire Boys*, pp. 170–95; A. Warren, 'Citizens of the Empire: Baden-Powell, Scouts and Guides, and an Imperial Ideal', in MacKenzie, *Popular Culture*; A. Warren, 'Popular Manliness: Baden-Powell, Scouting and the Development of Manly Character', in Mangan and Walvin, *Manliness and Morality*; Gillis, *Youth and History*, pp. 141–7. M. Girouard, *The Return to Camelot: Chivalry and the English Gentleman*, Yale University Press, New Haven, Conn., 1981, pp. 250–8, draws out the importance of chivalry to the movement. C. D. Eby, *The Road to Armageddon: The Martial Spirit in English Popular Literature 1870–1914*, Duke University Press, Durham, NC, 1988, pp. 10–37, 61–85, links the Scouts, invasion scares and popular literature in which adventure moves from the Empire to the 'Home Country'.

123 R. Dyer, 'Entertainment as Utopia', in R. Altman (ed.), *Genre: The Musical*, Routledge & Kegan Paul, 1981. Splitting in imaginaries produces different forms of utopia. On domestic utopias, see M. Laplace, 'Producing and Consuming the Women's Film: Discursive Struggle in *Now, Voyager*', in C. Gledhill (ed.), *Home Is Where the Heart Is: Studies in Melodrama and the Women's Film*, BFI, 1987.

124 Pollock, *Way to Glory*; L. Cooper, *Havelock*, Bodley Head, 1957; C. Wood, *'H': Being Monologues at Front of Burning Cities*, Methuen, 1970. Pollock's is by far the superior of the two biographies. Wood's play deserves study in its own right, and in the context of his other dramatic critiques of British militarism, including the controversial television play about the Falklands War, *Tumbledown* (BBC, 1988).

125 MacKenzie, *Propaganda*, note 28 to p. 180; he is summarizing (pp. 174–83) the 1927 Board of Education Handbook. For a discussion of school histories from the 1920s to 1970s, see ibid., pp. 189–93.

126 ibid., p. 193.

127 Pollock, *Way to Glory*, pp. 3, 32 (and note 2), 257–8; Cooper, *Havelock*, p. 72, and, on the 'private self', pp. 26–8.

128 See, for example, Pollock, *Way to Glory*, pp. 155, 176.

129 ibid., pp. 153, 156–7, 187, 191, 207–8.

130 ibid., p. 4.

131 For the decline of the military expedition, see Morris, *Farewell the Trumpets*, pp. 125–44. For the 'waning of adventure', see P. Brantlinger, *Rule of Darkness: British Literature and Imperialism 1830–1914*, Cornell University Press, Ithaca, NY, and London, 1988, pp. 37–44. For the decline of religion, see Gilbert, *Religion and Society*, pp. 187, 202–7.

132 MacKenzie, *Propaganda*, p. 79. For memories of the Raj on recent British film and television, see F. Dhondy, 'All the Raj', *New Socialist*, March/April 1984; S. Rushdie, 'Outside the Whale', *Granta*, 11, 1984; T. Wollen, 'Over Our Shoulders: Nostalgic Screen Fictions for the 1980s', in J. Corner and S. Harvey (eds), *Enterprise and Heritage: Cross-Currents of National Culture*, Routledge, 1991.

Part III

My naming of Arab people and places throughout Part III follows the spellings found in my English sources, including occasional inconsistencies (for example, Dera and Deraa, Hijaz and Hejaz). References to frequently cited texts will use the following abbreviations: *Images*, for S. E. Tabachnick and C. Matheson, *Images of Lawrence*, Jonathan Cape, 1988; *Strand*, for Lowell Thomas, '"The Uncrowned King of Arabia", Colonel T. E. Lawrence, The Most Romantic Career of Modern Times', *The Strand Magazine*, 59, January–June 1920; SP for T. E. Lawrence, *Seven Pillars of Wisdom: A Triumph*, Penguin, Harmondsworth, 1962.

1 H. Bhabha, 'Foreword' to F. Fanon, *Black Skins, White Masks*, Pluto, 1986, p. xiv.

2 SP, p. 30.

6 The blond Bedouin

1 M. Brown and J. Cave, *A Touch of Genius: The Life of T. E. Lawrence*, Dent, 1988; J. Wilson, *Lawrence of Arabia: The Authorised Biography of T. E. Lawrence*, Heinemann, 1989; 'Lawrence of Arabia', an exhibition at the National Portrait Gallery, London, 9 December 1988–12 March 1989; exhibition catalogue by J. Wilson, *Lawrence of Arabia*, National Portrait Gallery Publications, 1988.

2 *The Guardian*, 9 Feb. 1989; *Lawrence of Arabia*, directed by David Lean, Horizon, UK, 1962. The restored version (Columbia Tri-Star Films, USA) appeared in February 1989: by May, it had grossed $4.6 million in the USA and the Marble Arch Odeon had taken more than £12,000 in advance bookings (*Sunday Times*, 28 May 1989, p. C11). One reviewer claimed that the film 'outshone all the newcomers at the Cannes Film Festival' (*Daily Telegraph*, 25 May 1989, p. 20).

3 Wilson, *Lawrence: Authorised Biography*, pp. 622–6; *The Sphere*, 23 Aug. 1919; S. E. Tabachnick and C. Matheson, *Images of Lawrence*, Jonathan Cape, 1988 (hereafter referred to as *Images*), dustjacket and p. 22.

4 D. Stewart, *T. E. Lawrence*, Paladin Grafton, 1979, p.197; L. Thomas, '"The Uncrowned King of Arabia", Colonel T. E. Lawrence, The Most Romantic Career of Modern Times', *The Strand Magazine*, 59, January–June 1920, pp. 40–53, 141–53, 251–61, 330–8. In 1921, Lawrence described these articles as 'about 70 per cent inaccurate and about 10 per cent inaccurate and offensive to those Arabs and Englishmen who took part in the Arab Campaign. They were partly impure imagination, partly perverted quotation of articles (by myself and

others) [on the campaign]'. According to Wilson, *Lawrence: Authorised Biography*, pp. 652–3, this was despite the omission, at Lawrence's request, of 'the most outrageous inventions' in the original articles, published in the American magazine, *Asia*. For the controversy surrounding the nature and extent of Lawrence's 'collaboration' with Thomas, see Chapter 7, pp. 191–3 below. Thomas later expanded his material into the first book-length biography of Lawrence, *With Lawrence in Arabia*, Hutchinson, 1925 (repr. Hutchinson, 1967). The analysis that follows, however, is based upon the earlier, shorter version (referred to hereafter as *Strand*). Thomas's narrative, in both article and book form, abounds with factual inaccuracies, omissions and controversial claims, which over thirty subsequent biographers have assessed and challenged. *Images* provides the best short introduction to these competing versions, and an evaluation of the evidence they muster.

5 *Strand* p. 40. See also pp. 42–3, 48.

6 ibid., pp. 41–2.

7 Lawrence was in fact of Irish parentage: see note 96 to Chapter 4, and note 1 to Introduction, above.

8 E. W. Said, *Orientalism*, Routledge & Kegan Paul, 1978, pp. 226–7.

9 Argued by J. Morris, *Farewell the Trumpets: An Imperial Retreat*, Penguin, Harmondsworth, 1979, pp. 248–50.

10 In discussion of Lawrence with family and friends *before* the film's re-release might have jogged memories, two issues emerged: first, his ambivalent sexuality, and second, confusion about 'which side he was on'.

11 B. Bergonzi, *Heroes' Twilight: A Study of the Literature of the Great War*, Constable, 1965, p. 17; P. Fussell, *The Great War and Modern Memory*, Oxford University Press, Oxford, 1975, pp. 12–23.

12 G. W. Steevens, *Daily Mail* correspondent at Omdurman, quoted in J. O. Springhall, '"Up Guards and At Them!" British Imperialism and Popular Art 1880–1914', in J. M. MacKenzie (ed.), *Imperialism and Popular Culture*, Manchester University Press, Manchester, 1986, pp. 58–9; Morris, *Farewell the Trumpet*, pp. 89, 71–2, on Kitchener. For Omdurman, see also T. Royle, *War Report: The War Correspondent's View of Battle from the Crimea to the Falklands*, Grafton, 1989, pp. 60–72. For the Crimean War, see Chapter 4, p. 95 above. For Fussell's use of Northrop Frye's distinction between romantic and ironic modes of narrative, see Chapter 3, pp. 55–6 above.

13 J. M. MacKenzie, *Propaganda and Empire: The Manipulation of British Public Opinion 1880–1960*, Manchester University Press, Manchester, 1984, pp. 9–11; 80–91 on cinema; 216–23 on juvenile literature. See also J. Richards, 'Boys' Own Empire: feature films and imperialism in the 1930s', in MacKenzie, *Popular Culture*, pp. 140–64. Alison Light has argued that 'many of the sites of adventure were taken over by women's and girls' fiction in the period', with writers such as Daphne du Maurier reworking the literary landscape of nineteenth-century boys' adventure (*Forever England: Femininity, Literature and Conservatism Between the Wars*, Routledge, 1991, pp. 173, 256).

14 M. Green, *Dreams of Adventure, Deeds of Empire*, Routledge & Kegan Paul, 1980, pp. 325–6. See also L. Deighton, *The Battle of Britain*, Jonathan Cape, 1980: 'To the public in the 1920s and 1930s, the air was a thrilling new dimension, and pioneer pilots were glamorous figures' (p. 32). For the adventure of flying in the 1930s, see the biographies of Battle of Britain RAF pilots, such as R. Hillary, *The Last Enemy*, Macmillan, 1950.

15 MacKenzie, *Propaganda* p. 218. The transfer to film of boys' fiction 'gave the adventure tradition a new lease of life long after it had lost respectability among serious writers' (ibid., p. 89).

16 A. Rutherford, *The Literature of War: Studies in Heroic Virtue*, Macmillan, 1989, pp. 9–10.

17 Green, *Dreams of Adventure*, pp. 320–5.

18 Rutherford, *Literature of War*, pp. 38–63; J. Conrad, *Heart of Darkness*, Penguin, Harmondsworth, 1973. See also Conrad's *Lord Jim*, Norton, New York, 1968. For my discussion of *Seven Pillars*, see Chapter 7, below.

19 See H. Bhahba, 'The Other Question: Difference, Discrimination and the Discourse of Colonialism' in F. Barker, P. Hulme, M. Iversen and D. Loxley (eds), *Literature, Politics and Theory: Papers from the Essex Conference 1976–84*, Methuen, 1986. See also P. Brantlinger, *Rule of Darkness: British Literature and Imperialism 1830–1914*, Cornell University Press, Ithaca, NY, and London, 1988, pp. 255–74.

20 Quoted from the guide-notes to the exhibition.

21 Stewart, *Lawrence*, p. 169. Stewart dismisses as myth the speculation that Buchan based the hero of his novel *Greenmantle* (Hodder & Stoughton, 1916) on Lawrence (p. 145), but see below, p. 189, and note 72. On state control of the news during the First World War, see C. Lovelace, 'British Press Censorship during the First World War', in G. Boyce, J. Curran and P. Wingate (eds), *Newspaper History from the Seventeenth Century to the Present Day*, Constable, 1978, especially pp. 310–11, where he describes the government's Press Bureau, set up to withhold certain types of information from the public sphere. One criterion was 'whether it could unduly depress our people'. See, too, P. Knightley, *The First Casualty: The War Correspondent as Hero, Propagandist and Myth-Maker from the Crimea to Vietnam*, Quartet, 1978, pp. 79–135.

22 E. J. Leed, *No Man's Land: Combat and Identity in World War One*, Cambridge University Press, Cambridge, 1979, pp. 58–69. On the experience of mechanized warfare on the Western Front, see pp. 29–32; and Rutherford, *Literature of War*, pp. 65–9, who also compares the Arabian 'sideshow' (pp. 47, 68). See in particular Leed's argument about the profound stasis of trench life, and ensuing fantasies of mobility, pp. 121–6, 162.

23 H. Golding (ed.), *The Wonder Book of Soldiers*, Ward Lock, 1919, p. 83; quoted in MacKenzie, *Propaganda*, p. 222.

24 Leed, *No Man's Land*. On the adventure potential of the war in the Middle East, see Morris, *Farewell the Trumpets*, pp. 157–201. For modernism, see E. Lunn, *Marxism and Modernism*, Verso, 1985, pp. 33–64, where many of the themes in Leed's account of 'the first modern industrialized war' are picked up.

25 *Strand*, p. 141.

26 ibid., pp. 42–4, 52.

27 ibid., pp. 52 (but cf. p. 51 where he is described saluting Allenby!), 150, 42. On the element of the marvellous in romance, see N. Frye, *The Anatomy of Criticism*, Princeton University Press, Princeton, NJ, 1957, pp. 33–5. On the 'feminine' man, see Anthony Easthope's discussion of the iconography of Christ, in *What A Man's Gotta Do: The Masculine Myth in Popular Culture*, Paladin, 1986, pp. 23–5. On Lawrence's chivalric self-identification, see Chapter 7, p. 192 below.

28 *Strand*, pp. 46–7; M. Green, *Children of the Sun: A Narrative of 'Decadence' in England after 1918*, Constable, 1977, pp. 69, 73. See also *Strand*, p. 253, where Lawrence is described as 'the English lad just out of college'; and p. 152, where two years are stripped from his age to make him 28 years old on his entry to Damascus. See Green, *Dreams of Adventure*, pp. 82–3, on the close association between the idea of the 'young man' and themes of 'empire, frontier, exploration'.

29 Green, *Children of the Sun*, p. 74: 'He was portrayed everywhere in his long

robes and long hair, looking the reverse of the military type, with his virginal and narcissistic beauty. He appeared the reverse of say, Haig or Kitchener on the recruiting posters; yet while they had failed as soldiers, he had succeeded brilliantly.'

30 *Strand*, p. 46. On the irregular soldier, see below, pp. 189–90, and Chapter 8, p. 229.

31 See Morris, *Farewell the Trumpets*, pp. 248–50; J. Morris, *Heaven's Command: An Imperial Progress*, Penguin, Harmondsworth, 1979, pp. 417–21, 490–3; P. Mansfield, *The Arabs*, Penguin, Harmondsworth, 1978, pp. 137–54, 173, 191.

32 Richard Burton, quoted in Green, *Dreams of Adventure*, pp. 291–2. On Burton, see also Said, *Orientalism.*, pp. 194–7; Brantlinger, *Rule of Darkness*, pp. 158–69; Abdullah Achmed and T. C. Pakenham, *Dreamers of Empire*, Harrap, 1930 pp. 60–107. Charles Doughty's *Travels in Arabia Deserta* was one of Lawrence's own energizing myths: see Chapter 7, p. 192 below.

33 Morris, *Farewell the Trumpets*, p. 250. See Mansfield, *The Arabs*, pp. 491–502; Said, *Orientalism, passim*. The 'Arabs of the Desert' toy soldiers can be seen at the Bethnal Green Museum of Childhood, London.

34 For the Arab Revolt, the wider Allied campaign in the Holy Land under General Allenby, and the establishment of the short-lived British Empire in the Middle East, see Morris, *Farewell the Trumpets*, pp. 250–66; Mansfield, *The Arabs*, pp. 178–96.

35 *Strand*, p. 42.

36 E. Kedourie, 'Colonel Lawrence and his Biographers', *Islam in the Modern World*, Mansell, 1980, p. 269. This view is endorsed by Mansfield, *The Arabs*, p. 186: 'When the Arab Revolt came it was not an uprising of the whole Arab people to throw off the Turkish yoke. Only a small minority . . . saw it in those terms. Most of the Arab reformers wanted to change the empire in order to strengthen it, and the great majority of the Arab people remained loyal to the caliphate and the sultanate.'

37 After the war, this splitting is evident *within* the imagining of 'the Arab': 'The Arabs were accused of treachery and ingratitude and a perverse failure to appreciate the benefits that had been bestowed upon them by the imperial powers. A distinction was often made between the 'good Arab', the tribal shaikh, pasha or emir who was prepared to co-operate with the authorities, and the 'bad Arab', who was the radical nationalist of the towns' (Mansfield, *The Arabs*, p. 497). Thomas mentions Arab women on only four occasions in *Strand*: as victims of Turkish atrocities (p. 148), 'veiled beauties' (p. 259), jealous wives (p. 332) and villagers fleeing a Turkish attack (p. 337). In his book, however, he devotes a chapter to them, and also narrates an episode in which Arab women are actively engaged in armed combat: they 'fought with as great valour as their husbands and brothers, and played a vital role in routing the Turks' (Thomas, *With Lawrence*, pp. 188–94; 184–5).

38 *Strand*, pp. 48, 253, 52. For Social Darwinist theories that the existent power of a conquering race is evidence of their 'fitness' to rule, see C. Bolt, *Victorian Attitudes to Race*, Routledge & Kegan Paul, 1971, pp. 10–23. According to Lord Cromer, who ruled Egypt 1883–1907, the decline of the Ottoman Empire proved the failure of Islam (Mansfield, *The Arabs*, p. 496).

39 *Strand*, pp. 144; 47–8.

40 ibid., pp. 52, 144–5, 150, 257.

41 ibid., pp. 44, 46, 49, 146. On T. E. Lawrence's less-than-perfect Arabic, see Mansfield, *The Arabs*, note to p. 197.

42 *Strand*, p. 253; see also p. 53. For the controversy over Lawrence's role, see *Images, passim*.

43 *Strand*, pp. 142, 145.

44 *Strand*, pp. 48, 148, 52. On the nature of Turkish rule and reasons for Arab acceptance of it, compare Mansfield, *The Arabs*, pp. 73–94: 'It would be quite incorrect to suppose that the Ottoman Empire imposed an iron repression on the Arab provinces. The regime was authoritarian and deeply conservative but neither insensitive nor ruthless. . . . In many respects the empire was tolerant (p. 91). . . . There was certainly no institutionalized racial discrimination of the kind that was practiced in later Christian empires (p. 93). . . . While the Turks laid no claim to superiority over the Arabs in civilization, the Europeans did so with undisguised arrogance' (p. 186).

45 *Strand*, pp. 46, 52–3, 143, 147–8.

46 ibid., pp. 141–2. See Stewart, *Lawrence*, pp. 178–80, for analysis of the oscillations about 'train-bashing' in Lawrence's letters home, where it is variously described in the 'schoolboy language' attributed to him by Thomas, and as a nerve-shattering nightmare: 'This killing and killing of Turks is horrible.' These oscillations can be understood in terms of the Kleinian depressive position, as described in Chapter 2, above. The national specificity of cultural imaginaries can be seen by comparing this version of the Turks with Australian Anzac narratives about the Gallipoli peninsula, where they are a much-admired and respected enemy. I am grateful to Alistair Thomson for this point.

47 *Strand*, pp. 47, 141.

48 ibid., pp. 253–4, 260, 53.

49 ibid., pp. 253, 43, 258.

50 ibid., pp. 142, 46, 147.

51 ibid., pp. 144–5. The size of the Arab army was greatly exaggerated by Thomas. For competing assessments of Lawrence's role in the capture of Akaba, see *Images*, p. 121; Kedourie, 'Colonel Lawrence', p. 268.

52 *Strand*, pp. 148–9.

53 ibid., pp. 151–3.

54 ibid., p. 153; Stewart, *Lawrence*, p. 205. For the 'who got there first' controversy, see also Wilson, *Lawrence: Authorised Biography*, p. 1107; T. E. Lawrence, *Seven Pillars of Wisdom: A Triumph*, Penguin, Harmondsworth, 1962 (hereafter SP), pp. 664–9; *Images*, p. 72. Thomas's false claim that, after Damascus, Lawrence was involved in the capture of Beirut and Aleppo was not included in *With Lawrence*.

55 *Strand*, p. 258.

56 ibid., pp. 144, 252, 255, 335.

57 ibid., pp. 330–4.

58 ibid., pp. 260, 142–3, 329, 255, 259.

59 ibid., pp. 253, 53. Lawrence's camel-riding feats are unquestioned even by critics.

60 ibid., pp. 260, 142. On knowledge, power and colonialism, see Said, *Orientalism*, *passim*, and his discussion of Lawrence, pp. 235–44.

61 *Strand*, p. 251. For Lawrence's comments on the political expediency of wearing Arab dress, see note 5 to Chapter 7, below.

62 Thomas describes the Arabs' belief in Lawrence's 'untold wealth' as being crucial to his prestige (p. 161), while the help he received from the British Navy in the Red Sea 'was partly responsible for the impression which the King [Hussein] had of Great Britain's unlimited power' (pp. 144–5). See also pp. 149, 256. The importance of British gold and naval power is confirmed by Mansfield, *The Arabs*, p. 197.

63 *Strand*, p. 251. See, for example, Captain Good in H. Rider Haggard's *King Solomon's Mines*, Penguin, Harmondsworth, 1958, pp. 15, 91–2; and the 'miracle' of the immaculately attired chief accountant at the trading station in the African interior in Conrad, *Heart of Darkness*, pp. 25–6.

64 For the Kleinian concept of projective identification, see Chapter 2, pp. 33–4 and 43–4 above.
65 Cf. the 'reconciling [of] English superiority with romantic primitivism' in Rider Haggard's Sir Henry Curtis and Rice Burroughs's Tarzan, identified by B. Street, *The Savage in Literature: Representations of 'Primitive' Society in English Fiction 1858–1920*, Routledge & Kegan Paul, 1975, pp. 20, 43 – another example of Thomas's continuities with pre-war adventure.
66 *Strand*, pp. 52, 50.
67 Letter by T. E. Lawrence, Jan. 1920, quoted in *Images*, p. 38; Thomas, *With Lawrence*, '1967 Foreword', p. xii.
68 *Strand*, p. 42.
69 For the Sykes–Picot agreement, see Mansfield, *The Arabs*, p. 196. For T. E. Lawrence's military thinking and accomplishments as a guerrilla leader, see *Images*, pp. 119–27.
70 Green, *Dreams of Adventure*, pp. 23–4; and see Chapter 3, above.
71 See pp. 62–6 and 74–6 above.
72 F. S. Brereton, *With Allenby in Palestine*, Blackie, 1919, pp. 198–237; Buchan, *Greenmantle*. See also J. Buchan, *The Three Hostages*, Penguin, 1953; and James Buchan, 'Romancers Entwined: How T. E. Lawrence and John Buchan invented one another', *The Times Literary Supplement*, 29 May 1992, pp. 13–14.
73 For the 'temporary soldier', see Green, *Dreams of Adventure*, p. 26. For the disguise motif, which warrants further study, see my discussion of Scott's *Waverley* above, Chapter Three; note 32 to this chapter, above, on Burton, who gained entrance to Mecca disguised as an Arab; and A. E. W. Mason, *The Four Feathers*, John Murray, 1902. For Scouting, see note 122 to Chapter 5, above. Lawrence himself was not in disguise whilst with the Arabs, except on his journeys across Turkish lines.
74 *Images*, p. 125. I return to this theme in Chapter 8, p. 229 below; and see Chapter 9, pp. 248–50 below, for *The Victor*.

7 The public and private lives of T. E. Lawrence

1 M. Bradbury, 'London 1890–1920', in M. Bradbury and J. MacFarlane (eds), *Modernism 1890–1930*, Penguin, Harmondsworth, 1976, p. 179. See D. Stewart, *T. E. Lawrence*, Paladin Grafton, 1979, pp. 215–18.
2 Bradbury, 'London', pp. 179–83.
3 M. Green, *Dreams of Adventure, Deeds of Empire*, Routledge & Kegan Paul, 1980, pp. 326–8. For the argument that a chivalric 'ideal self' formed a central component in Lawrence's personality, see J. Meyers, *The Wounded Spirit: A Study of 'Seven Pillars of Wisdom'*, Martin Brian & O'Keefe, 1973, pp. 114–29; and see below, p. 199. See Stewart, *Lawrence*, pp. 41–125 on Lawrence's pre-war visits to the Middle East, and pp. 41, 64, 225, 246 on Doughty; '[his] book helped guide us to victory in the East', wrote Lawrence in his Introduction to the 1921 edition of *Arabia Deserta* (C. M. Doughty, *Travels in Arabia Deserta*, ed. T. E. Lawrence, Jonathan Cape, 1921). For key themes in the Arabian imaginary, see Chapter 6, pp. 177–8 above.
4 See *Images*, pp. 37–41, 107–27 and 41–91 *passim* for a concise review of the historical evidence. Tabachnick's own view is that 'the basic stories of Lawrence's leadership of the Arabs and his secret intelligence work are true' (p. 40). (For abbreviated forms of reference see introductory note to Part III.)
5 See Lawrence's comments on the political expediency of wearing Arab dress, in his 'Twenty-seven Articles' (of advice to political agents working with the Bedouin), *Arab Bulletin*, 20 Aug. 1917, quoted in P. Mansfield, *The Arabs*,

Penguin, Harmondsworth, 1978, p. 179: 'If you can wear Arab kit when with the tribes, you will acquire their trust and intimacy to a degree impossible in uniform. It is, however, difficult and dangerous.' Lawrence's alleged homoeroticism is a theme developed at length in Stewart, *Lawrence*, including his involvement with the 'Uranian' movement (pp. 20–2), his relationship with the young Arab, Dahoum (pp. 99–108), and his seductiveness in Arab dress (p. 191).

6 Stewart, *Lawrence*, p. 218; M. Green, *Children of the Sun: A Narrative of 'Decadence' in England after 1918*, Constable, 1977, pp. 69–74; Bradbury, 'London', p. 181.

7 Cf. Stewart, *Lawrence*, p. 151. For the importance of 'social recognition' to the composition of identity, see Chapter 1, pp. 23–5 above; and Chapter 10, below.

8 Stewart, *Lawrence*, p. 197, including quote from Thomas; Lawrence's letter to E. L. Greenhill, quoted in *Images*, p. 22.

9 *Images*, p. 22. See also Stewart, *Lawrence*, p. 232. Evidence that he attended the show at least once can be found in a letter quoted in L. Thomas, *With Lawrence in Arabia*, Hutchinson, 1925, p. 275: 'My Dear Lowell Thomas, I saw your show last night. And thank God the lights were out! T. E. Lawrence.'

10 *Strand*, p. 43; *Images*, pp. 91, 22, 40; Stewart, *Lawrence*, pp. 52–4.

11 J. M. MacKenzie, *Propaganda and Empire: The Manipulation of British Public Opinion 1880–1960*, Manchester University Press, Manchester, 1984, pp. 32–5, puts Thomas's show in the context of the widespread use from the 1880s of magic-lantern slides with a lecturer to promote imperial themes, and their gradual supersession by film from the early twentieth century. On the interwar press, see J. Curran and J. Seaton, *Power Without Responsibility: The Press and Broadcasting in Britain*, Methuen, 1985, pp. 52–74.

12 R. Dyer, *Heavenly Bodies: Film Stars and Society*, Macmillan, 1987, pp. 8–14, and p. 50 where he discusses Marilyn Monroe in terms of 'the person who inhabits and produces the sexy image . . . the person who plays the fantasy'.

13 Stewart, *Lawrence*, p. 249.

14 Dyer, *Heavenly Bodies*.

15 Quoted in Stewart, *Lawrence*, p. 226. Hogarth and Storrs were Lawrence's superiors at the Arab Bureau.

16 SP.

17 *Images* p. 156. My discussion of SP is especially indebted to Stephen Tabachnick's succinct and suggestive reading, pp. 155–63.

18 SP, pp. 282–3. See also pp. 387, 565–9. Cf. Mansfield's analysis of Lawrence's politics, *The Arabs*, p. 196: 'There can be little doubt that Feisal was deliberately chosen by Lawrence as the ideal instrument for maintaining British control over the Arabian national movement, and ultimately for achieving Lawrence's personal objective, shared in some form or other by most of his colleagues, of an Arab "brown dominion" within the British Empire. . . . Feisal trusted Lawrence entirely in the firm belief that he would help the Arabs achieve complete independence under the rule of the Hashemite family. For a while the relationship between Feisal and Lawrence was an open and honest one. But soon Lawrence learned through the Arab Bureau of the Foreign Office's plans to carve up Syria and Iraq between Britain and France after the war. Hogarth and Lawrence were appalled – but not because they believed in the Arab right to independence: the two imperialists simply wanted the hated French to have no share in the eastern half of the Arab world. Although ultimately they failed, Lawrence did manage to keep the terms of the agreement from Feisal until he was totally dependent on Britain and unable to withdraw from the British-backed uprising.'

19 SP, pp. 226–7, 85–6, 580, 560.
20 Meyers, *Wounded Spirit*, p. 106. See, for example, SP, pp. 192 (dysentery fever), 254 (travelling in the desert wind), 387 (scorpion bite), 488–9 (weather), 618 (wounded).
21 SP, p. 187. On 'train-blowing', see ibid., pp. 371–90, 434–43; and for Thomas's account, see Chapter 6, pp. 181–2 above.
22 SP, pp. 483–92. In Thomas, plans do not 'go adrift' like this.
23 ibid., pp. 396, 423–33. The intervening pages tell the full story of the raid.
24 ibid., p. 28.
25 ibid., pp. 459–61, 456. For Deraa, see pp. 450–6.
26 Meyers, *Wounded Spirit*, pp. 114–29; SP, pp. 454, 477. See also SP, p. 508 for Lawrence's hatred of sex and procreation, and p. 547 on the body and the will.
27 E. Said quoted in *Lawrence of Arabia* (BBC, 1986, produced by J. Cave and M. Brown). For discussion of this debate, see Chapter 8, below.
28 J. Benjamin, 'Master and Slave: The Fantasy of Erotic Domination', in A. Snitow, C. Stansell and S. Thompson (eds), *Desire: The Politics of Sexuality*, Virago, 1984.
29 ibid., pp. 292–8, 303–8.
30 On the Deraa incident, see also my discussion of its treatment by Lawrence's biographers and in the David Lean/Robert Bolt film, *Lawrence of Arabia* (1962), Chapter 8, below.
31 SP, pp. 512–14.
32 ibid., pp. 651–5.
33 ibid., pp. 666–71.
34 ibid., pp. 670, 682–3. Lawrence's exclusion from the Arab national community and consequent feeling of isolation and sadness is graphically captured in an image (p. 674) of him listening to the calls to prayer from a nearby mosque after the fall of Damascus: 'The clamour hushed, as everyone seemed to obey the call to prayer on this first night of total freedom. While my fancy, in the overwhelming pause, showed me my loneliness and lack of reason in their movement: since only for me, of all hearers, was the event sorrowful and the phrase meaningless.' The world he is barred from is one in which providential design continues to operate.
35 *Images*, pp. 156–60.
36 See the account of modernism in E. Lunn, *Marxism and Modernism*, Verso, 1985, pp. 36–7.
37 M. Berman, *All That Is Solid Melts into Air: The Experience of Modernity*, Verso, 1983, pp. 18–19.
38 SP, pp. 27–8.
39 Berman, *All That Is Solid*, pp. 21–2, quoting Nietzsche. See Stewart, *Lawrence*, pp. 239–40 on Lawrence's interest in Nietzsche.
40 Lunn, *Marxism*, p. 37.
41 R. Ellmann, *The Identity of Yeats*, Faber, 1964; Lunn, *Marxism*, pp. 58–64.
42 Lunn, *Marxism*, p. 40.
43 Meyers, *Wounded Spirit*, pp. 106–8.
44 SP, p. 30. The passage is quoted in full at the head of Part III, above.
45 *Images*, pp. 160–3. See, for example, Lawrence's description of himself wearing Arab robes in the cold mountains as like a 'hard-iced Bridal cake' (SP, p. 508).
46 *Images*, p.156.
47 T. E. Lawrence, letter to Robert Graves, quoted in Meyers, *Wounded Spirit*, p. 119.
48 Stewart, *Lawrence*, p. 233. See pp. 231–55, 274–5, 290 for a sceptical account of the writing and publishing of *Seven Pillars*. Both books were instant bestsellers in

English and other languages, and *Seven Pillars* has been continuously in print ever since (*Images*, p. 156).

49 *Images* provides a useful summary of Lawrence's multiple identifications, but see also Stewart, *Lawrence*, for 'his ability to put tight compartments between the different sectors of his life' (p. 285).

50 E. Kedourie, 'Colonel Lawrence and his Biographers', *Islam and the Modern World*, Mansell, 1980, pp. 263–5, 272–5.

51 Stewart, *Lawrence*, pp. 34–7.

52 ibid., pp. 286–90 on Lawrence's relations with women; pp. 281–3 on Clouds Hill. See also *Clouds Hill, Dorset*, The National Trust, 1989, especially pp. 4–5. Eric Leed, writing on drill as an expression of 'the values of community inherent in the army', suggests that Lawrence was one who valued the military life for its structure: a measure of the distance between the 'biographical' T. E. Lawrence and Thomas's imaginary 'Lawrence of Arabia', for whom drill was anathema. See E. J. Leed, *No Man's Land: Combat and Identity in World War One*, Cambridge University Press, Cambridge, 1979, pp. 55–6; and Chapter 6, p. 175 above.

8 Public pathologies

1 D. Stewart, *T. E. Lawrence*, Paladin Grafton, 1979, p. 275; J. Morris, *Farewell the Trumpets: An Imperial Retreat*, Penguin, Harmondsworth, 1979, p. 303. For the interwar press, see J. Curran and J. Seaton, *Power Without Responsibility: The Press and Broadcasting in Britain*, Methuen, 1985, pp. 52–74; J. Stevenson, *British Society 1914–45*, Allen Lane, 1984, pp. 402–7. Archive film of Lawrence in various stages of his career can be seen in the television documentary *Lawrence of Arabia* (BBC, 1986, produced by J. Cave and M. Brown). In 1926, there were 3,000 cinemas in Britain, increasing to nearly 5,000 by 1938; and in 1934, 903 million tickets were sold (Stevenson, pp. 395–6).

2 See, for example, P. Knightley, 'Was there really a rape in Dera?', *The Independent on Sunday*, 19 Aug. 1990, p. 6.

3 *Images*, pp. 71–4; Stewart, *Lawrence*, pp. 276–82. Bruce had undertaken to keep his secret while Lawrence's mother remained alive, but after her death he sold publishing rights on a typescript describing his friendship with Lawrence to the *Sunday Times*, who ran his story in weekly instalments from 23 August 1968 (republished as P. Knightley and C. Simpson, *The Secret Lives of Lawrence of Arabia*, Nelson, 1969). (For abbreviated forms of reference see introductory note to Part III.)

4 For the television documentaries, see *Images*, pp. 83–91. For Lean's film, which reappeared on British television in its re-edited form during the autumn and Christmas seasons, 1990, see below.

5 The most useful analysis of the multi-faceted Lawrence image is *Images*, but see also E. Kedourie, 'Colonel Lawrence and his Biographers', *Islam in the Modern World*, Mansell, 1980; B. H. Reid, 'T. E. Lawrence and his Biographers', in B. Bond (ed.), *The First World War and British Military History*, Clarendon Press, Oxford, 1991.

6 R. Graves, *Lawrence and the Arabs*, Thames & Hudson, 1976 (first published 1927), quoted in *Images*, pp. 41–3. See also Reid, 'Biographers', pp. 231–8.

7 N. Rose, *The Psychological Complex: Psychology, Politics and Society 1869–1939*, Routledge & Kegan Paul, 1985, pp. 1–10.

8 J. Meyers, *The Wounded Spirit: A Study of 'Seven Pillars of Wisdom'*, Martin Brian & O'Keefe, 1973, p. 115. See above, p. 199.

9 C. Kaplan, 'The Thorn Birds: Fiction, Fantasy and Feminism', in V. Burgin, J. Donald and C. Kaplan (eds), *Formations of Fantasy*, Methuen, 1986, pp. 150–2.

10 A. Nutting, *Lawrence of Arabia: The Man and the Motive*, Hollis, 1961; cited and discussed in *Images*, p. 61. See also Reid, 'Biographers', p. 250. For biographical treatments of Deraa, see also *Images, passim*; Stewart, *Lawrence*, pp. 187–9, 244. For the continuing controversy, see L. James, *The Golden Warrior*, Weidenfeld & Nicolson, 1990, and the review by Knightley, 'Was there really a rape at Dera?'. For Benjamin, see Chapter 7, pp. 199–200 above. For an analysis of homophobia, see J. Dollimore, 'Homophobia and Sexual Difference', *Oxford Literary Review*, 8/1–2 (1986), special issue, 'Sexual Difference', pp. 5–12.

11 *Images*, p. 71. Others include the Tafas episode and the secret ride north into Syria in June 1917, when Lawrence allegedly met the Turkish commander Ali Riza Pasha Rehabi. For the latter, see *Images* pp. 45, 111–12; Stewart, *Lawrence*, pp. 166–8.

12 E. Said, quoted in *Lawrence of Arabia* (BBC, 1986); Stewart, *Lawrence*, pp. 187–9; 244.

13 Stewart, *Lawrence*, pp. 299–305; H. Montgomery Hyde, quoted in *Images*, p. 79.

14 *Images*, p. 89.

15 Quoted in Stewart, *Lawrence*, p. 191; and Morris, *Farewell the Trumpets*, footnote 1, p. 255.

16 Meyers, *Wounded Spirit*, p. 138.

17 B. Liddell Hart, *T. E. Lawrence: In Arabia and After*, Cape, 1934, cited in *Images*, p. 46. Lawrence's response was that Liddell Hart 'seems to have no critical sense in my regard'. See also Reid, 'Biographers', pp. 231–3, 238–42; M. Green, *Children of the Sun: A Narrative of 'Decadence' in England after 1918*, Constable, 1977, p. 74.

18 R. Aldington, *Lawrence of Arabia: A Biographical Inquiry*, Collins, 1955, quoted in *Images*, pp. 52–5. See also Reid, 'Biographers', pp. 243–9.

19 J. Mack, *A Prince of Our Disorder: The Life of T. E. Lawrence*, Weidenfeld & Nicolson, 1976, cited in *Images*, p. 75. See also Reid, 'Biographers', pp. 254–5.

20 E. M. Hull, *The Sheik* (1921), discussed in C. Cockburn, *Bestseller: The Books That Everyone Read 1900–1939*, Sidgwick & Jackson, 1972. Rudolph Valentino starred in *The Sheik* (1922) and *Son of the Sheik* (1926).

21 S. Rowbotham, *Hidden from History: 300 Years of Women's Oppression and the Fight against It*, Pluto, 1977, pp. 119, 123–7. See also J. Weeks, *Sex, Politics and Society: the Regulation of Sexuality Since 1800*, Longman, 1981, pp. 187–224.

22 Green, *Children of the Sun*, pp. 23–7, 62–3, 72–4.

23 Morris, *Farewell the Trumpets*, p. 255. For this history, see ibid., pp. 207–47, 273–98; B. Porter, *The Lion's Share. A Short History of British Imperialism 1859–1970*, Longman, 1975, pp. 251–302.

24 Porter, *Lion's Share*, pp. 252–4.

25 ibid., pp. 322–30.

26 Morris, *Farewell the Trumpets*, pp. 522–9; P. Mansfield, *The Arabs*, Penguin, Harmondsworth, 1978, pp. 298–303.

27 Morris, *Farewell the Trumpets*, pp. 523, 528.

28 R. Hewison, *In Anger: Culture in the Cold War 1945–60*, Weidenfeld & Nicolson, 1981, p. 136, including quotation from Lessing (1957); and see also pp. 117–18, 127–41. A. Sinfield, *Literature, Politics and Culture in Postwar Britain*, Blackwell, Oxford, 1989, p. 116; and see pp. 134–9 on the impact of decolonization on British literature.

29 Quoted in Hewison, *In Anger*, p. 134. Cf. J. Osborne's *The Entertainer*, Faber & Faber, 1957, where the sense of futility, the end of a morally bankrupt traditional culture, and forms of masculine dilemma posed by this, are articulated explicitly to the Suez 'adventure'.

30 K. Tynan, quoted in Hewison, *In Anger*, p. 134. On the questioning of traditional authorities, see also P. Lewis, *The Fifties*, Heinemann, 1978, pp. 158–86.
31 Quoted in Kedourie, 'Biographers', pp. 263–4 (no reference given).
32 R. Aldington, quoted in *Images*, p. 55; S. Mousa, *T. E. Lawrence: An Arab View*, Oxford University Press, Oxford, 1966, cited ibid., p. 73. On Mousa, see also ibid., pp. 67–8; Reid, 'Biographers', pp. 250–1. See also Reid, pp. 248–9 on Aldington's charge. For homosexuality in the post-war period, see Alan Sinfield's discussion of 'Queers and treachery', in *Literature, Politics and Culture*, pp. 60–85; and for Fifties homophobia, L. Segal, 'Look Back in Anger: Men in the Fifties', in *Slow Motion: Changing Masculinities, Changing Men*, Virago, 1990, pp. 16–22.
33 *Images*, p. 51.
34 A. Nutting, quoted ibid., p. 61.
35 *Lawrence of Arabia*, Horizon, UK, 1962. On previous attempts to produce a screen version of the Lawrence story, see *Screen International*, 26 Sept. 1981, p. 18. The quotations below are transcribed from a video recording of the film.
36 *Images*, pp. 61–3.
37 Kedourie, 'Biographers', p. 262.
38 A. Turner, 'Slash it again, Sam', *The Guardian*, 25 May 1989, p. 23.
39 P. French, *The Observer*, 28 May 1989, p. 44. The critic was Kit Lambert, later mentor of 'The Who', self-appointed spokespersons of the generation gap.
40 Quoted in Turner, 'Slash it again, Sam'.
41 Quoted in *Journal of the Society of Film and Television Arts*, 10, Winter 1962–3, special issue on *Lawrence of Arabia*, p. 4.
42 Most obviously in the case of Anthony Quinn, complete with prosthetic hooked nose, who stars as Auda and plays him as the comic-book figure out of Thomas.
43 SP, pp. 260–3.
44 In SP this occurs on a quite separate occasion and is hardly the dramatic moment imagined by the film (see SP, p. 129).
45 Cf. the nineteenth-century narrative of providential design that structures the significance of the Havelock adventure, in Chapter 5, above. For phantasies of the giving and taking of life, see the discussion of Melanie Klein in Chapter 2, above; and my analysis of Indian Rebellion narratives, Chapter 4, above.
46 On the Faust legend and modernity, see M. Berman, *All That Is Solid Melts into Air: The Experience of Modernity*, Verso, 1983, pp. 37–86.
47 For the execution in SP, see p. 187. The journey and meeting with Allenby is handled humorously in the book, a quality entirely lacking from this episode of the film: see ibid., pp. 323–30. For the very different death of Daum in the book, see ibid., p. 520.
48 In this scene, Bolt has Lawrence confess to Allenby his disturbance at having killed, including the fictitious claim (derived from Nutting) that 'I enjoyed it'. The film's treatment of this key episode is over-simplistic and unconvincing. Cf. the representation of Allenby in SP, discussed above, p. 202.
49 See the discussion of the Deraa incident in Chapter 7, above.
50 For the Tafas episode in SP, see Chapter 7, above.
51 SP, p. 682.
52 Feisal fears 'the great hunger for desolate places' of the 'desert-loving English': no Arabs love the desert, he says, because 'there is nothing in it' (a perception that should have ironic significance for an oil-age audience). Feisal's own wish is to acquire the technology of a modern, mechanized army to fight the Turks, while Sharif Ali desires an education in the working of modern, democratic political institutions. While the film's treatment of the Arab leaders undoubtedly repro-

duces many of Thomas's 'childlike noble savage' motifs – for example, Ali is shown learning his politics from a children's school textbook – their desire for 'the modern' distinguishes them from 'traditional' noble savages such as Auda. In representing Feisal and Ali as modern, desiring subjects in their own right, the film dramatizes Homi Bhabha's argument that the formation of subjectivities under colonial conditions is marked not only by the projective investments of the colonizer in the colonized other, but also by the (ambiguous) desire of the colonized for the position and power of the master. See his 'Foreword' to F. Fanon, *Black Skin, White Masks*, Pluto, 1986.

53 See the reviews in *What's On*, 17 May 1989, pp. 64–5, and 24 May 1989, p. 61; and by V. Mather, *Daily Telegraph*, 25 May 1989, p. 20.

54 I. Johnstone, *Sunday Times*, 28 May 1989, p. C11; D. Denby, *Première*, Feb. 1989, quoted in 'National Film Theatre Programme Notes'. O'Toole was a head taller than T. E. himself, who stood at only 5 feet 4 inches.

55 K. Jackson, *The Independent*, 25 May 1989, p. 17; J. Hoberman, 'Radical Sheikh', *Village Voice*, 14 Feb. 1989, pp. 59–60.

56 Turner, 'Slash it again, Sam'. The re-edited film restored twenty minutes cut by the producer, Sam Spielberg, from the original release; including the full scene with the Turkish soldiers at Deraa, now seen for the first time (*The Guardian*, 9 Feb. 1989).

57 *Khartoum* (dir. B. Dearden, United Artists, USA/UK, 1966); *Zulu* (dir. C. Endfield, Paramount, UK, 1964). For the residual character of imperial imaginings in the 1960s, see J. M. MacKenzie, *Propaganda and Empire: The Manipulation of British Public Opinion 1880–1960*, Manchester University Press, Manchester, 1984; and Chapter 5, pp. 151–2 above. For Labour and the Empire, see S. Howe, 'Labour Patriotism 1939–83', in R. Samuel (ed.), *Patriotism: The Making and Unmaking of British National Identity*, vol. I: *History and Politics*, Routledge, 1989.

58 See G. Hurd (ed.), *National Fictions: World War Two on Film and Television*, British Film Institute, 1984. These themes are developed in Chapter 9, below.

59 J. Harris, *Harkaway's Sixth Column*, Arrow, 1984, dustjacket blurb.

60 ibid., p. 10.

61 ibid., pp. 11, 27, 151, 192–3 on the Somalis; pp. 119, 129–31, 138–9 on the Italians; pp. 27–8, 118, 120, 149 for references to the so-called 'Mad Mullah' – Muhammad Abd-Allah Hassan, sheikh of Somaliland – who led armed opposition to British rule between 1899 and 1904, and again in 1908–20. See R. Hyam, *Britain's Imperial Century 1815–1914: A Study of Empire and Expansion*, Batsford, 1976, pp. 284–5; D. J. Jardine, *The Mad Mullah of Somaliland*, Jenkins, 1923. For this kind of dual denigration, see the discussion of a comic-strip story from *The Victor* in Chapter 9, below.

62 Harris, *Sixth Column*, p. 33. See ibid., pp. 147, 149–50, 182–3, 206–7 for the sexuality theme; pp. 129, 153 for the conception of Harkaway's column as the 'Free British' and its association with Churchill and the Commandos. For the 'Sixth Column' as an irregular army, including an explicit association of Harkaway with Lawrence of Arabia, see pp. 260–2.

63 See, for example, *The Gulf War: The Arab View* (Channel Four, 1991). For the recent history of the Middle East, see P. Mansfield, *A History of the Middle East*, Viking, 1991, pp. 280–353. For Western television-news coverage of the region, see E. W. Said, *Covering Islam: How the Media and the Experts Determine how We See the Rest of the World*, Routledge & Kegan Paul, 1981.

64 E. W. Said, *Orientalism*, Routledge & Kegan Paul, 1978, pp. 284–328; E. W. Said, 'Empire of Sand', *The Guardian Weekend Supplement*, 12–13 Jan. 1991, pp. 4–7.

1 H. Segal, *Introduction to the Work of Melanie Klein*, Hogarth Press, 1973, pp. 20–1. Segal adds: 'It is certain that this patient had never read any analytical literature and had never heard of these concepts, particularly of the super-ego, otherwise the dream might be viewed with much more scepticism.'

2 M. Berman, *All That Is Solid Melts into Air: The Experience of Modernity*, Verso, 1983, pp. 22–3.

9 Playing at soldiers

1 For my arguments on introjection and the articulation of the psychic and the social, see Chapter 2, above.

2 See, for example, the autobiography of the Second World War RAF pilot, Richard Hillary, *The Last Enemy*, Macmillan, 1950. For a contemporary example relating to the Bosnian War, see 'A Caretaker Goes to War', *The Guardian* Section 2, 9 Feb. 1993, pp. 2–3.

3 For the psychology of institutionalized violence in combat, see R. Williams, *Politics and Letters*, New Left Books, 1979, pp. 55–60; J. Ellis, *The Sharp End of War: The Fighting Man In World War Two*, David & Charles, Newton Abbot and London, 1980, pp. 234–55, 315–26. For the connection to masculinity, see D. Morgan, 'Masculinity and Violence', in J. Hanmer and M. Maynard (eds), *Women, Violence and Social Control*, Macmillan, 1987; L. Segal, *Slow Motion: Changing Masculinities, Changing Men*, Virago, 1990, pp. 261–71.

4 For Cawelti, see Chapter 3, pp. 53–4 above. For Green, see Chapter 3, pp. 59–60 above.

5 See Chapter 5, pp. 144–8 above.

6 J. Opie, *Britains' Toy Soldiers 1893–1932*, Gollancz, 1985, pp. 13–15.

7 A. Fraser, *The History of Toys*, Weidenfeld & Nicolson, 1966, p. 183.

8 As a 7-year-old at boarding school, Churchill describes how 'I counted the days and the hours to the end of every term, when I should return home from the hateful servitude and range my soldiers in line of battle on the nursery floor.' Later, he claims that his pursuit of a military career was 'entirely due to my collection of soldiers' – some 1,500 plus artillery pieces – which his father came to 'inspect' one day. 'The toy soldiers turned the current of my life'. See W. Churchill, *My Early Life: A Roving Commission*, Odhams, 1947, pp. 9–10, 12, 19–20. For Meinertzhagen, see M. Green, *Dreams of Adventure, Deeds of Empire*, Routledge & Kegan Paul, 1980, p. 293.

9 H. G. Wells, *Floor Games*, Frank Palmer, 1911; cited in Fraser, *History of Toys*, pp. 178.

10 Fraser, *History of Toys*, p. 231.

11 See M. Ceadel, *Pacifism in Britain 1914–1945: The Defining of a Faith*, Oxford University Press, Oxford, 1980. For the Peace Movement in the 1980s, see D. Thompson (ed.), *Over Our Dead Bodies: Women against the Bomb*, Virago, 1983.

12 This outline of the rise of the American toy industry is taken from Fraser, *History of Toys*, pp. 196–230. For the economics of the toy industry since the 1970s and its effects upon the forms of toys, see G. Dawson, 'War Toys', in G. Day (ed.), *Readings in Popular Culture: Trivial Pursuits?*, Macmillan, 1990, pp. 98–111.

13 For the western, see J. G. Cawelti, *Adventure, Mystery and Romance: Formula Stories as Art and Popular Culture*, University of Chicago Press, Chicago, 1976, pp. 192–259; Fraser, *History of Toys*, pp. 226–30; K. Ferguson and S. Ferguson, *Western Stars of Television and Film*, Purnell & Sons, 1966. For the expansion of

broadcasting and the influence of American culture, see J. Curran and J. Seaton, *Power Without Responsibility: The Press and Broadcasting in Britain*, Methuen, 1985, p. 201; P. Lewis, *The Fifties*, Heinemann 1978, pp. 208–32.

14 Opie, *Toy Soldiers*, pp. 9, 13–16, 24–5; Dawson, 'War Toys', pp. 104–8. For the general expansion of cultural consumption from the late 1950s, see A. Marwick, *British Society since 1945*, Penguin, Harmondsworth, 1982, pp. 115–23.

15 This argument recapitulates the terms of the debate about fantasy discussed in Chapter 1, pp. 15–21 above. For a recent feminist critique of war toys, see J. Greenwell, 'War Toys', *The Guardian*, 29 Nov. 1988.

16 L. Daiken, *Children's Toys throughout the Ages*, Spring Books, 1963, pp. 137–9.

17 ibid.

18 Fraser, *History of Toys*, pp. 51, 230–1.

19 ibid., pp. 150, 183, 230–1.

20 L. Rodwell, 'Hard Sell for Soft Toys', *The Times*, 29 July 1985, p. 9.

21 *Sunday Times*, 24 Feb. 1974, cited in B. Dixon, *Catching Them Young 2: Political Ideas in Children's Fiction*, Pluto, 1977, p. 45.

22 Cited in Fraser, *History of Toys*, p. 230.

23 J. Cross, 'How Action Man Derailed a Train . . .', *The Guardian*, 13 Dec. 1982, p. 8. See also C. Bazalgette and R. Paterson, 'Real Entertainment: The Iranian Embassy Siege', *Screen Education*, 37, Winter 1980/81. One example of SAS adventure fiction is T. Strong, *Whisper Who Dares*, Coronet, 1982, which had gone to ten print-runs by 1985. See also J. Newsinger, 'The SAS and Popular Fiction', *Race and Class*, 25/1, 1983. For toy advertising, see M. Messenger Davis, 'Robin Hood Is Grounded', *The Guardian*, 16 May 1988.

24 Evidence for this active choice can be found in feminist mothers' reflections upon culture, gender and the difficulties encountered in trying to bring up their children 'against the grain'. See, for example, M. Cohen, 'Gender Rules OK?', in M. Hoyles (ed.), *Changing Childhood*, Writers and Readers, 1979; M. Grabrucker, *There's a Good Girl*, Women's Press, 1988; A. Phillips, *The Trouble with Boys: Parenting the Men of the Future*, Pandora, 1993.

25 For an oral history of childhood, including forms of play, see T. Thompson (ed.), *Edwardian Childhoods*, Routledge & Kegan Paul, 1981. For ethnographic studies of childhood and adolescence, see A. James, 'The Structure and Experience of Childhood and Adolescence: An Anthropological Approach to Socialization', doctoral thesis, University of Durham, unpublished, 1983, especially pp. 214–62; A. McRobbie, 'Working Class Girls and the Culture of Femininity', in Women's Studies Group, *Women Take Issue*, Hutchinson, 1978; P. Willis, *Learning to Labour: How Working Class Kids Get Working Class Jobs*, Saxon House, Farnborough, 1977. For an introduction to ethnographic work in cultural studies, including work on media audiences, see G. Turner, *British Cultural Studies: An Introduction*, Unwin Hyman, 1990, pp. 131–80.

26 See L. Stanley, 'Biography as Microscope or Kaleidoscope? The Case of "Power" in Hannah Cullwick's Relationship with Arthur Munby', *Women's Studies International Forum*, 10/1, 1987; A. Thomson, *Anzac Memories: Living with the Legend*, Oxford University Press, Melbourne, 1994; V. Walkerdine, 'Video Replay: Families, Films and Fantasies', in *Schoolgirl Fictions*, Verso, 1990.

27 For autobiographical explorations of boyhood fantasy during wartime, see J. Boorman, *Hope and Glory*, Faber & Faber, 1987; J. G. Ballard, *Empire of the Sun*, Grafton, 1985; and the films based on these texts. See also D. Jackson, *Unmasking Masculinity: A Critical Autobiography*, Unwin Hyman, 1990.

28 A. Thomson, 'Gallipoli: A Past That We Can Live By?', *Melbourne Historical Journal*, 14, 1982.

29 For an approach to memory in the reading of oral history interviews and popular

autobiographies, see Popular Memory Group, 'On Popular Memory: Politics, Theory, Method', in Centre for Contemporary Cultural Studies, *Making Histories*, Hutchinson, 1982. For a more sophisticated approach, see Thomson, *Anzac Memories*. Other work using autobiography to explore the cultural making of identities within particular historical circumstances, and the 'memory' process itself, includes: E. Wilson, *Mirror Writing*, Virago, 1982; R. Fraser, *In Search of a Past*, Verso, 1984; C. Steedman, *Landscape for a Good Woman*, Virago, 1986; L. Heron (ed.), *Truth, Dare or Promise; Girls Growing Up in the 1950s*, Virago, 1985.

30 H. Segal, *Klein*, Harvester, Brighton, 1979, p. 36. Klein's writing on play analysis includes: 'The Psychological Principles of Infant Analysis' (1926), and 'The Psycho-Analytic Play Technique: Its History and Significance' (1955), both in *The Selected Melanie Klein*, ed. J. Mitchell, Penguin, Harmondsworth, 1986; 'Personification in the Play of Children' (1929), in M. Klein, *Contributions to Psycho-Analysis 1921–45*, Hogarth Press/Institute of Psycho-Analysis, 1948; *The Psycho-Analysis of Children*, Hogarth Press/Institute of Psycho-Analysis, 1949.

31 Klein, 'Psycho-Analytic Play Technique', pp. 51–2.

32 M. Klein, 'Love, Guilt and Reparation', in M. Klein and J. Riviere, *Love, Hate and Reparation*, Hogarth Press/Institute of Psycho-Analysis, 1937, pp. 96–8.

33 Klein, *Psycho-Analysis of Children*, pp. 215–16.

34 See Chapter 2, pp. 46–8 above. For arguments linking war play and aggression, see Chapter 1, above.

35 Klein, 'Psycho-Analytic Play Technique', pp. 38–41. Later, Klein allowed the children to bring their own toys. H. Segal, *Introduction to the Work of Melanie Klein*, Hogarth Press, 1973, p. 44, describes the therepeutic aim as 'the analysis of the internal figures composing the super-ego, [and] the resolution of anxiety and guilt connected with these figures . . . aimed at diminishing its severity, [and allowing] a strengthening and better development of the ego'. See also Klein, 'Psychological Principles', pp. 62–3.

36 Cohen, 'Gender Rules OK?', p.180.

37 For an account of transference at work in everyday adult social relationships, see I. Salzberger-Wittenberg, *Psychoanalytic Insight and Relationships: A Kleinian Approach*, Routledge & Kegan Paul, 1970.

38 In a manner comparable to psychoanalysis itself, the responses of an other who is not involved in the process in the same way – in this case, the friends and colleagues who have read and discussed my writing with me – has proved indispensable to the research process, in helping to generate a critical perspective and often as a catalyst for insight. I am particularly grateful for discussions in the Popular Memory Group at the Centre for Contemporary Cultural Studies, University of Birmingham, and with Alistair Thomson and Dorothy Sheridan.

39 *Zulu*, dir. C. Endfield, Paramount, UK, 1964.

40 The following section draws from a longer, more detailed autobiographical study of forms of war toy, story and play, in G. Dawson, 'Soldier Heroes and Adventure Narratives: Case Studies in English Masculine Identities from the Victorian Empire to Post-Imperial Britain', doctoral thesis, University of Birmingham, 1991, pp. 428–64.

41 J. Batsleer, T. Davies, R. O'Rourke, C. Weedon, *Rewriting English: The Cultural Politics of Gender and Class*, Methuen, 1985, p. 76. For the form and ideology of children's comics, see Dixon, *Catching Them Young*, pp. 1–55; M. Barker, *Comics: Ideology, Power and the Critics*, Manchester University Press, Manchester, 1989. For D. C. Thomson, see J. M. MacKenzie, *Propaganda and Empire: The Manipulation of British Public Opinion 1880–1960*, Manchester

University Press, Manchester, 1984, pp. 218–19. For the blurring of fiction and history, see Chapter 5, pp. 146–7 above.

42 G. Dawson and B. West, 'Our Finest Hour? The Popular Memory of World War Two and the Struggle over National Identity', in G. Hurd, (ed.), *National Fictions: World War Two on Film and Television*, BFI Publishing, 1984. See also R. Bromley, *Lost Narratives: Popular Fiction, Politics and Recent History*, Routledge, 1988, especially pp. 157–88.

43 *The Victor Book For Boys 1967*, D. C. Thomson, 1966.

44 ibid., pp. 5–16. See Chapter 8, pp. 228–9 above. For the campaign in the desert, see D. Fraser, *And We Shall Shock Them: The British Army in the Second World War*, Sceptre, 1988, pp. 113–30.

45 See Marwick, *British Society*, pp. 64–101.

46 L. Davidoff and C. Hall, *Family Fortunes: Men and Women of the English Middle Class 1780–1850*, Hutchinson, 1987, and see Chapter 3, above.

47 See Chapter 1, pp. 22–3 above.

48 See note 4, above.

49 *Bugles in the Afternoon*, William Cagney/Warner Brothers, USA, 1952.

50 Green, *Dreams of Adventure*, pp. 82–3, and see p. 176 above. For Harkaway, see Chapter 8, above.

51 For paranoid-schizoid persecution anxieties, see Chapter 2, above. For the punitive super-ego, see Segal, *Klein*, pp. 43–4; Klein, 'Personification', pp. 219–20. For Klein's reformulation of the Oedipus Complex, see Segal, *Introduction*, pp. 103–16.

52 See Chapter 2, pp. 40–2 above.

53 Segal, *Introduction*, p. 84. See above, Chapter 2, for my discussion of triumphalist phantasies; Chapter 4 for evidence of these structures in the narratives of the Indian Rebellion; and Chapter 6 for their appearance in Thomas's version of Lawrence.

54 See Chapter 2 for my discussion of Klein's concept of depressive anxiety; Chapter 7 for its appearance in Lawrence's *Seven Pillars of Wisdom*; and Chapter 8 for its treatment in Lean and Bolt's *Lawrence of Arabia* film.

55 See Chapter 3 for my discussion of the contradictory relations between the 'domestic imaginary', masculinity and adventure.

10 Self-imagining

1 See P. Wollen, 'Do Children Really Need Toys?', M. Hoyles (ed.), *Changing Childhood*, Writers and Readers, 1979.

2 See M. Klein, 'Personification in the Play of Children', *Contributions to Psycho-Analysis 1921–45*, Hogarth Press/Institute of Psycho-Analysis, 1948.

3 For a study of the impact of power relations upon the recognition of children by parents, see V. Walkerdine, 'Video Replay: Families, Films and Fantasies', in *Schoolgirl Fictions*, Verso, 1990.

4 M. Cohen, 'Gender Rules OK?', in Hoyles, *Changing Childhood*, p. 182.

5 In workshop discussions of earlier drafts of this chapter, a surprising number of women remembered girlhood desires in the 1950s and 1960s to 'be a cowboy', and their thwarting, for no other reason than that they were girls, as a traumatic moment of misrecognition. Exclusions of this kind may become part of the taken-for-granted order of things for boys.

6 The following analysis is derived from a more detailed account of boy culture in and out of school, in G. Dawson, 'Soldier Heroes and Adventure Narratives: Case Studies in English Masculine Identities From the Victorian Empire to

Post-Imperial Britain', doctoral thesis, University of Birmingham, 1991, pp. 473–91.

7 I have been influenced here by Paul Willis's work on the cultures of masculinity among older boys and young adults. See P. Willis, *Learning to Labour: How Working Class Kids Get Working Class Jobs*, Saxon House, Farnborough, 1977; 'Male School Counterculture', in Open University (U203), *The State and Popular Culture One*, Open University, Milton Keynes, 1982.

8 These classic themes of boy culture – involving a transplanting of the Crusoe story from Empire to English rural neighbourhood – are explored in B. B.'s children's story, *Brendon Chase*, Ernest Benn, 1968. I am grateful to Bob West for sharing and analysing his memories of 'Harding's Wood' with the Popular Memory Group during our autobiographical work together.

9 The history of childhood suggests that its vaunted freedoms have always been closely circumscribed by class and gender inequalities. See Hoyles, *Changing Childhood*; S. Firestone, *The Dialectic of Sex: The Case For Feminist Revolution*, Paladin, St Albans, 1972, pp. 73–102; L. Davidoff and C. Hall. *Family Fortunes: Men and Women of the English Middle Class 1780–1850*, Hutchinson, 1987, pp. 343–8, 385–8, 403–5. With the increasing perception of dangers posed to unsupervised children in public spaces in the 1980s and 1990s, it seems likely that the freedom of independent mobility enjoyed by children is currently undergoing a further historical shift.

10 There is some documentary evidence of this in school reports, which had once worried about me as a classroom 'daydreamer', but now registered my energetic participation in most activities at school.

11 See Chapter 2, pp. 41–2 and note 40 above.

12 See the analyses of 'masculine' and 'feminine' romance in J. Batsleer, T. Davies, R. O'Rourke, C. Weedon, *Rewriting English: The Cultural Politics of Gender and Class*, Methuen, 1985, pp. 70–105; and my summary in Chapter 3, pp. 63–4 above.

13 See A. Marwick, *British Society since 1945*, Penguin, Harmondsworth, 1982, pp. 114–85.

14 C. S. Forester, *The Happy Return*, Penguin, Harmondsworth, 1951; *A Ship of the Line*, Michael Joseph, 1938; and *Flying Colours*, Penguin, Harmondsworth, 1951. For Forester's debt to G. A. Henty, see J. M. MacKenzie, *Propaganda and Empire: the Manipulation of British Public Opinion, 1880–1960*, Manchester University Press, Manchester, 1984, p. 220.

15 Cf. the use of martial rank to symbolize the internal world and its conflicts in the naval officer's dream quoted at the head of Part IV above; and the significance of rank in both adventure stories and my play-fantasies, Chapter 9, pp. 246, 251, 254 above.

16 Forester, *Ship of the Line*, pp. 38–9.

17 ibid., p. 39. All these themes can be found ibid., pp. 7–20.

18 C. S. Forester, *Lord Hornblower*, Penguin, Harmondsworth, 1964.

19 See *Ship of the Line*, pp. 8, 42–3; C. S. Forester, *Hornblower and the Atropos*, Companion Bookclub edition, no date, pp. 34–50; C. S. Forester, *Hornblower and the Hotspur*, Penguin, Harmondsworth, 1968, pp. 5–26.

20 See the contrast established in, for example, *Ship of the Line*, pp. 26–39.

21 Forester also wrote *Nelson: A Biography*, Bodley Head, 1929 – a further instance of the intertwining of biographical and fictional narratives that has interested me throughout this book.

22 For the counter-culture in Britain, see E. Nelson, *The British Counter-Culture 1966–73: A Study of the Underground Press*, Macmillan, 1989; D. Glover, 'Utopia and Fantasy in the Late 1960s', in C. Pawling (ed.), *Popular Fiction and Social Change*, Macmillan, 1984, pp. 185–211. Among its key texts were H. Hesse, *Steppenwolf*, Penguin, Harmondsworth, 1965; H. Hesse, *The Glass Bead*

Game, Penguin Books, 1972; J. R. R. Tolkien, *The Lord of the Rings*, George Allen & Unwin, 1968.

23 For feminism and the counter-culture, see J. Mitchell, *Women's Estate*, Penguin, Harmondsworth, 1971; R. Morgan, 'Goodbye to All That', in J. C. Albert and S. E. Albert (eds), *The Sixties Papers: Documents of a Rebellious Decade*, Praeger, New York, 1984; M. Wandor (ed.), *The Body Politic: Writings from the Women's Liberation Movement in Britain 1969–72*, Stage 1, 1972. For Lennon, see H. Kureishi, 'Boys Like Us', *The Guardian* (Weekend supplement), 2–3 Nov. 1991, pp. 4–7. For Bowie, Bolan and the 'gender-bending' styles of 1970s glam-rock, see D. Hebdige, *Subculture: The Meaning of Style*, Methuen, 1979. The phrase 'playpower' was used by Richard Neville, an editor of the underground magazine, *Oz*, to describe an alternative to the work ethic governing 'straight society'. Neville became one of my new heroes during the famous 'Oz Trial' in summer 1971, when he and the other editors were charged with conspiracy to corrupt the public morals. I followed developments on television, and was scandalized when Neville's hair was forcibly cut while he was on remand. See R. Neville, *Playpower*, Paladin, St Albans, 1971; and T. Palmer, *Trials of Oz*, Blond & Briggs, 1971.

24 For the peace movement, including opposition to the Vietnam War, see C. Harman, *The Fire Last Time: 1968 and After*, Bookmarks, 1988.

25 A. Maclean, *The Guns of Navarone*, Fontana, 1959; T. Leary, *The Politics of Ecstasy*, Paladin, St Albans, 1969.

26 See Chapter 2, pp. 43–4 above.

27 See Chapter 9, pp. 243–4 above.

28 See Dawson, 'Soldier Heroes', pp. 481–4, for examples.

29 Ngũgĩ wa Thiong'o, 'Ambivalent Feelings about Biggles', *The Guardian*, 13 Aug. 1992. For an ideological analysis of Biggles, see B. Dixon, *Catching Them Young 2: Political Ideas in Children's Fiction*, Pluto, 1977, pp. 105–10.

30 See Margaret Thatcher, Speech to a Rally at Cheltenham Racecourse, 3 July 1982, discussed in Chapter 1, above.

Afterword

1 S. Frosch, *The Politics of Psychoanalysis: An Introduction to Freudian and Post-Freudian Theory*, Macmillan, 1987, p. 127.

2 For the white feather, see M. Ceadel, *Pacifism in Britain 1914–1945: The Defining of a Faith*, Oxford University Press, Oxford, 1980; and the fictional treatment of its impact in A. E. W. Mason, *The Four Feathers*, John Murray, 1902. For accusations of treachery levelled against the BBC, and Labour MPs Tony Benn and Tam Dalyell, during the Falklands-Malvinas War, see R. Harris, *Gotcha! The Media, the Government and the Falklands Crisis*, Faber & Faber, 1983, pp. 50–1, 75, 81–2.

3 For the SAS, see note 23 to Chapter 9. For recent war toys, see G. Dawson, 'War Toys', in G. Day (ed.), *Readings in Popular Culture: Trivial Pursuits?*, Macmillan, 1990, pp. 104–8.

4 *The Guardian*, 13 Aug. 1990; *Khartoum*, dir. B. Dearden, United Artists, USA/UK, 1966.

5 For Michael Ryan, perpetrator of 'the Hungerford massacre' in 1987, see the report in *The Guardian*, 21 Aug. 1987, p. 1, '"Mummy's Boy" Who Kept Armoury in Garden Shed': 'The Rambo figure that burst on to the small market town's streets wearing a headband and paramilitary gear and with guns blazing from each hand may have been the man Ryan saw in his fantasies, but there was nothing aggressive or heroic about him in reality.' For analyses of Ryan in terms

of war fantasies and imagined masculinities, see R. Coward, 'The Killing Games', *The Guardian*, 1 Sept. 1987; J. Rutherford, *Men's Silences: Predicaments in Masculinity*, Routledge, 1992, pp. 173–94. For domestic violence, see L. Segal, *Slow Motion: Changing Masculinities, Changing Men*, Virago, 1990, pp. 254–61; L. Smith, *Domestic Violence: An Overview of the Literature*, HMSO, 1989.

6 Margaret Thatcher, Speech to a Conservative Rally at Cheltenham Racecourse, 3 July 1982, quoted in A. Barnett, *Iron Britannia: Why Parliament Waged Its Falklands War*, Allison & Busby, 1982, pp. 149–53, with Barnett's commentary: 'Thatcher's rejoicing in military victory as the beginning of the Great British renaissance reveals, then, an almost uncontrolled nostalgia' (pp. 79–80).

7 See Chapter 2, pp. 40–3 above.

8 M. Rustin, 'A Socialist Consideration of Kleinian Psychoanalysis', *New Left Review*, 131, 1982, pp. 71–96.

9 For Klein on colonialism, see Chapter 2, pp. 45–6 above. For British policy in India after 1858, see F. G. Hutchins, *The Illusion of Permanence: British Imperialism in India*, Princeton University Press, Princeton, NJ, 1967, pp. 79–100. Paul Keating is quoted in *The Guardian*, 13 Oct. 1993, p. 24 (g/h). The Keating Government's subsequent backtracking over its controversial legislation granting land-rights to Aboriginals underlines the importance of transformative practice, if reparation is to become something other than a mere fantasy. I am grateful to Alistair Thomson for discussion on this point.

10 K. Marx, *Economic and Philosophic Manuscripts of 1844*, Lawrence & Wishart, 1959, pp. 90–101; *Capital*, vol. I, Lawrence & Wishart, 1974, pp. 488, 592; 'Preface to *A Contribution to the Critique of Political Economy*', in K. Marx and F. Engels, *Selected Works in One Volume*, Lawrence & Wishart, 1968, pp. 181–2. See also F. Engels, 'Socialism: Utopian and Scientific', ibid., 424–6.

11 For the articulation of a new 'politics of culture and identity' influenced by postmodernism, see, for example, J. Rutherford (ed.), *Identity: Community, Culture, Difference*, Lawrence & Wishart, 1990. For a critique of postmodernist conceptions of subjectivity and cultural politics, see A. Callinicos, *Against Postmodernism: A Marxist Critique*, Polity Press, Cambridge, 1989; C. Norris, *Uncritical Theory: Postmodernism, Intellectuals and the Gulf War*, Lawrence & Wishart, 1992.

12 See G. Turner, *British Cultural Studies: An Introduction*, Unwin Hyman, 1990, pp. 24–9, 197–215; P. Brantlinger, *Crusoe's Footprints: Cultural Studies in Britain and America*, Routledge, 1990, pp. 68–107.

13 J. R. Greenberg and S. A. Mitchell, *Object Relations in Psychoanalytic Theory*, Harvard University Press, Cambridge, Mass., 1983, p. 134; Marx, *Capital*, p. 174.

14 *The Last of the Mohicans*, Morgan Creek International/Warner Brothers, USA, 1992; J. Fenimore Cooper, *The Last of the Mohicans*, Penguin, Harmondsworth, 1986 (first pub. 1826).

15 S. Sontag, *The Volcano Lover: A Romance*, Vintage, 1993 (first pub. 1992).

16 For hybridity, see H. K. Bhabha, 'Signs Taken for Wonders: Questions of Ambivalence and Authority under a Tree outside Delhi, May 1817', in H. L. Gates (ed.), *'Race', Writing and Difference*, University of Chicago Press, Chicago, 1990; S. Hall, 'The Local and the Global: Globalization and Ethnicity', in A. D. King (ed.), *Culture, Globalization and the World System*, Macmillan, 1991; R. Young, *White Mythologies: Writing History and the West*, Routledge, 1990, pp. 141–56; *New Formations* 18, Winter 1992, 'Hybridity' issue. On fiction and hybridity, see also S. Rushdie, *Is Nothing Sacred?* (The Herbert Read Memorial Lecture, 1990), Granta, 1990; M. Bakhtin, *The Dialogic Imagination*, University of Texas Press, Austin, 1983.

17 S. Rushdie, *The Satanic Verses*, Viking-Penguin, Harmondsworth, 1988.

INDEX

Page references in *italic* refer to figures.

Lightning Source UK Ltd.
Milton Keynes UK
UKOW06f1214010715

254396UK00003B/14/P